Munch
and
Women
Image
and
Myth

Munch
and
Women
Image
and
Myth

Patricia G. Berman
Jane Van Nimmen

with a foreword
by Sarah G. Epstein

Art Services International
Alexandria, Virginia
1997

This volume accompanies an exhibition organized
and circulated by Art Services International,
Alexandria, Virginia.
Copyright © 1997 Art Services International.
All rights reserved.

Library of Congress Cataloging-in-Publication Data
Berman, Patricia G.
 Munch and women : image and myth / Patricia G.
Berman, Jane Van Nimmen ; with a foreword by Sarah G.
Epstein
 p. cm.
 Catalog accompanying an exhibition organized
and circulated by Art Services International.
Includes bibliographical references and index.
 ISBN 0-88397-121-6
 1. Munch, Edvard, 1863–1944—Exhibitions.
2. Women in art—Exhibitions. 3. Epstein family—art
collections—Exhibitions. 4. Prints—Private collections—
Washington (D.C.)—Exhibitions, I. Van Nimmen, Jane,
1937– . II. Art Services International. III. Title.
NE694.M8A4 1997 96-29322
769.92—dc20 CIP

Editor	Jane Sweeney
Indexer	Trudi Olivetti
Designer	The Watermark Design Office
Printer	Dai Nippon Printing

Cover	cat. 20, *Madonna* (detail)
Frontispiece	cat. 35, *To the Forest* (detail)

ISBN 0-88397-121-6
Printed and Bound in Hong Kong

Participating Museums

San Diego Museum of Art
Portland Art Museum, Oregon
Yale University Art Gallery

Photo Credits

Dean Beasom, figs. 4, 5, 24, cat. ills. 31, 70; Ebbe Carlsson,
Göteborgs Konstmuseum, fig. 7; Tim Druckrey, fig. 5; Zeki
Findikoglu, cat. ills. 39 (top), 57; Harvard University Libraries,
fig. 11, cat. ill. 39 (bottom); Fotograf Henriksen a.s., figs. 1, 6;
© 1996 J. Lathion, Nasjonalgalleriet, Oslo, figs. 9, 12, 13, 14,
19, cat. ills. 2, 6, 36, 42; © Oslo Kommunes Kunstsamlinger,
figs. 2, 3, 8, 15, 17, 18, 22, cat. ills. 43, 51, 52, 63, 64; Photo
24, Inc., fig. 16.

Table of Contents

Acknowledgments

The Norwegian artist Edvard Munch has had the misfortune of being labeled a woman-hater. Tempering that myth is the mission of this catalogue and the accompanying exhibition. The pages that follow provide extensive evidence of Munch's varied relationships with women who were members of his family, friends, lovers, patrons, and subjects of his work. Some of these alliances were loving, some were social, and at least one passion ended in bitter tragedy. *Munch and Women: Image and Myth* places the artist's friendships into a unified perspective, belying that myth that Munch was a mysogynist.

We are sincerely grateful to Sarah G. Epstein and the Epstein Family Collection for so generously lending the seventy-one prints and drawings included in this exhibition. As the second exhibition tour that Art Services International has organized from the collection, its wealth is apparent. We particularly salute Sally Epstein's lifelong devotion to collecting Munch's graphic art and her dedication to educating the public about Edvard Munch.

With much enthusiasm, we applaud the scholarship and dedication of Patricia G. Berman, Associate Professor of art at Wellesley College. Her sensitive selection of the prints and drawings clearly illustrates the multifaceted nature of Munch's alliances with women. Through her insightful essay and catalogue entries—which examine the artist's family, circles of friends, and artistic and intellectual influences, both male and female—she has outlined for the public the sources of the myths by which Munch has been misunderstood. Her scholarship will help correct the conceptual basis by which Munch is appreciated. Jane Van Nimmen, a long-time curator of the Epstein Family Collection and Munch author, has enumerated Munch's female patrons, connoisseurs, and interpreters in her essay and has also shed new light on the appreciation of Munch by female scholars in her essay's bibliographic appendix. We congratulate her careful research.

We are pleased to acknowledge the Honorary Patron of the exhibition, His Excellency Tom Vraalsen, Ambassador of the Kingdom of Norway. Ambassador Vraalsen has, from the outset, been most supportive of our efforts to cast new light on the work of Norway's best-known expressionist artist. We send a special note of thanks to Eivi Homme, Counselor for Press and Cultural Affairs of the Embassy of the Kingdom of Norway, for being so generous with his assistance.

The enthusiasm of museums across the United states has made this study of Edvard Munch possible. We extend our gratitude to Steven L. Brezzo, Director of the San Diego Museum of Art, John E. Buchanan, Jr., Director of the Portland Art Museum, Oregon, and Susan M. Vogel, Director, Yale University Art Gallery, for sharing *Munch and Women: Image and Myth* with their audiences. Through their collaboration, a much wider public will come to appreciate, better understand, and enjoy the work of Edvard Munch.

We are pleased to recognize the assistance we have received from the staff of the Epstein Family Collection, notably Vivi Spicer and Jeanne Kendig, as well as the professional team who have turned the manuscripts into such a polished catalogue: Jane Sweeney, editor, Lynne and Don Komai of the Watermark Design Office, and Becky Bunting of Dai Nippon Printing, New York. In their usual fashion, the staff of Art Services International have done an excellent job of handling the myriad details of the exhibition and catalogue. Ana Maria Lim, Douglas Shawn, Donna Elliott, Betty Kahler, Sally Thomas, Mina Koochekzadeh, and Patti Bruch should once again be credited.

Art Services International takes great pleasure in presenting *Munch and Women: Image and Myth,* which would have been impossible without the assistance and good will of these and numerous others who have generously given their time and effort to this exciting and important venture.

Lynn K. Rogerson
Director

Joseph W. Saunders
Chief Executive Officer

Art Services International

Foreword

Sarah G. Epstein

Edvard Munch, *Summer Night (The Voice),* (detail), 1895, aquatint and drypoint. Epstein Family Collection

As a collector of Edvard Munch's graphic art, I have always felt an affinity for the women who knew him, his family members, friends, lovers, and female patrons. Little did I know in 1950, when a friend invited me to see the work of an unknown "modern" artist at the Boston Institute of Contemporary Art, that I would become a life-long admirer and collector of the work of the Norwegian artist Edvard Munch. When I saw that first American retrospective exhibit of his work, I was swept off my feet. As a graduate student at Simmons School of Social Work, I was fascinated by Munch's portrayal of the same situations facing patients in my fieldwork: jealousy, the deaths of children and parents, anxiety, sexuality, compassion, and love. I saw, too, my own dilemmas portrayed in his art. I could easily be the young woman in *Summer Night,* aware of the loving couple being rowed on the fjord in moonlight, yearning for a lover of my own. The exhibition catalogue by the Harvard University professor Frederick B. Deknatel taught me that Munch was portraying his own life. I felt a great sense of sympathy and understanding for him. He became my artist for life!

My former husband, Lionel Epstein, had also seen the Boston exhibition. In 1962, when he and I visited Norway, we saw Munch's art in museums and in the homes of Norwegian friends. Our enthusiasm for Munch was revitalized. That fall, more than eighty Munch prints went on view in New York at the Allan Frumkin Gallery. They had been originally assembled by J. B. Neumann, a German art dealer, and were later acquired by the German architect Ludwig Mies van der Rohe (finally they went to the Art Institute of Chicago). Frumkin also had in stock five Munch prints that had belonged to the architect Gene Summers, a former student and then associate of Mies'. Lionel negotiated to buy three of the Summers prints, which launched us on a long and exciting career as collectors.

Munch's graphics were readily available in the 1960s, when the bulk of the Epstein Family Collection was purchased. For each of our five children we bought additional prints of their favorite images in our collection because, like Munch, we wished to keep all our prints together as a "teaching" collection, yet wanted the children to enjoy meaningful art. The Epstein Family Collection and its library are now promised gifts to the National Gallery of Art in Washington.

Munch wanted to depict "a mirror of life" in his works, thereby helping viewers understand that life is a continuous cycle of many emotions. Through the years, I found I wanted to know as much as possible

about this artist who was so sensitive to the human condition. In 1979, I interviewed Adele Ipsen, the daughter of Munch's friends Harald and Aase Nørregaard. She told me how much she and her brother enjoyed visits with the artist. He always joked and played with them, but they did not like his friend Tulla Larsen, who tried to entice their approval with chocolates. Once, Adele reported, while watching him paint the portrait of a family friend, Christian Sandberg, Munch painted clowns, dragons, and other playful motifs in the foreground to amuse the children hovering around him. Of course, these were painted out in the final work. Adele remembered Munch telling her parents that the house with gingerbread trim that they were thinking of buying looked as if it needed a shave. She believed that as a young man Munch was seriously in love with her mother, a fellow artist. By the end of the interview, I was convinced that Munch was not the misogynist some historians have presented.

I have recorded more than ninety interviews, many with people who had known Munch. My subjects were his relatives, older Norwegians who could describe the customs and culture of the artist's epoch, members of families who had collected his work, Norwegian artists, and others influenced by Munch. I learned to view Munch as someone who faced tragedies in his life by sharing them through his art. I learned he was devoted to his aunt and siblings, dedicated to his work, and held an intense interest throughout his life in maintaining friendships with both men and women. I began to understand how he felt that his art, his "goddess," came first, why he would protect himself in later years from being constantly interrupted, and why, having lost his mother and favorite sister when young, he might be afraid of a dependent relationship with any woman. I was fortunate to interview three of his models and learn that he treated them with courtesy and respect. Those I interviewed about their portraits confirmed a warm, friendly relationship with Munch. Munch's portraits of women are neither distorted nor formulaic; each reveals her special character.

Through my research, I have met a number of female Munch scholars and have never encountered one who felt that Munch was a "woman hater." With female scholars, I have enjoyed an open and free exchange of information about the artist and our feelings about him as a person. It has long been my hope to present an exhibition such as this, which examines the misunderstandings that have colored Munch's reception and which focuses on women Munch knew or women who have studied his work or collected his art. I trust that viewers will leave this exhibition with a more rounded view of an artist who has so often been stereotyped by his images of *Harpy* and *Vampire* (which Munch called "Loving Woman" or "Love and Pain") or the popular and now universally known image, *The Scream*.

I wish to thank Patricia G. Berman and Jane Van Nimmen for their impeccable scholarship and for their interesting and enlightening perspectives on Munch. I extend my deepfelt gratitude to Art Services International and my personal staff, especially Vivi Spicer, without whom this exhibition would never have been possible. I can never thank enough my many friends, gained through an association with Munch, who have enriched my life beyond belief, and my wonderful family, who have supported and encouraged my journey with Munch and his "goddess art."

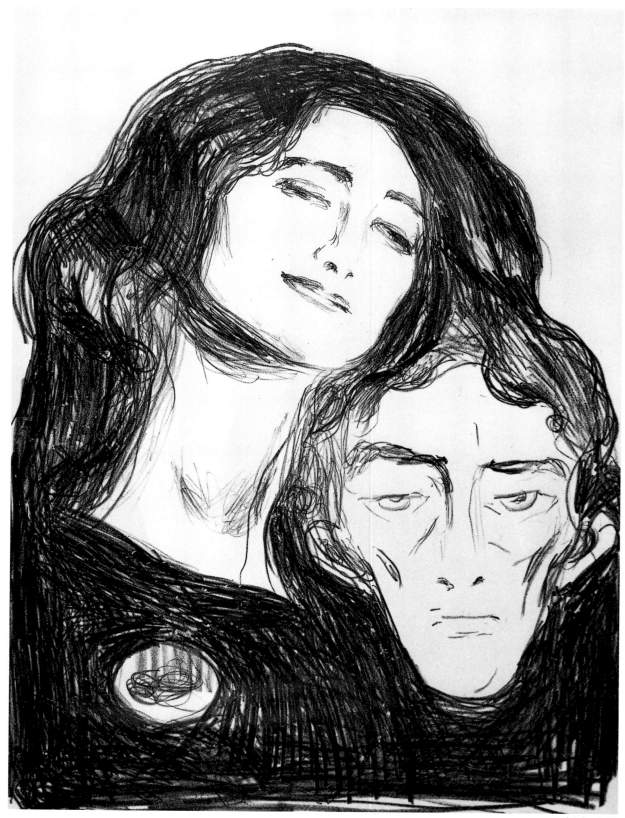

detail, cat. 61

Edvard Munch: Women, "Woman," and the Genesis of an Artist's Myth

Patricia G. Berman

Edvard Munch's representations of women have been among the most overexamined and underinterrogated images in the formidable literature on the artist (1863–1944). Moreover, they serve as cornerstones in studies of the fin de siècle. Munch's popular reputation rests in part on his brilliant formal innovations as a painter and a printmaker and in part on his deeply troubling images of women and pessimistic commentaries on sexuality. The pairing of innovation and sexuality in his work is in fact a trope of early modernism.[1] In this light, Munch has long been portrayed as both a relentless misogynist and an isolated genius, one of the chief architects of the turn-of-the-century femme fatale. In this role, he had the distinction of being featured in two articles in Linda Nochlin and Thomas Hess' landmark 1972 anthology *Woman as Sex Symbol*[2] and of serving, via such images as *Vampire* (cat. 30) and *Death and the Maiden* (cat. 18), as a virtual embodiment of fin-de-siècle misogyny and pessimism. Although the bitterness of some of his images and the sense of despair that they narrate support this view (see *Harpy*, *Ashes II*, and *Maiden and the Heart*, cats. 15, 26, and 28), an acknowledgement of Munch's broader production and an analysis of the artist's critical reception reveal its mythic dimensions.

Munch's representations of women are frequently conflated in the critical literature with his representations of "Woman." A turn-of-the-century literary and artistic trope, Woman was the collective invention of a male cultural imagination. An essentializing, timeless, and at times malevolent being, Woman was a stereotype that erased the complexity and diversity of women. Deployed by male intellectuals as a way of negating women's claims to increasing social and economic geography, Woman sexualized and silenced the cultural presence of real women. In Reinhold Heller's words, Woman was shaped by male "subconscious desires, fears and anxieties that became self-perpetuating," rather than by "the experience of real women."[3] Woman was a myth that devitalized and replaced women's lived experiences.

To locate Munch's representations of women solely in relation to Woman is to mythologize the artist. There is no question that, for several years, Munch was preoccupied by Woman as a theme in his work. As Wendy Slatkin has noted, Munch's work both shaped and was shaped by the antipathy toward women expressed in much Symbolist art and literature.[4] However, Munch also represented women as social types—mothers, laborers, New Women—and, more important, as individuals. As Kristie Jayne noted in 1989, the roles that Munch assigned women in his imagery were, in part, socially determined and not the invention of a uniquely misogynist imagination. Jayne also made the important observation that in portraits of the women with whom Munch was closest, his subjects appear individualized and assertive.[5] Sarah G. Epstein even proposed that the exuberance of such portraits as Munch's 1902 portrait of Aase Nørregaard (fig. 1) belies Munch's notoriety as a misogynist.[6]

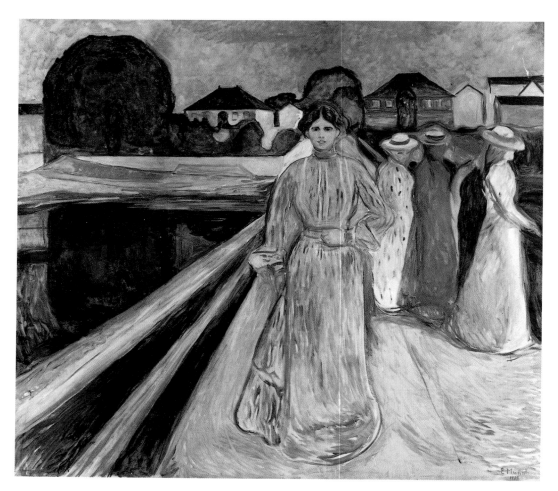

fig. 1. Edvard Munch, *Women on the Bridge (Aasa Nørregaard)*, 1902, oil on canvas. Bergen Billedsgalleri

Munch's reputation as a loner and a misogynist was initiated in part by the critical rhetoric of the artist's male colleagues in the 1890s, reinforced by key biographies written in the mid-twentieth century, and perpetuated by the publication and exhibition of a limited range of the artist's works. In this light, it is the aim of this study to provide a more nuanced view of the artist's representations of women by examining his best-known and most overtly sexualized images in the broader context of his work. It is neither the intention of this catalogue to "rehabilitate" Munch as a feminist trapped in the rhetoric of gynophobia nor to remove entirely from Munch the taint of misogyny. Nor does this essay apply psychoanalytic interpretations to Munch's representations of women, recapitulate his life story in an attempt to relocate his motifs in light of his biography, or propose an iconographic reading of Munch's Woman/Women. The literature on Munch is already strongly canted in this direction.[7]

This essay first examines the critical constructions of Munch, and of his "Woman," in the first decades of his career. It then considers the social environment within which Munch worked, particularly the increasingly unstable ways in which sexuality and gender were understood in the 1890s, as a frame both for his representations of women and for the meanings that his contemporaries invested in them. And it also suggests that many of Munch's representations of women from the 1890s are dialectical, and that Munch's "Woman/Women" may have been

more complicated in terms of the politics of gender than they at first appear.[8] In the period of what Elaine Showalter terms "sexual anarchy"—in which new constructions of femininity and masculinity arose with the New Woman and the decadent man; when public debates over marriage, prostitution, and syphilis entered discourses about sexuality; in which cultural insecurity was so strongly linked to anxieties about degeneration[9]—Munch emerged not so much as the reactionary priest of the femme fatale as a chronicler of gender crises.

The brutality of such images as *Harpy* (cat. 15) notwithstanding, Munch's conceptions of women, taken as a whole, are far less virulent and overtly stereotyping than those of many of his contemporaries.[10] Why, then, is Munch's oeuvre often represented by such a narrow repertory of images, and why are these typically identified as femmes fatales, women whose seductive charms imperil or annihilate men? Munch's seeming preoccupation with the femme fatale[11] has been identified with his painting series the Frieze of Life, perhaps alluding to a stronger reading of the fatal woman than the images themselves, or the series, might suggest. The Frieze of Life, which Munch initiated in 1893 and exhibited in several variations through the late 1920s, created a consistent and mutable frame of reference within which to read several of his individual motifs (fig. 2).[12] Despite the fact that Munch was active as an artist from the early 1880s through the mid-1940s, he is best known for his initial images that formed the Frieze of Life—*The Voice* (1893, Museum of Fine Arts, Boston), *The Kiss* (see cat. 31), *Vampire* (1893, Göteborgs Konstmuseum, see cat. 30), *Madonna* (see cats. 19 and 20), *Melancholy* (a variant is represented in cat. 39), and *The Scream* (1893, Nasjonalgalleriet, Oslo).

In March 1893, Munch explained to the Danish painter Johan Rohde that he was attempting to shape a kind of pictorial narrative through his paintings: "I am currently occupied with making a series of paintings. Many of my paintings already belong to it. . . . Up to now, people have found these quite incomprehensible. When they are seen together, however, I believe they will be more easily understood. Love and death is the subject matter."[13] Munch gave this painting series the titles Studies for a Series on Love (1893), Series: Love (1895), Love and Death

fig. 2. Edvard Munch exhibition, P. H. Beyer & Son, Leipzig, 1903. Photograph, Munch Museum, Oslo

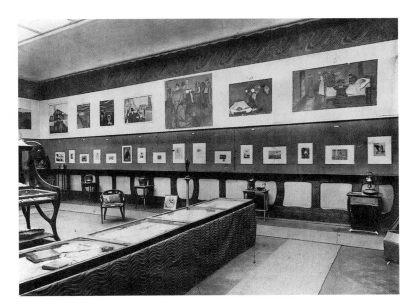

(1902), From the Modern Life of the Soul (1902), and, later, the Frieze of Life (1918). Nowhere did he exhibit the series with an overt reference to a "battle" between the sexes per se, but he narrated a gulf between men and women that he filled with ennui, frustration, loss, fulfillment, and yearning.[14] In Munch's words, "The Frieze is conceived as a series of paintings which taken together present a picture of life. . . . beneath the trees is life in all its fullness, its joys and sufferings. The Frieze is a poem of life, love, and death."[15] In addition, in 1897 Munch began to work on a related series of graphic works, which he entitled The Mirror. First abandoning the project and then resuming it in 1899, Munch attempted to expand the narrative possibilities of his painting series by probing his old motifs and inventing new ones.[16] So revolutionary were the Frieze of Life and The Mirror as narrative devices that Munch's entire body of work tends to be read as a continuous novel, in which all of his motifs are understood to be interdependent and mutually referencing. Many of his motifs are also read through the filter of Love and Death.

Many of Munch's motifs are also received as exclusive reflections of or testimonies to his own experiences. Indeed, few artists seem to present their public with as complete a union between their lives and their art as Edvard Munch. By seemingly representing himself, his family, and his friends as the protagonists of emblematic visual dramas, Munch, more than virtually any artist of the turn of the century, suggests the eradication of the boundary between private experience and public image. Munch left behind a prodigious body of work in painting and in the graphic arts. He also left behind vast writings, voluminous correspondence,[17] and comprehensive interviews that serve as the basis of biographies. The seemingly self-confessional nature of his images and his writings suggests that his art and his life are not only analogous, but that they are also homologous.

As Munch's biographers have chronicled, the artist's life provided rich and tragic source material for such a reading. Born into a distinguished Norwegian family in 1863, Munch lost his mother to tuberculosis when he was five and his beloved sister Sophie to the same disease nine years later. Raised by a pietistic and socially conscious father and by his mother's unmarried sister, Karen Bjølstad (1839–1931), Munch was a sickly child who grew into a complex, cerebral adult. Many of his most wrenching images recapitulate his traumatic childhood memories, such as The Dead Mother and Her Child (cat. 5) and Death Chamber (cat. 4). Munch's biographers also chronicle a succession of unhappy love affairs that left the artist emotionally, and in one case physically, scarred (see Death of Marat, cat. 44).

In his writings and in his interviews with biographers and others, Munch stated that his art was founded in his own experience and was made even more personal by being filtered through memory: "I do not paint what I see—but what I saw."[18] One of Munch's writings, which has come to be viewed as his manifesto, articulated his urgently felt desire to identify and represent experiences that are at once intimate and universal: "No longer will interiors and people reading and women knitting be painted. There shall be living people who breathe and feel and suffer and love. . . . People will understand that which is sacred in them and will take off their hats as if they were in church."[19] Anchoring such an ambition in his most intimate sensations, he stated: "All art, literature and music must be brought forth with your heart's blood. Art is your heart's blood."[20]

fig. 3. Asta Nørregaard,
Portrait of Edvard Munch,
1885, pastel. Munch
Museum, Oslo

Further, in a gender reversal of historical writing, Munch's critics have in many ways defined the artist in terms of the legacies of his sexual affairs. Because Munch wrote so extensively about his anxieties, and because his known sexual relationships with several women can be directly linked to some of his oeuvre, his few identified liaisons have become the polar stars of his imagery. His well-chronicled affair with "Mrs. Heiberg," a married bohemian woman in Christiania with whom he was obsessed for six years (*The Day After*, cat. 10); with Tulla Larsen (1869–1942), a Norwegian artist who was for some time his fiancée and from whom he parted with extreme acrimony (cats. 43 and 44); his relationships with the Norwegian writer and musician Dagny Juel Przybyszewska (1867–1901)[21] and the English musician Eva Mudocci (c. 1883–1953, cats. 59, 60, and 61) all seem to be invoked in his images. By extrapolating from these associations, some of Munch's biographers have left the impression that all of Munch's alliances with women were sexual. By doing so, important relationships have been overlooked or overinterpreted, including professional ties that Munch had with women. One of the earliest portraits of Munch (fig. 3) was by Asta Nørregaard (1853–1933), a successful portraitist who was among the first Norwegian artists to revive pastel drawing in the 1880s.[22] Her 1885 portrait, which endows Munch with vulnerability and inspiration, was begun in Paris, where a number of Norwegian artists congregated. Anne Wichstrøm notes that Munch's willingness to sit for the portrait and to receive it as a gift from the artist[23] suggests a collegial relationship, and she speculates that the older, established artist may have served as a mentor to Munch.[24]

The emphasis on sexual contact in Munch's relations with women may perhaps have colored historians' interpretations of Munch's long attachment to Aase Carlsen Nørregaard (whose husband, Munch's attorney, was a distant cousin of Asta Nørregaard's). Among the most vital of Munch's portraits (fig. 1; see also cat. 69) are his representations of Aase (1868-1908), a painter who was a member of his bohemian circle in Kristiania in the late 1880s. She knew his family,[25] and upon her death in May 1908 Munch wrote to her husband: "You know also that I have lost my best friend."[26] While there is evidence for an early romantic attachment,[27] the friendship that they maintained until her death, the financial support that she provided for Munch,[28] the closeness of Munch to her children,[29] and most immediately, the strength and expansiveness expressed in Munch's representations of her, narrate a different attachment.[30]

Nonetheless, in many discussions of Munch's images of women, the discourse of sexual mastery and pessimism persists. In particular, Munch's break with Tulla Larsen in 1902, in which the artist's finger was mutilated in the couple's tussle with a revolver,[31] has been a source of much extrapolation. In the years that followed their parting, Munch's increasing bitterness, coupled with alcoholism and the stress of his career, became invested in his most hostile images of women, including *Death of Marat* (cat. 44) and the graphic series Alpha and Omega (1908–09), a mythic fable of betrayal in which the perfidious Omega mates with a host of animals who, maenad-like, dismember Alpha (fig. 4).[32] In images such as this or *The City of Free Love*, the brutally satirical 1904–08 play that Munch wrote in which Larsen appears thinly disguised as the rapacious Dollar Princess (fig. 5), Munch seemed to be at his most self-confessional.

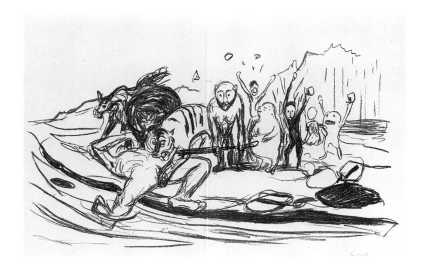

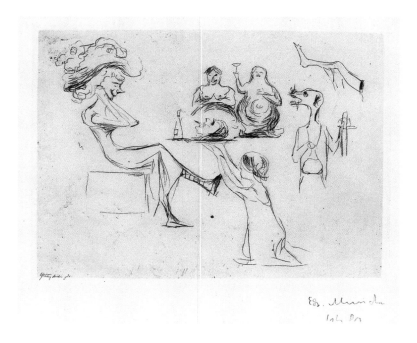

Munch's instabilities in the wake of his relationship with Larsen have coalesced in many historians' minds with his ties with all women. In particular, Munch's intimate friendship with Eva Mudocci, which began in 1903, has been shaped in the literature by such an association. Mudocci was an English violinist named Evangeline Muddock who, according to Waldemar Stabell, mythologized herself by assuming a Mediterranean-sounding name.[33] Mudocci and her accompanist and life partner Bella Edwards met Munch in Paris. In a letter to Stabell, Mudocci claimed that it was Munch's "ambition to make the most perfect portrait of me, but whenever he began a canvas for oils,—he destroyed it because he was dissatisfied with it. The lithographs went better, & the stones he used were sent up to our room in the hotel Sans Souci—in Berlin.—With one of them—the so-called 'Lady with the broche'[sic] came a note—'Here is the stone that has fallen from my heart.' He made that picture, also the one of both Bella &

Myself,—(with piano & violin)—in that same room. Also a third, with the two heads—according to himself—his & mine. It is called Salome & that title caused us the only disagreement we ever knew"[34] (see cat. 61). From the existing correspondence, it seems that Munch was friendly with both Mudocci and Edwards. He invited them to his summer house in Åsgårdstrand in 1903[35] and addressed them playfully in a postcard as "Madame Bella Edvards og E Munch-dotschi."[36] Munch's double portrait, *Violin Concert* (cat. 59), lacks the voyeuristic eroticism with which many of his male counterparts encoded representations of lesbian couples. Munch's portrait of Mudocci as Salome, which the model recalls challenging, may be layered in an irony that has been lost in the critical rhetoric.

The ascription of sexual anxiety has even been applied to Munch's portraits of his younger sister Inger (1868–1952). Patiently modeling for Munch over many years (see cats. 1 and 2), Inger was peripherally involved with her brother's bohemian circle in Kristiania,[37] and later in life she became a photographer and musician who compiled all of the family correspondence. As the model for his *Inger on the Beach* (fig. 6), Inger became one of the most familiar and introspective figures in Munch's early work. Reidar Dittmann's 1976 study, however, displaces Munch's sexual urges onto his sister: "Through such persistent preoccupation with the physical features of his sister, Munch . . . seems to be building up a shield against erotic involvements that would, in his view, lead to nothing but guilt and shame."[38]

Many of Munch's works are theatrical and should not be read as documents, but as semi-fictions. Carla Lathe calls attention to the performances that Munch stages in his work and to his interest in and flair for drama.[39] She also notes that a standard feature of art criticism in the 1890s was the examination of an artist's psyche rather than the formal characteristics of his or her productions.[40] Although biography and psychological analysis represent different modes of writing, they were often conflated in fin-de-siècle art criticism. By anchoring Munch's images in his psyche, Munch's earliest interpreters secured for the artist the intact artistic persona from which modern readings of misogyny and isolation

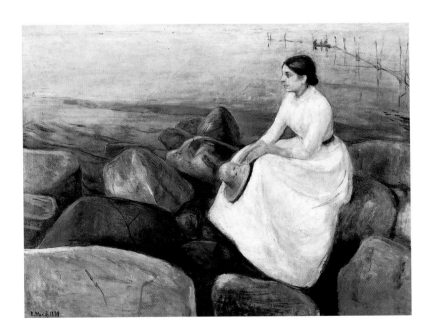

fig. 6. Edvard Munch,
***Inger on the Beach**, 1889,*
oil on canvas. Rasmus
Meyers Samlinger, Bergen

stem. These interpreters—the playwright August Strindberg (1849–1912), the art historian Julius Meier-Graefe (1867–1935), the writers Stanislaw Przybyszewski (1868–1927) and Willy Pastor (1867–1933), and the critic Franz Servaes (1862–1947), who were among northern Europe's chief voices of the avant-garde—were both Munch's first biographers and mythographers.

In *Edvard Munch: Vier beiträge*, a monograph issued in 1894, Przybyszewski, Pastor, Meier-Graefe, and Servaes presented the artist as a kind of transparent medium through which memories and emotions surged. They positioned his art as having crystallized the spontaneous eruption of a "primitive," pure, authentic, mystical spirit.[41] As a way of securing Munch's authenticity, Servaes identified Munch as an eruptive force—"the purified spirit of Thor in painting"[42]—who, unlike Paul Gauguin, "need not travel to Tahiti to see and experience the primitive in human nature. He carries his own Tahiti within him."[43]

Servaes and his colleagues established the mythic dimensions of Munch's career that continue to shape his reception.[44] At the time they wrote about the artist, one of the central themes in art criticism was the notion of the vanguard artist as an omniscient social outsider who projected "Truth" by virtue of his alienation from middle-class culture. A widely deployed means of reinforcing this position of distance was to provide a medical explanation for it, as illness was understood to separate its sufferer from "normal" society and to refine and purify the imagination. Following Charles Baudelaire, the notion of a sick body provided the distance from the bourgeoisie from which an artist (particularly a bourgeois artist) could critique its operations.[45] In a period in which mental illness was redirected from a biological to a psychological paradigm, Friedrich Nietzsche's *Birth of Tragedy from the Spirit of Music* (1872) positioned madness as a space of purified creativity.[46] Sickness—of both mind and body—was adopted in art criticism as a trope for creative and productive deviancy, for genius.

As Sander Gilman has demonstrated,[47] artistic biography was frequently shaped by medical and sociological theories of deviancy in the 1890s. At that time, artists occasionally constructed personae that suggested this association to communicate their authenticity to their public. Munch himself forged links between creativity and aberrancy in his diaries and literary notebooks, some of which were intended for public consumption.[48] Several of Munch's earliest critics in the 1890s enlisted these arguments to praise and authenticate the autobiographical themes and psychologically provocative imagery in Munch's work. The Norwegian critic Andreas Aubert, for example, identified Munch with the condition of neurasthenia in an attempt to locate the artist's work in the context of European vanguard art,[49] while Przybyszewski, Meier-Graefe, and later Max Linde[50] (see cats. 53, 54, and 55) emphasized the gulf between Munch's production and the work of his contemporaries by virtue of his psychological complexity and alienation.

For later critics, the "fact" of Munch's mental illness was confirmed by the dramatic medical spectacle of his hospitalization in Copenhagen in 1908–09 when, at the age of forty-three, he was treated for what appears to have been nervous exhaustion and acute alcoholism.[51] In part because his medical records no longer exist, the exact diagnosis has remained a matter of some debate. Since 1909, the artist's illness has confirmed long spec-

ulation that the artist was "abnormal," implicating his creativity in his instability.[52] Munch himself provided the support for such assumptions: "I was born dying. . . . Sickness, insanity, and death were the malevolent angels that guarded my cradle and have followed me through my life ever since."[53]

Evidence supporting received notions of Munch's mental disorders have been gleaned from sources close to the artist. In the years just after his death, a number of the artist's friends, models, and collectors published extensive biographical sketches.[54] Rolf Stenersen's *Edvard Munch. Close-Up of a Genius*, for example, suspends Munch in a state of perpetual adolescence: "To him life, a constant quest for a nonexistent happiness, was nothing but turmoil and need, sex, sorrow and anguish. The only possible source of anything divine was the sun and the light."[55] The young banker and art collector, himself an author with an emerging Existentialist orientation, wove from stories spun by the aging artist the portrait of extreme alienation and, it seems, fictive isolation. As recent scholarship has shown, and as many of Munch's life-long friends and contacts have testified, the artist could be sociable and at times even gregarious.[56]

Stenersen's testimonies to and speculations about Munch's attitudes toward women have likewise helped to construct the artist's iconography and reception: "A corpse frightened Munch. His memory of the dead bodies of members of his family was remarkably keen. The smile of death which Munch remembers must be that of his mother. Thus, it is reasonable to assume that Munch's problem with women was rooted in this, that he could not lie with a good, smiling woman without recalling his dead mother."[57] Such an assumption runs counter to what Munch himself described as the inspiration for his work in what is understood to be one of his earliest artistic statements: "a strong naked arm, a tanned powerful neck—a young woman rests her head on his arching chest. She closes her eyes and listens with open, quivering lips to the words he whispers into her long, flowing hair. . . . These two in that moment when they are no longer themselves but only one of thousands of links tying one generation to another generation."[58]

Munch's correspondence with his sisters, aunt, and female friends also argues against Stenersen's totalizing proposition. Although Munch refused to marry (using his family's history of tuberculosis and insanity as a rationale[59]), letters from his friends suggest an active and decidedly non-necrophilic love life.[60]

Paralleling the ways in which Munch emerged in the early literature as the collective fantasy of his associates, many of his motifs operate as rebuses—as layered with critical rhetoric as they are with ink, paint, and graphite—whose "meanings" reveal more about their interpreters than their producer. The titles and interpretations invented by Strindberg, Przybyszewski, and others invest identities in Munch's work that may not have begun with the artist. These identities have in turn coalesced with Munch's own (especially in the English literature), creating a cohesive notion of the artist's career and objectives rooted in sexual violence and death. For example, one painting that Munch initially exhibited under the title *Liebe und Schmerz* (Love and Pain) (fig. 7) in December 1893 was reborn as *Vampyr* in October 1894, following the June publication of Przybyszewski's article in *Edvard Munch: Vier beiträge*. Przybyszewski wrote:

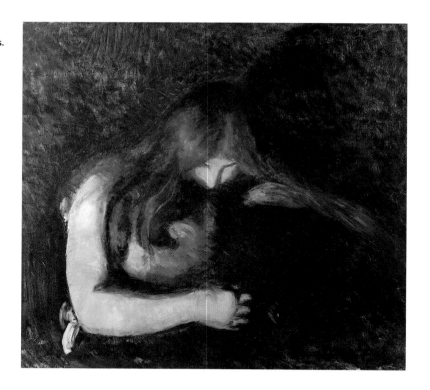

A man broken in spirit; on his neck, the face of a biting vampire. The background—
a remarkable mixture of blue, purple, green, yellow dashes of color, mixed together,
flowing together, next to each other like small, prickly splinters of crystal. There is
something terribly silent, passionless about this picture; an air of doom measureless
in its fateful resignation. The man spins around and around in infinite depths, with-
out a will, powerless—and he rejoices that he can spin like that, like a stone, totally
without volition. But he cannot rid himself of that vampire nor of the pain, and the
woman will always sit there, will bite eternally with the tongues of a thousand vipers,
with a thousand venomous teeth.[61]

In an 1896 review of Munch's work exhibited at Siegfried Bing's Maison de l'Art Nouveau,
August Strindberg again enlisted vampiric attributes in his description of the motif, this time
under the title *Red Hair*. In the June 1 issue of *La Revue Blanche*, Strindberg wrote: "A
shower of gold falling on a despairing figure kneeling before his worse self and imploring
the favor of being stabbed to death with her hairpins. Golden ropes binding him to earth
and to suffering. A rain of blood falling in torrents over the madman in quest of unhappi-
ness, the divine unhappiness of being loved, or rather of loving."[62] The ambivalence of the
original title, and the tentative gestures of the figures represented, are lost in the violence
of the commentators' descriptions.[63]

Munch later expressed uneasiness about such license. In 1933 he wrote, "'Vampire' is really
that which makes the picture literary. It is in reality only a woman who kisses a man on the
neck."[64] Elsewhere he stated, "It was in the time of Ibsen—and if people were really bent
on revelling in symbolist eeriness and called the idyll 'vampire,' why not?"[65] Nonetheless, as
Carla Lathe points out, Munch developed his associations with his literary compatriots as

part of his self-image.[66] It may be for that reason that when Hermann Esswein described *Vampire* in 1905 as depicting "a heavy, languorous burden of flesh . . . with the hidden lips seeming to suck with such fervor that we can almost hear the sounds,"[67] Munch approved of the reading because such interpretations had bolstered his reputation. He may also have been capitalizing on the nineteenth-century literary fascination with vampires, from Charles Baudelaire's "Metamorphoses of the Vampire" in *Les Fleurs du Mal* (1857) to two popular Victorian vampire stories, Joseph Sheridan Le Fanu's "Carmilla" (1870) and Bram Stoker's *Dracula* (1897).[68]

In the years in which art objects assumed what Rosalind Krauss calls "exhibitionability,"[69] the literary titles and fantasy readings attached to Munch's works may have served an important market function. Indeed, as numerous scholars and biographers (including Stenersen) have noted, Munch was a savvy promoter of his own work.[70] However, at the very moment that Munch began to assemble his patrons,[71] the artist's early biographers claimed that he was indifferent to, and had little concern with, his market. In 1895, when Julius Meier-Graefe issued a portfolio of eight of Munch's etchings (see cats. 6, 8, 10, and 12), he published an accompanying essay intended to position the artist as a social outsider. In this essay, the artist's alterity was in part premised on his disengagement from the art market: "If I were not aware of Munch's complete lack of economic insight, I would have thought that his most recent interest, that dealing with engravings, was an instance of well-timed cunning."[72] The story of Munch's naiveté bolstered his assertion of Munch's authenticity. Meier-Graefe even secured Munch's indifference to outside influence through an anecdote:

> He sits down intending to paint a portrait; the good lady, well-meaning like all good ladies, had bravely climbed four flights of stairs, and runs the risk of great damage to her clothes and her reputation. And suddenly he turns her into something very strange. Is it going to look like me? she asks a couple of times, in mortal fear. Terribly like you, he says, looking past her all the time,—above her, on the wall, there is a wonderful shadow. . . . Finally the picture turned into an evening landscape, replete with feeling—bad luck for the lady.[73]

Perhaps the most egregious projective fantasies to color Munch's work were Strindberg's and Przybyszewski's descriptions of the motif *The Kiss* (see cats. 31 and 32). In 1894, Przybyszewski wrote:

> One sees two human forms whose faces have melted together. There is no single identifiable feature; one sees only the area where they melt together and this looks like a giant ear which went deaf in the ecstasy of the blood. It looks like a puddle of melted flesh: there is something repulsive in it. Certainly this type of symbolization is something unusual; but the entire passion of the kiss, the terrible power of painful, sexual longing, the disappearance of personal consciousness, that melting together of two naked individualities—this is so honestly depicted that the repulsive and unusual can be overlooked.[74]

Strindberg's article about Munch in the June 1, 1896, *La Revue Blanche* supplemented Przybyszewski's reading of physical loss with an overt Darwinian commentary: "*The Kiss.* The fu-

sion of two beings, the smaller of which, shaped like a carp, seems on the point of devouring the larger as is the habit of vermin, microbes, vampires, and women. Man gives, creating the illusion that woman gives in return. Man begging the favor of giving his soul, his blood, his liberty, his repose, his eternal salvation."[75]

The motif itself seems to have evolved from a naturalistic drawing from 1890–91 entitled *Adieu* (fig. 8). A semi-imaginary description of a love affair in Munch's literary notes has been linked to the scene: "I pressed her to my body. Her head rested on me. We stood like that for a long time. A wonderful soft warmth passed through me. Softly I pressed her against me. She looked up, to one side. . . . We kissed each other for a long time. Total silence reigned in the large atelier."[76] *The Kiss*, wedged between the carp and the ear, assumes in text a degree of violence that the tenderness and sexual parity of its many permutations repudiate.

Such vituperative projection is not all that surprising in an era in which Joris-Karl Huysmans described Whistler's portrait of Lady Archibald Campbell as bearing "repulsion in her unpolished red mouth . . . a restless sphinx,"[77] or in which Walter Pater penned his famous description of Leonardo's *Mona Lisa* as a femme fatale: "She is older than the rocks among which she sits; like a vampire, she has been dead many times, and learned the secrets of the grave."[78] Nor is it surprising that in an era in which adolescent sexuality was first being acknowledged,[79] Przybyszewski would attribute to the child in *Puberty* (fig. 9, see cat. 9) an overwhelming, visceral heat.[80] More recent commentators have invested this particular image with specific psychosexual symbolism by reading into the shadow cast behind the adolescent a "fetus"[81] and "a huge sack-like shadow—the phallic symbol."[82] Such readings create a polyvalent image that inscribes the ten-

fig. 8. Edvard Munch, *Adieu*,
c. 1890, pencil drawing.
Munch Museum, Oslo

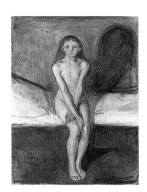

fig. 9. Edvard Munch, *Puberty*, 1894–95, oil on canvas. Nasjonalgalleriet, Oslo

fig. 10. Félicien Rops, *The Greatest Love of Don Juan*, illustrations to J. Barbey d'Aurevilly's "Les Diaboliques," softground etching. Musée royal de Mariemont, Morlanwelz, Belgium

sion of the young girl's body with precisely the kind of overt meaning that Munch's work resists.

As many of Munch's critics note, one of the reasons that his images attract such targeted interpretations is that they are open-ended and emblematic. The Norwegian painter and critic Christian Krohg (1852–1925) interpreted even Munch's earliest exhibited works in terms of these objectives: "He sees only the essence, and, consequently, paints only that. That is why Munch's pictures as a rule are 'unfinished,' as people have taken such delight in saying. Oh yes . . . he has the unique ability to show us how he felt and what gripped him, making everything else seem unimportant."[83] Further, unlike the works of many of his contemporaries, Munch's representations of women are untactile; whether rendered in paint or in graphic media, they lack both prurient specificity and eroticizing detail (fig. 10). Indeed, with notable exceptions (cat. 63, *The Sin*), the curious ambivalence toward erotic possession, as articulated by the flat and summarily described anatomies of many of Munch's female figures, both invites and destabilizes sexual reading.

When Przybyszewski, Meier-Graefe, and Strindberg wrote about Munch's female subjects, they wrote not about women, but about "Woman." J. K. Huysmans made the distinction between women as a class of people and woman as a timeless essence in an 1896 commentary on Baudelaire, ascribing to this essence a malevolent identity: "he has celebrated not contemporary women, not the Parisienne, whose simpering graces and dubious finery are not for him, but the essential and timeless Woman, the naked malignant Beast, the handmaid of Darkness, the absolute bondwoman of the Devil."[84] Cesare Lombroso's influential sociological study *The Female Offender* described women (collapsed into "She") as less differentiated than men, claiming that "atavistically She is nearer to her origin than the male."[85] Munch's colleague, the writer Sigbjørn Obstfelder, evoked the undifferentiated and changeable Woman in 1896: "There are thousands, hundreds of thousands of men in the world. But there is but one woman, only a single one. It is the same woman, who is in all women, the same lurking phantom,—who can make herself as small as a mouse—and as colossal and beautiful as a fata morgana."[86] Such claims were given legitimacy through scientific theories such as those promoted in the physician Max Nordau's 1885 *Paradoxes* that men are individuated while "woman" is amorphous[87] and in Otto Weininger's 1903 *Sex and Character*.[88] It is assumed that Munch was aware of both books.[89]

In the 1890s, when sexual commerce was routinely described in literature and the arts as a primal battle between men and women,

Woman's formlessness and changeability increased "her" danger. Compounding this anxiety, as Bram Dijkstra chronicles, psychologists began to examine the question of female sexuality, challenging the notion of a woman's sexual dependence on a man[90] and unbalancing what Luce Irigary terms the exchange of women within patriarchy. The recognition of sexual women—independent women with sexual volition—symbolized the acute new danger to social stability and masculinity. They were often represented as monsters in turn-of-the-century iconography. Defined as deviants, prostitutes, primitives, lesbians, and viragoes, women who chose to exercise their sexual freedom or to express sexuality were pathologized in both social science and artistic literature. This was the repertory of images that Strindberg and Przybyszewski invoked in their readings of Munch's *Vampire* and *Kiss*.

The later biographers who helped to introduce Munch to the English-speaking audience perpetuated this fin-de-siècle view by repeating such descriptions of sexual women. *Three Stages of Woman (The Sphinx)* (cat. 21) has been a particular source for this confusion. In 1957, Arve Moen described the central woman in the triad as "both the primitive and sophisticated female animal that no man can dominate and no civilization subdue."[91] And in his otherwise sensitive treatment of Munch's themes, Frederick Deknatel projected:

> With experience she becomes subject to the animal side of her nature, again a force beyond man's control which makes her both a danger to him and basically unobtainable by him. She can devour him as in *Vampire*. Although in love, she can exist in a different world as in *Ashes* . . . where the man is bowed in despondency while the woman stands as if in dream-like consciousness of her physical sensations (her meaning is made more explicit in the print of the same subject [see cat. 26]).[92]

It is important to separate these discourses from the images that Munch created. He repeatedly portrayed sexual women in the 1890s and located them in contexts in which they were, in turn, destructive, as in *Harpy* (cat. 15); comforted as in *Consolation* (cat. 29); victimized as in *Lust (The Hands)* (cat. 16); and exploring the sensations of their bodies (cat. 7). Such images do not solely represent women as femmes fatales (fatal women), but as fated women who negotiated complex and changing social identities. Reinhold Heller notes that some of Munch's essentializing images of women intersect with turn-of-the-century debates about women who attempted to transform society through gender equity.[93] Indeed, some of the motifs that Munch created, and what his colleagues responded to with such venom, were ambivalent typologies of the New Woman.

The challenge to traditional femininities posed by the image of the New Woman at the turn of the century was the source of tremendous anxiety and speculation that amplified and symbolized concerns about the social body throughout Europe.[94] Changes in domestic and work patterns and in the ways in which women began to explore their social environments (see cats. 46, 49, and 50) and operate as producers and consumers[95] intersected with a collective desire to control, protect, and circumscribe their femininity.[96] The Swedish feminist Ellen Key (1849–1926) proposed in her best-known works *Misused Womanpower* (1896) and *The Century of the Child* (1900) that women had the right to work, to control their own bodies, and to move freely within society, but she localized their options by appealing to the "unique" skills of women that predisposed them to motherhood, teaching, and other nurturing roles.[97] As women increasingly questioned patriarchy and engaged in public ac-

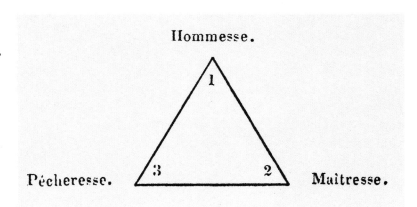

fig. 11. August Strindberg, from "L'exposition d'Edward Munch," *La Revue Blanche*, **June 1, 1896**

tivities that assured their political and economic independence, they were, like "sexual" women, demonized and distorted in literature and in visual culture as vampires, sphinxes, and other mythological figures of destruction. The New Woman was perceived to have allied herself with forces of cultural anarchism and decay precisely because she wanted to reinterpret the sexual relationship.[98] The gynecologist Max Runge used his prestige as a medical specialist to warn of the "unnatural goals" of feminists.[99] Max Nordau characterized feminists as "hysterical, nymphomaniacal, perverted in maternal instinct—They are not fit for marriage—for European marriage with one man only. Promiscuous sexual intercourse and prostitution are their most deeply seated instincts."[100] Allying feminism with Havelock Ellis's description of homosexuality and lesbianism, he described an "inversion of the healthy and normal relations between the sexes" precipitated by such women.[101] The shifting social relations within the domestic and public spheres gave rise to a generational anxiety that men were being supplanted.

In 1884, women were for the first time allowed to sit for exams at the Royal Frederik's University (University of Oslo).[102] The notion of women seeking edification outside the home raised the specter of social decline and racial and national degeneration as women, assuming the "roles" of men, would assume the "shape" of men. The German pathologist Paul Möbius, for example, reported that "if we wish to have women who fulfill their responsibilities as mothers, we cannot expect them to have a masculine brain. If it were possible for the feminine abilities to develop in a parallel fashion to those of a male, the organs of motherhood would shrivel, and we would have a hateful and useless hybrid creature on our hands."[103]

Elaine Showalter has catalogued some of the ways in which the New Woman was caricatured at the turn of the century, as a masculinized *hommesse*, a *cerveline*, a pedant with an oversize head and withered body, and an androgynous *garçonnet*,[104] as monstrous, rapacious, distorted, and animalistic. Often the masculinized woman was also identified as a sexual woman, described by Lombroso, like Nordau, as having "excessive erotic drive, weak maternal instinct, [the drive to] dominate, virile characteristics, sexual voracity."[105] Strindberg engaged these terms in an 1895 article when defining the women's emancipation movement as "the dismissal of man, the reverting of the male to a state of dire need, and the creation of a female class of Androgynes."[106] Most pointedly, he invoked this construction in his 1896 review of Munch's work in *La Revue Blanche*. In a small diagram, Strindberg mapped a triad of womanhood: the *hommesse*, the *pècheresse*, and the *maitresse* (fig. 11), all newly-minted stereotypes of the New Woman. When

Strindberg analyzed Munch's motifs in 1896, he did so through the filter of his aversion to the New Woman as a symbol and a social force.

Liberated, professional, sexual women had played an important and far more positive role in Munch's literary milieu in Christiania in the mid-1880s. The political positioning of the "Kristiania Bohème," and the issues debated within its social environment, were, as Munch later claimed, fundamental to his work.[107] The chief chronicler of this milieu, Hans Jæger (1854–1910), described the preoccupations and activities within this circle in his two-volume semi-autobiographical novel *Fra Christiania Bohemen* (1885). The immediate banning of this book and the public debates surrounding it have flattened the objectives of the group into a sexual discourse. Members of the group around Jæger included the painters Christian Krohg, Oda Lasson Krohg (and her sister Mimi), Karl Gustav Jensen-Hjell, and Munch; the writers Knut Hamsun, Arne Garborg, and the siblings Inge and Gunnar Heiberg; the journalist Jappe Nilssen; and the poets Sigurd Bødtker, Vilhelm Krag, and Sigbjørn Obstfelder. The most controversial elements in the social environment, and the elements that define the group for many of Munch's biographers, were Jæger's and his colleagues' attacks on the institution of marriage,[108] a critique shared with the newly formed Christiania Feminist Union (begun in 1884), but more to the point, his promotion of "free love," the practice of sexual exchange among married and unmarried men and women. Paralleling the ideas of the British socialist Edward Carpenter (1844–1929), Jæger proposed free love as a form of sexual socialism out of which gender equity and social health would arise. One of Jæger's projects was to engage in a love triangle so that each participant would chronicle her or his perceptions, presumably the point of which was to map the identities of both the men and women as they knew themselves. In 1887–88, Jæger, Christian Krohg, and Oda Lasson Krohg (1860–

fig. 12. Edvard Munch, *Melancholy*, 1892, oil on canvas. Nasjonalgalleriet, Oslo

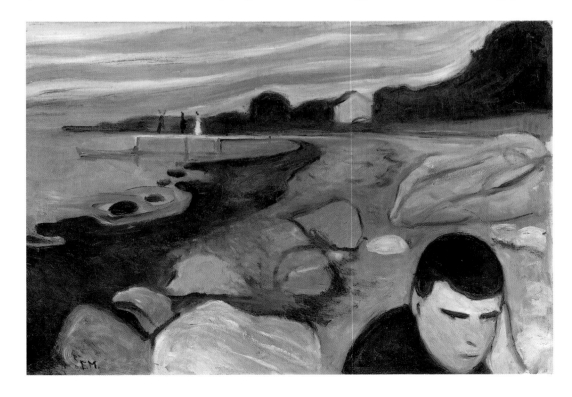

fig. 13. Christian Krohg,
*Portrait of the Painter Oda
Krohg*, 1888, oil on canvas.
Nasjonalgalleriet, Oslo

1935) experimented with such an arrangement out of which Jæger produced the novel *Syk Kjærlihet* (1893), chronicling their relationships between November and July.

Anne Wichstrøm notes that, for a century, critics have romanticized the eroticism of the Bohème, and that their political engagement and political presence in the small community have been downplayed. For example, Krohg began to publish the paper *Impressionisten* from within this circle, an important organ of political commentary and social change.[109] Oda Krohg's sister, Bokken Lasson, reports how unusual and liberating it was for women and men to go out together at this time, and that this milieu provided an unusual freedom of mobility and expression for the women who participated in it.[110] Munch illustrated the milieu in several images (see cats. 11 and 12). *Kristiania-Bohème II* (cat. 12) depicts members of the group engaged in the ritual of drinking and smoking at a café: appearing, from the left, are Munch, Krohg, Jappe Nilssen, Hans Jæger, Oda Krohg, Gunnar Heiberg, and Oda's former husband Jørgen Engelhart.

Oda Krohg, whom Jæger dubbed "une vraie princesse de la Bohème,"[111] has frequently been described as a femme fatale in the literature of the period.[112] A highly unconventional woman who left her first husband, lived alone with her two children, and then engaged in an affair with Krohg, Oda has, as Anne Wichstrøm notes, been overeroticized in the literature. Often portrayed solely as the woman who seduced and then abandoned the young critic Jappe Nilssen and who appears as a phantom image in the background of Munch's 1892 painting *Melancholy* (fig. 12), Oda Krohg was also a serious painter and public figure. Munch represents her in his etching *Kristiania-Bohème II* as an assertive presence in the world of men. Munch's image is based on Christian Krohg's portrait of Oda from 1888 (fig. 13), an image that suggests her strength, humor, and confidence. To persist in sexualizing her to the exclusion of her other identities—as mother, painter, friend, and writer—is to engage in the process of translating the New Woman into a deviant and to redirect the signification of Munch's image.

As Anne Wichstrøm has also noted, the Kristiania Bohème should be seen within the larger context of cultural debates over marriage and women's rights in 1880s Christiania. The debate over the double morality of bourgeois men who policed strict social roles for their wives while visiting prostitutes had since 1882 been a preoccupation of the Christiania Socialist Organization and was a source of debate for the members of the Bohème.[113] Beginning in 1840, all women working as prostitutes were obligated to submit to internal examinations once or twice per week; those found infected with syphilis were hospitalized. Their customers were not likewise controlled. In 1876, the police organized Christiania prostitutes into categories that determined their physical, cultural, and geographical freedom.

One man who called public attention to the immorality and hypocrisy of this situation was Christian Krohg through his controversial novel *Albertine* (1886). *Albertine*, which was the subject of a public trial, chronicles the degradation of a working-class girl whose seduction and then brutal treatment by the Christiania police entrap her into prostitution. In the novel, Krohg countered

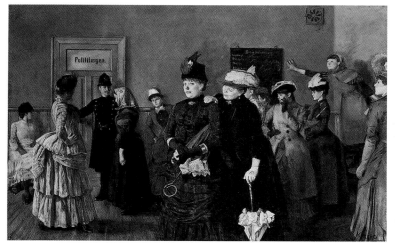

the prevailing view that, in the later words of Austrian writer Otto Weininger, prostitution was a biological condition: "The disposition for and inclination to prostitution is as organic in woman as is the capacity for motherhood."[114] Rather, Krohg defined prostitution as an economic problem perpetuated by a complacent local bourgeoisie. The novel included a lurid description of Albertine's first pelvic examination, in which, in response to the girl's terror and confusion, the police surgeon says, "Do you think we do this for fun, slut? Spread your legs."[115] This was one of the pivotal moments in the novel, one that was publicized in the newspaper *Verdens Gang* in connection with Krohg's trial[116] and that formed the basis for his monumental canvas *Albertine in the Police Doctor's Waiting Room* (fig. 14). The painting records the moment when Albertine is escorted into the police doctor's office. While the issue of prostitution had been debated throughout the Christiania community in the 1880s, particularly within the Socialist Organization and the newly founded Feminist Union, Krohg's painting helped to crystalize the issues for the broader public. In fact, in the controversy that followed Krohg's exhibition of the painting, the artist was supported by a large constituency from within the Feminist Union, including its leaders Gina Krog, Margrethe Vullum, and Amalie Skram.

Munch's later painting *Inheritance* (fig. 15) and the print related to it (cat. 48) may be seen in this context. The print in particular articulates the milieu in which the tragic, syphilitic recapitulation of the Madonna and Child theme is located: On the back wall is a broadside displaying the word "REGULATIONS." Sander Gilman has noted that, in the nineteenth century, the popular image of syphilis shifted from representations of male "victims" to female carriers, seductresses—sexual women (fig. 16).[117] Far from portraying the mother in either of his images as a venereal peril, Munch portrays her as the double victim: the recipient of a man's hidden legacy of disease and the mother of a doomed baby.

Showalter notes that, throughout Europe, syphilis was a symbolic illness, tinged with anti-Semitism in Austria and Germany, with anti-immigrant sentiment in the U.S., with foreignness and femaleness everywhere,[118] with profligates and prostitutes seen as its risk group. Henrik Ibsen's *Ghosts* (published 1881), a likely source for Munch's interpretation, used syphilis as a metaphor in which religious and patriarchal repression produced disfigurement. As D. H. Lawrence noted, the rising syphilis rates throughout Europe reshaped the terms of sexual expression for men: "The very sexual act of procreation might bring as one of its consequences a foul disease, and the unborn might be tainted from the moment of conception. . . . The fearful thought of the consequences of syphilis . . . gives a shock to the impetus of fatherhood in any man, even the cleanest."[119] Munch's motif shifts such anxiety about the child's legacy from the father to the mother. Identified, through the details of her environment, as a member of the proletariat, and perhaps as a prostitute, the woman in Munch's composition is an emblem of social inequity and not moral condemnation. As this image might suggest, Munch's participation in the Kristiania Bohème instilled in him insights into the operations of patriarchy.

Nonetheless, Munch's most immediate (and best acknowledged) legacy of the bohemian period was the intense love affair that he had with "Mrs. Heiberg," his literary code name for a

married woman whom the art historian Trygve Nergaard identified as Emilie (Milly) Ihlen Thaulow.[120] Munch identified the affair as formative: "The era of the Boheme came with its doctrine of free love. God and everything else was overthrown. . . . Then the experienced Woman of the World came on the scene and I received my baptism by fire. I was made to feel the entire unhappiness of love . . . and for several years it was as if I were nearly crazy. The horrible face of mental illness then raised its twisted head. . . . After that I gave up the hope of being able to love."[121] As his numerous diary entries and literary notebooks indicate, Munch was preoccupied by Thaulow, or more to the point, with the pain that her departure caused, and he used the sensations of loss, jealousy, rage, and yearning as some of the sources for his imagery. Heller and others have suggested that it was the erotic attachment that Munch developed for Mrs. Heiberg that helped him to formulate his ideas about artistic production and about the necessity for an artist to confess his intimacies in his work.[122] Like the other women with whom Munch can be associated romantically, Mrs. Heiberg was a bohemian, a New

Woman, who exercised the relatively free expression of her sexuality and her social prerogatives. According to Munch, she once claimed, "I have my free will in everything."[123]

Similarly, Munch's relationship with Dagny Juel, a Norwegian music student and writer with whom he was closely allied while living in Berlin, reveals the artist's complicated responses to the New Woman and belies the image of him as a misogynist. A friend of Munch's from the same cultural milieu and social class[124] and a peripheral member of the Kristiania Bohème, Juel may have been, as many authors have speculated, one of Munch's most serious love interests.[125] It has been assumed that between her arrival in Berlin in early March 1893 and her marriage to Stanislaw Przybyszewski in the summer of that year, Juel was sexually involved with Strindberg, Munch, and the writer Bengt Lidforss. It is also a commonplace in the Munch literature that Juel was the model for some of Munch's motifs for the Frieze of Life—*Madonna* (cats. 19 and 20) and *Three Stages of Woman (The Sphinx)* (cat. 21). It seems, however, that there is much mythology here. Juel was not the direct model for *Madonna*, according to Munch, but did resemble the model whom he used: "They are the same type," he said.[126] By the same token, according to Mary Kay Norseng, following Arne Brenna,[127] it is not clear that Munch and Juel were involved sexually, although there is ample evidence to suggest, at least from Munch's point of view, an initial erotic desire.

Norseng notes that Munch did not demonize Juel in his literary diaries as he did Tulla Larsen and Milly Thaulow, and that the two remained friendly until Juel's death in 1901, suggesting that whatever involvement they had calls into question the assumptions of an overpowering, pessimistic passion.[128] Upon Juel's death, Munch published a statement in *Dagbladet* describing her in devout terms: "Proud and free she moved among us, encouraging and sometimes comforting as only a woman can." He also described her as a comrade who helped him to arrange his exhibitions.[129] While Munch's statement was conditioned by the rhetoric of the obituary form, it nonetheless describes the kind of respect and camaraderie that is also reflected in the artist's portrait of Juel (fig. 17). By elevating Juel subtly above the viewer, raising her eyebrows, and tilting her head slightly to the left, Munch communicates a strong sense of this woman's self-possession. It is precisely on the basis of Juel's independence that Strindberg and other male colleagues in Berlin vilified her and set the terms by which she has been described historically and by which Munch's images of her (or the model who resembles her) have been received. The burden of the readings to which Munch's images have been subjected may reside in a crisis of masculinity among the male members of his and Juel's Berlin circle.

As many of Munch's biographers have noted, the artist's involvement with August Strindberg and his circle at the wine shop *Zum Schwarzen Ferkel* (The Black Pig) between 1892 and 1895 was formative both for Munch and for modernism in Germany. According to Carla Lathe, the circle that met regularly there included some of Germany's, Scandinavia's, and Eastern Europe's preeminent playwrights, essayists, critics, and poets. In an unusually rich moment of intellectual confluence, Strindberg, Munch, Przybyszewski, Meier-Graefe, Servaes, Richard Dehmel, and others shared their preoccupations with art, mysticism, psychology, science, and sexuality[130] and established an environment in which genius was examined and staged extravagantly. Munch began to experiment with graphic media while he was involved in this milieu, and many of his motifs have been located in relation to the authors with whom he was in intimate contact. Przybyszewski's intro-

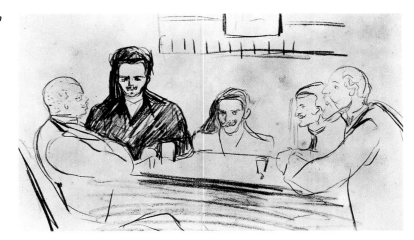

duction to his 1893 novel *Totenmesse*, for example, has coalesced with Munch's own objectives and has been identified with the erotic narrative that runs throughout the artist's Frieze of Life: "In the beginning was sex. Nothing outside it—everything contained in it. Sex is fundamental to life . . . the innermost essence of individuality."[131] As Reinhold Heller has noted, and as the 1894 monograph *Edvard Munch. Vier beiträge* demonstrates, the community of artists that congregated at the *Ferkel* was also of fundamental importance to the launching of Munch's career in Germany.[132]

In a sketch by Munch (fig. 18), the community that gathered at the *Ferkel* is represented as exclusively male. Indeed, Carla Lathe reports that the male members of the group seemed to avoid public relationships with women, and that some, following the lead of Friedrich Nietzsche, proposed elaborate rationales for the dismissal of women altogether.[133] For example, Dehmel claimed that women posed a threat to male spiritual growth. By definition, therefore, a man could not couple with a woman without compromising the integrity of his ego.[134] Such myths that bound the *Ferkel* together suggest that the male writers and artists were engaged in a mutually creative intellectual and artistic exchange resembling male parthenogenesis. In a pattern that Elaine Showalter describes as a rejection of natural paternity, a gift of "begetting that requires no female assistance,"[135] Strindberg, Dehmel, and their colleagues created a world of male muses and male collaborators, a confraternity in which women were examined as fantasy projections but were not allowed to participate as intellectuals. In *Double Talk: The Erotics of Male Literary Collaboration*, Wayne Koestenbaum calls attention to the fact that such male collaborative authorship must be viewed along the kind of continuum that Eve Kosofsky Sedgwick has called homosocial—and that in such a circumstance male bonding, homoeroticism, and misogyny coincided.[136]

Using the terms of intense male bonding and invoking homosocial environments drawn from medieval chivalry and the recent gold rush, Strindberg described the roles that women were assigned when they entered the *Ferkel* confraternity: "It *[Ferkel]* intends to admit ladies to its Round Table. . . . in a gold-miner's camp that is risky. Women mean color and life, but conflict and evil as well. It's only natural that every man should want to have a woman of his own in his tent."[137] In Strindberg's view, women were trophies in a male sexual competition: "today [the circle] was enlarged by some lady artists. It was high time for the company to be enlivened by a new element, especially of the female sex, for topics of conversation had been worn threadbare, and the general tone had become coarse and acrimonious. Now everyone was competing in their efforts to appear at their best."[138]

The competition and male rivalry that Strindberg mythologizes crystallized in his writings, and in subsequent accounts of the community, around Dagny Juel. Like Munch's reputation as a misogynist, Juel's reputation as femme fatale was cast in literary Berlin. Her male colleagues described her in terms that variously bestialized her and made her mysterious. Strindberg, who was obsessed with Juel and embittered by her dismissal of him, invoked images of temptation and dissolution: "The fact was that when she talked she never opened her lips, which were curved like a snake's, but produced the sounds from her throat, which was always husky from late nights, strong drink and tobacco smoke"[139]; "a most modern type, refined and delicate, a temptress of the mind rather than of the flesh, a highly differentiated creature. . . . Her face is unusual, aristocratic, sympathetically alive. There is something searching in it; a trembling of her nostrils. Her lids are lowered, but the eyes underneath them pertly prey on things. . . . A vampire longing for higher things."[140] The Finnish writer Adolf Paul, one of Strindberg's chief supporters, describes her as a *vagina dentata*, with a "smile that made you wish for kisses but at the same time inspired fear of the two rows of pearl-white sharp teeth, which waited behind her thin lips as if for a chance to strike."[141] Invoking and integrating the tropes for the sexual woman and the New Woman, these and other authors[142] translated Juel's independence and lack of social inhibition into a theme of sexual predation. To quote Griselda Pollock, "there is no woman present"[143] in these descriptions, but rather the projected personae and anxieties of the authors who constructed Juel with words. Like Munch's motifs, the descriptions of Dagny Juel Przybyszewska and the legacy that they have created in the literature are mediated by the anxieties of the male authors and by the paradigms that they used to define their masculinities.[144]

To Strindberg and some members of his circle, Juel, the New Woman, embodied sexual decadence, an idea supported by the emerging field of sexology, which offered expert testimony on the evolutionary differences between men and women and on the sexual de-evolution that seemed to be occurring at the century's end.[145] Among the most disequilibrious of the writings was the proposal that the spheres of femininity and masculinity were not as clearly defined as earlier theorists had proposed. Using a horticultural metaphor, Otto Weininger blamed the condition of modernity for the appearance of what he termed "sexual intermediates."[146] In *The Psychology of Sex*, Havelock Ellis elaborated the notion: "we may not know exactly what sex is, . . . we do know that it is mutable, with the possibility of one sex being changed into the other sex, that its frontiers are often mutable, and that there are many stages between a complete male and a complete female."[147] Munch's Berlin circle was known to read and debate the psychological literature that examined the implications, such as hysteria, of such gender indeterminacy. According to Carla Lathe, their sources included Max Nordau's *Paradoxes* (1885), Hippolyte Bernheim's *De la suggestion* (1886), and Theodule Ribot's *Les maladies de la volonté* (1883) and *Les maladies de la personnalité* (1885),[148] all of which focused in part on sexual pathologies and hysteria. Reinhold Heller notes that Munch's motifs from the 1890s repeat and amplify such issues and their accompanying anxieties.[149]

While one of the chief themes that Munch explored in the mid nineties was the inaccessible and overpowering Woman in relation to men, he also represented Man as enervated, paralyzed, and volitionless in relation to women.[150] Implicated in this pairing is the representation of men out of control, a theme that ran throughout the psychological literature: Max Nordau claimed

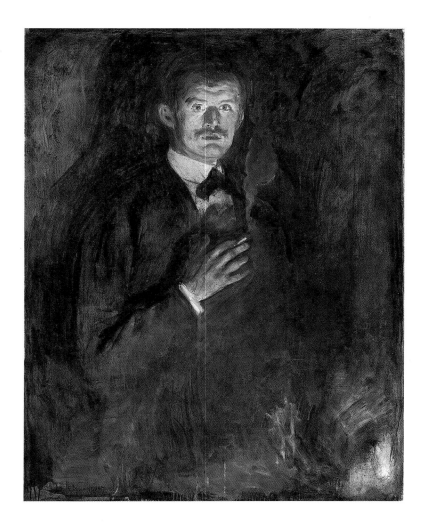

the "morbid activity of his sexual centers rules him. . . . He necessarily sees in woman, there-
fore, an uncanny, overpowering force of nature, bestowing supreme delights of dealing de-
struction, and he trembles before this power, to which he is defenselessly exposed."[151] While on
one level such a statement reifies the image of the femme fatale, it also engages the notion of
a febrile male, an "intermediate sexuality," which embodied and represented a form of cultural
degeneration. Such a male, whose defenselessness feminizes him in the presence of a mas-
culinized, sexualized woman, was a trope of Decadence. A literary movement that amplified
Baudelaire's themes of decay and hypersensitivity and that attributed redemptive power to moral
deformation, Decadence circumvented patriarchy.[152] Max Beerbohm, writing in 1894, identified
the negation of fixed gender identities and the "amalgamation of the sexes" as one of the chief
themes of Decadence.[153] As a discourse interwoven with the inquiries into unstable gender iden-
tities provided by sexology and early psychoanalysis, the idea of decadence provided both a pos-
itive platform for avant-garde objectives and the crystallization of social and sexual crisis.

Przybyszewski, writing in 1897, elevated the idea of decadence to a form of social liberation:
"For that which is normal is stupidity, and 'degeneration' is genius."[154] Munch's work and
writings seem to affirm this notion. In the images that are often described as his repertory of

femmes fatales—Strindberg's *hommesses*, *maitresses*, and *pècheresses*—there appear men who are "Woman's" decadent counterparts: often faceless and assuming postures that suggest vulnerability and a lack of volition (*Separation I*, *Ashes II*, and *Vampire*, cats. 23, 26, and 30), these men are symbolizations of social instability. Paralleling the way in which Munch overlay his *Self-Portrait with Cigarette* (fig. 19) with the canonical literary attributes of the decadent man—pale, haggard, sickly, feminized[155]—he made of Man a sexual spectacle in which any notion of a fixed masculinity is both insecurely established and ultimately forestalled. Linda Dowling notes the widespread pairing of the decadent male and the New Woman in turn-of-the-century literature. Operating as both profound threats to stable notions of sex, class, and race[156] and as the terms by which members of the avant garde encoded themselves, both "types" helped to map the terrain of alterity and male genius. Munch's literary associates expressed profound ambivalence about these "types." Strindberg expressed repulsion toward these social categories: "The manly woman is a product and victim of our false civilization. . . . Effeminate men instinctively select them, so that they multiply and put into the world beings of an indefinite sex for whom life is cruel."[157] However, Przybyszewski and Dehmel were interested in the idea of androgyny and fragmented sexuality: Dehmel's 1893 poetry cycle *Die Verwandlungen der Venus*, to which Przybyszewski made reference in his 1894 essay on Munch,[158] included the poem "Venus Sapiens," which explored polyvalent sexuality.[159] By acknowledging a crisis in masculinity, Munch articulated both the hypermasculine rhetoric of the *Ferkel* brotherhood and its examination of gender and represented unstable positions of both masculinity and femininity in the gender economy. In this regard, Munch's Frieze of Life may not narrate a dialogue between the sexes as much as an interrogation of variant sexualities.

The ambiguities and ambivalence that Munch expresses about masculinity and about the crises of femininity suggest that Munch was neither hopelessly reactionary nor misogynist. Carla Lathe has noted that Munch's treatment of themes of stress and sexual instability increased during and after his close association with groups of writers and dramatists and declined with his withdrawal from the literary scene.[160] The literary dialogues in which Munch engaged helped to shape the terms by which he essentialized women and defined them relationally: "Woman in her changing nature is a mystery to man. Woman, who at one and the same time is a saint, a whore, and an unhappy lover."[161] The motifs that Munch produced from within his literary milieux echo his and his colleagues' attempts to control women and their social and intellectual authority. At the same time, Munch also portrayed individual women with regard to their personalities and achievements. The slippage between one category of imagery and the other has reduced the complexity of both, while also underscoring the notion that Munch's interrogations of gender did not extend to masculinity. In the same way that the construction of the New Woman, with all of its attendant fears and anxieties, challenged stable views of femininity during Munch's formative years as an artist, Munch responded to the gender instabilities of the 1890s by stripping masculinity of its fixity. With a separation of Munch from the intellectual projects of his mythologizers and of his mythologized images from the real women whom they represent, Munch emerges as a more contradictory social observer than he is often portrayed. Rather than the author of a female bestiary and the unwitting agent of irrepressible anxieties, Munch interrogated the security of social categories in his formative years, and, as the following catalogue suggests, throughout his career.

Notes

I wish to thank my collaborator Jane Van Nimmen, whose wisdom and generosity as a scholar have enriched this exhibition at every stage. I am indebted to Sam Engelstad, Alice T. Friedman, Robert Lubar, and Reinhold Heller for their criticism and advice in the preparation of this catalogue. I also extend my thanks to Lynn Rogerson of Art Services International for her support throughout the project, to Jane Sweeney for editing the manuscript, to Vivi Spicer for research assistance, and to Wellesley College for providing generous support through the Class of '32 Humanities Fund. My deep gratitude also goes to Sarah G. Epstein and to her family for their support of this exhibition. Ms. Epstein's knowledge, enthusiasm, and unstinting generosity continue to stimulate and nourish Munch's American audience, and I am grateful to have had the opportunity to work with her. Finally, I dedicate this catalogue to the memory of David B. Gillespie.

1. See Carol Duncan, "Virility and Domination in Early Twentieth-Century Vanguard Painting" (1973), in *Feminism and Art History: Questioning the Litany*, ed. Norma Broude and Mary D. Garrard (New York: Harper & Row, 1982), 293–314.
2. See Martha Kingsbury, "The Femme Fatale and Her Sisters," and Alessandra Comini, "Vampires, Virgins and Voyeurs in Imperial Vienna", in *Woman as Sex Object: Studies in Erotic Art, 1730–1970*, ed. Thomas B. Hess and Linda Nochlin (New York: Allen Lane, 1973), 293–314 and 206–21.
3. Reinhold Heller, "Some Observations Concerning Grim Ladies, Dominating Women, and Frightened Men Around 1900," in *The Earthly Chimaera and the Femme Fatale: Fear of Women in Nineteenth-Century Art* (exh. cat. Chicago: The David and Alfred Smart Gallery, The University of Chicago, 1981), 9. This catalogue locates Munch's images of women within a dialectical frame, both in terms of the broader field of Symbolist art and in terms of the (perceived) precarious social position of men at the turn of the century.
4. Wendy Slatkin, "Maternity and Sexuality in the 1890s," *Woman's Art Journal* 1, 1 (Spring/Summer 1980), 13–19.
5. Kristie Jayne, "The Cultural Roots of Edvard Munch's Images of Women," *Woman's Art Journal* 10, 1 (Spring/Summer 1989), 34, n. 1.
6. Sarah G. Epstein, *Edvard Munch: Master Prints from the Epstein Family Collection* (exh. cat. Washington: National Gallery of Art, 1990), 28.
7. For this, see Carol Ravenal, *Edvard Munch: Paradox of Woman* (exh. cat. New York: Aldis Browne Fine Arts, Ltd., 1981).
8. Jane Van Nimmen's essay, "Loving Edvard Munch: Women Who Were His Patrons, Collectors, Admirers," considers a different aspect of Munch's social environment by examining the women who patronized, supported, and interpreted his work, removing Munch from the exclusive male environment in which he is often discussed. Neither her essay nor mine provides extensive consideration of any of the individual images included in the exhibition; therefore, brief commentaries, which provide biographical information, are included in the Catalogue herein.
9. Elaine Showalter, *Sexual Anarchy: Gender and Culture at the Fin de Siècle* (New York: Penguin Books, 1990), 3.
10. This was made evident in the recent exhibition and accompanying catalogue, *Lost Paradise: Symbolist Europe*, ed. Jean Clair (exh. cat. Montreal: Montreal Museum of Fine Arts, 1995). See also Bram Dijkstra, *Idols of Perversity: Fantasies of Feminine Evil in Fin-de-Siècle Culture* (New York: Oxford University Press, 1986); and Philippe Jullian, *The Symbolists*, trans. Mary Anne Stevens (London: Phaidon Press, 1973).
11. On the typology of the femme fatale, see Mario Praz, *The Romantic Agony* (Oxford University Press, 1970). Reinhold Heller (in Chicago 1981) notes that this term only emerged in the twentieth century and is applied retrospectively to nineteenth-century images (p. 11).
12. For a history of this formulation and of the permutations and exhibition of the Frieze of Life, see Reinhold Heller, "Edvard Munch's 'Life Frieze': Its Beginnings and Origins," unpublished Ph.D. dissertation (Bloomington: Indiana University, 1969); Arne Eggum, *Edvard Munch: Livsfrisen fra Maleri til Grafikk* (Oslo: J. M. Stenersens Forlag, 1990); and *Edvard Munch: The Frieze of Life*, ed. Mara-Helen Wood (exh. cat. London: National Gallery, 1992).
13. Reinhold Heller, *Edvard Munch. His Life and Work* (London: John Murray Publishers, Ltd., 1984), 103.
14. A recent nuanced interpretation of the erotics of the Frieze of Life, in which the relations between men and women are treated as a problematic rather than as a determinist discourse, is provided in Iris Müller-Westermann, "Im männlichen Gehirn: Das Verhältnis der Geschlechter im *Lebensfrise*," in *Munch und Deutschland* (exh. cat. Munich: Kunsthalle der Hypo-Kulturstiftung, 1994), 30–38.
15. Edvard Munch, *The Frieze of Life* (c. 1918–19), translated in Arne Eggum, "The Frieze of Life," *Edvard Munch 1863–1944* (exh. cat. Stockholm: Liljevalchs och Kulturhuset, 1977), 40. On the dating of this text, see Reinhold Heller, "Form and Formation of Edvard Munch's Frieze of Life," in London 1992, 37, n. 7.
16. Bente Torjusen, "The Mirror," in *Edvard Munch: Symbols and Images* (exh. cat. Washington: National Gallery of Art, 1978), 185–228.

17. Munch's letters are published in *Edvard Munch og Jappe Nilssen. Efterlatte brev og kritikker*, ed. Erna Holmboe Bang (Oslo: Dreyers Forlag, 1946); *Edvard Munchs brev. Familien*, ed. Inger Munch (Oslo: Munch Museets Skrifter 1, 1949); *Edvard Munch—Dr. Max Linde Briefwechsel 1902–1928*, ed. Gustav Lindtke (Lübeck: Senat der Hansestadt Lübeck Amt für Kultur, 1974); Jens Dedichen, *Tulla Larsen og Edvard Munch* (Oslo: Dreyers Forlag, 1981); John Boulton-Smith, *Frederick Delius and Edvard Munch: Their Friendship and the Correspondence* (Rickmansworth: Triad Press, 1983); *Edvard Munch/Gustav Schiefler. Briefwechsel*, 2 vols., ed. Arne Eggum et al. (Hamburg: Verlag Verein für Hamburgische Geschichte, 1987).

18. Edvard Munch, *The Frieze of Life* (c. 1918–19), quoted in London 1992, 11.

19. Munch, manuscript in the Munch Museum archives dated St. Cloud, 1889, translated in Heller 1969, 54. On the dating of this manuscript and its relation to Munch's other statements from the period, see pp. 52–61. On the conditions under which this statement was written, see also Heller, "Edvard Munch's 'Night,' the Aesthetics of Decadence, and the Content of Biography," *Arts* (October 1978), 80–105.

20. Quoted in Reinhold Heller, "The Iconography of Edvard Munch's *The Sphinx*," *Artforum 9*, no. 2 (October 1970), 72.

21. Munch's affair with Dagny Juel has been a foregone conclusion in the Munch literature; this assumption is based in part on the writings of August Strindberg (see below). Mary Kay Norseng has called the sexual aspect of their relationship into question in *Dagny: Dagny Juel Przybyszewska, The Woman and the Myth* (Seattle: University of Washington Press, 1991).

22. Anne Wichstrøm, *Kvinner ved staffeliet: Kvinnelige malere i Norge før 1900* (Oslo: Universitetsforlaget, 1983), 55.

23. Anne Wichstrøm, "Asta Nørregaard og den unge Munch," *Kunst og Kultur* 65, 2 (1982), 77.

24. Wichstrøm 1982, 72–73 and 76.

25. Munch's aunt, Karen Bjølstad, mentioned an encounter with Nørregaard in a letter dated December 14, 1890, in *Brev. familien*, 92.

26. *Brev. Familien*, 216.

27. Arne Eggum, *Edvard Munch. Paintings, Sketches and Studies* (Oslo: J. M. Stenersens Forlag, 1984), 63–64, quotes from a letter from Munch in Paris (March 1890) to Nørregaard: "How many evenings have I not sat alone by the window, and regretted that you are not here, so that together we could admire the setting outside in moonlight." Likewise, Reinhold Heller ascribes longing and regret to their early relationship, reporting that after being pursued by Nørregaard, Munch hid behind a column at her wedding, wondering whether she "thought of her 'pale bohemian' when she took her vows." Manuscript T2771, Munch Museum archives, translated in Heller 1984, 45.

28. See Jane Van Nimmen's essay in this volume.

29. Sarah Epstein records the fond memories that the Nørregaards' children had of Munch's visits to their home and of Munch's portrait sessions with their mother. Sarah G. Epstein, *The Prints of Edvard Munch: Mirror of His Life* (exh. cat. Oberlin, Ohio: Allen Memorial Art Museum, 1983), 123–24.

30. On their relationship and on Munch's portraits of Nørregaard, see Arne Eggum, *Edvard Munch: Portretter* (exh. cat. Oslo: Labyrinth Press, 1994), especially 18–20 and 89–91.

31. The most detailed account of this episode is provided in Arne Eggum, "The Green Room," in Stockholm 1977, 82–100. The chronicle of Munch's relationship with Larsen is provided in Jens Dedichen, *Tulla Larsen og Edvard Munch* (Oslo: Dreyers Forlag, 1981).

32. For reproductions of the illustrations and the texts of Alpha and Omega and *The City of Free Love*, see Arne Eggum et al., *Edvard Munch: Alpha and Omega* (exh. cat. Oslo: Munch Museum, 1981).

33. Waldemar Stabell, "Edvard Munch og Eva Mudocci," *Kunst og Kultur* 56, 4 (1973), 213.

34. Stabell 1973, 217.

35. Ragna Stang, *Edvard Munch: The Man and His Art*, trans. Geoffrey Culverwell (New York: Abbeville Press, Inc., 1979), 298, n. 231.

36. The card was signed "Hilsen Edv. Munch og R. Blix" and dated Copenhagen September 7. Cited in Stabell 1973, 231.

37. Heller 1970, 80, reports that Inger Munch had been engaged briefly to the writer Sigurd Bødtker.

38. Reidar Dittmann, *Eros and Psyche: Strindberg and Munch in the 1890s* (Ann Arbor: UMI Research Press, 1982), 85.

39. Carla Lathe, "Edvard Munch's Dramatic Images, 1892–1909," *Journal of the Warburg and Courtauld Institutes* 46 (1983), 191.

40. Carla Lathe, "Edvard Munch and Modernism in the Berlin Art World 1892–1903," in *Facets of Modernism: Essays in Honor of James McFarlane*, ed. Janet Garton (Norwich: University of East Anglia, 1985), 105.

41. Stanislaw Przybyszewski et al., *Das Werk des Edvard Munch. Vier beiträge* (Berlin: S. Fischer Verlag, 1894).

42. Franz Servaes in Przybyszewski 1894, 37.

43. *Ibid.*, 37.

44. For analyses of the literature on Munch, see Arne Nygård-Nilssen, "Munch-Litteraturen," *Kunst og Kultur* 20 (1934), 59–64; Arne Eggum, "Litteraturen om Edvard Munch gjennom nitti år," *Kunst og Kultur* 65, 4 (1982), 270–79; and Patricia G. Berman, "(Re-)Reading Edvard Munch: Trends in the Current Literature," *Scandinavian Studies* 66, 1 (Winter 1994), 45–67; and an early bibliography is provided by Hannah B. Muller in *Edvard Munch: A Bibliography* (Oslo: Munch Museum, 1951). Johan Langaard and Reidar Revold's *Edvard Munch fra år til år (A Year by Year Record of Edvard Munch's Life)* (Oslo: A. Aschehoug and Co., 1961), the standard chronology and exhibition list, is currently under revision by the staff of the Munch Museum. See also Sissel Biørnstad's bibliographies in Eggum 1984, 1988, 1990, 1992, and 1994.

45. See Barbara Spackman, *Decadent Genealogies: The Rhetoric of Sickness from Baudelaire to D'Annunzio* (Ithaca: Cornell University Press, 1989).

46. Louis A. Sass, *Madness and Modernism: Insanity in the Light of Modern Art, Literature, and Thought* (Cambridge: Harvard University Press, 1992), 4.

47. See Sander L. Gilman, "The Mad as Artists," in *Difference and Pathology: Stereotypes of Sexuality, Race, and Madness* (Ithaca: Cornell University Press, 1985), 217–38, and "Constructing Creativity and Madness," in *Parallel Visions: Modern Artists and Outsider Art* (exh. cat. Los Angeles County Museum of Art, 1992), 230–45.

48. Nygård-Nilssen 1934 makes the point on p. 61 that Munch probably intended some of his writings to be published. For an excellent summary of Munch's literary ambitions and the ways in which they reflected the themes and ideas of his literary milieux, see Gerd Woll, "The Tree of Knowledge of Good and Evil," in Washington 1978 (exh. cat. first cited in note 16), 229–47.

49. This criticism is translated and analyzed in Heller 1978, 81.

50. Max Linde, *Edvard Munch und die Kunst der Zukunft* (Berlin: Friedrich Gottheiner Verlag, 1902).

51. See Heller 1984, ch. 6.

52. Peter Schjeldahl, for example, alludes to this idea in "Edvard Munch: The Missing Master," *Art in America* (May–June 1979), reprinted in *The Hydrogen Jukebox* (Berkeley and Los Angeles: The University of California Press, 1991), 19–36.

53. K. E. Schreiner, "Minner fra Ekely," in *Edvard Munch som vi kjente ham. Vennene forteller* (Oslo: Dreyers Forlag, 1946), 17.

54. See, for example, *Vennene forteller*; J. P. Hodin, *Edvard Munch. Der Genius des Nordens* (Stockholm, 1948); and Christian Gierløff, *Edvard Munch selv* (Oslo: Gyldendal, 1953).

55. Rolf Stenersen, *Edvard Munch: Close-Up of a Genius*, trans. Reidar Dittmann (Oslo: Gyldendal Norsk Forlag, 1969), 15.

56. See especially Alf Bøe, *Edvard Munch* (New York: Rizzoli, 1989); Lathe 1985; and Bessie (Tina) Yarborough, "Exhibition Strategies and Wartime Politics in the Art and Career of Edvard Munch, 1914–1921," unpublished Ph.D. dissertation, University of Chicago, 1995; and Epstein in Oberlin 1983.

57. Stenersen 1969, 66–67.

58. Munch, *Livsfrisens tilblivelse*, translated in Heller 1978, 101.

59. Jens Dedichen, *Tulla Larsen og Edvard Munch* (Oslo: Dreyers Forlag, 1981).

60. For example, an undated letter in the Munch Museum archives from Aase Nørregaard to Munch, probably written two months after her wedding in 1889, inquires somewhat playfully about his relationships with several women. Aase Nørregaard, undated letter addressed "Hytta, Mandag," Munch Museum archives, Oslo.

61. Przybyszewski 1894, 19–20, translated in Heller 1969, 186.

62. August Strindberg, "L'exposition d'Edvard Munch," *La Revue Blanche* 10 (June 1, 1896), 525–26. As Barbara Bimer notes, Strindberg's essay is frequently read as Munch's own gloss on his work rather than Strindberg's interpretation. Barbara Susan Travitz Bimer, "Edvard Munch's Fatal Women: A Critical Approach," unpublished M.A. thesis, North Texas State University, Denton, Texas, 1985, 6.

63. In Heller in Chicago 1981, 39–40, Lila Lang acknowledged the ambivalence of the gestures represented in the painting and printed versions of the motif, providing a commentary that circumvents Przybyszewski's and Strindberg's readings: "However, the gesture of the woman also seems to be tender and nurturing, belying her apparent threat. Munch, with unusual compassion for his time, recognized that female sexual and love drives were inherent, and that woman was forced to remain socially repressed, but could gain personal dominance through her physical attributes." See also Müller-Westermann in Munich 1994, 32 (as in note 14).

64. Draft of a 1933 letter to Jens Thiis, translated in Woll, in Washington 1978, 230.

65. Christian Gierløff, "Kampår," in *Vennene forteller*, 133, quoted in Carla Lathe, "Munch and Modernism in Berlin 1892–1903," in London 1992, 43.

66. *Ibid.*

67. Hermann Esswein, *Edvard Munch* (Munich and Leipzig, 1905), 33, translated in Heller 1969, 187.

68. See Dijkstra 1986 (as in note 10), 334–48.

69. Rosalind Krauss, "Photography's Discursive Spaces," in Richard Bolton, ed., *The Contest of Meaning: Critical Histories of Photography* (Cambridge: M.I.T. Press, 1989), 288: "Aesthetic discourse as it developed in the nineteenth century organized itself increasingly around what could be called the space of exhibition . . . the crucial medium of exchange between patrons and artists within the changing structure of art in the nineteenth century."

70. In focusing her attention on the years surrounding World War I, Tina Yarborough in particular has provided a definitive study of Munch as an artist who was acutely aware of his public image and who strategized "accommodations to contemporary criticism and public expectations." See Yarborough 1995 (as in note 56). Arne Eggum notes that on the occasion of Munch's seventieth birthday, while choreographing press visits to his home, Munch described himself as an isolated genius who lived in dialogue with "his children," by which he meant his art. By funneling this information to the press, Munch could be certain that the myth of his separateness from the rest of society was secured. At this time, Munch also exerted considerable control over the extensive biographies issued by Pola Gauguin and Jens Thiis in 1933, correcting what he saw as popular misconceptions of his life and work. See Eggum 1982, 271.

71. See Jane Van Nimmen's essay in this volume.

72. Julius Meier-Graefe, "Edvard Munch. Eight Intaglio Prints," [1895] in *Edvard Munch 1895. Første år som grafiker* (Oslo: Munch Museum) 1995, 33.

73. *Ibid.*, 36.

74. Przybyszewski 1894, 18–19, translated in Heller 1969, 173.

75. Strindberg 1896, 525–26.

76. *Edvard Munch: Tegninger, skisser og studier* (Oslo: Munch Museum, 1973), 4, translated in Heller 1984, 76.

77. J. K. Huysmans, *Certains* (Paris, 1904), 69–70, translated in Shearer West, *Fin de Siècle: Art and Society in an Age of Uncertainty* (New York: The Overlook Press, 1994), 95.

78. Walter Pater, "Leonardo da Vinci," in *The Renaissance* (1873; New York: Random House, The Modern Library, 1924), 109.

79. See John Neubauer, *The Fin-de-Siècle Culture of Adolescence* (New Haven: Yale University Press, 1992).

80. Przybyszewski 1894, 18.

81. Dittmann 1982, 70.

82. Stenersen 1969, 16.

83. Christian Krohg, *Dagbladet* (November 27, 1891), quoted in Arne Eggum, "Edvard Munch: A Biographical Background," in London 1992, 20.

84. See J. K. Huysmans in *Le Plume* (1896) as cited in Robert Delevoy, *Symbolists and Symbolism* (New York: Rizzoli, 1982), 60.

85. Cesare Lombroso and William Ferrero, *The Female Offender* (New York: D. Appleton & Co., 1895), 113 and 107.

86. Sigbjørn Obstfelder, *Korset* [1896], in *Skrifter II* (Copenhagen and Oslo), 1927, 86–87, quoted in Anne Wichstrøm, *Oda Krohg: Et Kunstnerliv* (Oslo: Gyldendal Norsk Forlag, 1988), 75.

87. Max Nordau, *Paradoxes* (Chicago: L. Schick, 1886), 48–49.

88. Otto Weininger, *Sex and Character*, trans. from the sixth German edition (London: William Heinemann, 1903), 7, 198.

89. Lathe 1983, 198, notes that Nordau's *Paradoxes* was read and discussed by Munch's close-knit literary circle in Berlin. Johan Roede recalls seeing a copy of Weininger's *Sex and Character* in Munch's possession in the summer of 1904 in "Spredte erindringer om Edvard Munch," in *Vennene forteller*, 40.

90. Dijkstra 1986, 68.

91. Arve Moen, *Edvard Munch: Woman and Eros* (Oslo: Forlaget Norsk Kunstreproduksjon, 1957), 9.

92. Frederick B. Deknatel, *Edvard Munch* (New York: Chanticleer Press, 1950), 26.

93. Heller 1970, 80.

94. Deborah L. Silverman, *Art Nouveau in Fin-de-Siècle France: Politics, Psychology, Style* (Berkeley: University of California Press, 1989), 63.

95. See Michael B. Miller, *The Bon Marché: Bourgeois Culture and the Department Store* (Princeton: Princeton University Press, 1981).

96. Mary Lynn Stewart, *Women, Work, and the French State: Labour Protection and Social Patriarchy, 1878–1919* (London: McGill-Queen's University Press, 1989), 43.

97. Ellen Key, *Missbrukad kvinnokraft och kvinnopsychologie* (1896; Stockholm: Albert Bonniers Förlag, 1914), 22.

98. Linda Dowling," The Decadent and the New Woman," *Nineteenth Century Fiction* 33, 4 (March 1979), 440–41.

99. Max Runge, *Das Weib in seiner geschlectsindividualität* (2d edition, Berlin: Springer, 1897).

100. Max Nordau, *Degeneration* (New York: D. Appleton and Company, 1895), 412.

101. *Ibid.*, 414.

102. Gina Krog, *Norske Kvinders Retslige og Sociale Stilling* (Kristiania: H. Aschehoug & Co. Forlag, 1894), 53.

103. Paul Möbius, *On the Physiological Debility of Woman* (1898), 14, quoted in Dijkstra 1986, 172.

104. Showalter 1990, 38.

105. Lombroso and Ferrero 1895, 187–88.

106. August Strindberg, "Kvinnohat och kvinnodyrkan," *Samlade Skrifter* 27 (Stockholm: Albert Bonniers Förlag, 1911–27), 576, translated in Dittmann 1982, 88.

107. Pola Gauguin, *Edvard Munch* (Stockholm: Albert Bonniers Forlag, 1947), 13.

108. Reinhold Heller, "Love as a Series of Paintings," in Washington 1978, 93.

109. Wichstrøm 1988 (as in note 86), 25.

110. Patricia G. Berman, "Edvard Munch's *Self-Portrait with Cigarette*: Smoking and the Bohemian Persona," *Art Bulletin* 75, 4 (December, 1993), 640.

111. Wichstrøm 1988, 21.

112. For example, Reinhold Heller, *Edvard Munch: The Scream* (New York: Viking Press, 1973), 38, writes of this scene: "The woman belongs to none of them and all of them belong to her, and the sole products of her love were thoughts of suicide and tormented jealousy and hopeless despair."

113. Marcus Monrad, *Lutersk Ugeskrift* (1886), 335f., quoted in Anna Caspari Agerholt, *Den norske kvinnebevegelses historie* (1937; Oslo: Glydendal Norsk Forlag, 1973), 99.

114. Weininger 1903, 217.

115. Christian Krohg, excerpt from *Albertine*, in *Kampen for Tilværelsen* (Oslo: Gyldendal Norsk Forlag, 1989), 19.

116. *Verdens Gang* (October 19, 1887), reproduced in Krohg 1989, 22–25.

117. Sander L. Gilman, *Disease and Representation: Images of Illness from Madness to AIDS* (Ithaca: Cornell University Press, 1988), 255.
118. Showalter 1990, 189.
119. D. H. Lawrence, in *Phoenix: The Posthumous Papers of D. H. Lawrence*, ed. Edward D. McDonald (New York: Viking Press, 1968), 552–55, quoted in Showalter 1990, 199.
120. Trygve Nergaard, "Refleksjon og visjon. Naturalismens dilemma i Edvard Munchs Kunst, 1889–94," unpublished thesis, University of Oslo (1968), 72–73 and n. 163, as cited in Heller 1978, 105, n. 149.
121. Heller in Washington 1978, 93.
122. Heller in London 1992, 28.
123. Heller 1973, 36.
124. Knut Heber, "Dagny Juel: Utløseren av Edvard Munchs Kunst i Kampårene 1890–1908," *Kunst og Kultur* 60, 1 (1977), 4.
125. In London 1992, for example, Juel is represented solely as a love object and a muse.
126. Sonja Hagemann, "Dagny Juel Przybyszewska: Genienes Inspiratrise," *Samtiden* 72, 10 (1963), 655–56.
127. Arne Brenna, "Edvard Munch og Dagny Juel," *Samtiden* 87 (1978), 51–64.
128. Norseng 1991, 179–80, n. 17.
129. Edvard Munch, "Fru Dagny Przybyszewska," *Dagbladet* (June 27, 1901).
130. An exceptionally rich description and analysis of this milieu is provided in Carla Lathe, "The Group *Zum Schwarzen Ferkel*: A Study in Early Modernism," unpublished Ph.D. dissertation (Norwich: University of East Anglia, 1972).
131. Stanislaw Przybyszewski, *Totenmesse* (1893; Berlin: F. Fontane & Co., 1900), 5–6.
132. See Reinhold Heller, "Affæren Munch, Berlin 1892–93," *Kunst og Kultur* 52 (1969), 175–91.
133. Lathe 1972, 132.
134. Richard Dehmel, *Ausgewählte Briefe* I (Berlin, 1923), August 13, 1893, no. 66, p. 111, cited in Lathe 1972, 132.
135. Showalter 1990, 78.
136. Wayne Koestenbaum, *Double Talk: The Erotics of Male Literary Collaboration* (New York and London: Routledge, 1989), 3.
137. August Strindberg, paraphrased in Frida Strindberg, *Marriage with Genius* (London: Jonathan Cape, 1937), 71.
138. August Strindberg, *The Cloister*, ed. C. G. Bjurström, trans. Mary Sandbach (New York: Hill and Wang, 1969), 27.
139. August Strindberg 1969, 50.
140. Frida Strindberg 1937, 77 and 127.
141. Adolf Paul, *Min Strindbergsbok* (Stockholm: Norstedt Förlag, 1930), 91.
142. For a catalogue of the *Zum Schwarzen Ferkel* writers' descriptions of Juel, see Norseng 1991, 17–36.
143. Griselda Pollock, "Degas/Images/Women; Women/Degas/Images: What Difference Does Feminism Make to Art History," in Richard Kendall and Griselda Pollock, *Dealing with Degas: Representations of Women and the Politics of Visions* (New York: Universe, 1992), 25.
144. Norseng 1991, 7.
145. Showalter 1990, 8.
146. Weininger 1903, 7 ff.
147. Havelock Ellis, *The Psychology of Sex* (New York: Ray Long and Richard R. Smith, 1933), 225.
148. Lathe 1983, 198.
149. See Heller in Chicago 1981.
150. Bimer 1985, p. 198, calls attention to the dialectical relationship implicated in the image of the monstrous woman.
151. Nordau, *Degeneration*, 168–69.
152. On Decadence as a literary idea and on its definitions and appearances as a theme and trope in numerous intellectual endeavors at the turn of the century, see *Degeneration: The Dark Side of Progress*, ed. Edward J. Chamberlin and Sander L. Gilman (New York: Columbia University Press, 1985).
153. Max Beerbohm, "A Defense of Cosmetics," *The Yellow Book* I (1894), 78, cited in Dowling 1979, 443.
154. Stanislaw Przybyszewski, in *Auf Wegen der Seele* (Berlin), 1897, 47, translated in Lathe in London 1992, 42.
155. On this, see Berman 1993.
156. Dowling 1979, 436.
157. August Strindberg, quoted in Frida Strindberg 1937, 50–51.
158. Przybyszewski 1894, 18.
159. Richard Dehmel, "Venus Sapiens," from the cycle *Die Verwandlungen der Venus*, in *Aber die Liebe* (Munich, 1893), 225–27, as discussed in Lathe 1972, 149.
160. Lathe 1983, 193.
161. Quoted in Heller 1970, 79.

detail, cat. 60

Loving Edvard Munch: Women Who Were His Patrons, Collectors, Admirers
(with bibliographic appendix)

Jane Van Nimmen

Dedicated to Sissel Biørnstad, librarian of the Munch Museum, Oslo, and among the most generous of his collectors

The passion that is the subject of this essay is a form of free love. Unbound by formal ties, it endures and grows. It is often love at first sight, a *coup de foudre.* A licit passion, with rendezvous in public spaces, it has been felt in equal measure by men and women. This essay, however, deals with less than half the universe of those lovers: it introduces a sampling of women who adore the work of Edvard Munch. It is followed by an annotated list that recognizes the contributions of women to the literature on Munch.

The passion for Munch is medium-rare in frequency, but its intensity corresponds to the powerful grip of his work. Not everyone feels it; loving Munch seems to be a more vigorous and demanding emotion than the mass public betrothal to the work of Renoir or Monet. No marriages of convenience result from this love, and the devotee learns to respond to wary, if not derisive, comments on what is often deemed a misalliance. Once launched, an affair with Munch cannot remain clandestine. And among those who share the attachment, its revelation forges new links.

A Munch passion is thus something of an emotional voltage indicator. If this is true today—if the current still surges after the postcards, posters, cartoons, and T-shirts, the giant, free-standing, inflatable *Screams* and the shrunken plastic icons of anxiety on key chains—what was it like to see Munch images soon after they were made? The jolt of such an encounter is difficult to grasp and to gauge.

Gustav Schiefler (1857–1935), a middle-aged Hamburg magistrate, art lover, husband, and father, recorded his first reaction to Munch's prints in his diary on October 11, 1902: "These etchings deal for the most part with subjects that touch upon the deepest feelings of the heart; they move me particularly, however, through their composition and line. It is the strongest, I can even say the most exciting impression I've ever had from works of contemporary art."[1]

Schiefler became Munch's cataloguer. He explained late in life that he did not know the source of the etchings' power, "but it became clear to me from the outset that it was not the ostensible object of sensation that thrilled me, but rather a moment of a purely artistic kind."[2]

Schiefler's puzzle—the need to differentiate emotional from aesthetic impact, content from form—may no longer trouble the thoughtful viewer of Munch prints. Today's equable young

museum goers, exposed since infancy to proliferating sources of visual stimulation, admit a range of causes for their gasps or yelps before a Munch work. For some reason—be it composition, color, or brushstroke, the evocative white lines in woodcuts that forever link or separate pairs of lovers, the story of the dying teenage sister, the title *Vampire* with a redheaded woman bending to embrace a man, the unthinkable yet perfect pink snow of a grand winter landscape—they stop and look more closely. Munch is cool. He is hot. Or as the Germans say: Munch is *starker Tabak*.

The women discussed in this essay all inhaled this strong tobacco. They share an investment in Munch, whether of time or money. Alive or dead, he came into their lives and occupied space on their walls, on their desk tops, in their minds. Some of them who have thought and written about Munch are listed in the bibliographical appendix to the essay. The commitment of others, more than a century's worth of Munch collectors and wives of collectors, is a subject neglected until recently in the vast Munch literature.[3] Research on Munch's female collectors, his impact on female artists, and his reception by twentieth-century women in general is in a preliminary stage. Within the scope of the present essay, one can savor only a whiff of his fragrant smoke and meet a few of the women it inspired.

KAREN BJØLSTAD

Munch's first and most significant collector was a woman. His mother's sister Karen Bjølstad (1839–1931) joined the Munch household when Edvard was five years old, soon after Laura Bjølstad Munch died of tuberculosis at Christmastime 1868. Aunt Karen became a substitute mother for her sister's children, ranging in age from six-year-old Sophie to the baby, Inger. As the children grew, Aunt Karen preserved drawings and watercolors by all five; Edvard and Sophie were particularly gifted. Thanks to Karen Bjølstad, the Munch Museum in Oslo can mount an entire show of the Munch children's art. Her nurturing attention to the products of Edvard's hands is an incalculably strong element in his development as an artist.

Despite frequent moves from one flat to another in Christiania, now Oslo,[4] Karen Bjølstad maintained the family archives of letters, drawings, diaries, and paintings. Her example was taken to heart by Edvard Munch, who became his own best collector. The astonishing body of materials housed today in the Munch Museum is a defiant rebuttal to the forces of illness and death that gnawed at this family, to the limitations of genteel poverty, and to the tumult of war. By 1897, when Munch bought a cottage in the fishing village of Åsgårdstrand on the western shore of the Oslofjord, only three members of his immediate family survived to join him there each summer: his sisters Laura and Inger and his Aunt Karen.

The children's father, Christian Munch (1817–89), became a widower at fifty-one. An overworked physician to the urban poor, he suffered from headaches that imposed an absolute silence on the cramped apartment. Karen Bjølstad tactfully encouraged the children's quieter activities: drawing, painting, botanizing, writing diaries. As she knitted, their father read aloud the bloody sagas from a distant Nordic past recorded by his late brother, the eminent historian P. A. Munch (1810–63), instilling in them at once a national and a family pride. Whereas Edvard was named for his paternal grandfather, Dr. Munch christened his second son Peter Andreas, in honor of the boy's famous uncle. Other women on the

Munch side, sisters of P. A. and Christian Munch, also reminded the children of their heritage. These aunts fed their sickly nephews and nieces cocoa and gave them illustrated books during regular visits to the aunts' apartment, where family portraits hung over the horsehair sofa. When Edvard decided to become an artist, they commissioned him to paint a picture of their sitting room.

For the young artist, family connections brought opportunities but only a few sales and commissions. His steadiest supporter in Norway was the National Gallery in Oslo, which purchased several important works from Munch in the 1890s.[5] His principal Norwegian patron was the brewing and textile heir Olaf Schou (1861–1925), who donated a major part of his collection of contemporary Norwegian art to the National Gallery in 1909–10, including nine Munchs.[6] Additional support came from the polar explorer Fridtjof Nansen (1861–1930), who returned from his three-year voyage on the *Fram* (Forward) in the summer of 1896.[7] The well-meaning demands of these eminent patrons inadvertently provoked a conflict between two collecting couples in Munch's inner circle of friends, Oda and Christian Krohg and Aase and Harald Nørregaard.[8] The complex story is worth the telling, as it amounts to a custody battle revealing the passionate tenacity of two Norwegian women who collected the work of Edvard Munch.

ODA KROHG

The painter Oda (Ottilie) Lasson (1860–1935) was a central figure in the Kristiania Bohème, the group of artists and writers to which Munch also belonged.[9] She became the owner of Munch's early masterpiece *The Sick Child* (1885–86, Nasjongalleriet, Oslo) in 1888 when she and Munch's mentor Christian Krohg (1852–1925) were married (the young artist had given the painting to Krohg soon after it was completed in 1886). Several years later, probably in 1893, Munch asked the Krohgs to return *The Sick Child* so that he could sell it to his patron Schou, offering the Krohgs another painting in exchange. They obliged, choosing *Starry Night* (1893, The J. Paul Getty Museum, Malibu) as a replacement. In 1895 the generous Schou learned how much Oda missed her other Munch painting. He then returned *The Sick Child* to the Krohgs and commissioned a copy from Munch, who painted a second version in 1896. Schou included the second version of *The Sick Child* (Gothenburg Art Gallery, Sweden) in his gift to Nasjonalgalleriet in 1909.

Sometime between 1896 and 1902, Munch tried his luck with the Krohgs once more. He asked them to return *Starry Night* so he could sell it to Nansen. The Krohgs complied, and soon the landscape hung in the home of the Norse hero.

AASE NØRREGAARD

In 1902, Oda Krohg attempted a similar maneuver with her own early masterpiece, *Summer Night at Filtvedt* (location unknown, 1887). Its owners were Harald Nørregaard (1864–1938), Munch's attorney, and his painter wife Aase Carlsen Nørregaard (1869–1908), one of Munch's closest female friends and the central figure in *On the Bridge* (1903, Thielska Galleriet, Stockholm) and *Women on the Bridge (Aase Nørregaard)* (fig. 1). Oda Krohg asked them if she could buy back her own painting in order to sell it to Nasjongalleriet. The Nørregaards agreed and instructed the gallery in 1903 to pay the purchase price to Oda Krohg, as she had already reimbursed them "by other means" for the painting.

This compensation consisted of a magnanimous loan: Oda Krohg offered them the original version of Munch's *Sick Child*. The Nørregaards apparently misunderstood or ignored the temporary clause in Oda's offer; she had said that they could have the painting until they found another of her paintings that they liked as well as her *Summer Night*. In 1903, they hung *The Sick Child* over their horsehair sofa. The Nørregaards never found another painting by Oda to equal her *Summer Night*.

In May 1908, Aase Nørregaard died suddenly of pneumonia. Her loss, followed in July by the painful death from syphilis of Munch's German friend and long-time supporter, the painter Walter Leistikow (see cat. 52), contributed to the deep depression and intensifying alcohol abuse that led the artist to enter a psychiatric clinic in Copenhagen in October 1908. Soon after he began a cure in the hands of Dr. Daniel Jacobson, the Danish specialist in nervous disorders who was known for his successful treatment of women and artists, Munch learned that Harald Nørregaard had remarried.

During Munch's eight-month stay in the clinic, he received Norway's prestigious Order of Saint Olav. Buoyed by this official recognition and by the prospect of having a major body of his work acquired by the Norwegian national collections, Munch returned in May 1909 to settle in his homeland and assume a position in the forefront of its artistic school. With Aase Nørregaard dead and Munch back in the country, the Krohgs, themselves resettled after many years as expatriates, decided in the fall of 1909 to initiate legal proceedings to force Harald Nørregaard to return to them the 1885–86 version of *The Sick Child*. Munch became actively involved.

Whatever motives prompted the Krohgs and Harald Nørregaard to sue and countersue for possession of the painting, Munch's long-term interest was clear. He regarded all of his paintings as his "children," and the original version of *The Sick Child*, he insisted, was something of a firstborn: it lay at the core of his art. It belonged with his other major early works in the holdings of Nasjongalleriet in Oslo. The legal proceedings went on for more than twenty years, during which time the painting remained in the Nørregaards' living room.

Not until 1931 did Harald Nørregaard agree to a complicated three-way exchange with Nasjongalleriet and Oda Krohg, now a widow. The museum returned to Oda its 1896 copy of *The Sick Child*, which had been acquired with the Schou gift in 1909 and which Oda immediately sold to the Gothenburg Art Gallery. The Oslo museum returned to Harald *Summer Night at Filtvedt*, the Oda Krohg painting that he and Aase had liked so much, which was auctioned with Nørregaard's estate in 1938 and has disappeared.[10] Harald gave the museum the original version of *The Sick Child*. Munch saw his disputed offspring secure at last at the National Gallery in Oslo.

MARIE LINDE

In November 1902, as Oda Krohg was launching her initial efforts to sell her *Summer Night* to Nasjongalleriet, Munch fled Norway for Germany. Still shaken by his traumatic break in September with his lover Tulla Larsen—in a final quarrel, a revolver shot had mutilated the third finger on his left hand—he set to work, despite his bandage, after he arrived in Lübeck at the home of Dr. and Mrs. Max Linde.

Linde (1862–1940), a forty-year-old eye specialist, and his wife, Marie (1873–1940), had invited Munch to make an etching series of their family.[11] The Lindes had met Munch in Berlin in March of that year, and their purchase of *Fertility* for a thousand crowns marked a turning point in Munch's fortunes in Germany.[12] By the time Munch arrived in November to begin the portfolio that his new patrons called the "Lübeck Cycle," Max Linde was completing a book entitled *Edvard Munch und die Kunst der Zukunft* (Edvard Munch and the Art of the Future). He had become one of Munch's most energetic promoters.

The Lindes' hospitality in late 1902 gave Munch an interlude of upscale domestic life at one of the most troubled junctures of his career. Munch used a new camera to photograph the splendid neoclassical house, built in 1804 by the Danish architect Joseph Christian Lillie, and the extensive grounds dotted with sculpture.[13] The Lindes, according to a critic who described their collection in 1904, owned more Rodins than anyone in Europe except Rodin himself.[14] Munch also photographed the Lindes' "quadriga," the doctor's affectionate term for their four sons: Hermann, Theodor, Helmuth, and Lothar with his distinctive cowlick, who was born in 1899. Munch relied on family photographs as well as his own: for the drypoint called *A Mother's Joy* (cat. 54), he used a studio portrait by Hermann Linde—Dr. Linde's father, a professional photographer—taken perhaps at the time of Lothar's christening.

Munch returned by mid-December to Berlin, where he came down with the flu and got into a serious quarrel with his printer Otto Felsing. Dr. Linde's tact (and perhaps his liquidity) smoothed over the dispute, and Felsing went back to work pulling impressions for the Linde portfolio. Dr. Linde reported that the boys in Lübeck were asking for their Uncle Munch, though three of them, as well as his wife, had also caught the flu. After a long convalescence, Marie Linde left for a rest cure at Partenkirchen in mid-February 1903; her husband described her to Munch as "extremely nervous."[15] She remained at the resort in the Bavarian Alps until her birthday in mid-May. During her absence Linde commissioned Munch's portrait masterpiece *The Four Sons of Dr. Linde* (1903, Museum für Kunst und Kulturgeschichte der Hansestadt Lübeck, Behnhaus) as a surprise birthday present. Linde himself told Munch how much he admired the finished work, but his letters after her return do not mention his wife's reaction. She left with the children almost immediately, in June, to spend the summer on the North Frisian island Amrum.

Linde appears from his correspondence to be a sanguine, capable man, advising Munch on business matters, packing and framing, aesthetic issues, print techniques, and medical problems with equal confidence ("No alcohol!" was a frequent closing prescription). He was an active sportsman, winning prizes in yachting regattas, sailing from Bordeaux to London, riding his horse along the German coastal roads and heaths, enthusiastically taking up skiing in the winter of 1906. Marie, in contrast, was frequently ailing. From the beginning of their association with Munch, she nevertheless participated in major collecting decisions. She was in Berlin with her husband when they bought *Fertility*, and she visited the Felsing workshop when the "Lübeck Cycle" was in production. In January 1904, Gustav Schiefler asked Munch for his intercession in obtaining permission to buy an impression of Mrs. Linde's profile portrait made for the portfolio, and she vehemently opposed the sale. Aggrieved that her husband had already given Schiefler the first proof of his own drypoint portrait in gratitude for Schiefler's article on Munch in the Hamburg *Correspondent*,[16] she argued that the charm of

the series lay in its intimate nature and the unavailability of any copies of the images in the portfolio for purchase.[17] She finally agreed to let Schiefler have the print on the condition that it was the last time impressions would be removed from the series. It was Schiefler's own argument that persuaded her, Dr. Linde said, that her portrait would be included in a good collection and was in no risk of falling into the hands of an art dealer.[18] The incident reveals Marie Linde's sense of privacy, in opposition to her husband's flair for publicity, as well as her position of power.

The power may have been confined to the disposition of her own portrait or to copies of the Lübeck cycle, or it may well have been more fundamental. In 1890, shortly before her marriage to the young medical graduate, the seventeen-year-old Marie Holthusen inherited a fortune of some twenty-seven million gold marks from her maternal grandfather. It was not Dr. Linde's medical practice that paid for the historic house on twelve acres of land, the boats, horses, and ponies, not to mention the Rodins and the works by Manet, Monet, Böcklin, and Degas. Marie Linde had grown up in a large, comfortable house in Hamburg. Her mother, Marie Henriette Wehber, married just a year, had died at age twenty-one giving birth to Marie. Her father remarried when she was ten; as an adolescent, she adjusted to a stepmother who had been governess to her cousins and to the birth of three half-brothers and a half-sister. Marie's father, Gottfried Holthusen (1851–1917), served as a senator in Hamburg from 1896 to 1913 and was friendly with Alfred Lichtwark (1852–1914), director of the Hamburg Kunsthalle.[19] Both Marie Linde's father and grandfather Wehber were donors to the museum, and Senator Holthusen became a Munch patron himself when he bought *The Sick Child* etching, several paintings, and later commissioned a portrait that Munch never executed.

Marie Holthusen's marriage to Max Linde was a merger of means and vision, which, within only a few years after the couple moved from Hamburg to the doctor's home town of Lübeck in 1897, made her the owner of a world-class private gallery of contemporary art. Dr. Linde's increasingly stern imperatives to Munch that he swear off drinking afford a glimpse of the artist in full mid-life crisis during the years he was their frequent guest. Marie Linde nonetheless evinced a lifelong sympathy and understanding for Munch's art and for Munch himself, with whom she shared fragile nerves and the scars of growing up without a mother.

LUISE SCHIEFLER

The tumultuous years 1902–08 were also the years of Gustav Schiefler and his wife Luise's closest ties with Munch. Though their means were modest in comparison with the Lindes', the Schieflers made immediate purchases. In fact, it was Luise (1865–1967) who chose the first painting. In April 1903, she offered 300 marks for Munch's *Fir Landscape* (Private Collection) on exhibit in Paul Cassirer's Hamburg gallery. Gustav bought the vivid *Female Nude on a Red Blanket* (1902, Staatsgalerie, Stuttgart) for 450 marks. Schiefler described his decision about the nude in his diary: "Luise was shocked at first, but didn't dissuade me, and in the end rather encouraged me."[20]

Luise hung the landscape in her own sitting room when it arrived in May and was particularly pleased that her children enjoyed and understood the picture. The nude was hung in Gustav's study, where four-year-old Ottilie Schiefler (cat. 56) stood before it and remarked: "The poor child hasn't got a stitch on; where did she leave her clothes?"[21]

Munch sent frequent gifts of his prints to the Schieflers. Once they found a color impression of *Vampire* in the morning post! Schiefler, thrilled with his growing collection, gratefully recorded gifts and purchases in his diary. When Munch sent the couple each different portraits of the English violinist Eva Mudocci, *Woman with a Brooch* and *Salome (Self-Portrait with Eva Mudocci)* (cats. 60 and 61), Luise Schiefler herself wrote to the artist:

> I thank you straight from the heart for the beautiful lithograph Madonna. It is such a wonderfully vivid and yet ideally composed female portrait that I am totally enchanted by it. I admire very much the technique that renders so exquisitely the light in the eyes. Many thanks, you have given me great joy with it. But I'm not yet finished. I will leave it to my husband to thank you for his picture [*Salome*], which interests me very much through its entirely different expression of what seems to me to be the same model.[22]

A week later, Munch replied from Weimar: "It made me very happy that you understood the two works. It is just as you thought two heads inspired by the same model and with different expressions."[23]

With Luise's keen eye and constant support, particularly after failing vision forced her husband to retire from his position in the district courts in 1914, Gustav Schiefler devoted the remainder of his life to contemporary printmakers, producing catalogues of Munch and Max Liebermann in 1907, Emil Nolde in 1911, Wilhelm Laage in 1912, and Ernst Ludwig Kirchner in 1924. Additional update volumes for Nolde (1926), Munch (1927), and Kirchner (1931) followed. This collecting couple joyfully invested more than a fortune; to the artists they cared about, they gave themselves.

ELISABETH FÖRSTER-NIETZSCHE

Munch mentioned in his letter from Weimar to Luise Schiefler that the previous day—March 17, 1904—he had visited the sister of the influential German philosopher Friedrich Nietzsche (1844–1900). During that year, Elisabeth Förster-Nietzsche (1846–1935) completed the second and final volume of an adulatory biography of her late brother. Her dissimulations and distortions of Nietzsche's life and thought in her books became legendary in modern intellectual history, earning her the enmity of scholars. Yet the same determination that led her to magnify Nietzsche's fame at any price also worked on behalf of Edvard Munch. During the brief but critical period between 1904 and 1908, she secured for Munch wider international acclaim and new ties among a European elite. She was at once the most prominent and the least admirable of his female patrons.

When her brother collapsed into insanity at the age of forty-four in 1889, Elisabeth Förster-Nietzsche was in South America. In June that year her husband, Bernhard Förster, committed suicide when his anti-Semitic colony in Paraguay, Nueva Germania, was exposed as a fraudulent scheme.[24] After a futile attempt to salvage what she called her "principality" in the New World, Elisabeth returned to Europe. There she staked out a new colonial territory: she took over her incapacitated brother's literary remains and deployed her boundless energies as the sole manager of his reputation.

Nietzsche's admirers at the turn of the century supported Elisabeth despite, not because of, her anti-Semitic views. Among the most ardent and generous devotees of her brother was the young aristocrat, Count Harry Kessler (1868–1937). Later known as a social democrat and the diarist of his age, Kessler in his twenties was a patron of the avant garde with wide-ranging interests.[25] He had bought impressions of Munch's earliest etchings in 1895, when he also sat for a lithographic portrait in Munch's fourth-floor walk-up in Berlin. Nearly ten years later, Kessler was director of a new museum in Weimar, and he invited Munch there to paint his portrait. Kessler's introduction to Elisabeth led Munch into a web of contacts and friendships in eastern Germany. While arranging exhibitions of his work, drinking heavily, and taking cures at various Thuringian spas, Munch found patrons in the manufacturing city of Chemnitz, the university town of Jena, and, most important, the lively intellectual center of Weimar.[26]

Weimar took a prominent place on the cultural map in the late eighteenth and early nineteenth centuries as the home of Goethe and Schiller, on the political map in 1919 as the site of the congress that formed a new German republic, and on the map of shame in 1945 when the Allies liberated the nearby concentration camp called Buchenwald. In the first decade of the twentieth century, the twilight years of the Grand Duchy of Sachsen-Weimar-Eisenach, the stately classical town experienced a somewhat artificially induced rebirth. Munch was one of several artists and architects recruited for a role in the Weimar renaissance stimulated substantially by Elisabeth Förster-Nietzsche.[27] When she chose Weimar as the seat of the Nietzsche-Archiv in 1897, the Villa Silberblick, a property large and impressive enough to house her, the archives, and the mad philosopher himself, immediately became a pilgrimage site for growing cohorts of dedicated Nietzscheans.

In January 1901, Grand Duke Karl Alexander (1818–1901) died; the youthful new ruler Wilhelm Ernst (1876–1923) was persuaded that Elisabeth's grandiose schemes for Weimar offered him an opportunity to emulate his illustrious forebears as a patron of literature and the arts. He decided to found a state art museum, with Count Kessler, one of the first and most faithful visitors and a charter supporter of the Nietzsche-Archiv, as its director.[28] Even before his own appointment was secure, Kessler, prompted by Elisabeth, lobbied successfully to have the Belgian designer Henry van de Velde (1863–1957) called to Weimar as artistic advisor to the court.[29] As soon as van de Velde began his new duties in 1902, Elisabeth enlisted him to undertake the costly remodeling of the ground floor of the Villa Silberblick (it survives as one of the Belgian's important interior designs and reopened as a museum in 1991).

Thus, in 1904, Munch entered the villa through a pair of stunning new van de Velde doors, passed a marble herm of Nietzsche sculpted by Max Klinger (at Kessler's expense), and sat in the elegant paneled reading room for his first interview with Elisabeth.[30] In April Munch made a portrait of Elisabeth in drypoint. It was only the beginning of his connection with the controversial guardian of Nietzsche's memory.

HANNI ESCHE

The following year, van de Velde recommended Munch to his clients, the Chemnitz stocking manufacturer Herbert Esche (1874–1962) and his wife Hanni (1879–1911), who wanted portraits of their children. Van de Velde had seen and admired Munch's 1903 portrait of the four

fig. 20. Carl Larsson, *Signe Thiel*, 1907. Thielska Galleriet, Stockholm

Linde sons during a visit to Lübeck. The Esches, as befits the inhabitants of a harmonious van de Velde environment, were fastidious collectors who favored neo-Impressionist masters such as Paul Signac and Théo van Rysselberghe or the Nabi painters Pierre Bonnard and Edouard Vuillard. Checking references, the Esches consulted the Lindes, and Hanni Esche, convinced by their recommendation, wrote to Munch inviting him to Chemnitz.[31] Munch arrived in October to undertake the commission. He first alarmed the Esches by several weeks of seeming inactivity, then in a brandy-fueled burst of energy produced seven family portraits in oil and a drypoint of the three-year-old daughter Erdmute (1903–90).

Soon after he had completed the Esche portraits, Munch wrote on November 9 to Schiefler that he intended to paint Förster-Nietzsche as well as van de Velde.[32] Linde had suggested van de Velde to Munch as a portrait subject because of the Belgian's wonderful, almost Roman head, with fantastic wrinkles.[33] In the spring of 1906, Munch sent an impression of his lithograph of van de Velde to Schiefler. His charming lithograph of the van de Veldes' youngest children, the twin toddlers Tilla and Thyl standing in front of one of their father's distinctive chairs, may have been done at the same time. Munch also confided to Schiefler that he was feeling the pressure of completing a new and important portrait assignment.[34]

SIGNE THIEL

In April 1905, Ernest Thiel (1859–1947), an ardent Swedish Nietzschean, visited the Nietzsche-Archiv. He had already corresponded with Elisabeth to ask for translation rights for Nietzsche's books. In the summer after his visit, Elisabeth wrote to suggest that he commission Munch to paint a posthumous portrait of her brother.[35] Thiel, until 1900 a prominent Stockholm banker, had begun collecting modern art soon after his second marriage in 1897 to Signe Peters Hansen, a young widow. During her first marriage, Signe Hansen had moved in Stockholm's artistic circles, impressing many with her beauty and her feeling for art and artists. When she was twenty-four, Signe's merchant husband had died bankrupt, and their small son died a few months later. Ironically, the first Mrs. Thiel, Anna Josephson, had taken the destitute widow into her house as a companion to prevent her breaking up the marriage of Ernest Thiel's brother. Thiel credited Nietzsche's *Thus Spake Zarathustra* with bracing him for his decision

to divorce his wife and forsake their five children.[36] During 1905, Thiel was building a lavish villa in Stockholm, designed by Ferdinand Boberg, to house his beautiful new wife (fig. 20) and the collection she had inspired.

Delighted with Munch's portrayal of Nietzsche, completed in 1906, Thiel asked for a painting of the philosopher's sister (fig. 21), a tribute in honor of her sixtieth birthday. Photographs from this period have captured the imposing Elisabeth Förster-Nietzsche clad in a flowing dress in a van de Velde fabric.[37] Munch's oil, seemingly based on a photograph (fig. 22), reveals nothing of the design.

Thanks to the Thiels' patronage, the Nietzsches, brother and sister, now hang together in Stockholm in the Thiel Gallery, along with ten other Munch paintings (one of them is Munch's tribute to Aase Nørregaard, *On the Bridge*, 1903). The Thiel collection's ninety Munch prints include an etching of Signe unknown to Schiefler (fig. 23).

fig. 21. Edvard Munch,
Portrait of Elisabeth Förster-
***Nietzsche*, 1906, oil on**
canvas. Thielska Galleriet,
Stockholm

Signe Thiel, a particular favorite of Elisabeth's, committed suicide in 1915. Ernest Thiel lost his fortune but the collection remained intact, for after his declaration of bankruptcy in 1922, the house and collection were purchased by the Swedish government. Thiel's faithful support of the Nietzsche-Archiv dwindled after his financial ruin and stopped when Elisabeth boasted that the institution had become a rallying point for National Socialism. In their long friendship, Thiel had never told Elisabeth he was half Jewish.

GERTA WARBURG

The inflation after World War I ruined the Lindes as well as many of Munch's other German patrons. One of the victims was Gertrude Margarethe Rindskopf Warburg (1856–1944), known as Gerta. Her husband Albert Warburg (1843–1919) managed the W. S. Warburg Bank in Altona, where a separate branch of the famous Hamburg banking family had long participated in the artistic life of the city.[38] In late 1904, Gerta Warburg asked Munch to paint a portrait of her twenty-eight-year-old daughter Helene-Julie, called Ellen (1877–1943), just before the young woman married Edgar Burchard.[39]

fig. 22. Edvard Munch,
Elisabeth Förster-Nietzsche,
1906, gelatin silver print.
Munch Museum, Oslo

Schiefler was stunned by the beauty of the finished portrait in late January 1905 when he went to Altona to see it in the Warburg mansion at 33 Palmaille. "The head is all eyes: like dark coals they dominate the face. The nose and mouth, which in the model are somewhat coarse, were almost understated."[40] Gerta Warburg was taken aback when Schiefler said that Munch's portrait—destined for an upstairs corridor and finally sold in 1922 to the Zurich collector Alfred Rütschi, who gave it to the Kunsthaus Zürich in 1929—would put her entire collection to shame. "What, my old Dutch masters?" she exclaimed, confiding that Munch was too nervous and, to her dismay, had put his palette on the floor. Photographs, thought to be taken by Gerta Warburg, document Munch at work on this painting: her daughter and Munch next to the canvas, the young woman maintaining her pose, and Munch, brushes and palette in hand.[41] Within twenty years of the completion of the painting, Gerta Warburg's husband had died, inflation had sapped his fortune, and her house and collection had been sold. She survived in reduced circumstances until she and her daughter were apprehended by the Nazis after attempting to flee across the Dutch border. Both mother and daughter died in concentration camps.

ELSA GLASER

For some German collectors of Munch, the land of Cockaigne, "Schlaraffenland"—a phrase appropriated by Heinrich Mann in his novel of 1900 to describe turn-of-the-century Berlin, its wealthy art and literary patrons, and their protégés—turned into a wasteland of poverty after World War I. Under the Nazis, it became a nightmare. Many faced exile or extinction in the Holocaust.[42]

Fig. 23. Edvard Munch,
Signe Thiel, 1907, etching.
Thielska Galleriet,
Stockholm

Munch had gone hungry in Schlaraffenland. He had first arrived in Berlin in 1892, about the same time as the protagonist in Mann's novel. It was not until ten years later, when he exhibited with the Berlin Secession, sold his *Fertility* to the Lindes, and signed promising contracts with dealers operating at the very heart of the German art market, did his fortunes change.

Most of Munch's collectors, as the women mentioned so far suggest, were out-of-towners. They came to Berlin to buy their works of art, but they took them home to Hamburg or Düsseldorf, Hagen or Jena. Just before World War I, however, two Berlin couples active in the final days of Schlaraffenland started notable Munch collections. These couples were the cousins Elsa Glaser (1878–1932, see fig. 24) and Käte Perls (1889–1945) and their husbands Curt Glaser (1879–1943) and Hugo Perls (1886–1977), who were cousins also. Curt Glaser joined the Berlin Kupferstichkabinett in 1909 and remained there until his appointment as director of the Staatliche Kunstbibliothek in

fig. 24. Edvard Munch, *Curt and Elsa Glaser*, 1913, pastel drawing. Epstein Family Collection

1924; during this period he built the substantial German national collection of Munch prints.

The Glasers' first private Munch purchases were prints, including two impressions of the color lithograph *The Sick Child* purchased during a trip to Paris in 1910.[43] After the Sonderbund exhibition of 1912 closed in Cologne, they bought the painting *Worker in the Snow* (1910, Museum of Western Art, Tokyo) in the name of Elsa's father, Hugo Kolker, a Breslau chemical-factory owner.[44] By the time the Nazis dismissed Glaser from his post in September 1933—because of love for his wife he had converted to Judaism in 1914—he owned thirteen paintings by Munch, as Astrit Schmidt-Burkhardt has established. Four of these works are now in the Kunsthaus Zürich: portraits of Elsa Glaser and the art dealer Albert Kollman (1837–1915), *Lübeck Harbor* (1907), and the remarkable early work *Music on Karl Johan Street* (1889). The Glasers regarded the latter, a Kristiania street scene, as the most important work in their collection. On Elsa's death in July 1932, Glaser gave it to the Nationalgalerie, Berlin, on the condition that it bear a memorial plaque in her name. Because she was a Jew, this condition could not be fulfilled under the National Socialists, and the painting was returned to Glaser. When he fled Germany at the end of 1933, he deposited it with the Zurich museum, which acquired it in 1941.[45]

ALMA MAHLER

Another female collector who also lost her Munch painting while fleeing the Nazis was the composer Alma Schindler Mahler (1879–1964, fig. 25). The name she is known by is that of her first husband, the Austrian composer Gustav Mahler (1860–1911). When Mahler died, Alma became the lover of the painter Oskar Kokoschka (1886–1980), then left him to marry the architect Walter Gropius (1883–1969).[46]

It was Gropius who gave her the Munch. He was at the front on October 5, 1916, when their daughter, Manon, was born. Since he could not be with his wife, he sent her a Munch landscape, *Summer Night on the Shore* (Österreichische Galerie, Vienna, c. 1902). She loved the painting if not more, at least longer, than she did the donor. When the gifted seventeen-year-old Manon contracted polio and died, the resplendent landscape was there to console her mother.

Because her third husband, the poet Franz Werfel (1890–1945), was Jewish, Alma Mahler had to flee Austria in March 1938. She gave power of attorney and responsibility for her property, including the Munch, to her stepfather, the painter and art dealer Carl Moll, who had bought his own first work by Munch in 1904 from the nineteenth Vienna Secession exhibition (*Winter Night*, c. 1900, Kunsthaus Zürich).

Widowed in 1945, Alma Mahler became an American citizen and decided to return to claim her possessions in Vienna. In 1947 the city was still in ruins, an atmosphere depicted in Carol Reed's film *The Third Man*. She saw that her stepfather's house, designed by Josef Hoffmann, still stood on the Hohe Warte in the nineteenth district; her own houses had been bombed or sold. Moll, his daughter Marie (Alma's half-sister), and son-in-law—all three dedicated Nazis—had killed themselves on April 13, 1945, rather than face capture by the Russian liberators of Vienna. Moll had sold Alma's Munch to help pay for their intended escape. Despite the battery of lawyers she hired, her Munch landscape, which she called "The Midnight Sun," was never restored to her.

fig. 25. Franz Löwy, *Portrait of Alma Mahler.* Courtesy Österreichischie Nationalbibliothek Bild-Archiv und Porträt-Sammlung, Vienna

CONCLUSION

These few women, among the most prominent of Munch's collectors, stand for dozens of others who have chosen to live with works by Munch. Especially deserving of attention are Anna Silbergleit Auerbach, whose husband Felix Auerbach (1856–1933), professor of physics at the University of Jena, died a suicide a few weeks after the National Socialists seized power; Selma Aaron Harden (1863–1932), married to the German writer Maximilian Harden (1861–1927); Anna Mohr Leistikow (1863–1950), a Danish textile artist and the wife of the painter Walter Leistikow (see cat. 52); Sigrid Hølm Hudtwalcker (1879–1926) and Maria Agatha Hudtwalcker (1895–1966), the wives of Heinrich Hudtwalcker (1880–1952), another great Munch collector in Hamburg; Hjørdis Nielsen Gierløff (1879–1962, see cat. 57), the wife of the Norwegian journalist Christian Gierløff (1879–1962); Edith Nebelong Rode (1879–1956), a prominent Danish novelist married to the writer Helge Rode (1870–1937); and Ingrid Lindbäck Langaard (1897–1982), a Norwegian art historian whose extensive collection included important holdings of Munch's caricatures.[47]

Much more can be said of recent women who are collectors. The most active American collections—those assembled by Sarah G. Epstein and Lionel C. Epstein since 1962, and Lynn and Philip A. Straus since 1969—have given new meaning to the term generosity. Sally Epstein has emulated Munch himself in disseminating wide understanding of his work by lending it freely, to galleries large and small, and organizing significant traveling shows from the Epstein holdings. The family has promised the bulk of their collection and library as a gift to the National Gallery of Art in Washington. Similarly, Lynn and Philip Straus have facilitated major exhibitions based on their collection and supported scholarly research on the artist. Their assistance has resulted in important Munch acquisitions by the Fogg Art Museum of Harvard University and the creation of a permanent position there for a prints conservator. Their support of the Fogg has augmented the position of the Cambridge-Boston area as a center for Munch studies. Significantly, the Museum of Fine Arts, Boston, had been the first museum in the country to purchase a Munch painting (*The Voice*, 1893), and Boston was the opening venue for the first Munch retrospective in America in 1950. Another North American couple who have built a substantial Munch collection, Vivian and David Campbell, are recognized in a traveling exhibition opening in 1997 in their home city of Toronto at the Art Gallery of Ontario.[48]

Neglected here and ripe for a study of their own are the female artists inspired by Munch, including Marianne Werefkin (1860–1938), Helene Schjerfbeck (1862–1946), Emily Carr (1871–1945), and others. With the exposure resulting from the increasing number of exhibitions in the second half of the twentieth century, artists' writings should prove a fertile source for those attempting to trace Munch's visual legacy.

Another legacy is the growing Munch literature, based on the continuing efforts of the Munch Museum in Oslo to catalogue its holdings and publish relevant documents. Munch and his friends live on in the correspondence of many people. From these volumes one learns, for example, that the memory of Munch and his works was dear to the aging and impoverished Lindes; that Schiefler's widow enjoyed looking at his prints with her neighbors, the Hudtwalckers. In her last letter to Edvard Munch, sent out of Nazi Germany into occupied Norway, Luise Schiefler wished him a happy eightieth birthday and reminded him that she was only a year and a half behind him. She remarks: "We were always so 'modern' my husband and I." She asks about Munch's dogs and recalls her last visit to Norway fifteen years earlier, adding: "We're getting old. Nevertheless, we can still hope to see each other again and hope for a good year for you as an artist."[49]

Luise Schiefler's appreciation of years of friendship and work and her understanding of Munch's central purpose come through as strongly as ever in her birthday message. Although the artist died a few weeks later, Luise Schiefler lived on through the war and long after it in the pretty Hamburg suburb of Mellingstedt. Her youngest daughter Ottilie (1899–1992), whom Munch always called "the little angel," saw many of her father's papers through to publication. Her parents' catalogues, correspondence, and the network of activity they engaged in stand as a monument to what it was like to be "modern" and to be among the first to love Edvard Munch.

Notes

At the Epstein Family Collection, Sally Epstein, Jeanne Kendig, and Vivi Spicer provided invaluable research support at crucial stages of the preparation of the manuscript. Their helpful corrections and suggestions have been incorporated in the final version, as have those of Jane Sweeney, editor. Lynne Woodruff, acting head librarian, was extremely generous in introducing me to the remarkable panoply of electronic research facilities at the University of Maryland Art Library, College Park. I am grateful, as always, to Armand Van Nimmen for his careful reading and comments and to Asha Van Nimmen for her diligence in checking facts. To Patricia G. Berman I owe special thanks for obtaining and captioning the illustrations in my essay, for the insights she has shared with me over more than a decade in the course of her fine, multifaceted studies of Munch and his period, and for encouraging me to explore the passion of other women who love his work.

1. *Edvard Munch/Gustav Schiefler Briefwechsel*, Band 1, 1902–1914, Arne Eggum, ed., in collaboration with Sibylle Baumbach, Sissel Biørnstad, and Signe Böhn (Hamburg: Verlag Verein für Hamburgische Geschichte, 1987), 37.

2. Gustav Schiefler, *Meine Graphiksammlung*, Gerhard Schack, ed. (1927; new edition Hamburg: Christians Verlag, 1974), 29–30.

3. Stefan Pucks, in his essay "'Und die Deutschen begannen, mich kräftig zu unterstützen.' Edvard Munchs Förderer in Deutschland 1902–1912" in *Munch und Deutschland*, ed. Dorothee Hansen and Uwe M. Schneede (exh. cat. Berlin: Nationalgalerie, Staatliche Museen zu Berlin, 1994), 91–99, discusses several German family collections. In n. 22, p. 99, Pucks credits a number of collectors' wives for their support of the artist: Gerta Warburg, Luise Schiefler, Anna Auerbach, Hanni Esche, Elsa Glaser, and Käte Perls. Astrit Schmidt-Burkhardt in her article "Curt Glaser—Skizze eines Munch-Sammlers," *Zeitschrift des deutschen Vereins für Kunstwissenschaft* 42, no. 3 (1988): 63–75, mentions Elsa Glaser's participation in collecting.

4. The city of Oslo was called Christiania until 1877, when it became Kristiania; in 1925, it was renamed Oslo.

5. The first purchase was *Night in Nice* from the Kristiania autumn exhibition in 1891. The museum bought *Self-Portrait with Cigarette* in 1895; *Portrait of Hans Jæger* in 1897; *Portrait of the Artist's Sister Inger* and *Spring* in 1899; and *Winter* in 1901. In 1895 an 1885 portrait by Munch of the painter Jørgen Sørensen was donated to the museum. By the time he left for Germany in 1902—not yet forty years old—Munch had more than half a dozen pictures in the national collection.

6. See Tone Skedsmo, *Olaf Schous gaver til Nasjonalgalleriet* (exh. cat. Oslo: Nasjonalgalleriet, 1987) for a study of Schou and a chronology of his gifts.

7. On Nansen, see Louise Lippincott, *Edvard Munch. Starry Night*, Getty Museum Studies on Art 1 (Malibu, California: The J. Paul Getty Museum, 1988): 66–73.

8. The intricacies of this dispute were admirably sorted out by Tone Skedsmo in "Tautrekking om Det syke barn," *Kunst og Kultur* 68, no. 3 (1985): 184–95.

9. On the Kristiania Bohème and the painter Oda Krohg's role in the group, see Patricia G. Berman's essay in this catalogue.

10. Oda had traded to the National Gallery her 1905 portrait of the Swedish painter Ivar Arosenius so that they could return her long-disputed summer landscape to Nørregaard. The above account is based entirely on Skedsmo's article and on *Katalog over Norsk Malerkunst* (Oslo: Nasjonalgalleriet, 1968), 213, 235–47. See also Anne Wichstrøm, *Oda Krohg. Et Kunstnerliv* (Oslo: Gyldendal Norsk Forlag, 1988), 114.

11. "Edvard Munchs Brev fra Dr. Med. Max Linde," *Oslo Kommunes Kunstsamlinger, Munch-Museets Skriften* 3 (Oslo: Dreyers Vorlag, 1954, no. 426 (October 31, 1902): 7.

12. See Pucks in Berlin 1994, 93–94, and Jane Van Nimmen, "Patrons and Friends at the Turn of the Century," *Prints of Edvard Munch: Mirror of His Life* (Oberlin, Ohio: Allen Memorial Art Museum, 1983), 102–16.

13. The house is still standing in Lübeck; it has become a public marriage registry office. Dr. Linde had to parcel and sell the park, now the site of a street Linde insisted be named Edvard-Munchstrasse.

14. Emil Heilbut, "Die Sammlung Linde in Lübeck, II," *Kunst und Künstler* 2, no. 7 (May 1904): 315–16. Munch would paint Linde's cast of *The Thinker* two years after it was installed in the spring of 1905 (*The Thinker in the Garden of Dr. Linde*, Musée Rodin, Paris, 1907). On this outstanding cast, which has been at the Detroit Institute of Arts since 1922, see J. Patrice Marandel, "Rodin's *Thinker*: Notes on the Early History of the Detroit Cast, Followed by Part One of a Correspondence between Auguste Rodin and Max Linde," and "Rodin's *Thinker*: Notes on the Early History of the Detroit Cast, Followed by Part Two of a Correspondence between Auguste Rodin and Max Linde," *Bulletin of the Detroit Institute of Arts* 62 (1987): 32–52 and 63 (1988): 33–55. The painting is reproduced in color in Berlin 1994, 192.

15. *Brev. Linde*, no. 437 (March 18, 1903), 16.

16. *Edvard Munch/Gustav Schiefler Briefwechsel*, Band 1, no. 20 (February 1, 1903), 50; *Brev. Linde*, no. 435 (undated), 14.

17. *Brev. Linde*, no. 461 (January 10, 1904), 30–31.

18. *Edvard Munch/Gustav Schiefler Briefwechsel*, Band 1, no. 69, letter from Max Linde to Schiefler (January 18, 1904), 76.

19. I am grateful to Jo-Jutta and Wilhelm Holthusen, Hamburg, for granting an interview to Sally Epstein and me in 1988 and for the opportunity to review the materials on Marie Linde's background that they so generously donated to the Epstein Family Collection.

20. *Edvard Munch/Gustav Schiefler Briefwechsel*, Band I, no. 30 (April 10, 1903), 54.

21. *Edvard Munch/Gustav Schiefler Briefwechsel*, Band 1, no. 37, Schiefler to Munch (May 9, 1903), 58.

22. *Edvard Munch/Gustav Schiefler Briefwechsel*, Band 1, no. 78, Luise Schiefler to Munch (March 10, 1904), 81.

23. *Edvard Munch/Gustav Schiefler Briefwechsel*, Band 1, no. 81, Munch to Luise Schiefler (March 18, 1904), 84.

24. See H. F. Peters, *Zarathustra's Sister: The Case of Elisabeth and Friedrich Nietzsche* (1977; New York: Markus Wiener Publishing, 1985) and Ben Macintyre, *Forgotten Fatherland: The Search for Elisabeth Nietzsche* (Basingstoke: Macmillan, 1992).

25. See *Harry Graf Kessler. Tagebuch eines Weltmannes*. Marbacher Katalog 43, ed. Gerhard Schuster and Margot Pehle (exh. cat. Marbach am Neckar: Deutsches Literaturarchiv in Schiller-Nationalmuseum, 1988); and the long-awaited biography of Kessler by Peter Grupp, *Harry Graf Kessler, 1868–1937: Eine Biographie* (Munich: Beck, 1995), especially ch. 4.

26. On these connections, see Volker Wahl, "Edvard Munchs Thüringer Aufenthalt 1904 bis 1907," *Jena als Kunst-stadt 1900–1933* (Leipzig: E. A. Seeman, 1988), 78–106.

27. For slightly differing views of Elisabeth Förster-Nietzsche's influence, see Grupp 1995, ch. 4, and Jürgen Krause, *"Märtyrer" und "Prophet." Studien zum Nietzsche-Kult in der bildenden Kunst der Jahrhundertwende* (Berlin/New York: De Gruyter, 1984).

28. Roswitha Wollkopf, "Das Nietzsche-Archiv im Spiegel der Beziehungen Elisabeth Förster-Nietzsches zu Harry Graf Kessler," *Jahrbuch der deutschen Schiller-Gesellschaft* 34 (1990): 125–67. Grupp 1995 outlines the court intrigues surrounding Kessler's appointment and his dismissal three years later.

29. In 1906, van de Velde became architect and eventually head of the Weimar school of arts and crafts, which evolved after World War I into the Bauhaus under the direction of the architect Walter Gropius.

30. For color photographs of the reading room, see Alexandre Kostka, "Der Dilettant und sein Künstler. Die Beziehung Harry Graf Kessler" in Klaus-Jürgen Sembach and Birgit Schulte, *Henry van de Velde: Ein Europäischer Künstler seiner Zeit* (exh. cat. Cologne: Verlag Köln, 1992), 253–73. During Munch's stay, Kessler opened a major show of French impressionists at his new museum.

31. On the Esche commission, see Reinhold Heller, "Strømpefabrikanten, Van de Velde og Munch," *Kunst og Kultur* (1968): 89–104; Pucks in Berlin 1994, 96.

32. *Edvard Munch/Gustav Schiefler Briefwechsel*, Band 1, no. 145, Munch to Schiefler (November 9, 1905), 132.

33. Linde to Munch (November 8, 1905), *Brev. Linde*, no. 487, 48.

34. *Edvard Munch/Gustav Schiefler Briefwechsel*, Band 1, no. 191, no. 2 (March 7, 1906), 161; no. 196 (March 12, 1906), 164; no. 204, Munch to Schiefler (undated), 168.

35. Brita Linde, *Ernest Thiel och hans Konstgalleri* (Stockholm, 1968); Ulf Linde, *Thielska Galleriet* (Stockholm: Thielska Galleriet, 1979); Arne Eggum, *Munch and Photography* (New Haven: Yale University Press, 1988), 84–88.

36. Peters 1977, 191.

37. Compare Birgit Schulte, "'Ich bin diese Frau, die um jeden Preis, Ihr Glück will . . .' Maria Sèthe und Henry van de Velde—eine biographische Studie," in Cologne 1992 (as in note 30), 110; and the photograph by Nicola Perscheid reproduced in Cologne 1988 (as in note 25), no. 6, 94.

38. See Ron Chernow, *The Warburgs: The Twentieth-Century Odyssey of a Remarkable Jewish Family* (New York: Random House 1993; Vintage ed., 1994), 505–06.

39. Chernow 1994 cites Gerta's physician daughter as "Betty," not Ellen, as she is called in the Munch literature. He bases his account on a book by Gerta's granddaughter, Gertrud Wenzel, *Broken Star: The Warburgs of Altona* (Smithtown, N.Y.: Exposition Press, 1981), 97.

40. *Edvard Munch/Gustav Schiefler Briefwechsel*, Band 1, no. 116, diary entry (January 29, 1905), 106–07.

41. Eggum 1988, 80–82, and Monica Knaben-Cossardt, "Bildnis Fräulein Warburg (Helene Julie, gen. Ellen), 1905," *Edvard Munch im Kunsthaus Zürich*, Sammlungsheft 6 (Zurich: Kunsthaus Zürich, 1977), 49–53. See also *Edvard Munch. Sein Werk in Schweizer Sammlungen* (exh. cat. Basel: Kunstmuseum Basel, 1985), no. 13, 32–33; and F. M. [Franziska Müller], "Portrait Fräulein Warburg, 1905," *Edvard Munch* (exh. cat. Zurich: Kunsthaus Zürich, 1987), no. 66, who cites Gertrud Wenzel-Burchard, "Granny, Gerta Warburg und die Ihren," *Hamburger Schicksale* (Hamburg: n.d.).

42. Munch's German friends and collectors were assassinated (the political leader Walther Rathenau in June 1922), committed suicide (the physicist Felix Auerbach in February 1933), were denounced by household staff or neighbors, their property confiscated (Kessler in 1933), fled for their lives, or died in concentration camps (*Berliner Tageblatt* editor Theodor Wolff escaped Germany in 1933 with his hand-painted Munch print, only to be handed over to the Gestapo in Nice some years later; he was taken to Sachsenhausen camp in Berlin where he became fatally ill and died in 1943). Munch watched the dire events of European history unfold from the relative security of Norway. His reputation rose steadily after his return to Norway in 1909, and in 1927 the Berlin Nationalgalerie mounted a major retrospective of his work. Ten years later his paintings were purged from all German museums and sold at auction in Oslo in 1939. A few private German Munch collections survived the war in bank vaults (the Heinrich Hudtwalcker collection in Hamburg, for example) or in hiding places (the Arnold Budzcies collection in Bremen). See Sarah G. Epstein, "Living with Edvard Munch Images: A Collector in Three Stages," *Edvard Munch: Master Prints from the Epstein Family Collection* (exh. cat. Washington: National Gallery of Art, 1990), 33.

43. Hugo Perls, *Warum ist Kamilla Schön? Von Kunst, Künstlern und Kunsthandel* (Munich: P. List, 1962), 13, and Schmidt-Burkhardt 1988, 63 and nn. 2, 3.

44. Schmidt-Burkhardt 1988, 68–69, cites Glaser's first letter to Munch dated November 4, 1912, indicating that previous suggestions in the literature that the Glasers met Munch in Cologne are incorrect. Schmidt-Burkhardt in her 1988 study was the first to explore the Glasers' collecting activities.

45. Eva Korazija and Caroline Kesser, "Musik auf der Karl-Johan-Strasse, 1889," *Edvard Munch im Kunsthaus Zürich* (1977), 14–26; Schmidt–Burkhardt 1988, 71. See also F. M. [Franziska Müller], "Musik auf der Karl Johan Straße, 1889," cat. 20, and Felix Baumann, "Munch und Zürich," 9, in *Edvard Munch 1863–1944* (Zurich, 1987); and *Edvard Munch. Sein Werk in Schweizer Sammlungen*, cat. 2, 14–15. Müller, Baumann, and Schmidt-Burkhardt state that Glaser acquired the painting from the German painter Oskar Moll, not the Viennese painter and art dealer Carl Moll, as Korazija and Kesser suggest.

46. For accounts in English of the life of the composer Alma Schindler Mahler, see Françoise Giroud, *Alma Mahler, or the Art of Being Loved* (Oxford University Press, 1991) and Susanne Keegan, *The Bride of the Wind: The Life and Times of Alma Mahler-Werfel* (London: Secker and Warburg, 1991). A brilliant and factually reliable biographical drama is the Israeli playwright Joshua Sobol's *Alma*, commissioned for the Wiener Festwoche '96 and staged in June of that year in the building and grounds of the Purkerdorf Sanatorium, Vienna, an architectural masterpiece of 1903 by Josef Hoffmann.

47. On Ingrid Langaard's life, see Gerd Hennum, *Ingrid Lindbäck Langaard. Viljesterk Kvinne i Kunsten* (Oslo: Dreyer, 1987). Langaard's will stipulated that her Munch collection be sold to benefit a foundation she had established to support young Norwegian artists. The executors of her estate asked Galerie Kornfeld in Bern, where she had purchased so many Munchs, to auction the collection; the sale catalogue was designed as a tribute to her scholarship and collecting. See Galerie Kornfeld, *The collection of Works by Edvard Munch Formed by Ingrid Lindbäck Langaard and Sold for the Benefit of the Ingrid Lindbäck Langaard Foundation*, Auction Sale 186, June 21, 1984 (Bern: Galerie Kornfeld, 1984).

48. See Elizabeth Prelinger, *The Symbolist Prints of Edvard Munch: The Vivian and David Campbell Collection* (exh. cat. New Haven, Conn.: Yale University Press, 1996), and Sarah Jennings, "Living with Art: A Munch in Every Room (Vivian & David Campbell)," *Art News* 93 (October 1994): 113–14.

49. *Edvard Munch/Gustav Schiefler Briefwechsel*, Band 2, 1915–1935/1943 (Hamburg: Verlag Verein für Hamburgische Geschichte, 1990), no. 903 (December 3, 1943), 283–84.

Bibliographic Appendix: Women Writing about Munch

Although women have played an important role in creating the vast literature on Edvard Munch, their contributions have not yet been tallied or recognized as a whole. This long-overdue acknowledgment, like all Munch studies, is a work in progress, intended as a tool for understanding the insights that women have brought to Munch research and as a tribute to these writers.

There are many reasons why this compilation may prove less than comprehensive. First, a bibliography based on gender depends on recognizably feminine names; ambiguous Robins, Jans, and Dominiques pose problems, as do indexes that use only initials (Art Bibliographies Modern online is a case in point). Modern cataloging rules permit only three authors' names in bibliographic records; exhibition catalogues with many contributors or any book with multiple authors will not reveal the full complement of participating scholars through an electronic search, even in the usual "added entry" or "other authors" fields. In contrast, European catalogers often credit the museum editor or copy editor with full intellectual responsibility when no name appears on the title page.

Time and space impose other limitations. Novelists who mention Munch works, such as Iris Murdoch who does so repeatedly, have not been listed here. The contributions of women to documentary films on Munch and to radio and television broadcasts about the artist, for example Susan Stamberg's segment for National Public Radio heard throughout the United States in 1981, have also been excluded. Apart from a few early items, newspaper articles, a rich source for reviews and publicity in conjunction with exhibitions, have been omitted. Similarly, general books or articles on European modernism have been cited only when they include significant discussions of Munch and his work. Group exhibitions, for the most part, are not included in the list.

Two developments during the past decade have altered the method and the function of bibliographical work in the humanities: the broadening access to electronic networks and the growing influence of reception theory. Both innovations enhance the role of compiler as interpreter. Art historical databases and a planetary pool of library catalogues linked by the Internet have made a lush jungle of the information landscape. At the same time, quickening interest in learning viewers' responses to works of art has stimulated art documentation in new areas. Exhibition reviews, ephemera, statements, and archival materials from collectors and dealers as well as from artists serve as raw material for research and pose additional challenges for indexers and scholars.

Deploying new and traditional tools, bibliographers reshuffle their data. Chronological sorting reveals the evolution of the literature, name and title indexes complete a grid of cross-references. Alphabetical or chronological lists of exhibition venues have contributed to the expanding girth and substance of catalogues. Such compilations now are recognized as necessities, not luxuries, as indispensable to a good catalogue as an index. Indexes themselves, once reserved for monographs produced by the scholarly presses, appear even in modest exhibition catalogues.

Complementing such lists, narrative bibliographies are increasingly frequent in the journal literature. Conceived as captioned snapshots of a field and its research currents, such bibliographical essays offer channel markers in a sea of information. An exemplary study of this kind for the Munch literature is Patricia G. Berman's 1994 article cited below, an update of a similar essay published in 1982 by Arne Eggum, chief curator of the

Munch Museum. At the same time, the traditional hard-copy bibliography survives among competing modalities, in formats more stately and more convenient (during library opening hours) than those of its raw electronic siblings. The value added by the compiler consists of indexes and, particularly, annotations.

The bibliographical net cast to compile this list was woven from all these methods. Its purpose—to measure and acknowledge the contributions of women to Munch studies—is more unusual than its published format. Only a chronological ordering could reveal the development through the years of female authors' various views of a single artist; under each year, entries appear alphabetically by author. Entries in multiple-author exhibition catalogues or books for women who contributed are grouped alphabetically under the main entry rather than under the year as a whole. Where titles are not explanatory, annotations indicate the approaches these women take and the context of their work.

This list accounts for only a few of the curators, preparators, editors, translators, designers, registrars, librarians, and docents who have given freely of their efforts on hundreds of Munch exhibitions held all over Europe, the United States, Canada, Mexico, Israel, Japan, Australia, and New Zealand since Munch began exhibiting in 1883 in what is now Oslo. After the opening in 1963 of the Munch Museum, built to house Munch's generous bequest to the city, its staff has contributed beyond measure to every exhibition, whether in terms of actual loans, documentation, photographs, or indirectly through a flood of museum publications. Ragna Stang, Gerd Woll, Sissel Biørnstad, Iris Müller-Westermann, and Ingebjørg Ydestie are cited below for some of their published works. Along with these dedicated women at the Munch Museum, one should recall that, for more than twenty-five years, the contributions of Arne Eggum, the conservator Jan Thurmann-Moe, the former director Alf Bøe, the current director Per Boym, and many other staff members underlie each and every publication. And behind every scholarly project resulting in a Munch study on this list there are teachers, both men and women, who read, supported, and guided the scholars under their tutelage. Two such mentors in the United States have given so generously to anyone studying Munch that they deserve a special citation and endless thanks: they are Reinhold Heller and Robert Rosenblum.

1908

Maria, Inge. "Edvard Munch," *Das Magazin* 5 (1908).
> Munch exhibited twice in Berlin in 1908: four paintings in the fifteenth Berlin secession show in April and twenty-six prints in December at the sixteenth.

Schapire, Rosa. "Edvard Munch," *Zeitschrift für Literatur, Kunst, und Wissenschaft. Beilage der Hamburger Correspondent* 25 (1908).
> Cataloger of the German expressionist Karl Schmidt-Rotluff, print connoisseur, and an active participant, like Gustav Schiefler, in the rich cultural life of Hamburg, Dr. Schapire (1874–1952) reviewed for this literary supplement the first volume of Schiefler's catalogue raisonné of Munch's works on paper (*Verzeichnis des graphischen Werks Edvard Munchs bis 1906*, Berlin: Bruno Cassirer, 1907). Munch had a one-man print show in June at the Kunstsalon Louis Bock & Sohn, Hamburg, a gallery that held its first Munch show in 1894.

1912

Nissen, Fernanda. "Munchs Billedern i Universitets festal," *Sosial democraten* (June 29, 1912).
> This account of the University Aula mural project appeared in a liberal Norwegian periodical.

1924

Tietze-Conrat, Erika. "Edvard Munch," *Graphische Künste* 47 (1924): 75–88.
> The eminent Viennese Titian scholars Erika Tietze-Conrat (1883–1957) and her husband Hans Tietze (1880–1954) both wrote on Munch in the 1920s.

1928

Ingebretsen, Eli. *Om Norsk grafisk kunst.* Oslo: Gyldendal, 1928.
 Munch figured prominently in Ingebretsen's study of Norwegian graphic art (85–88).

1932

Ingebretsen, Eli. *Edv Munch (grafikk) med 11 billeder.* Oslo: Grondahl, 1932.
 Ingebretsen prepared this brief illustrated guide, part of the museum's Veileder series, to the graphic collections of art by Munch in the National Gallery in Oslo.

Munch, Inger. *Akerselven.* Oslo, 1932.
 Inger Munch (1868–1952) was Munch's youngest sister, born the year of their mother's death from tuberculosis. She was his only sibling to survive him.

1935

Christie Kielland, Else. "Intensjon og stil i malerkunsten, *Kunst og Kultur* 21 (1935): 113–30.

1937

Lund, Ida K. "Edvard Munch," *Parnassus* 9, no. 3 (March 1937): 21–24.
 Lund presents an overview of Munch's development as a painter and describes him "as vigorous as ever at seventy-three."

1939

Ingebretsen, Eli. "Munch-auksjonen og utstillingen 1938–39," *Kunst og Kultur* 2 (1939).
 A summary of the auction year that included the sale in Oslo on January 23, 1939, of fifty-seven Munch prints and fourteen Munch paintings purged by the Nazis from German museums.

1943

Ingebretsen, Eli. "Edvard Munch og John Gabriel Borkman," *Vi selv og våre hjem* 3 (1943): 2–6.
 Henrik Ibsen's play *John Gabriel Borkman* (1896) inspired Munch in his sixties. He had drawn a portrait of Ibsen for the program of the Théâtre de l'Œuvre production premiering in Paris on November 9, 1897.

1945

Munch, Inger. "Av Edvard Munchs brev og dagboker. Edvard Munch: erindring om sin mors død," *Urd,* no. 9 (September 1945).
 In this, one of the earliest publications on Munch after World War II, Inger Munch established her entitlement to editing the letters bequeathed to her by her brother upon his death in January 1944. Later, she placed the letters in Munch's archives held by the city of Oslo, the repository of his literary writings and diaries under the terms of his will.

1946

Bang, Erna Holmboe, ed. *Edvard Munch og Jappe Nilssen. Efterlatte brev og kritikker.* Oslo: Dreyers Forlag, 1946.
 A brief introduction on Munch's relationship to Nilssen (pp. 7–16) precedes the correspondence and Nilssen's criticism of several late Munch exhibitions and an essay on the murals for the Freia chocolate factory (1922).

Ingebretsen, Eli. "Edvard Munch's tresnitt," *Konstrevy* 22 (1946): 182–85.

_____. *Edvard Munchs tresnitt.* Exh. cat. Oslo: Nasjonalgalleriet, 1946. Catalogue of an exhibition held at the National Gallery, Oslo, in March–April, 1946.
 Ingebretsen wrote the introduction to this thirty-nine-page catalogue of an exhibition of 140 woodcuts.

Munch, Inger. "Noen Munchminner. (Fra Åsgårdstrandstiden)," *Urd,* no. 2 (January 1946).

Edvard Munch som vi kjente ham. Vennene forteller. Oslo: Dreyer, 1946.
 Ingeborg Motzfeldt Løchen and Birgitte Prestøe are among the friends whose reminiscences were included in this volume, reprinted from a special Munch number of *Kunst og Kultur* 29, nos. 3–4 (1946): 73–232.

Prestøe, Birgit. "Småtrekk om Edvard Munch," *Kunst og Kultur* 29, nos. 3–4 (1946): 205–16.

1947

Johnson, Ellen. "The Development of Edvard Munch." *Art Quarterly* 10, no. 2 (1947): 86–89.
 The Oberlin College art professor Ellen Johnson (1910–92) was the first female American scholar to publish on Munch.

1948

Bang, Erna Holmboe. "Edvard Munch som jeg minnes ham," *Jul i Bygda* (1948).
 Bang presents her memories of Munch for a popular audience.

Munch, Inger. "Edvard Munchs akvarell fra H. Bottolfsens landsted," *Urd,* no. 18 (1948).
 An early watercolor is described.

_____. "Edvard Munch med 'Fips' og 'Boy,'" *Urd,* no. 26 (1948).
 Inger Munch recalls Munch's dogs.

1949

Hoffmann, Edith. "Expressionism at the Stedelijk Museum, Amsterdam," *Burlington Magazine* 91 (December 1949): 344–48.
 In this exhibition review, Hoffmann points out that Munch played as great a part in the history of modern painting as Ibsen did in the history of modern drama. She finds *Girls on the Shore* (1903/04, Kunsthalle, Hamburg) a perfect image to suggest Munch's style as an influence on expressionism, but objects to his portrait of Strindberg as too French and irrelevant to the exhibition. At the time Hoffmann published this article, there were no women on the editorial committee of the prestigious *Burlington Magazine.*

Munch, Inger, ed. *Edvard Munchs brev. Familien.* Oslo Kommunes Kunstsamlinger, Munch-Museets Skrifter 1. Oslo: Johan Grundt Tanum Forlag, 1949.
 Five years after Munch's death, the museum established through his bequest to the city of Oslo initiated the publication of his correspondence with letters to his father, his aunt Karen Bjølstad, and other family members.

1950

Ingebretsen, Eli. "Edvard Munch's Graphic Art" in *Edvard Munch. Etchings, Woodcuts and Lithographs.* Exh. cat. London: Arts Council of Great Britain, 1950. Catalogue for a traveling exhibition held in Wakefield, May 6–29; Cambridge, June 3–24; Grantham, July 3–21; Worksop, July 29–August 19; Manchester, August 26–September 16; Bridgewater, October 21–November 11; York, November 25–December 16.

Louchheim, Aline Bernstein. "Munch: An Unknown is Introduced Here," *New York Times Magazine* (April 16, 1950): 28–29.
 The opening of Munch's first American retrospective exhibition in Boston is publicized for a mass audience in this article.

Muller, Hannah B. "Selected Bibliography" in Frederick B. Deknatel, *Edvard Munch*. Exh. cat. New York: Museum of Modern Art, in collaboration with the Institute of Contemporary Art, Boston, Chantecleer Press, 1950, 116–20.
 Assistant librarian at the Museum of Modern Art, New York, 1943–54, Muller (b. 1916) compiled the first annotated bibliography on Munch in English. A selected list of 112 entries was included in the catalogue of the first monographic exhibition of Munch's work in America. The show, organized by James S. Plaut (1912–96), director of the Institute of Contemporary Art, Boston, traveled to ten American cities and to four venues in Europe after its Boston showing April 19–May 19, 1950. For Plaut, *Edvard Munch* was the second in a trio of pioneering Expressionist shows. He had arranged the first American exhibition of the work of the Austrian Oskar Kokoschka in 1948, and followed the Munch tour with the first showing of the Belgian artist James Ensor in 1952.

1951

Kuh, Katharine. "Edvard Munch: Retrospective Exhibition of Paintings and Prints," *Art Institute of Chicago Bulletin* 45 (1951): 22–25.

Hoffmann, Edith. "Edvard Munch. Paintings and Prints at the Tate," *Burlington Magazine* 93, no. 585 (December 1951): 390–94.
 Hoffmann comments on Munch's reception in England in her article on an exhibition at the Tate Gallery, London, sponsored by the Arts Council of Britain; it had previously been seen at venues at Brighton and Glasgow. She discusses links between Munch and other European artists and offers astute critical remarks on the Munch literature, commending Hannah B. Muller's bibliography in the 1950 exhibition catalogue by Frederick B. Deknatel.

_____. "Munch in England," *The Norseman* 6 (1951).

Muller, Hannah B. "Edvard Munch. A Bibliography," *Oslo Kummunes Kunstsamlinger. Årbok 1946–1951*. Oslo: Oslo Kommunes Kunstsamlinger, 1951, 101–30.
 In the headnote to her selective list in the 1950 exhibition catalogue, Muller mentioned a comprehensive bibliography on file at the library of the Museum of Modern Art, New York. This twenty-nine-page, 245-entry bibliography with a chronology of exhibitions represents the more complete bibliography, published by the city of Oslo art collections in their first yearbook. In the second volume (1952–59), a supplement including entries 246–472 was published.

1952

Hougaard, Birthe. "Livsfrisen—et kunstnerisk storverk. *Aarstiderne* 3 (1952): 89–95.
 The author discusses the series Munch called the Frieze of Life.

Möller, Ingeborg. "Et møte med den unge Edvard Munch," *Vinduet* 6, no. 1 (1952).
 An encounter with the young Munch is described.

1953

Gløersen, Inger Alver. "Samtaler med Edvard Munch," *Urd*, no. 25 (1953).
 Conversations with the artist are the subject of this reminiscence.

_____. "I den gamle sofa," *Urd*, no. 26 (1953).
 The stiff, carved-back horsehair sofa was a staple of the late nineteenth-century parlor. It appears in many of Munch's early works.

1954

Prestøe, Birgit. "Modellen," *Norsk Dameblad* 1 (1954).
 The model for *Gothic Girl* and other late works recalls, for a popular audience, her association with Munch.

_____. Essay in *Edvard Munch mennesket og kunstneren*. Oslo: Gyldendal, 1954.
 Prestøe's memoir presents the only woman's viewpoint in this collection of essays.

1955

Berggrav, Grete. "The Death of Edvard Munch," *The Norseman* 13, no. 6 (November/December 1955).

_____. "Våpenlos kamp," *Brogger* (1955).
 The title "unarmed combat" refers to the struggle of an artist for recognition.

1956

Ahlström, Stella. *Strindbergs erövring av Paris*. Stockholm: Almqvist & Wiksell, 1956.
 Relations between the Swedish writer August Strindberg and Munch in Paris in 1896 are discussed.

Gløersen, Inger Alver. *Den Munch jeg møtte*. Oslo: Gyldendal Norsk Forlag, 1956.
 Gløersen, the step-daughter of Munch's close friend Sigurd Høst, offers personal recollections of her long association with the artist.

Valstad, Tilla. "Et besøk i Edvard Munchs hjem," *Norges kvinner* no. 7 (1956).
 Valstad describes a visit to Munch's home for a women's magazine.

1960

Langaard, Ingrid. *Edvard Munch Modningsår. En studie i tidlig ekspresjonisme og symbolisme*. Oslo: Gyldendal Norsk Forlag, 1960.
 The collector and scholar Langaard's monographic study of the early stages of Munch's career was a major contribution to the literature. An English summary is included.

1963

Bang, Erna Holmboe. *Edvard Munchs kriseår. Belyst i brever*. Oslo, Gyldendal Norsk Forlag, 1963.
 Through correspondence, Bang elucidates Munch's crisis year of 1902.

Brosemann, Marianne. "Notizen zu Munch und der zeitgenössischen Literatur" in *Edvard Munch, 1863–1944*. Exh. cat. East Berlin: Staatliche Museen, Kupferstichkabinett, 1963. Catalogue of an exhibition held at the Kupferstichkabinett, December 1963–March 1964.
 Berlin's print room honors Munch on the centenary of his birth with an exhibition including a bibliography of contemporary criticism.

Greve, Eli [Ingebretsen]. *Liv og verk i lys av tresnittene*. Oslo: J. W. Capellens Forlag, 1963.
 A narrative presentation of woodcuts of the major periods, followed by an annotated catalogue, by the curator who worked with the print collection at the National Gallery, Oslo.

Hagemann, Sonja. "Dagny Juell Przybyszewska, genienes inspiratrice," *Samtiden* 10 (1963).
 Juel is seen as the "inspirer of genius."

Udinotti, Agnese. "Three Aspects of the Art Nouveau as Seen in the Works of Gustav Klimt, Jan Toorop, and Edvard Munch." Unpublished Master's thesis, Arizona State University, Tempe, 1963.

Wild, Doris. "Die Bildnisse von Edvard Munch im Kunsthaus Zürich," *Neuer Zürcher Zeitung* 42 (January 6, 1963).

1964

Karpinski, Caroline. "Munch and Lautrec," *Metropolitan Museum of Art Bulletin* 23 (November 1964): 125–34.

Kisch-Arndt, Ruth. "A Portrait of Felix Auerbach by Munch," *Burlington Magazine* 106 (March 1964): 131–33.
> Auerbach (1856–1933) was a professor of physics and mathematics at Jena whose work on wave theory interested Munch. The artist met Felix and Anna Auerbach in Weimar and went to Jena in early 1906 to paint the professor's portrait, described and published here for the first time. Kisch-Arndt, who reports that the Auerbachs treated her as if she were their own child, quotes letters from Munch to the couple and reproduces two examples. She notes that the Auerbach house in Jena, designed by Walter Gropius in 1924, was among the liveliest cultural centers in Thuringia in the years before 1933. She describes Anna Auerbach as a talented writer who shared her husband's enthusiasms.

McCullough, Norah. *Edvard Munch: Graphic Arts*. Exh. cat. Edinburgh: Scottish National Gallery of Modern Art, 1964. Catalogue of an exhibition held April–September 1964.

1965

Hoffmann, Edith. "Some Sources for Munch's Symbolism," *Apollo* 81 (1965): 87–93.
> Hoffmann regards the influence of Max Klinger (1857–1920) as greater than that of any other artist on Munch, surpassing that of the German painter Arnold Böcklin, the Belgian graphic artist Félicien Rops, and Paul Gauguin. She notes that Klinger was the friend and colleague of Munch's early mentor Christian Krohg; Klinger and Krohg had studied together in Karlsruhe and Berlin in the 1870s. Although crediting Munch's European sources, Hoffmann underlines his individuality and innovative strength.

Masaryková, Anna. "Edvard Munch v Praze," *Výtvarna Uměni* 14 (1964): 132–38.
> This article on Munch in Prague includes a German summary.

Schiefler, Luise. "Edvard Munch—neue Aspekte der Sammlung" in *Gustav Schiefler. Aus der Erinnerungen von Luise Schiefler aufgezeichnet von Hans Platte*. Hamburg, 1965, 21–24.
> The widow of Munch's cataloguer publishes her reminiscences of their collecting activities.

Ventura, Anita. "Survey of the Use of the Human Form in Art Through the Ages at Three San Francisco Museums," *Arts* 39 (January 1965): 77.

1966

Nochlin, Linda. "Edvard Munch: The Limits of Content," *Artforum* 4 (1966): 34–38.
> Nochlin, then best known for her work on French realism, published this article at the time of the second major American Munch retrospective held at the Guggenheim Museum in New York in 1966.

Koht, Lise. "Edvard Munchs personlighetsutvikling sett it lys av maleriene," *Samtiden* 4 (1967): 214–22.
> The development of Munch's personality seen in the light of paintings is the subject of this article.

1967

Radakovich, Mary Sims. "The Only Wise Men: An Essay." Unpublished Master's thesis, Tulane University, New Orleans, 1967.

1968

Lohmann-Siems, Isa, ed. *Edvard Munch: Graphik aus dem Munchmuseum, Oslo*. Exh. cat. Hamburg: Ernst Barlach Haus, 1968. Catalogue of an exhibition held at Ernst Barlach Haus, Stiftung Hermann F. Reemtsma, July 12–October 6, 1968.

1969

Feinblatt, Ebria. *Edvard Munch: Lithographs, Etchings, Woodcuts*. Exh. cat. Los Angeles: Los Angeles County Museum of Art, 1969. Catalogue of an exhibition held January 28–March 9, 1969.
> The print curator Feinblatt wrote the extensive notes for this exhibition, introduced by William S. Liebermann.

Linde, Brita. *Ernest Thiel och hans konstgalleri*. Stockholm: Thielskagalleri, 1969.
> The collector Ernest Thiel's gallery in Stockholm is presented, with a passage on his acquisition of thirteen Munch paintings and ninety prints.

Torjusen, Bente. "Edvard Munch and Czech Art," *Papers from the Xth AICA Congress at the Munch-Museet*. Oslo: Munch-Museet, 1969.

Van Nimmen, Jane. Catalogue notes in *Washington Print Club: The Work of Edvard Munch from the Collection of Mr. and Mrs. Lionel C. Epstein*. Exh. cat. Washington, D.C.: The Phillips Collection, 1969. Catalogue of an exhibition held March 15–April 20, 1969.
> Marjorie Phillips, the director of the gallery and widow of the founder Duncan Phillips, contributed the foreword for this 48-page collection catalogue prepared for the first exhibition of the Epstein Collection; Alan M. Fern wrote an introduction.

1970

Gløersen, Inger Alver. *Lykke huset. Edvard Munch og Åsgårdstrand*. Oslo: Gyldendal Norsk Forlag, 1970.
 Gløersen focuses her reminiscences on Munch at his summer cottage in Åsgårdstraand.

1971

Herbig, Eva, ed. *Edvard Munch: Aquarelle und Zeichnungen aus dem Munch-museet Oslo*. Exh. cat. Berlin: Deutsche Akademie der Künste zu Berlin, 1971. Catalogue of an exhibition held December 16, 1971–January 30, 1972.
 Watercolors and drawings by Munch were the subject of this exhibition.

Torjusen, Bente. "Edvard Munch utstilling i Praha 1905," *Kunsten Idag* 97, no. 3 (August 1971): 5–55.
 Torjusen's article on an exhibition at the Manes gallery in Prague has an English summary (52–55).

Torjusen, Bente, and Jiri Kotalik. *Edvard Munch og den Tsjekkiske Kunst*. Exh. cat. Oslo: Munch-Museet, 1971. Catalogue of an exhibition held at the Munch Museum, February 27–April 30, 1971.
 Torjusen describes the artistic context of Munch's important 1905 exhibition at the Manes gallery in Prague, Czechoslovakia, February 5–March 12, 1905. Included is a comprehensive bibliography relating to Munch's reception and his influence on Czech art.

1972

Irvin, Karen Anne. "A Comparison of Edvard Munch and August Strindberg." Unpublished senior honors thesis, College of William and Mary, Williamsburg, Virginia, 1972.

Henkel, Kathryn. "Munch and Strindberg: A Study of Their Association and Its Significance to Munch's Art." Unpublished Master's thesis, University of Maryland, College Park, Maryland, 1972.

Jaworska, Wladyslawa. "Edvard Munch and Stanislaw Przybyszewski," *Polish Perspectives* 15 (1972): 61–72.

Lathe, Carla. "The Group 'Zum schwarzen Ferkel.' A Study in Early Modernism." Unpublished Ph.D. dissertation, University of East Anglia, Norwich.
 Lathe produced the first detailed study in English of the Berlin milieu at the wine shop nicknamed by Strindberg, "At the sign of the black piglet." In the 1890s, the wine shop gave its name to the group of avant-garde artists and writers who met there, including Munch and other Scandinavian expatriates as well as Przybyszewski and German intellectuals.

Van Nimmen, Jane. Catalogue notes in "The Epstein Collection," *Allen Memorial Art Museum Bulletin* 29 (Spring 1972): 134–98. Catalogue of an exhibition held at the Allen Memorial Art Museum, Oberlin, Ohio, April 28–May 31, 1972.
 An update of the 1969 catalogue of the collection, including recent acquisitions, the catalogue includes an essay by Reinhold Heller, "Edvard Munch and the Clarification of Life," and a foreword by John R. Spencer.

Woll, Gerd. "Edvard Munchs arbeiderfrise." Unpublished Ph.D. dissertation, Oslo University, 1972.
 Woll's was a pioneering scholarly study of the late Munch and his interest in workers as a subject.

1973

Castleman, Riva. *The Prints of Edvard Munch*. Exh. cat. New York: Museum of Modern Art, 1973. Catalogue of an exhibition held February 13–April 29, 1973.
 Highlights from the large collection at the museum are the basis of this exhibition.

Jaworska, Wladyslawa. "Munch und Przybyszewski" in *Edvard Munch. Probleme—Forschungen—Thesen*. Henning Bock and Günther Busch, eds. Munich: Prestel-Verlag, 1973.
 This collection also includes studies on Munch and Rodin and on Munch's photography by J. A. Schmoll gen. Eisenwerth as well as an extensive bibliography and exhibition list compiled by Lucius Grisebach.

Næss, Trina. "Edvard Munch og Den fri Kjærligheds by," *Kunst og Kultur* 3 (1973): 145–60.
 The article concerns Munch's satiric works called "The City of Free Love."

Sherman, Ida Landau. "Edvard Munch: The Evolution of the 'Alma Mater' Mural." Unpublished Master's thesis. Georgia State University, Atlanta, 1973.

Wilson, Mary Gould. "Edvard Munch. A Study of His Form Language." Unpublished Ph.D. dissertation. Northwestern University, Evanston, Illinois, 1973.
 The author contends that Munch's expression of feelings depends on the shape and placement of forms, not on color.

1974

Andersen, Evelyn. "Edvard Munch: His Life and Art." Unpublished Master's thesis, Hofstra University, Hempstead, New York, 1974.

Gilmour, Pat. "Munch," *Arts Review* 26 (January 1974): 25, 27.

Hougen, Pål, and Ingrid Krause. *Edvard Munch 1863–1944*. Exh. cat. Munich: Haus der Kunst, 1974. Catalogue of an exhibition held in the Haus der Kunst, October 6–December 16, 1973; Hayward Gallery, London, January 8–March 3, 1974; Musée National d'Art Moderne, Paris, March 22–May 12, 1974.
> Krause cooperated with Pål Hougen, at that time curator of the Munch Museum, on this traveling exhibition.

Jaworska, Wladyslawa. "Edvard Munch and Stanislaw Przybyszewski," *Apollo* 100, no. 152 (October 1974).

Werenskiøld, Marit. "Die Brücke und Edvard Munch," *Zeitschrift des deutschen Vereins für Kunstwissenschaft* 28 (1974): 140–52.
> Werenskiøld, a Norwegian scholar specializing in expressionism, turns her attention to the Brücke, a German artists' group of the early twentieth century, and its contacts with and response to Munch.

1975

Groot, Irene M. de. "De Sfinx, een litho door Edvard Munch," *Bulletin van het Rijksmuseum* 23, no. 2 (May 1975): 85–86.

Ingersoll, Berit. "Edvard Munch: His Psychic-Artistic Development." Unpublished psychology honors thesis, Oberlin College, Oberlin, Ohio, May 1975.

Kelm, Bonnie. "The Negative Feminine Archetype in the Works of Edvard Munch." Unpublished Master's thesis, Bowling Green State University, Bowling Green, Ohio, 1975.

Kress, Annelise. "Van Gogh and Munch," *Bulletin of the Rijksmuseum Vincent Van Gogh* 3 (1975): 27–40.

Matthews, Shirley R. Wittman. "The Biblical Concept of the Image of Man in the Works of Edvard Munch, Georges Rouault, and Max Beckmann." Unpublished Master's thesis, Stephen F. Austin State University, Nacogdoches, Texas, 1975.

Sherman, Ida. "Edvard Munchs 'Alma Mater.' Tretti år i kamp med et motiv," *Kunst og Kultur* (1975): 137–53.

1976

Cochran, Bente Roed. "The Artistic Depiction of Man-Woman Relationships by Sigbjørn Obstfelder and Edvard Munch." Unpublished Master's thesis, University of Alberta, 1976.
> Cochran explores the relationship between the work of Munch and Obstfelder (1866–1900), a prominent Norwegian Symbolist poet.

Hougen, Pål, and Ursula Perucchi-Petri. *Munch und Ibsen*. Trans. Randi Sigg-Gilstad. Exh. cat. Zurich: Kunsthaus, February 29–April 11, 1976.
> Perucci-Petri contributed to the catalogue of the exhibition she organized with Hougen based on loans from the Munch Museum, Oslo.

Sherman, Ida. "Edvard Munch og Félicien Rops," *Kunst og Kultur* (1976): 243–58.
> Sherman relates Munch to the Belgian printmaker often thought to have influenced Munch's *Puberty*.

Woll, Gerd. "Munch's Graphic Art" in *Edvard Munch: The Major Graphics*, 17–20. Exh. cat. Washington, D.C.: Smithsonian Institution Traveling Exhibition Service, 1976. Catalogue of an exhibition held in 1976–77.
> This traveling loan exhibition from the Munch Museum commemorated the United States Bicentennial. The catalogue included a brief essay by Arne Eggum on "Munch and America."

Wylie, Harold W., Jr., and Carol Ravenal. "Edvard Munch: A Study of Narcissism and Artistic Creativity," paper delivered to a meeting of the American Psychoanalytic Association, December 17, 1976.

1977

Blagg, Margaret. *The Prints of Edvard Munch*. Beaumont, Texas: Beaumont Art Museum, 1977. Brochure for children accompanying an exhibition held February 2–23, 1977.

Comini, Alessandra. "For Whom the Bell Tolls: Private versus Universal Grief in the Work of Edvard Munch and Käthe Kollwitz," *Arts Magazine* 51, no. 7 (March 1977): 142.

Holmes, Aeralyn G. "Edvard Munch: The Development of Intensified Emotion Through the Themes of Love and Death." Unpublished Master's thesis (M.S. Teaching—Art), University of Wisconsin—Oshkosh, 1977.

Stang, Ragna Thiis. *Edvard Munch: mennesket og kunstneren*. Oslo: Aschehoug, 1977.
> Ragna Thiis Stang (1909–1978), the director of the Munch Museum between 1966 and 1971, was the daughter of Munch's close friend Jens Thiis (1870–1942), director of the Oslo National Gallery from 1909 until the German occupation. Her monograph was the second postwar view of the artist based on primary sources to be widely translated and remain in print. It includes an extensive bibliography.

Stang, Ragna Thiis. *Edvard Munch: The Man and His Art*. Translated by Geoffrey Culverwell. New York: Abbeville Press, 1977.

Korazija, Eva, and Caroline Kesser. "Musik auf der Karl-Johan-Strasse, 1889" in *Edvard Munch im Kunsthaus Zürich*, 14–25. Sammlungsheft 6. Zurich: Kunsthaus, 1977.

> This entry and the following nine are the result of an exemplary art history seminar at the University of Zurich under Prof. Dr. Emil Maurer in the summer of 1975. The students completed brief guides for the museum's visitors on each Munch work as well as the more extensive version for publication. Other entries were written by Guido Magnaguagno ("Winternacht, um 1900," 27–36) and Urs Hobi ("Schiffswerft, 1911," 61–67).

Hasler, Barbara. "Bildnis Albert Kollmann, um 1900" in *Edvard Munch im Kunsthaus Zürich*, 37–48.

Knaben-Cossardt, Monika. "Bildnis Fräulein Warburg (Helene Julie, gen. Ellen), 1905" in *Edvard Munch im Kunsthaus Zürich*, 49–53.

Mönch, Katrin. "Hafen von Lübeck, 1907" in *Edvard Munch im Kunsthaus Zürich*, 55–60.

Höfliger, Yvonne. "Bildnis Frau Else [*sic*] Glaser, 1913" in *Edvard Munch im Kunsthaus Zürich*, 69–76.

_____. "Apfelbaum, 1921" in *Edvard Munch im Kunsthaus Zürich*, 78–85.
Burckhardt, Jacqueline. "Bildnis Dr. Wilhelm Wartmann, 1923" in *Edvard Munch im Kunsthaus Zürich*, 87–94.

Würgler, Regula. "Winter in Kragerø, 1925–1931" in *Edvard Munch im Kunsthaus Zürich*, 95–100.

Burckhardt, Jacqueline. "Zu Munchs Bildnissen" in *Edvard Munch im Kunsthaus Zürich*, 101–5.

Würgler, Regula, and Urs Hobi. "Landschaft im Werk von Edvard Munch. Voraussetzungen, Bedeutung und Entwicklung" in *Edvard Munch im Kunsthaus Zürich*, 106–21.

1978

Otterness, Ann Marie. "The Human Experience in the Paintings of Edvard Munch." Unpublished Master's thesis, University of Texas at San Antonio, 1978.

Schütz-Rautenberg, Gesa. *Klinger und Munch*. Weltanschauung unk Psyche in Bildzyklen der Jahrhundertwende. Exh. cat. Kiel: Kunsthalle zu Kiel and Schleswig-Holsteinischer Kunstverein, 1978. Catalogue of an exhibition held at the Kunsthalle, Kiel, April 26–May 24, 1978.

> In her study of turn-of-the-century image cycles, the author relates the work of Munch to that of Klinger.

Stang, Ragna. "The Aging Munch. New Creative Power" in *Edvard Munch: Symbols & Images*, 77–86. Exh. cat. Washington: National Gallery of Art, 1978. Catalogue of an exhibition held November 11, 1978–February 19, 1979.

> Stang's essay discusses Munch's break with symbolism and a new monumentality, harmony, and vitality in pictures such as *Fertility* (1898), *Girls on the Pier* (Nasjonalgalleriet, Oslo, 1900), and *Men Bathing* (Art Museum of the Ateneum, Antell Collection, Helsinki, 1907). She firmly dates the renewal in his style to the period preceding his recovery in Dr. Daniel Jacobson's Copenhagen clinic in 1908–1909, and elucidates Munch's vigorous undertaking of the Oslo University mural project and his later deliberate isolation on his property at Ekely near Oslo.

Torjusen, Bente. "The Mirror" and "Catalogue of the Mirror" in *Edvard Munch: Symbols and Images*, 185–227.

> The Mirror was a series of twenty-five prints exhibited in 1897. Nine lithographs and three woodcuts from the series rediscovered in 1973 appeared in the 1978–79 show at the National Gallery of Art, Washington; they were later acquired by the Fogg Art Museum, Harvard University, through the generosity of Lynn and Philip A. Straus.

Woll, Gerd. "The Tree of Knowledge of Good and Evil, " translated by Erik J. Friis, in *Edvard Munch: Symbols and Images*, 229–47.

> Woll, prints and drawings curator at the Munch Museum, offers a painstaking study of one of the artist's principal compilations of texts, drawings, and mounted prints. She dates most of the work on this volume of ninety-nine huge cardboard pages to 1916, about the time of his purchase of Ekely and his move in April of that year. A full description and translation of Munch's texts by Alf Bøe follows Woll's essay.

1979

Christensen, Charlotte, ed. *Edvard Munch tegninger og akvareller*. Ex. cat. Copenhagen: Kunstforeningen, 1979. Catalogue of an exhibition held October 5–November 4, 1979.

> This Danish exhibition catalogue presents drawings and watercolors by Munch.

Franke-Höltzermann, Carola. "Edvard Munch und sein erster Berlin-Aufenthalt in den Jahren 1892–1895." Unpublished Master's thesis for Tübingen University, 1979/80.

Krause-Zimmer, Helga. "Edvard Munch zum Linde Haus," *Die Drei. Zeitschrift für Wissenschaft, Kunst und soziales Leben* 49 (November 11, 1979): 713–19.

Lathe, Carla. "Edvard Munch and the Concept of 'Psychic Naturalism,'" *Gazette des Beaux-Arts*, ser. 6, 93 (March 1979): 135–46.

> Basing her study on a term used by Stanislaw Przybyszewski in an 1895 review of Munch's work, Lathe explores Munch's understanding of the concept.

_____. *Edvard Munch and His Literary Associates*. Exh. cat. Norwich, England: Library, University of East Anglia, 1979. Catalogue of an exhibition held in the library concourse, October 6–28; Hatton Gallery, University of Newcastle-upon Tyne, November 5–30, 1979; Crawford Centre for the Arts, University of St. Andrews, December 8, 1979–January 6, 1980.

> The exhibition and catalogue focuses on Ibsen, Strindberg, Ola Hansson, Friedrich Nietzsche, Gunnar Heiberg, Przybyszewski, and others to reveal Munch's connections with those shaping modern literature in the 1890s.

Stang, Ragna. *Edvard Munch—der Mensch und der Künstler*. Königstein i Ts: 1979.

> A translation of her 1977 monograph.

1980

Edvard Munch. Liebe—Angst—Tod. Exh. cat. Bielefeld: Kunsthalle Bielefeld, 1980. Catalogue of an exhibition held at the Kunsthalle Bielefeld, September 28–November 23, 1980; Krefeld, Kaiser Wilhelm Museum, January 25–March 15, 1981; Kaiserslautern, Pfalzgalerie, March 29–May 10, 1981.

> The catalogue to this important thematic show based on the Frieze of Life images (Love, Anxiety, Death) included essays by Arne Eggum, Gerd Udo Feller, Reinhold Heller, Günter Hofer, Peter W. Guenther, Heribert Heere, Gundolf Winter, and Ulrich Weisner in addition to the two cited below.

Torjusen, Bente. "Der Speigel. Eine graphische Folge und ein Graphik-Blatt" in *Edvard Munch. Liebe—Angst—Tod*, 377–86.

> Torjusen contributes the results of her study of the Mirror series for this German exhibition catalogue.

Woll, Gerd. "Angst findet man bei ihm überall" in *Edvard Munch. Liebe—Angst—Tod*, 315–34.

Vander Schaff, Elizabeth Ann. "Edvard Munch's Archetypal Image of Women." Unpublished Master's thesis, University of Oregon, Eugene, 1980.

Wilson, Mary Gould. "Edvard Munch's 'Woman in Three Stages': A Source of Inspiration for Henrik Ibsen's 'When We Dead Awaken,'" *Centennial Review* 24, no. 4 (1980): 492–500.

Morrissey, Leslie D. "Edvard Munch's 'Alfa og Omega,'" *Arts Magazine* 54, no. 5 (January 1980): 124–29.

> Morrissey discusses the 1908–9 lithograph series Alpha and Omega.

Slatkin, Wendy. "Maternity and Sexuality in the 1890s," *Woman's Art Journal* 1, no. 1 (Spring–Summer 1980): 13–19.

> Slatkin sees Munch as a contributor to the growing tide of antipathy to women.

Wood, Mara-Helen. "Foreword" in *Munch Landscapes*. Exh. cat. Newcastle upon Tyne: Polytechnic Gallery, 1980.

> The first of four exhibitions in the 1980s organized by Wood in collaboration with the Munch Museum, Oslo, with a catalogue text by Arne Eggum.

Wylie, Harold W., Jr., and Mavis L. Wylie. "Edvard Munch," *American Imago* 37, no. 4 (Winter 1980): 413–43.

1981

Farago, Claire. *Edvard Munch and the Female Paradigm*. Exh. cat. Richmond, Va.: The Virginia Museum, 1981. Catalogue of an exhibition held January 30–March 15, 1981.

> This foldover checklist includes a brief summary essay.

Hartten, Rosemary J. "The Image of Woman: Seen Through the Plays of August Strindberg and the Art of Edvard Munch, Connected with the Year 1892 in Berlin." Unpublished Master's thesis (M. Litt.), Drew University, Madison, New Jersey, 1981.

Judrin, Claudie. "Acquisition par le musée Rodin d'une peinture de Munch," *Revue du Louvre* 31, nos. 5–6 (1981): 387–89.

> Judrin discusses the recently acquired *Rodin's Thinker in the Garden of Dr. Linde* (1907), the first painting by Munch to enter a French public collection.

Ravenal, Carol. "Women in the Art of Edvard Munch" in *Edvard Munch: Paradox of Woman*. Exh. cat. New York: Aldis Browne Fine Arts, Ltd., 1981. Catalogue of an exhibition held at Aldis Browne Fine Arts, Ltd., October 28–December 5, 1981; McNay Art Institute, San Antonio, Texas, January 17–February 21, 1982; Abilene Fine Arts Museum, Abilene, Texas, March 20–April 26, 1982; Denver Art Museum, Denver, Colorado, June 12–July 25, 1982 (with a supplement of twenty-eight portrait prints selected by Cameron Wolfe); University Art Galleries, University of Southern California, Los Angeles, September 12–October 23, 1982; Minnesota Museum of Art, St. Paul, December 3–January 23, 1983.

Woll, Gerd. "The Alpha and Omega Portfolio" in *Edvard Munch: Alpha and Omega*. Translated by Christopher Norman. Exh. cat. Oslo: Munch Museum, 1981. Catalogue of an exhibition held at the Munch Museum, March 25–August 31, 1981.

 Woll's essay discusses the printmaking aspects of the portfolio, complementing Arne Eggum's general essay.

1982

Maeyer, Lise de. *Ensor og Munch, paralleler*. Exh. cat. Oslo: Munch Museum, 1982, 9–31.

 The Belgian painter and printmaker James Ensor (1860–1949) is compared with Munch in this exhibition.

Skedsmo, Tone. "Patronage and Patrimony" in *Northern Light: Realism and Symbolism in Scandinavian Painting 1880–1910*, 43–51. Exh. cat. New York: The Brooklyn Museum, 1982. Catalogue of an exhibition held at Corcoran Gallery of Art, Washington, D.C., September 8–October 17, 1982; The Brooklyn Museum, November 10, 1982–January 6, 1983; and The Minneapolis Institute of Arts, Minnesota, February 6–April 10, 1983.

 Skedsmo discusses two important Munch collectors, Ernest Thiel and Rasmus Meyer. Kirk Varnedoe was curator of this exhibition; Patricia Gray Berman was chief research assistant. She contributed the headnote for the Munch section and five of the eight Munch entries; Emily Braun wrote the other three entries.

_____. "Hos kunstnere, polarforskere og mesener," *Kunst og Kultur* 65, no. 3 (1982): 131–44.

 Artists' houses and patronage in the Lysacker group of artists are the subjects of this study; the role of the polar explorer Fridtjof Nansen in the group is highlighted.

Wichstrøm, Anne. "Asta Nørregaard og den unge Munch," *Kunst og Kultur* 65, no. 2 (1982): 66–77.

 Asta Nørregaard (1853–1933), not to be confused with Aase Nørregaard, painted the first portrait of Munch; Wichstrøm examines the possibility that he studied under her briefly when she returned from Paris in 1885.

Zdanek, Felix, and Ulrike Köcke. *Grafik aus dem Munch Museum in Oslo und dem Museum Folkwang, Essen*. Exh. cat. Linz: Neue Galerie der Stadt Linz, 1982. Catalogue of an exhibition held October 21–December 5, 1982.

 Prints from Oslo and Essen were brought together for this Austrian exhibition.

1983

Epstein, Sarah G. Ed. by Jane Van Nimmen. Foreword by Chloe H. Young. *The Prints of Edvard Munch: Mirror of His Life*. Exh. cat. Oberlin, Ohio: Allen Memorial Art Museum, 1983. Catalogue of an exhibition held at Allen Memorial Art Museum, March 1–27, 1983; Columbus Museum of Art, Ohio, May 31–June 24, 1983; Portland Art Museum, Oregon, July 27–August 28, 1983; Bowdoin College Museum of Art, Brunswick, Maine, September 23–November 13, 1983; Williams College Museum of Art, Williamstown, Massachusetts, November 20, 1983–February 12, 1984.

 Illustrating major periods of Munch's life with prints, Epstein explores the connections between images and memories.

 Van Nimmen, Jane. "Patrons and Friends at the Turn of the Century" in *The Prints of Edvard Munch: Mirror of His Life*, 101–30.

 Munch's patrons in Germany are described, as well as the Swedish financier Ernest Thiel and Munch's intimate Norwegian friends Aase and Harald Nørregaard and Christen Sandberg.

Guisset, Jacqueline. "Salomé au XIXe siècle: rapports entre littérature et arts plastiques," *Annales d'histoire de l'art et d'archéologie* 5 (1983): 67–82.

 The Salome theme in music, literature, and art of the nineteenth century is discussed in this article, which includes an analysis of the use of the motif in Munch works.

Norklun, Kathi, "Edvard Munch; expressionist paintings, 1900–1940," *Artweek* 14, no. 11 (March 19, 1983): 24.

This article reviews the important traveling exhibition on Munch as an expressionist that opened in Madison, Wisconsin, at the University of Wisconsin, Elvehjem Museum of Art, in 1982 and traveled to Newport Beach, California, Seattle, Washington, and St. Paul, Minnesota.

Prelinger, Elizabeth. *Edvard Munch: Master Printmaker. An Examination of the Artist's Works and Techniques Based on the Philip and Lynn Straus Collection*. Exh. cat. New York: W. W. Norton and Busch-Reisinger Museum, 1983. Book accompanying an exhibition held at the Busch-Reisinger Museum, Harvard University, and Roy Neuberger Art Museum, State University of New York, Purchase.

 Based on a close comparison of the holdings of Philip and Lynn Straus with those of the Munch Museum and other collections of Munch works on paper, Prelinger's text is an important contribution to an understanding of Munch's graphic techniques. She portrays Munch's passion for experiment as he tirelessly reworks his print matrices.

Lathe, Carla. "Edvard Munch's Dramatic Images, 1892–1909," *Journal of the Warburg and Courtauld Institutes* 46 (1983): 191–206.

 Munch's work related to Henrik Ibsen is the focus of the article.

1984

Baas, Jacquelynn, and Richard S. Field. *The Artistic Revival of the Woodcut in France 1850–1900*. Exh. cat. Ann Arbor: University of Michigan Museum of Art, 1984. Catalogue of an exhibition held at The University of Michigan Museum of Art, November 4, 1983–January 6, 1984; Yale University Art Gallery, New Haven, Connecticut, February 1–March 25, 1984; Baltimore Museum of Art, Maryland, April 17–June 3, 1984.
 Baas and Field rethink the often-repeated formula of Munch as the inventor of the jigsawed woodblock.

Carlsson, Anni. *Edvard Munch. Leben und Werk*. Stuttgart, Zurich: Belser, 1984.

Edvard Munch. Alpha and Omega. Its Gestation and Resolution. Prints from the Collection of Sarah G. and Lionel C. Epstein. Curated by Richard A. Epstein, with Mary Delahoyd and Jane Van Nimmen. Exh. cat. Bronxville, N.Y.: Sarah Lawrence College Gallery, 1984. Catalogue of an exhibition held at the Sarah Lawrence College Gallery, October 2–November 18, 1984.
 Delahoyd compiled notes for Richard Epstein's introductory essay and the illustration section, with the assistance of Deborah Felstehausen. The show included the entire lithograph series as well as thirty-four other prints.

Gup, Audrey Rosa. "Munch's *The Voice*, an Image of Woman." Unpublished Master's thesis, Brown University, Providence, Rhode Island, 1984.

Kirst-Gunderson, Karoline Paula. "Surmounting a Cliche: Woman in the Art of Edvard Munch." Unpublished Master's thesis, City College of New York, 1984.

Schneede-Sczesny, Marina. "Um so Nackensteifer, Je Zäher die Widerstände. Hamburg und Munch" in *Edvard Munch— Höhepunkte des malerischen Werks im zwanstigsten. Jahrhundert*. Exh. cat. Hamburg: Kunstverein, 1984–85, 155–58.

Woll, Gerd. *Munch and the Workers*. Exh. cat. Newcastle upon Tyne: Newcastle Polytechnic Gallery, 1984. Catalogue of an exhibition held at the Newcastle Polytechnic Gallery, October 8–November 30, 1984; Aberdeen Art Gallery, January 12–February 2, 1985; The Barbican, London, February 14–March 31, 1985; City Art Centre, Edinburgh, April 18–May 18, 1985; Ulster Museum, Belfast, May 30–June 24, 1985; Walker Art Gallery, Liverpool, July 4–August 18, 1985.
 Newcastle curator Mara-Helen Wood organized this loan exhibition from the Munch Museum, the second major international exhibition tour originating in the Newcastle Polytechnic Gallery.

Warick, Lawrence, and Elaine R. Warick. "Transitional Process and Creativity in the Life and Art of Edvard Munch," *Journal of the American Academy of Psychoanalysis* 12, no. 5 (1984): 413–24.

Werenskiøld, Marit. *The Concept of Expressionism: Origin and Metamorphoses*. Oslo: Universitetsforlaget, 1984.

Yarborough, Bessie Rainsford. "The Misogyny of Edvard Munch: A Study of His Images of Women." Unpublished Master's thesis, University of South Carolina, Columbia, S.C., 1984.

1985

Anderson, Katherine E. "The Landscapes of Edvard Munch: A Medium of Communication and the Continuation of a Tradition." Unpublished Master's thesis, Michigan State University, East Lansing, 1985.

Bimer, Barbara Susan Travitz. "Edvard Munch's Fatal Women: A Critical Approach." Unpublished Master's thesis, North Texas State University, Denton, Texas, December 1985.

Fine, Vivian. *Quintet: (After Paintings by Edvard Munch): Oboe, Clarinet, Violin, Violoncello, and Piano*. New York: Henmar Press, 1985.

Graen, Monika. *Das Dreifrauenthema bei Edvard Munch*. Europäische Hochschulschriften, Reihe 28, Kunstgeschichte, 48, Frankfurt am Main; New York: Lang, 1985.
 Graen's study is a Ph.D. dissertation presented at the University of Freiburg in Breisgau on the theme of three women in Munch's art.

Höfliger, Yvonne. "Munch und Zürich—Spuren einer Begegnung" in *Edvard Munch. Sein Werk in Schweizer Sammlungen*. Exh. cat. Kunstmuseum Basel, 1985. Catalogue of an exhibition held June 9–September 22, 1985.
 Arrangements for Munch's 1922 Kunsthaus exhibition, his relationship with Wilhelm Wartmann (1882–1970), director of the museum, his influence on the art patron Alfred Rütschi (d. 1929) and the artists Max and Eduard Gubler are discussed as Höfliger documents the "traces of an encounter." The catalogue includes commentary by Christian Geelhaar, Dieter Koepplin, Gustav Coutelle, and Martin Schwander as well as interviews with Joseph Beuys and Georg Baselitz on Edvard Munch.

Krämer, Gunhild-Barbara. "Das Berliner Kunstleben 1880 bis 1895 und die Edvard Munch-Ausstellung 1892 in Berlin." Unpublished Master's thesis for University of Munich, 1985.

Lathe, Carla. "Edvard Munch and Modernism in the Berlin Art World 1892–1903," *Facets of European Modernism. Essays in Honour of James McFarlane*. Janet Garton, ed. Norwich: University of East Anglia, 1985, 99–129.
 Lathe continues her authoritative work on the cultural milieu in which Munch moved during his period of activity in Berlin.

Lind, Ingela. "The Origin of the Image of Scandinavia in the U.S.A.: The 1912 Exhibition of Danish, Norwegian, and Scandinavian Art," *Scandinavian Review* (Winter 1985): 35–49.

> Lind's article is the first study of the American Scandinavian Society Scandinavian art exhibition in 1912–13; research on the tour is relevant to Munch's reception in North America.

Schütz, Barbara M. "Farbe und Licht bei Edvard Munch." Ph.D. dissertation, University of Saarland, Germany.

> This is a scholarly examination of Munch's use of color and light in his work.

Skedsmo, Tone. "Tautrekking om Det syke Barn," *Kunst og Kultur* 68, no. 3 (1985): 184–95.

> Skedsmo describes the conflict over the ownership of Munch's *The Sick Child* (Nasjonalgalleriet, Oslo, 1885–86), originally given to Christian Krohg and later the subject of a legal battle between Oda Krohg and her husband and Aase and Harald Nørregaard.

Stassaert, Lucienne. *Karen: Een Ontmoeting in de Ruimte*. Antwerp: Manteau, 1985.

> This imaginative treatment of Munch's aunt, Karen Bjølstad, is published by a Flemish press. The subtitle is "a meeting in space."

Stefano, Eva di. "Die zweigesichtige Mutter" in *Début eines Jahrhundert. Essays zur Wiener Moderne*. Wolfgang Pircher, ed. Vienna: Falter Verlag, 1985.

> Munch's *Madonna* and *Vampire* are considered in di Stefano's broad examination of ambiguous maternity in the 1890s. Other examples range from Gustav Klimt to Oskar Kokoschka.

Woll, Gerd. "The Graphic Production of Edvard Munch" in *Munch*. Exh. cat. Milan: Mazzotta, 1985, 173–88. Catalogue of an exhibition held in Milan, Palazzo Reale, Palazzo Bagatti Valsecchi, December 4, 1985–March 16, 1986; and Palazzo Braschi, Rome, March 27–June 1, 1986.

> Woll offers an overview based on the 20,000 prints in the Munch Museum.

1986

Baas, Jacquelynn. *Encounter in Space: Double Images in the Graphic Art of Edvard Munch*. Exh. cat. Hanover, New Hampshire: Hood Museum of Art, 1986. Catalogue of an exhibition held at Franklin and Marshall College, Lancaster, Pennsylvania, September 26–October 26, 1986; Hood Museum of Art, Dartmouth College, Hanover, New Hampshire, November 8, 1986–January 4, 1987; Wellesley College Museum of Art, Wellesley, Massachusetts, February 7–March 22, 1987.

> Baas brings together a variety of prints from the Epstein Family Collection using paired lovers, portrait subjects, and objects.

Berman, Patricia G. *Edvard Munch: Mirror Reflections*. Exh. cat. West Palm Beach, Florida: Norton Gallery and School of Art, 1986. Catalogue of an exhibition held at the Norton Gallery and School of Art, February 22–April 13, 1986. A portion of this exhibition traveled to the Achenbach Foundation, California Palace of the Legion of Honor, Fine Arts Museums of San Francisco, under the title *The Prints of Edvard Munch. Mirror of His Life II*, April 26–July 27, 1986.

> Berman provides new documentation for the supplementary prints and paintings from various public and private collections exhibited in this expanded version of the 1983 Oberlin show of prints from the Epstein Family Collection.

Ravenal, Carol M. "Three Faces of Mother: Madonna, Martyr, Medusa in the Art of Edvard Munch," *Journal of Psychology* 13, no. 4 (1986): 371–412.

Maluquer, Elvira, ed. *Munch, 1863–1944*. Exh. cat. Barcelona: La Fundacio, 1986. Catalogue of an exhibition held at the Centre Cultural de la Fundacio Caixa de Pensions, January 27–March 22, 1987.

> This exhibition catalogue includes texts in Catalan, Spanish, and English.

McDonnell, Patricia. "The Kiss: A Barometer for the Symbolism of Gustav Klimt," *Arts Magazine* 60, no. 8 (April 1986): 65–73.

> Both Munch and Ferdinand Hodler (1853–1918) are compared with the Austrian Gustav Klimt (1862–1918) in terms of the iconography of kissing.

Torjusen, Bente. *Words and Images of Edvard Munch*. Chelsea, Vermont: Chelsea Green Publishing Co., 1986.

> Munch's writings face reproductions of his images, with an introductory text highlighting The Mirror series (see Torjusen 1978) and reproducing the twelve prints in color for the first time.

Tuteur, Marianne. "Munch's Spell," *Connoisseur* 216, no. 893 (June 1986): 92–97.

> An interview with the Munch collector Sarah G. Epstein.

Woll, Gerd. *Edvard Munch: Death and Desire: Etchings, Lithographs and Woodcuts from the Munch Museum, Oslo*. Ex. cat. Adelaide: Art Gallery of South Australia, 1986. Catalogue of an exhibition held at the gallery, September 5–October 18, 1986; Brisbane, Queensland Art Gallery; Melbourne, National Gallery of Victoria; Hobart, Tasmanian Museum and Art Gallery; and Perth, Art Gallery of Western Australia.

1987

Brody, Martin, and Patricia G. Berman. *Edvard Munch, Music and Aesthetics*. Program notes. Wellesley, Massachusetts: Wellesley College Museum, 1987.

Edvard Munch/Gustav Schiefler Briefwechsel. Band 1 1902–1914. Arne Eggum, with the collaboration of Sibylle Baumbach, Sissel Biörnstad, and Signe Böhn, eds. Hamburg: Verlag Verein für Hamburgische Geschichte, 1987.
> This exemplary collaboration of the Munch Museum and the Schiefler family resulted in two volumes (see 1990) of annotated correspondence between Munch and his cataloger. It is accompanied by a comprehensive exhibition list and two invaluable indexes, one to the titles of works and the other to personal names, with their life dates and notations on their position and role in Munch's life.

Böhn, Signe. "Edvard Munch und die deutsche Sprache" in *Edvard Munch/Gustav Schiefler Briefwechsel Band 1*, 29–32.
> Böhn provides a brief but vivid account of Munch's use of the German language.

Fahr-Becker-Sterner, Gabrielle. *Edvard Munch. Aus dem Munch Museum Oslo. Gemälde, Aquarelle, Zeichnunben, Druckgraphik, Fotografien*. Exh. cat. Munich: Villa Stuck, April 28–July 5; Salzburger Landesammlungen, Rupertinum, July 16–October 4; Brückemuseum, Berlin, October 15–December 12, 1987.
> This loan exhibition from the Munch Museum included paintings, works on paper, and photographs by Munch.

Hennum, Gerd. *Ingrid Lindbäck Langaard. Viljesterk kvinne i Kunsten*. Oslo: Dreyer, 1987.
> This book represents a sympathetic view of a Norwegian Munch collector and writer heretofore not properly appreciated.

Mitchell, Dolores. "The Iconography of Smoking in Turn-of-the-Century Art," *Source. Notes on the History of Art*. 6, no. 3 (Spring 1987): 27–33.
> Munch is among the artists examined as Mitchell traces the iconographical thread of smoking images.

Prelinger, Elizabeth. "The Symbolist Print." Unpublished Ph.D. dissertation, Harvard University, 1987.

Schütz, Barbara M. "Die Farbe bei Edvard Munch" in *Edvard Munch*, 77–88. Exh. cat. Essen, Zurich: Museum Folkwang, Kunsthaus Zürich, 1987. Catalogue of an exhibition held at the Museum Folkwang, Essen, September 18–November 8, 1987; and Kunsthaus Zürich, November 19, 1987–February 14, 1988.
> Schütz analyzes Munch's painting practice, color by color, for the catalogue to the fourth major retrospective show in Zurich (1922, 1932, and 1952; a specialized exhibition on Munch and Ibsen was mounted in 1976). Guido Magnaguagno served as curator for the 1987–88 exhibition, and Schütz, Franziska Müller, and Tone Skedsmo were among those contributing catalogue entries.

Warick, Lawrence, and Elaine R. Warick. "Edvard Munch: The Creative Search for Self," *Psychoananalytic Perspectives in Art* 2 (1987): 273–305.
> Munch's creativity is seen as saving him from "psychologic disintegration."

1988

Bowen, Anne McElroy. "Munch and agoraphobia: His art and his illness," *Revue de L'Art Canadienne* 15, no. 1 (1988): 23–24, 49–50.

Gilmour, Pat. "Cher Monsieur Clot," *Lasting Impressions: Lithography as Art*. Philadelphia: University of Pennsylvania Press, 1988.
> This study of the great Parisian color printer Auguste Clot examines his work for Munch, including the color lithographs *The Sick Child*, *Portrait of a Woman*, and other prints.

Lippincott, Louise. *Edvard Munch: Starry Night*. Malibu, California: Getty Museum Studies on Art, no. 1, 1988.
> The first in a Getty series focusing on single works in the collection, Lippincott's graceful study examines the 1984 acquisition in the context of the European mood landscape, then analyzes the Åsgårdstrand motif and its meaning for Munch. Finally, she discusses a former owner, the polar explorer Fridtjof Nansen (1861–1930).

Schmidt-Burkhardt, Astrit. "Curt Glaser—Skizze eines Munch-Sammlers," *Zeitschrift des deutschen Vereins für Kunstwissenschaft* 42, no. 3 (1988): 63–75.
> In a special issue of the journal dedicated to Berlin collectors of the early modern period, with an introduction by Thomas W. Gaehtgens, Schmidt-Burkhardt uses photographs of Curt and Elsa Glaser's apartment by Martha Huth to document the installation of works by Munch and Max Beckmann. She is the first to present a detailed study of one of the earliest and most important Munch collections and to credit Elsa Glaser's participation.

Wichstrøm, Anne. *Oda Krohg: Et Kunstnerliv*. Oslo: Gyldendal Norsk Forlag, 1988.
> Wichstrøm studies Oda Lasson Krohg's artistic achievement and her position in the Scandinavian avant garde at the turn of the century in the book subtitled "an artist's life." Krohg's relationship with Munch is clarified.

Woll, Gerd. "Edvard Munchs grafikk i tre norddiske samlinger," *Konsthistorisk Tidskrift* 57, nos. 3–4 (1988): 76–82.
> Woll examines the print collections of Rasmus Meyer (1858–1916), Ernest Thiel (1859–1947), and Max Linde (1862–1940).

1989

Berman, Patricia Gray. "Monumentality and Historicism in Edvard Munch's University of Oslo Festival Hall Paintings." Unpublished Ph.D. dissertation, New York University, 1989.

 Berman's study delineates Munch's individualistic approach to a major public art commission in the context of the nationalist revival after Norwegian independence.

Deike, Marion. *Edvard Munch. Doppelporträt 1897, Stallburg.* Unpublished seminar paper, Kunsthistorisches Institut, University of Vienna, 1989.

Groot, Irene M. de. "Twee vrouwen aan het strand, 1898," *Bulletin van het Rijksmuseum* 37, no. 3 (1989): 265–67. De Groot devotes this article to Munch's *Two Women on the Shore*, examining both the print technique and the iconography.

Jayne, Kristie. "The Cultural Roots of Edvard Munch's Images of Women," *Woman's Art Journal* 10, no. 1 (Spring/Summer 1989): 28–34.

 The context of family life in late nineteenth-century Europe reframes Munch's interpretations of women's roles. Jayne's study contributes to new readings of his female portraits.

Müller-Westermann, Iris. "Edvard Munchs Selbstbildnisse. Widersprüche als Herausforderung" in *Wunderblock. Eine Geschichte der modernen Seele.* Jean Clair, Cathrin Pichler, and Wolfgang Pircher, eds. Exh. cat. Vienna: Löcker, 1989, 514–27.

 The evolution of Munch's self-portrait is related to stages and events in Munch's life.

Skedsmo, Tone. *Edvard Munch: Nasjonalgalleriet.* Oslo: Nasjonalgalleriet, 1989.

 Skedsmo, now director of the National Gallery, Oslo, highlights its important Munch holdings.

Wood, Mara-Helen. "Foreword" in *Munch and Photography.* Exh. cat. Newcastle upon Tyne: The Polytechnic Gallery, 1989. Catalogue of an exhibition held at the Hatton Gallery, Newcastle University, May 2–June 10, and Newcastle Polytechnic Gallery, May 2–June 16, 1989; The City Art Centre, Edinburgh, August 5–September 16; City Art Gallery, Manchester, September 23–November 5, 1989; and The Museum of Modern Art, Oxford, January 14–March 18, 1990.

 Wood points out that this fourth Munch exhibition to be organized by Newcastle Polytechnic Gallery in the 1980s honors the 150th anniversary of the invention of photography. Arne Eggum, chief curator of the Munch Museum, Oslo, supplied a biographical text and an essay "Edvard Munch and Photography."

Wylie, Mavis L., and Harold W. Wylie. "The Creative Relationship of Internal and External Determinants in the Life of an Artist," *The Annual of Psychoanalysis* 17 (1989): 73–128.

1990

Edvard Munch/Gustav Schiefler Briefwechsel. Band 2 1915–1935/1943. Arne Eggum, with the collaboration of Sibylle Baumbach, Sissel Biørnstad, and Signe Böhn, eds. Hamburg: Verlag Verein für Hamburgische Geschichte, 1990.

 The Munch Museum and the Schiefler family complete with this volume their important collaborative publication (see 1987). The exhibition list is extended through 1943, additions to index entries for the first volume are listed, and a new title and personal name index complement the correspondence in the second volume.

 Woll, Gerd. "Der 'Nordische Katalog' zur Graphik von Edvard Munch" in *Edvard Munch/Gustav Schiefler Briefwechsel. Band 2,* 9–24.

 A close examination of the works designated in the scond volume of Schiefler's catalogue (1927) with 'N' numbers reveals the quality and tenacity of the cataloger to be exceptional for the period. Woll's is a seminal contribution to research on modernist printmaking and the historiography of work catalogues.

Epstein, Sarah G. "Living with Edvard Munch Images: A Collector in Three Stages" in *Edvard Munch: Master Prints from the Epstein Family Collection.* Exh. cat. Washington: National Gallery of Art, 1990, 11–45. Catalogue of an exhibition held at the National Gallery of Art, May–August 1990; Honolulu Academy of Arts, September 12–October 28, 1990; Los Angeles County Museum of Art, November 22, 1990–January 6, 1991; Center for the Fine Arts, Miami, January 19–March 3, 1991; Indianapolis Museum of Art, March 23–May 5, 1991; Nelson-Atkins Museum of Art, Kansas City, May 26–July 7, 1991; The High Museum of Art, Atlanta, August 17–November 10, 1991; The Dixon Gallery and Gardens, Memphis, November 30, 1991–January 12, 1992.

 Charged by Andrew C. Robison, curator of the exhibition, to write a personal essay on her experiences as a collector, Epstein contibutes a detailed account of her family's involvement with Munch since 1962. In addition to documenting her personal response to the artist, she places the development of the Epsteins' collection in the historical context of the postwar art market and Munch collecting in general.

Brengmann, Hedwig. "Edvard Munch und Frankreich." Unpublished Master's thesis, Rheinischen Friedrich-Wilhelms-Universität, Bonn, 1990.

Chattopadhay, Collette. (Exhibition review). *Artweek* 21 (December 27, 1990): 15.

 This is a review of the traveling·exhibition "Master Prints from the Epstein Family Collection" as seen at the Los Angeles County Museum of Art, November 22, 1990–January 6, 1991.

Moshenson, Edna, ed. *Edvard Munch: Prints: The Charles & Evelyn Kramer Collection at the Tel Aviv Museum of Art*. Exh. cat. Tel Aviv Museum of Art, 1990. Catalogue of an exhibition held in the autumn of 1990 in the Sam and Ayala Zacks Hall of the museum.

 Texts in Hebrew and English present the Kramers' collection and include an essay by Gerd Woll.

1991

Berman, Patricia G. "Edvard Munch and Photography" [Book review], *Scandinavian Studies* (Fall 1991): 10–13.

Cinotti, Mia. "La passione e la nausea," *Arte* 21, no. 222 (October 1991): 118–21, 123, 169.
 Munch is the principal subject of this article, which also discusses French post-impressionists.

Grubert-Thurow, Beate. *Edvard Munch: Holzschnitte*. Rutlingen: Das Kunstmuseum, 1991. Catalogue of an exhibition held at the Stadtisches Kunstmuseum, December 2, 1990–January 27, 1991.
 This German exhibition focused on woodcuts.

Heath, Elizabeth F. "The Theme of Anxiety in Selected Works of Henrik Ibsen, Edvard Munch and Ingmar Bergman." Unpublished Master's thesis (M.L.A.), University of South Florida, Tampa, 1991.

Müller-Westermann, Iris. "Huden som speil for selvopplevelsen," *UKS: Forum for Samtidskunst* 3–4 (1991): 4–7.
 Self-portraits by Munch are the focus of this article; the title is translated "The skin as a mirror of self-experience."

Munch et la France. Exh. cat. Paris: Editions de la Réunion des Musées Nationaux, 1991. Arne Eggum and Rodolphe Rapetti, eds. Catalogue of an exhibition held at the Musée d'Orsay, Paris, September 24, 1991–January 5, 1992; Munch Museum, Oslo, January 27–April 21, 1992; and Schirn Kunsthalle, Frankfurt, May 30–August 9, 1992.
 This effort to relocate and define sources and influences of French culture on Munch's work emphatically contributes to the view of Munch as an internationalist. It includes several essays by Eggum and Rapetti as well as the two cited below.

 Aitken, Geneviève. "Edvard Munch et la scène française" in *Munch et la France*, 222–39.
 A useful table lists the theatrical performances Munch might have seen during his sojourns in Paris, from his documented attendance at *Ghosts* (May 29–30, 1890) at the Théâtre-Libre of André Antoine through Romain Rolland's *The Wolves* at A. F. Lugné-Poe's Théâtre de l'Œeuvre on May 15, 1898. Aitken discusses possible influences of the Belgian playwright Maurice Maeterlinck, Munch's Swedish friend August Strindberg, and Oscar Wilde's *Salome*.

 Woll, Gerd. "Le Graveur" in *Munch et la France*, 240–75.
 In a masterful accompaniment to the seventy-seven prints from the Munch Museum on exhibit, Woll draws together recent research by Gabriel P. Weisberg on Munch's May 1896 exhibition at Siegfried Bing's l'Art Nouveau, confirming a redating of *The Cat* to 1895. Discussing Munch's Parisian printers, she places Eberhard Kornfeld's discovery that it was Alfred Porcaboeuf who printed the series of small etchings on zinc plates, not Lemercier, in the context of Munch's activities of 1896.

Norseng, Mary Kay. *Dagny: Dagny Juel Przybyszewsa. The Woman and the Myth*. Seattle: University of Washington Press, 1991.
 In a long-overdue treatment of one of the most important of Munch's female friends, Norseng restores Juel to her rightful position as a poet and human being rather than as sexual object, muse, or victim of the male art and literary world.

Sandberg, Inger. "Edvard Munch, Skrubben og Kragerø," *Arsskrift for Kragerø of Skåtoy Historielag*. Kragerø 1991.
 Sandberg's study examines Munch's first new home in Norway after his return in 1909 and its meaning as a landscape motif.

1992

Alison, Jane, and Carol Brown, eds. *Border Crossings: Fourteen Scandinavian Artists*. Exh. cat. London: Barbican Art Gallery, 1992.
 Munch is prominently featured in this group show.

Bollinger, Michele A. "Narration and Allegory in Figurative Painting and Graphics: The Work of Odilon Redon, Edvard Munch, Francisco Goya, and Balthasar Klossowski (Balthus)." Unpublished Master's thesis (M.F.A.), Cornell University, Ithaca, New York, 1992.

Danto, Ginger. "Munch and France" (exhibition review), *Art News* 91 (February 1992): 140.

Kampf, Indina. "Gustav Schiefler (1857–1935)—Der programmatische Dilettant" in *Avantgarde und Publikum. Zur Rezeption avantgardistischer Kunst in Deutschland, 1905–1933*, Henrike Junge, ed. Cologne, Weimar, Vienna: 1992, 291–97.

Lande, Marit. *—for aldrig meer at skilles—: fra Edvard Munchs barndom og ungdom i Christiania*. Oslo: Universitets Forlaget, 1992.

Ledbetter, Baylor Irene. "Edvard Munch and the Destructive Force of Love." Unpublished senior thesis, Colorado College, Colorado Springs, 1992.

Rynn, Ruth Anisfield. "The Eve Motif: A Comparative Study of the Artwork of Paul Gauguin and Edvard Munch." Unpublished Master's thesis, California State University, Long Beach, 1992.

Schulze, Sabine. "Munch und Frankreich," *Kunstchronik* 45, no. 6 (June 1992): 233–37.
 Schulze, who edited the catalogue of the exhibition *Munch et la France* held at the Musée d'Orsay, Paris, in 1991–92, discusses the scope of the exhibition and the related international colloquium held at the museum October 17–18, 1991. The exhibition covered the years 1885–1908, and Schulze notes that during his visits to France Munch balanced his participation in the avant garde with a firm independence.

Tanner, Marcia. "Fatal Attractions (exhibition review)," *Artweek* 24 (March 4, 1993): 14–15.
 Tanner reviews the only American venue of the *Munch and His Models* exhibition, organized at the University Art Museum, University of California, Berkeley, by Jacquelynn Baas.

Wood, Mara-Helen, ed. *Edvard Munch. The Frieze of Life*. Exh. cat. London: National Gallery Publications, 1992. Catalogue of an exhibition held in the National Gallery, London, November 12, 1992–February 7, 1993.
 Entries for the catalogue were written by Arne Eggum with Sissel Biørnstad, Marit Lande, Iris Müller-Westermann, Tone Skedsmo with Ellen J. Lerberg, Gerd Woll, Ingebjørg Ydestie, and Frank Høifødt.

 Lathe, Carla. "Munch and Modernism in Berlin 1892–1903" in *Edvard Munch. The Frieze of Life*, 38–44.
 The impact of the precipitate closing of Munch's 1892 exhibition at the Verein Berliner Künstler is described, as well as Munch's perception by the "Black Piglet" circle.

 Woll, Gerd. "The Frieze of Life Graphic Works" in *Edvard Munch. The Frieze of Life*, 45–50.
 Woll reviews Munch's decisions to exhibit his prints as series. Siegfried Bing's exhibition at l'Art Nouveau is mentioned as including two series hangings, one for paintings and one for prints. Munch's work on *The Sick Child* with the printer Auguste Clot is discussed.

Wichstrøm, Anne. "Oda Krohg. A Turn-of-the-Century Nordic Artist," *Women's Art Journal* (Fall 1991/Winter 1992): 3–8.
 A summary, in English, based on Wichstrøm's 1988 biographical study. This article casts new light on Oda Krohg as an artist, highlighting her complexity and accomplishments.

1993

Berman, Patricia G. "Edvard Munch's *Self-Portrait with Cigarette*. Smoking and the Bohemian Persona." *Art Bulletin* 75, no. 4 (December 1993): 627–46.
 Deploying research on the social history of smoking and the literature on decadence at the turn of the century, Berman convincingly reveals the claim for a place in the Bohemian art world implicit in Munch's self-depiction.

———. "Body and Body Politic in Edvard Munch's Bathing Men" in *The Body Imaged: The Human Form and Visual Culture Since the Renaissance*. Kathleen Adler and Marcia Pointon, eds. Cambridge: Cambridge University Press, 1993, 71–83, 195.

Gerner, Cornelia. *Die "Madonna" in Edvard Munchs Werk: Frauenbild im ausgehenden 19. Jahrhundert.* Artes et litterae septentrionales 9. Morsbach: Norden Reinhardt, 1993.
 Gerner presented this originally as a Master's thesis for Berlin Technisches Universität, 1990.

Schmidt-Linsenhoff, Viktoria. "Fridas Bett, Munch Modelle: Zur Rezeption feministischer Forschung im Ausstellungsbetrieb," *Kritische Berichtie* 21, no. 4 (1993): 105–10.

Schneider, Andrea. "The 'Divided-Self' in the Lives and Works of Edvard Munch and August Strindberg." Unpublished senior honors thesis, Brandeis University, Waltham, Massachusetts, 1993.

Tanner, Marcia. "Fatal Attractions (Exhibition review)," *Artweek* 24 (March 4, 1993): 14–15.
 Tanner reviews the only American venue of the "Munch and His Models" exhibition, organized at the University Art Museum, University of California, Berkeley, by Jacquelynn Baas.

Weigle, Friederike, Horst Mauter, and Ingo Timm. *Das Porträtgemälde Walther Rathenaus von Edvard Munch*. Berlin: Kulturstiftung der Länder in Verbindung mit dem Märkischen Museum Berlin, 1993. Patrimonia, no. 76.
 Weigle was among the contributors to this book on the 1907 portrait by Munch in the Märkisches Museum Berlin of his friend and patron Walther Rathenau.

Woll, Gerd. "From Aulaen to Radhuset: Edvard Munch's Monumental Projects 1909–1930," in *Edvard Munch, monumentale prosjekter, 1909–1930*. Exh. cat. Lillehammer : Lillehammer bys, 1993. Catalogue of an exhibition held at the Lillehammer Art Museum, June 3–August 22, 1993.

Zeller, Ursula, Marion Keiner, and Johann-Karl Schmidt. *Edvard Munch und Seine Modelle*. Exh. cat. Stuttgart: G. Hatje, 1993. Catalogue of an exhibition held in the Galerie der Stadt Stuttgart, April 17–August 1, 1993.
 This is the catalogue to a German version of the exhibition about Munch and his models, seen in Japan, at Berkeley, California, and other venues during this period.

1994

Affentranger-Kirchrath, Angelika. "Die Frage nach dem Menschen: Porträtmalerei um 1900 am Beispiel Ferdinand Hodlers und Edvard Munchs," *Zeitschrift für Schweizerische Archäologie und Kunstgeschichte* 51, no. 4 (1994): 295–308.
> In this article titled "the question of the human being," the author examines turn-of-the-century portraiture and self-portraiture using Ferdinand Hodler and Munch as examples; an English summary is provided.

Berman, Patricia G. "(Re-)Reading Edvard Munch. Trends in the Current Literature 1982–1993," *Scandinavian Studies* 66 (Winter 1994): 45–67.
> Berman updates Arne Eggum's bibliographical essay of 1982 in *Kunst og Kultur* in this trenchant "state-of-the-field" article.

_____. "Edvard Munch. Portrait of Irmgard Steinbart." *Selections from the Collection of the Washington University Art Gallery*. Joseph Ketner, ed. Exh. cat. St. Louis: Washington University Art Gallery, 1994, 96–97.

Carroll, Karen Lee. "Artistic Beginnings: The Work of Young Edvard Munch," *Studies in Art Education* 36, no. 1 (Fall 1994): 7–17.

Costantino, Maria. *Munch*. Edison, N.J.: Chartwell Books, 1994.

Di Stefano, Eva. *Munch*. Florence: Giunti, 1994. Art Dossier, no. 96.
> This and the Costantino entry above are brief biographies.

Ehret, Gloria. "Munch und Deutschland," *Weltkunst* 64, no. 21 (November 1, 1994): 2944.
> Ehret reviews the exhibition at its Munich venue (Hypo-Kulturstiftung).

Gløersen, Inger Alver. *Munch as I Knew Him*. Trans. Reginald Spink. Hellerup, Denmark: Edition Bløndal, 1994.

Grimes, Nancy. "A Dauber of Nasty Pictures (book review)," *Art News* 93 (Summer 1994): 29.

Hansen, Dorothee, and Uwe Schneede, eds. *Munch und Deutschland*. Exh. cat. Berlin: Nationalgalerie, Staatliche Museen zu Berlin, 1994. Catalogue of an exhibition held at the Kunsthalle der Hypo-Kulturstiftung, Munich, September 23–November 27, 1994; Hamburger Kunsthalle, December 8, 1994–February 12, 1995; Altes Museum Berlin, February 24–April 23, 1995.
> Intelligently conceived by its Hamburg curators Schneede and Hansen, who signed the excellent entries, this exhibition and catalogue soundly cover every significant aspect of Munch's presence in Germany. The handsomely designed catalogue, with high-quality color reproductions, was made available at an affordable price. Hansen also produced a sleek yet useful chronology of Munch's activities relating to Germany. Essays by Schneede on Munch the expatriate, the Frieze of Life, and on the 1912 Sonderbund show; by Stefan Pucks on the German patrons; by Arne Eggum on Munch's relationship with German art after 1905; by Ulrich Bischoff on the acquisition of Munch's work by German museums; by Lothar Brauner on the impressive Berlin retrospective of 1927; and by Roland März on Munch vis-à-vis Germanic myth and National Socialism, in addition to the articles cited below, add up to a stunning contribution to the Munch literature.

Kampf, Indina. "'Ein enormes Ärgernis' oder, Die Anarchie in der Malerei. Edvard Munch und die deutsche Kritik 1892–1902" in *Munch und Deutschland*, 82–90.
> Kampf reviews the critical reception of Munch in Germany in the important decade between the first Berlin show and the 1902 Secession exhibition. The role of Max Nordau's 1892–93 bestseller *Entartung* (Degeneration) is underlined as an influence on attempts to discredit Munch and his art.

Müller-Westermann, Iris. "Drei Munch-Ausstellungen in Deutschland" in *Munch und Deutschland*, 261–74.
> An admirable illustrated reconstruction of three of Munch's most important German shows—Berlin in 1893, one year after the abrupt closing of his Verein Berliner Künstler exhibition; the fifth Berlin Secession show in the spring of 1902; and the Cologne Sunderbund exhibition of 1912—this closing contribution to the catalogue is a key resource in itself.

_____. "'Im männlichen Gehirn.' Das Verhältnis der Geschlechte im *Lebensfries*" in *Munch und Deutschland*, 30–38.
> A fresh reading of sexual relations in the familiar images of the Frieze of Life is offered in this article. The title phrase "In Man's Brain" refers to the 1897 woodcut. The embrace of the loving woman or *Vampire* is explored.

_____. "Mit Kopf und Hand. Zu Munchs Selbstverständnis als Künstler," in *Munch und Deutschland*, 39–45.
> A specialist in Munch's self-portraits, Müller-Westermann pays particular attention to *Self-Portrait with Cigarette* (National Gallery, Oslo, 1895) and *Self-Portrait with Paintbrushes* (Munch Museum, Oslo, 1904) to explore how they embody feelings on the role of the artist. The title comes from the phrase, "The head of the artist is in his hand."

Nestegaard, Jutta. "Munch-Ausstellungen in Deutschland von 1891 bis 1927" in *Munch und Deutschland*, 255–60.
> This comprehensive list of exhibitions is particularly useful as it includes complete dates, venue addresses, and number of works exhibited.

Woll, Gerd. "Munchs Graphik in Deutschland. Vom Zustandsdruck zur Massenauflage" in *Munch und Deutschland*, 46–57.
> New material on printers, dealers, and collectors make this study of the German print world invaluable for understanding market forces before World War II.

Jennings, Sarah. "Living with Art: A Munch in Every Room (Vivian & David Campbell)," *Art News* 93 (October 1994): 113–14.

Kaisla, Kirsi. "Akseli Gallen-Kallela and Germany." *Konsthistorisk Tidskrift* 63, nos. 3–4 (1994): 141–54.
> Munch is discussed in connection with his Finnish contemporary Gallen-Kallela (1865–1931).

Lange, Marit. "Edvard Munch og Max Klinger: Forbudtomrøde," *Konsthistrisk tidskrift* 63, nos. 3–4 (1994): 233–49.
> In an article based on research for her forthcoming study "Max Klinger und Norwegen," Lange dates the influence of Klinger on Munch to the early 1880s, long before Munch went to Germany in 1892. In 1891, the National Gallery in Oslo purchased fifty-three Klinger prints from Christian Krohg's collection.

Nobis, Beatrix. "Lebensgier und Todessehnsucht: vor 50 Jahren starb Edvard Munch," *Kunst & Antiquitaten*, nos. 1–2 (February 1994): 6–7.
> Munch's 1905–1908 painting *Youths and Ducks (Village Street)* (Oslo, Munch Museum) is discussed in this short article.

Nybom, Erika. "Sekelskifteskvinnan—vem var hon?", *Paletten* 2 (1994): 32–34.
> The author asks who was the fin-de-siècle woman. In this article for a Swedish journal, Nybom compares works by Munch with other works from the Symbolist period.

Ottesen, Bodil. "The Flower of Pain: How a Friendship Engendered Edvard Munch's Predominant Artistic Metaphors," *Gazette des Beaux-Arts*, ser. 6, 124 (October 1994): 149–58.
> Ottesen discusses the relationship of Munch with the Danish poet Emanuel Goldstein (1862–1921). Munch used the motif "Melancholy" as a frontispiece for Goldstein's collection entitled *Alruner* in 1892.

Spencer, Amanda M. "The Representation of Salome in Turn-of-the-Century Art as Depicted by Gustave Moreau, Aubrey Beardsley, Edvard Munch and Gustav Klimt." Unpublished senior thesis, Colorado College, Colorado Springs, 1994.

1995

Andres-Cunningham, Allie. "Persephone in Erebus: A Modern Paradigm." Unpublished Master's thesis, Eastern Washington University, Cheney, 1995.
> This thesis compares the myth of Persephone in Munch and Edward Burne-Jones (1833–98).

Ehrhardt, Ingrid, ed. *Okkultismus und Avantgarde: von Munch bis Mondrian 1900–1915*. Exh. cat. Frankfurt: Schirn Kunsthalle, 1995. Catalogue of an exhibition held June 3–August 20, 1995.
> Ehrhardt was general editor for the catalogue of this fascinating study of the occult and the avant garde; twenty works by Munch, including several photographs, were included in the exhibition.

Karpf, Gabriele. *Edvard Munch, Gemälde*. Exh. cat. Munich: Galerie Thomas, 1995. Catalogue of an exhibition held at ART Basel 26 '95, June 13–19, and at Galerie Thomas, June 23–September 23, 1995.

Lathe, Carla. "Edvard Munch and Great Britain." *Scandinavia. An International Journal of Scandinavian Studies* 34, no. 2 (November 1995): 211–20.
> Lathe's meticulous study of Munch's contacts and reception in Britain during his lifetime includes discussions of his participation in group exhibitions in 1928 and 1932, the opening exhibition at Mrs. Clifford Norton's London Gallery, and the shipowner Thomas Olsen's 1939 gift of *The Sick Child* to the Tate Gallery.

Steinberg, Norma S. *Munch in Color*. Exh. cat. *Harvard University Art Museums Bulletin* 3, no. 3 (Spring 1995): 1–54.
> In her catalogue essay for an exhibition based largely on the Lynn and Philip A. Straus Collection and that of the Fogg Art Museum, Steinberg discusses Munch's color prints as "tone-poems" created in a rich context of spiritualist and symbolist color theory.

Warick, Elaine. "Edvard Munch: A Study of Loss, Grief and Creativity" in *Creativity & Madness: Psychological Studies of Art and Artists*. Burbank, California: Aimed Press, 1995.

Woll, Gerd. *Edvard Munch, 1895: forste ar som grafiker*. Exh. cat. Oslo: Munch Museum, 1995.
> Woll outlines Munch's first year as a printmaker.

Yarborough, Bessie Rainsford (Tina). "Exhibition Strategies and Wartime Politics in the Art and Career of Edvard Munch, 1914–1921." Unpublished Ph.D. dissertation for the University of Chicago, December 1995.

1996

Berman, Patricia G. "Edvard Munch's Peasants and the Invention of Norwegian Culture" in *Nordic Identities: Exploring Scandinavian Cultures*. Berit I. Brown, ed. Westport, Connecticut: Greenwood Press, 1996.

_____. "The Invention of History: Julius Meier-Graefe, German Modernism, and the Genealogy of Genius" in *Imagining Modern German Culture, 1889–1910*. Studies in the History of Art. Washington, D.C.: National Gallery of Art, Center for Advanced Studies, 1996.

> In this paper originally presented at a CASVA symposium held in Washington, January 28–29, 1994, Berman explores the critical stance of Meier-Graefe (1867–1935), whose first art historical publication was an essay on Munch in *Das Werk des Edvard Munchs. Vier Beiträge von Stanislaw Przybyszewski, Franz Servaes, Willy Pastor, Julius Meier-Graefe* (Berlin, S. Fischer, 1894).

Landi, Ann. "A Little Munch Music (Review of CD of Edvard Munch's poetry set to music)," *Art News* 95 (February 1996): 40.

Prelinger, Elizabeth. *The Symbolist Prints of Edvard Munch: The Vivian and David Campbell Collection*. Exh. cat. New Haven: Yale University Press, 1996. Catalogue of an exhibition to be held at the Art Gallery of Ontario, Toronto, February 1997, and at the Cincinnati Art Museum at a later date.

> This catalogue represents the first book-length study of the most important Canadian collection of Munch's works. In addition to Prelinger's essay, the catalogue includes an article by Michael Parke-Taylor on Munch's reception in North America and an essay by Peter Schjeldahl.

Reitsma, Ella. "Vogelpoep en Regenwater: Edvard Munch, Schilder van het Leven," *Vrij Nederland* (April 20, 1996), Supplement, unpaginated.

> Reitsma published this seven-page illustrated article in conjunction with the exhibition at the Stedelijk Museum, Amsterdam, April 16–June 9, 1996, "Munch en na Munch of de hardnekkigheid van schilders" (Munch and after Munch, or the stubbornness of painters). During a visit to Oslo, she interviewed Munch Museum director Per Boym and chief conservator Jan Thurmann-Moe. Reitsma gives a vivid account of Thurmann-Moe's thirteen years as conservator of Munch's bequest to the city of Oslo before the Munch Museum opened in 1963. Working at Munch's estate, Ekely, Thurmann-Moe gained an unparalleled understanding of Munch's painting techniques. Thurmann-Moe was the first to study the aftereffects of the "horse cure" to which Munch subjected his paintings. He speculates that Munch may have borrowed the idea of drying his paintings outdoors from Whistler and reports that Munch, like van Gogh, had a strong aversion to varnish.

Ydestie, Ingeborg. "Herman Colditz' roman, *Kjærka. Et Atelier-Interior*, som generasjons-portrett og kildeskrift til tidens kunstliv," *Kunst og Kultur* 79, no. 1 (1996): 29–55.

> Ydestie provides an exemplary and long-overdue study of the single novel by Colditz (1861–89), set in the Oslo art world of the 1880s. Colditz died of tuberculosis in Monterey, California, the year after *Kjærka* appeared. In this key novel, Edvard Munch appears as the character Nansen, a name Munch used for himself in his diary entries.

Catalogue

Note to the Reader

Dimensions of images are in centimeters, height preceding width, followed by inches in parentheses. Corollary illustrations in the catalogue entries are denoted as "illustration"; those that accompany the essays in the front of the catalogue are numbered and denoted as "fig." "Schiefler" followed by a number refers to the catalogues of Munch's prints compiled by Gustav Schiefler in 1907 and 1927 (see Select Bibliography).

detail, cat. 7

1 **Inger in an Interior**
1889
Pencil with blue, gray, white, red, yellow,
and brown wash
31.46 x 43.8 cm (12$^7/_{16}$ x 17$^1/_4$ in.)

Not surprisingly, among Munch's earliest compositions are representations of his family and his home. In his father, aunt, and siblings, Munch found sympathetic models. Among them, Munch's youngest sister Inger Marie (1868–1952) seems to have the been the most patient and was one of the most frequently represented. She was the model for such ambitious compositions as *Inger on the Beach* (fig. 6) as well as informal studies such as *Inger in an Interior*. Inger was Munch's model, helpmate, and, later, chronicler.

In this drawing, the twenty-one-year-old Inger is posed against a cabinet, her hands held behind her back, supporting her weight. Staring off toward the left of the composition and wedged behind the rocking chair that looms in the foreground, she is as firmly embedded in the domestic environment as the corner stove or the books and bibelots on the shelves behind her.

In the mid 1880s, Inger Munch was a peripheral member of Munch's bohemian circle and was, according to Reinhold Heller, briefly involved romantically with the poet Sigurd Bødker (Heller 1984, 45). An artist, pianist, and aspiring photographer, Inger was the only member of Munch's immediate family to outlive him. After Munch's death in 1944 she undertook the arduous task of organizing her brother's voluminous correspondence, publishing, in 1949, the first comprehensive collection of his letters.[1] Throughout Munch's career, and particularly during his periods of professional activity outside Norway, Inger, remaining in Oslo, helped her brother with his business. As strained as their relationship seemed to be in their later years (Stenersen 1969, 59–60, and others report that they rarely saw one another), the two kept up their familial ties throughout their lives.

Note
1. Inger Munch, ed. *Edvard Munchs brev: Familien* (Oslo: Munch-Museets Skrifter I, Oslo, 1949).

Inger Munch
c. 1908–09
Woodcut
32.7 x 21.6 cm (12⁷/₈ x 8¹/₂ in.)

2

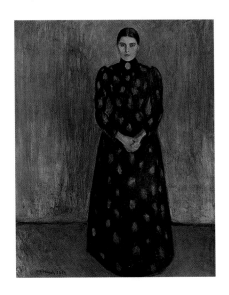

Edvard Munch, *The Artist's*
***Sister Inger*, 1892, oil on**
canvas. Nasjonalgalleriet, Oslo

In contrast to Munch's 1889 drawing of Inger (cat. 1), here Inger returns the artist's gaze. A closely cropped and dynamically carved representation of his sister's face, this woodcut appears to be based on Munch's 1892 portrait of Inger (illustration). Such details as the slight asymmetry of Inger's face, the particular way in which her lips are pursed, and the brooch that she wears suggest that the artist worked in dialogue with the earlier oil painting. That full-length portrait, exhibited under the Whistlerian title *Harmony in Black and Violet* in his 1893 Equitable Palast exhibition in Berlin, reflects many of Munch's formal preoccupations during the early 1890s: the synthetic treatment of form, the simplification of the composition, the limited tonal range, and the frontality and isolation of the figure. Similarly, the woodcut provides a summary of Munch's aspirations as a graphic artist in 1908–09: the dramatic excavation of the wooden board, the bravura variations in linear texture, the stark value contrasts.

The appearance of Inger's image throughout such transformations in Munch's art was speculatively identified as a method of erotic displacement by at least one of his biographers: "Through such persistent preoccupation with the facial features of his sister Munch . . . seems to be building up a shield against erotic involvements that would, in his view, lead to nothing but guilt and shame" (Dittmann 1982, 85). However, it may be more accurate to credit the availability of the model, her willingness to assist her brother in his art and his career, and the sense of rootedness that she and their aunt, Karen Bjølstad, provided for Munch.

3 **Childhood Memory**
c. 1920
Lithograph
33.6 x 22.8 cm (13¼ x 9 in.)

Munch's mother, Laura Catherine Bjølstad Munch (1838–68), died of tuberculosis in her thirtieth year, leaving behind her husband Christian Munch (1817–89), a military physician, and five children: Sophie, age six, Edvard, five, Peter Andreas, three, Laura, eighteen months, and the newborn Inger. As was customary in such circumstances in middle-class families, Laura's unmarried sister Karen Bjølstad (1839–1931) moved into the household to care for Christian Munch and his children. She became an integral part of the family and a close ally and support for Edvard throughout his career. In 1877, Sophie, the closest of Munch's siblings, also died of tuberculosis as the two entered their adolescence. Compounding the loss of his mother, the death of Edvard's sister punctuated the artist's early life with the strongest sense of loss and grief, emotional states into which he later tapped to create some of his most compelling and disturbing motifs.

The trauma and confusion of attempting to come to terms with grievous childhood loss were starting points for many of Munch's motifs in the 1880s and 1890s, particularly in the years just after his father's death in 1889. *The Dead Mother and Her Child* (cat. 5) and *Death Chamber* (cat. 4) are among the motifs that Munch created in an attempt to communicate to a larger audience the depth of his early crises.

Based on a drawing of 1890–91, *Childhood Memory* illustrates an early recollection that Munch had of his mother. The earlier drawing bears the title *The Double Bed*, referring to the wooden headboard that frames the image of the two small children in the foreground. Arne Eggum has linked this motif to references in Munch's diary from around 1892: "Underneath the large double bed sat two small children's chairs; the tall woman stood on the side, large and dark against the window. She said she would leave them, must leave them—and asked if they would grieve when she departed—and said that they must promise that they would pray to Jesus so that they would meet her again in heaven. They understood little—but they thought it was so unbelievably sad that they began to cry—to cry loudly."[1]

In the lithograph, which dates to between 1916 and 1920, Munch has placed the large, faceless image of his mother between the partly open window and a circular lamp in the background. The children, five-year-old Edvard and six-year-old Sophie, bend forward in anguish, their small bodies huddled against the headboard. In this memory image, Munch's mother appears vast, dark, and indistinct, her face obscured by the veil of memory and by the window and lamplight silhouetting her. In this image, she, like the children, has been transformed from an individual to an archetype, large, mysterious, and ungraspable by memory.

Note
1. Quoted in Eggum 1990, 280.

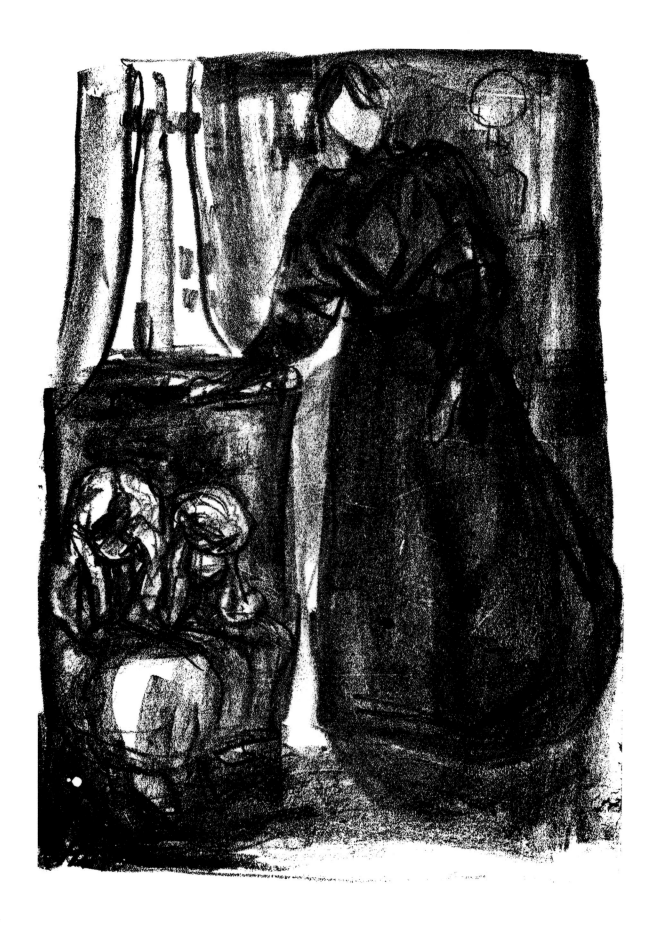

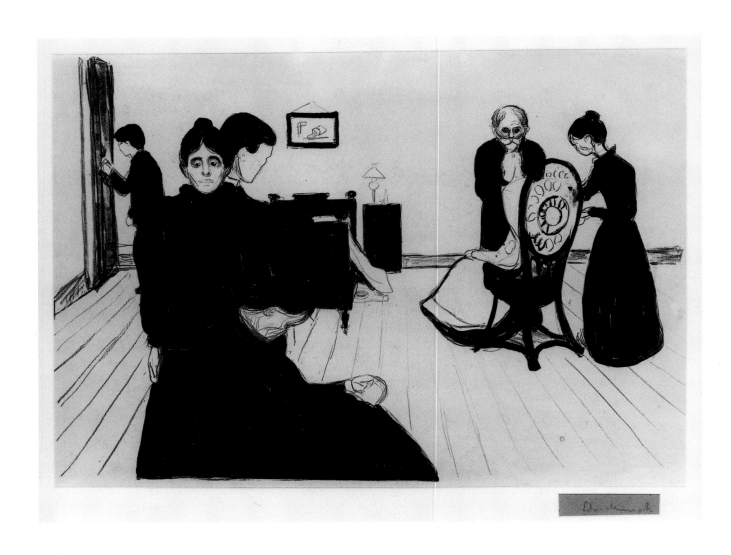

4 **Death Chamber**
1896
Lithograph
34.8 x 55 cm (15^1/$_8$ x 21^5/$_8$ in.)

Set in a spare stagelike space, *Death Chamber* recounts the death of Munch's sister Sophie in 1877 at age fifteen. At the time of Sophie's death, Munch was thirteen and his other siblings significantly younger. However, in this image, all of the family members are portrayed as adults. This lithograph is based on several painted versions of the motif from 1893 that Munch included in his narrative painting cycle, the Frieze of Life. By the time Munch created the lithographic version, three members of his family had died: his father Christian (standing in the background at the right) in 1889; Sophie (seated in the wicker chair); and most recently, in 1895, his brother Andreas. The remaining siblings, Laura (seated in the foreground), Inger (standing *en face*), and Edvard, who looks backward into the room, are clustered together while their Aunt Karen tends to Sophie at the far right.

Although several of the figures share physical proximity, the siblings are isolated psychologically from one another, each experiencing grief in an individual and mute manner. Only Dr. Munch, his hands clasped in prayer, and Karen Bjølstad, who reaches outward to Sophie, engage in any overt activity. Small poignant details mark the course of illness: the few objects on the bedside table, the linens trailing from the bed, and the bedpan, resting on the floor.

Echoing Friedrich Nietzsche's belief that art is only meaningful when it is "written in the heart's blood," Munch frequently used as his public motifs his most agonizing and intimate memories. By anchoring his work in his innermost experience, Munch created the sense among his early critics that all of his work was as self-confessional as this one. Although in this and the other images drawn from Munch's childhood (cats. 3 and 6) the link between lived experience and invented motif seems clear, it is important for Munch's audience to remember that other motifs may be inventions or ironic commentaries, not confessions.

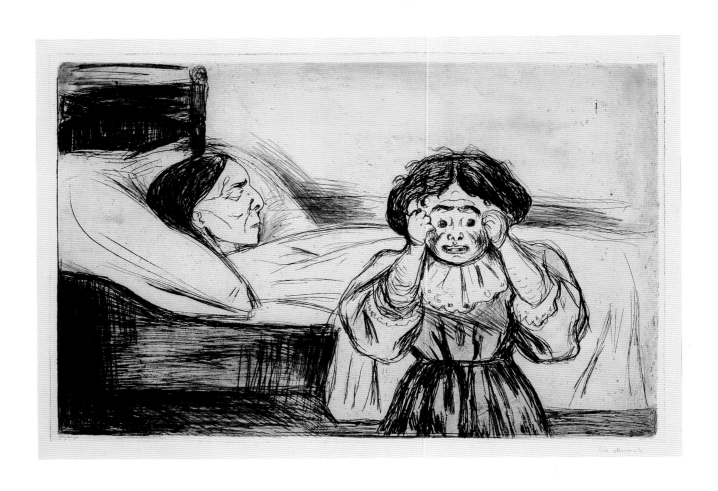

5 **The Dead Mother and Her Child**
1901
Etching, aquatint, and drypoint on zinc plate
31.1 x 48.3 cm (12¼ x 19 in.)

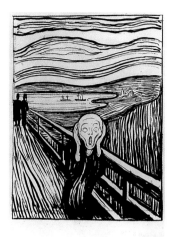

Geschrei

Edvard Munch, *The Scream*, 1895, lithograph. Epstein Family Collection

Max Klinger, *The Mother's Deathbed*, from the series *On Death, Part II*, 1889, engraving. Museum für bildenden Künste, Leipzig

During the mid-to-late 1890s, Munch created several variations of this motif in which a child stands before the dead mother in an attitude of extreme anguish. According to Marit Lande, the earliest sketch for the motif dates to 1889.[1] The image, a recapitulation of Munch's childhood loss of his mother, portrays the mother in a state of decomposition, her features ravaged by tuberculosis and by the decomposition of her body after death. The contrast between the inanimate and dissipated face of the corpse and the emphatically rounded, fleshy features of the child provides poignant commentary on the gulf that so brutally separates them. Borrowing the rhetorical gesture of emotional *extremis* from his motif *The Scream* (illustration), Munch creates a posture that is improbable in someone so young, suggesting the child as the projective fantasy of the adult artist.

It is generally understood that the starting point for this motif and for Munch's *Dead Mother* (1893, Munch Museum, Oslo) is an 1889 etching by the German artist Max Klinger (illustration), in which the flower-decked mother appears to be sleeping as the prescient baby attempts to awaken her. In his images of the dead mother, however, Munch has reduced the symbolic detailing and the aestheticization of death so that the sense of irretrievable loss is represented directly and forcefully.

Although this motif was repeated by Munch over the course of several years, the artist also represented mothers, and motherhood, in a number of more positive ways, dispelling the notion that motherhood held for Munch a negative or morbid valence. This motif is part of a continuum of Munch's images, such as *A Mother's Joy* (cat. 54) and *Alma Mater* (cat. 70), in which the artist's own emotional losses are mediated or even eclipsed by the world around him.

Note
1. Marit Lande, "The Dead Mother and Child," in London 1992, 111.

6 **The Sick Child**
1894
Drypoint with roulette
35.9 x 27 cm (14^{1}/$_{8}$ x 10^{5}/$_{8}$ in.)

Edvard Munch, *The Sick*
***Child*, 1885–86, oil on canvas.**
Nasjonalgalleriet, Oslo

The Sick Child, an image that recalls Munch's excruciating memory of his sister Sophie's death from tuberculosis in 1877 (see also cat. 4), is one of his most personal and pivotal motifs. This etching is based the painting from 1885–86 that Munch referred to as his breakthrough composition (illustration). According to the artist, the painted version underwent numerous reworkings over the course of a year as he struggled to formulate the image. His models, his aunt Karen Bjølstad (see cat. 51) and the maid Betzy Nielsen, reenacted for Munch the death of his sister. Collaborating with his aunt in such a way, Munch created a point of continuity between the traumatic event in his family's past and the motif that came to represent it.

As Munch noted, the motif dates to the "pillow era," in which tubercular children and women had become a popular theme in Norwegian art. Citing Christian Krohg's *Sick Girl* (1880–81, Nasjonalgalleriet, Oslo) as a point of departure, Munch rejected naturalistic description in this painting and chose instead to attempt a symbolic representation of the theme. Overpainted repeatedly and scored deeply with a palette knife, Munch overlaid the surface of his painting with stripes that were intended to represent the motif as though viewed through tear-laden lashes.

When exhibited in the 1886 Autumn Exhibition in Kristiania, the painting drew strong criticism from throughout the Kristiania arts community for its lack of finish: "No painting has ever caused such disapproval in Norway—On the opening day, when I came into the room where it was hanging, people were crowding in front of the picture—there was laughter and shouting" (London 1992, 118). It secured for Munch the reputation as being the most progressive among the young generation of painters, and it became one of his most repeated motifs.

Munch created this printed version in 1895, at about the same time that he painted another version. In the print, Bjølstad leans forward in a posture of extreme exhaustion or mourning while Nielsen sits erect, her head supported by the pillow and her eyes gazing past the grieving woman. Locked visually into her chair through the alignment of the pillow, two tables, and Bjølstad's rigid anatomy, the girl seems preternaturally fragile and alert. The uppermost part of the chair back, arching like a halo above the pillow, frames and sanctifies the suffering girl. Munch drew attention to the significance of the chair in which Nielsen modeled by noting that it had been the site of his own adolescent struggle with disease as well as the illnesses of his whole family: "In the same chair that I painted *The Sick Child*, I and all of my loved ones, from my mother on, have sat and longed for the sun" (Eggum 1990, 247). A small summer landscape that appears at the bottom of the motif, which resembles the predella of an altarpiece, illustrates the elusive object of such longing. Negotiating between the material fidelity to the motif and the illusory memory of adolescent loss, Munch represents the woman and the girl in a state of intimacy abrogated by disease.

7 **Bathing Girls**
1895
Aquatint and drypoint
22.2 x 32.4 cm (8³/4 x 12³/4 in.)

This motif, the mirror image of a pastel drawing from around 1893, represents one of Munch's early explorations of a theme that engaged him through 1919: bathers in the open air. A popular theme in European painting and pictorial photography, depictions of open-air bathing were particularly widespread, and held important implications for cultural renewal, in turn-of-the century Scandinavia and Germany (see Berman 1992). Representing both males and females swimming and languishing on the shore, Munch explored the notion of nature as a curative force, helping urbanites to regain their health and cleanse the body politic through immersion in the sea.

In *Bathing Girls*, Munch represents two adolescents, one partially clothed and the other nude, by the water's edge. One bends forward to attend to her hair. A third androgynous figure seems to tread water some distance from the shore. As in others of Munch's bathing compositions (see for example *Bathing Men*, 1905, Munch Museum, Oslo), this figure appears half human and half amphibian, as though immersion in the water has returned or de-evolved her or him to a primeval state. Unlike certain other of Munch's shoreline motifs from this period (cat. 21), there is little overt symbolization or narrative tension here. Instead Munch represents young girls, much as he does young boys from the same period, as they expose their bodies to the strong sunlight and engage in seaside contemplation and athleticism.

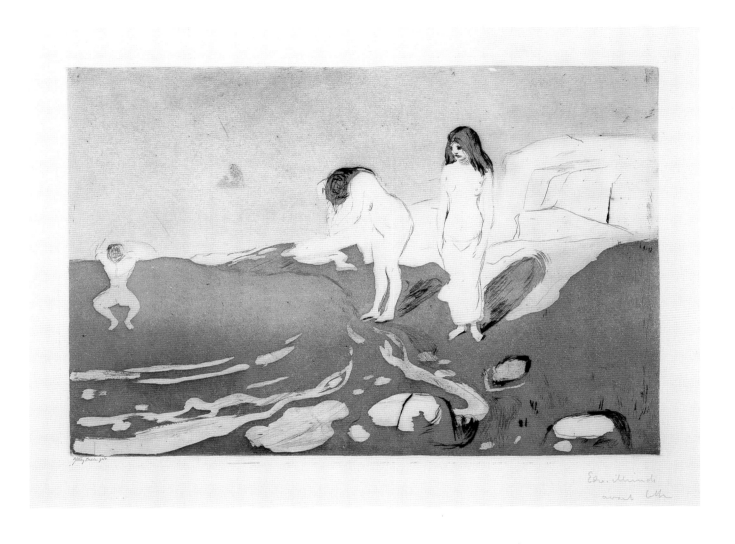

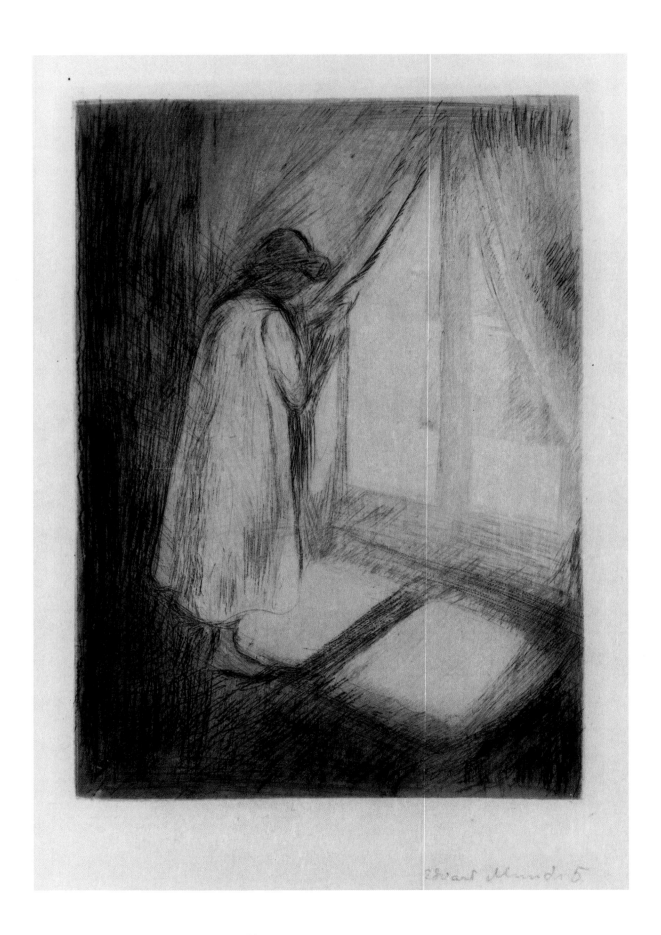

8 **Girl in a Nightdress at the Window**
1894
Drypoint with roulette
20.7 x 14.4 cm (8^1/$_8$ x 5^5/$_8$ in.)

Julius Meier-Graefe included *Girl in a Nightdress at the Window* in his 1895 portfolio of Munch's etchings (see p. 21). The print is based on an oil painting of 1891 (Private Collection). A motif that fuses naturalistic observation with a sense of otherworldliness, the etching represents a young model, her hair cascading over her left shoulder, holding back a drape to let moonlight enter a darkened room. The location of her body to the side of the enormous window suggests the tentativeness of her gesture, her desire to see and not be seen.

The window operates simultaneously as material fact and symbolic agent: as the threshold between domestic and public space, it reveals a world beyond the girl's environment. The lack of detail beyond the glass plane invites the projective fantasy of the viewer: a gas-lit city street, the symbol for an undefined future adulthood, or the awakening of sexuality. Likewise, the anonymity of the model, the lack of differentiation given her form under the nightdress, and the tentativeness of her gesture provide her with an open-ended identity that invites speculation. Whether the viewer favors a naturalistic or a symbolic grounding for the image—a child curious about the public world or an adolescent facing the inevitability of adult sexuality—the delicacy of Munch's technique and the simplicity of the composition endow it, and the model, with a sense of dignity.

9 **Puberty (At Night)**
1902
Etching
19.8 x 16 cm (7^{13}/$_{16}$ x 6^{5}/$_{16}$ in.)

The etching recapitulates the theme that Munch first created in a painting of the mid 1880s and then repainted in 1894–95 (fig. 9). In both painting and etching, a young girl is seated, naked, on the edge of a bed, her legs pressed together and her long, spindly arms extended down her torso as if in a gesture of self-protection. In the etching, the girl's body, flanked by vast swirling shadows, is greatly diminished in scale and, as a result, appears more vulnerable to the dark atmosphere that threatens to engulf it. As Arne Eggum and other scholars have noted, her gesture is reminiscent of the cowering woman represented in Félicien Rops' 1886 print *The Greatest Love of Don Juan* (fig. 10), and even the swelling shadow to the girl's right reflects the threatening figure of Don Juan himself. Although Munch denied using Rops' motif as a source for his own, the association between them enhances the identity of the shadow as a sexual metaphor (see pp. 22–23) and the theme of adolescence as both a biological awakening and a sexual threat.

John Neubauer has demonstrated that the theme of adolescence was widely treated in literature and visual culture at the turn of the century (Neubauer 1992) as a metaphor of cultural vulnerability and instability. It was during this period that adolescence was recognized in the social science literature as a distinct phase of human development and, in the art world, as a symbol of awakening instinct (Montreal 1995, 346–55). Like *Girl in a Nightdress at the Window* (cat. 8), *Puberty (At Night)* defines adolescence through the body of the changeling, suspended between childhood stability and the insecurity of an unknown future. The sensitivity of this image and its position within Munch's repertory of motifs suggests that female adolescence was a considered and psychologically poignant theme in Munch's work.

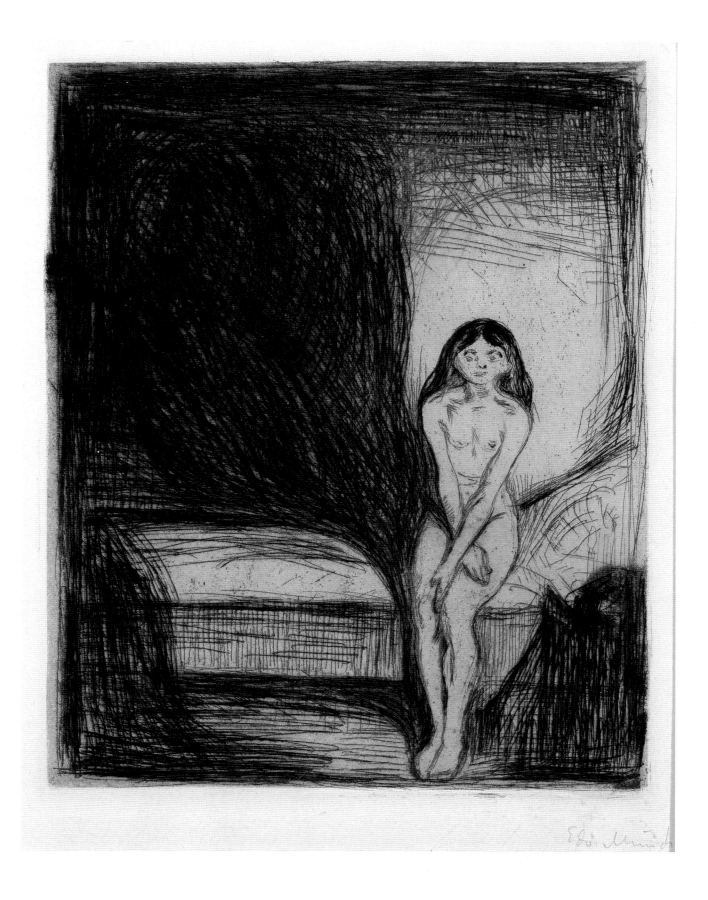

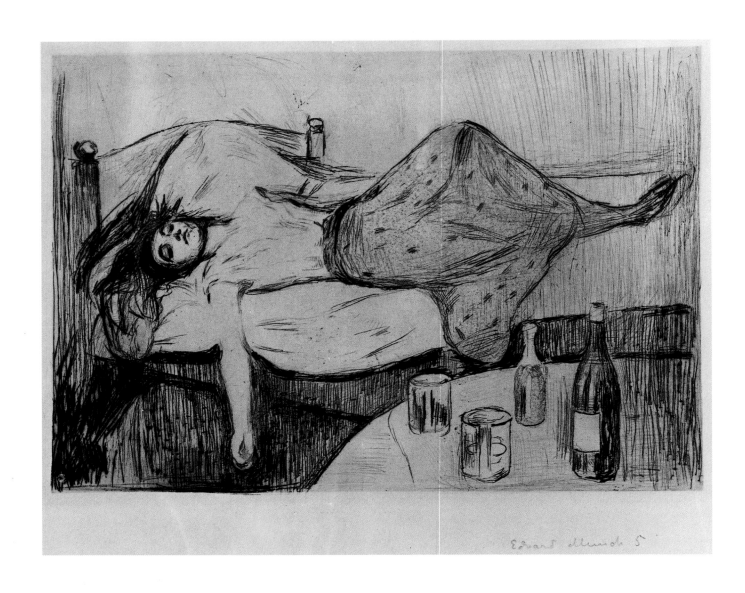

10 The Day After

1895
Drypoint and aquatint
21 x 29.8 cm (8¼ x 11¹¹/16 in.)

Santiago Rusiñol, *The Morphine Addict*, 1894. Museo del Cau Ferrat, Sitges

Created at about the same time as *The Sick Child* (cat. 6), *The Day After* was one of Munch's first etchings. The print is based on a painting from the early 1880s, now lost, that Munch re-created in 1894 while living in Berlin (Nasjonalgalleriet, Oslo). Describing the aftermath of a woman's drunken revelry through the bottles and glasses in the foreground and through her disheveled bodice, loosened hair, and rumpled sheets, *The Day After* represents a motif drawn from Munch's bohemian milieu.

The image of a drugged, unconscious woman, one that provided his contemporary male audience with a site for erotic speculation, was uncommon in painting of that period. Arne Eggum suggests that the motif can be associated with Henri Gervex's 1878 *Rolla* (Bordeaux, musée des Beaux-Arts), a sensationalistic scene of seduction and abandonment that Munch viewed at the 1885 Paris Salon and that he associated with his affair with "Mrs. Heiberg" (Paris 1992, 52). It also shares with Santiago Rusiñol's *Morphine Addict* of 1894 (illustration) a fascination with the culture and effects of intoxication as represented by the body of a woman. With her arm suspended over the edge of her bed and her legs splayed open, the model appears sexually available. At the same time, her nearly complete state of dress and her relaxed facial features veil the motif's sexual charge. As an image of the spent woman's isolation, *The Day After* evokes the ambivalent positions of bohemian women whose participation in the culture of alcohol both freed them from the restraints of their class and circumscribed them with an amoral identity.

11

Tête-à-tête
1895
Etching and drypoint
20.3 x 31.1 cm (8 x 12¼ in.)

This motif, extracted from Munch's involvement with café culture, represents the mingling of men and women within that milieu. The etching is based on a painting from around 1885 (Munch Museum, Oslo) that Munch painted using members of his immediate social circle (including his sister Inger) as models. In the foreground of this print, a small table supporting two glasses forms the point of convergence for two people who are in conversation. To the right sits a figure representing Munch's colleague, the painter and actor Karl Gustav Jensen-Hjell (1862–88), whom Munch portrayed in a controversial portrait of 1885 (private collection). The dandy-like Jensen-Hjell directs his attention to Inger Munch, who is seated *en face* in the background and directs her gaze toward him. Smoke from the man's pipe drifts across and bifurcates the woman's face, anchoring her to the background. In contrast to the darkened room in which the two figures sit, a window to the left reveals a bright and distant cityscape whose tiny, inconsequential inhabitants dot the street below. Like *The Day After* (cat. 10) and *Kristiania-Bohème II* (cat. 12), Munch's revision of his earlier café motifs into graphic form suggests his continued affiliation with the bohemian identities articulated in the images and his nostalgic view, ten years later, of the Kristiania bohemian scene and its social freedoms. In 1895, the year in which Munch issued these etchings, gender relations within his contemporary café circle in Berlin were far more complicated and threatening (see pp. 31–35), and the intellectual interchange among men and women was no longer a theme in Munch's new motifs (see, for example, *Lust [The Hands]*, cat. 16).

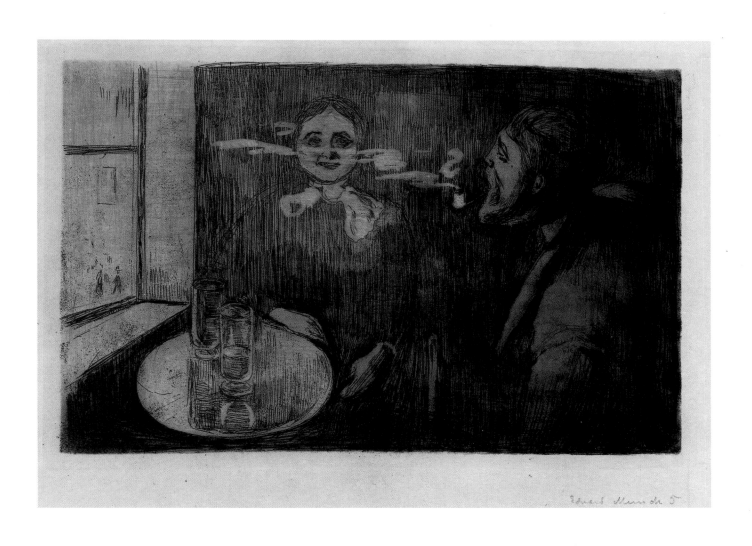

12 **Kristiania-Bohème II**
1895
Etching, aquatint, and drypoint
29.2 x 39.1 cm (11$\frac{1}{2}$ x 15$\frac{3}{8}$ in.)

This image of Munch's 1880s bohemian circle in Kristiania, rendered several years after Munch departed from its midst, takes its title and milieu from the author Hans Jæger's scandalous 1885 publication *Fra Christiania Bohemen* (see p. 25). It represents the cohesive circle of intellectuals who practiced liberal (and, in some cases, radical) social politics and who lived public lives that often contradicted the strict social codes of small, bourgeois Kristiania.

In the background stands Oda Lassen Krohg (see pp. 26–27), whose assertiveness as an artist and an intellectual and whose sexual relationships helped to set the terms for and mystique of the milieu. Krohg is represented as she stands framed by a curtained doorway. Her posture is derived from a portrait painted in 1888 by her husband Christian Krohg (fig. 13). Before her, seated at a rectangular table, are (from the left) a pale, retiring Munch, the painter Christian Krohg (see pp. 27–28), the art critic Jappe Nilssen (see cat. 39 and fig. 12), the author Hans Jæger, the playwright Gunnar Heiberg (see cat. 21), and, in the right foreground, Oda's ex-husband Jørgen Engelhart.

Like the men pictured in this composition, Oda Krohg participated in free love—the freedom for both men and women to explore sexuality outside the boundaries of marriage. Her involvement with Jæger was chronicled by him in *Sick Love*, a novel from 1889. Advocated by Jæger to be a form of resistance to social control, free love was one social practice through which the Kristiania bohemians defined themselves. Munch's representation of Oda Khrog as the symbolic anchor for this composition, relatively small in scale, shrouded in cigarette smoke, and visually paired with a bottle of alcohol, reduces her presence to one of muse-like inspiration for the men in this retrospective composition. This view diminishes her role as public intellectual and emphasizes her erotic appeal to the men around her. Like her husband Christian, who was one of Munch's mentors, Oda befriended the artist and involved him in her family as the godfather to her son Per in 1889.

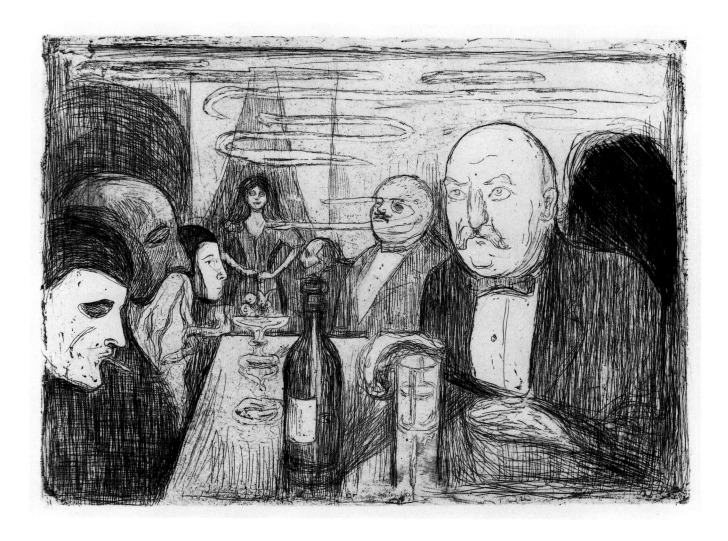

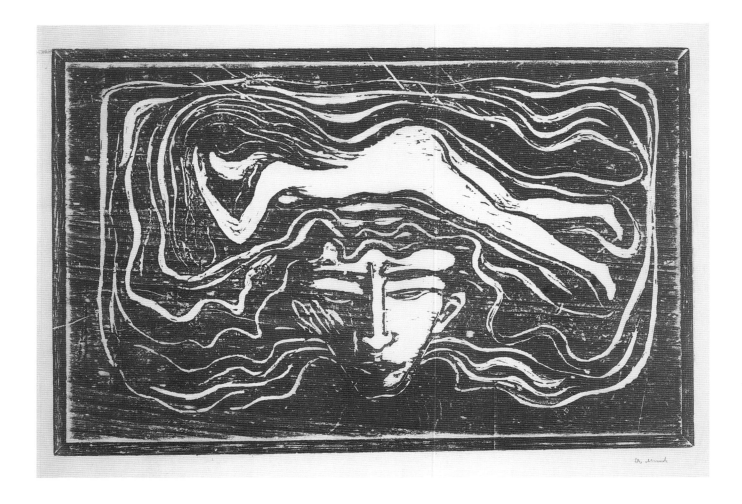

In Man's Brain
1897
Woodcut, printed in red
37 x 57 cm (14^9/$_{16}$ x 22^7/$_{16}$ in.)

As Iris Müller-Westermann has recently suggested, this motif thematizes Munch's approach to "Woman" in his Frieze of Life series[1] and provides wry commentary on male heterosexual erotic fantasy. The composition depicts a schematically rendered male head, above which hovers the prone body of a nude woman. Faceless and presenting her buttocks in a posture of supplication, the female is represented as the fantasy projection of the male thinker. Her body is surrounded by wavering lines that seem to emanate from the male's head, suggesting that it is his imagination that invents and animates her. Arne Eggum has called attention to Munch's interest in writings on magnetism and other occult phenomena (Eggum 1989, 60–64). In this light, this image suggests Munch's attempt to illustrate the interior imagination as a materialized magnetic field. The male, with his eyes half closed, his nose humorously made penile, and his face lit theatrically from below, operates as a stage upon which sexual spectacle unfolds. Suggesting this fantasy image as both overwhelming (in scale) and burdensome (in position), Munch articulates the complexity of eroticism and the ways in which women frequently appear in his work, not as people but as inventions.

Note

1. Iris Müller-Westermann, "'Im männlichen Gehirn': Das Verhältnis der Geschlechter in Lebensfrise," in *Munch und Deutschland* (1994), 30–31.

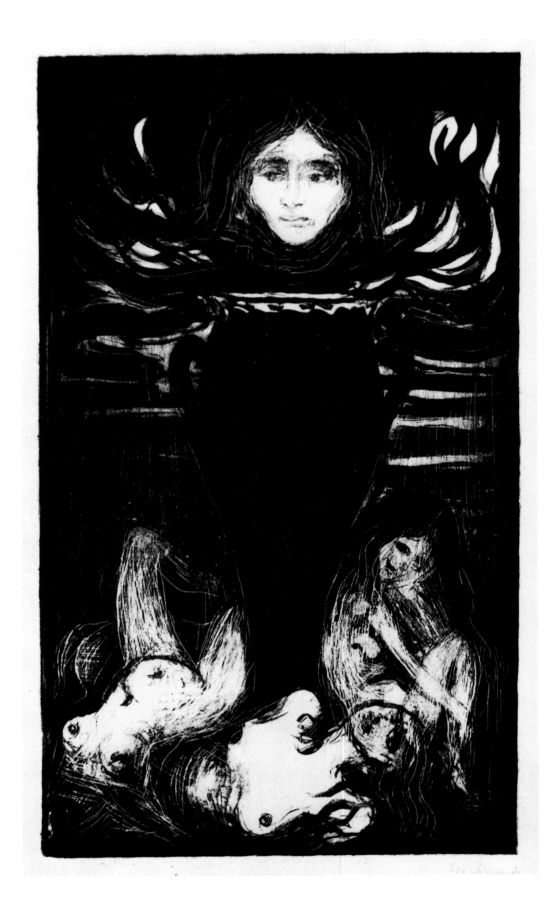

14 **The Urn**
1896
Lithograph
46 x 26.7 cm (18¹/8 x 10¹/2 in.)

The Urn, one of the most hermetic of Munch's compositions, is a motif that the artist explored in numerous graphic versions in the 1890s. Representing a large, dark krater with a Redon-like severed head floating above it and the bodies of three nude women writing below, *The Urn* does not exist as an oil painting. As Bente Torjusen notes, this composition is closely related to illustrations that Munch created for Charles Baudelaire's *Les Fleurs du mal*.[1]

The Urn was included in a text that Munch created in the second decade of the century entitled "The Tree of Life of Good and Evil." In this context, *The Urn* bore the inscription "The Urn—Rebirth" and the notation, referring to the detail of the floating female head, "Up from the filth rose a face full of sadness and beauty."[2] This text and the images that Munch selected for inclusion within it endeavored to examine the phenomenon of death as a process of transformation—as cleansing, as transubstantiation, and rebirth and nourishment (see also cat. 71). In *The Urn*, a classical funerary urn has become the site of transformation, in which libations poured through the vessel have in some fashion released rising lines of vapor and, at their center, invoked the face of a spirit that has transcended death. At the base of the urn, three women are represented in what appear to be states of mourning, death throes, and decay. Their nudity and the display of their bodies overlay the somber and violent scene with eroticism. Bringing together representations of sexuality, death, and rebirth, Munch created *The Urn* as a symbol of the passage from death to new life, a theme that preoccupied him throughout his life and one that he examined in its most literary form in this image.

Notes
1. Bente Torjusen, "The Mirror," in Washington 1978, 201–03.
2. *Ibid.*, 203.

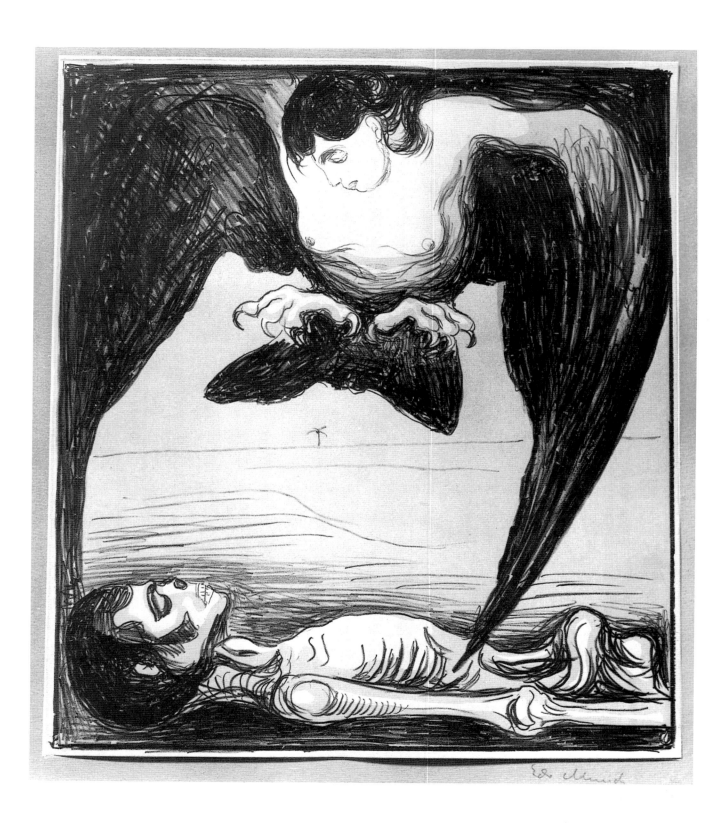

15 **Harpy**
1900
Lithograph in black and light blue
36.5 x 31.7 cm (14³/₈ x 12¹/₂ in.)

One of Munch's most violent representations is *Harpy*, which represents female sexuality through the monstrous, rapacious body of a mythical creature that is half woman, half bird. The bird-woman, in the upper portion of the composition, hovers over her prey, the recumbent skeletonized body of a man. With her talons extended below her breasts and her wings forming a set of curtains that enframe and engulf the body below her, the harpy is shown in the act of possession. Suspended between the two figures is a barely discernible horizon line on which sits a palm tree. Reidar Dittmann has suggested that this detail locates the scene in August Strindberg's one-act play, *Samum* (Dittmann 1982, 148). Set in Algeria and referring through its title to a dangerous desert wind that is personified by a harpy (Eggum 1990, 203), *Samum* was intended for publication in the German journal *Quickborn*, which was to include texts by Strindberg and illustrations by Munch. An 1898 drawing (Munch Museum, Oslo), which serves as the starting point for the lithographic print, was, according to Eggum, specifically created to accompany Strindberg's text.

In the lithograph, the scene is bathed in a highly saturated pale blue field, interrupted by white passages that emphasize the harpy's head, chest, and talons and the skeleton's face, chest, and arm and pelvic bones. Munch's illustration of a bestialized sexual woman and the emasculated object of her desire had been the subject of his 1895 etching *Harpy* (also entitled *Vampire*, Schiefler 4), in which the bird-woman perches triumphantly on her victim's chest. In this later version, the male victim is reimagined as carrion and the hovering monster as the predator who will pull the remaining flesh from his bones.

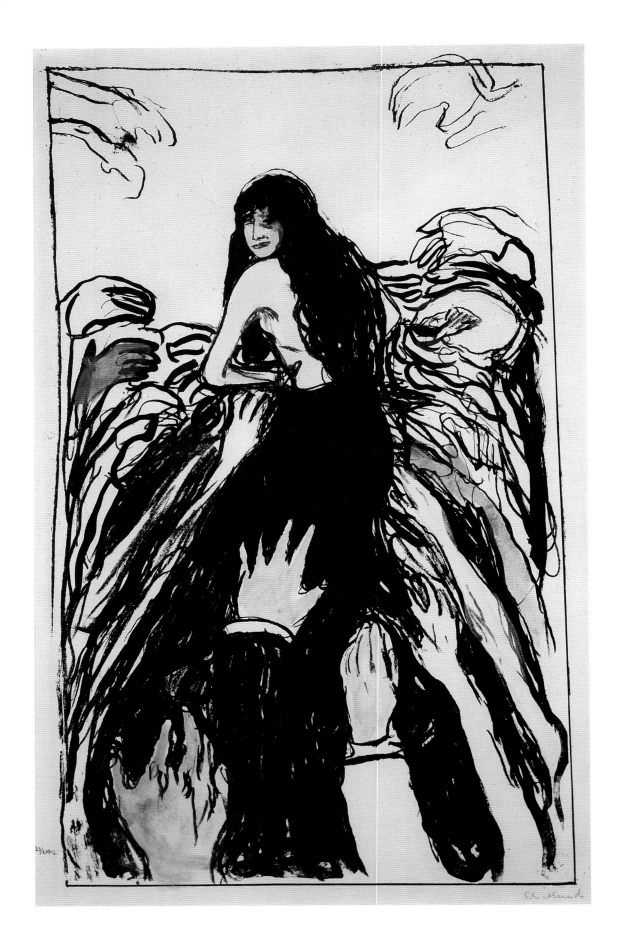

16 **Lust (The Hands)**
1895
Lithograph, hand colored with red, yellow,
and pale pink watercolor
48.4 x 29.1 cm (19^{1}/$_{16}$ x 11^{7}/$_{16}$ in.)

This print was also exhibited under the title *Hands. Lust for Woman* in Munch's 1897 exhibition at the Diorama Hall in Kristiania as part of his print series The Mirror. It represents a woman shown from behind, nude above the waist and with her hair cascading down her back, who turns backward to present her face to the viewer. Her features register an expression that may be read as a leer or a grimace as she is surrounded and consumed by a mass of hands that reach toward her body. In a painted version of the motif from 1893 (Munch Museum, Oslo), the woman acts out the role of seductress. In this image, she seems to be less willfully on display.

The hands, which extend inward from virtually all edges of the print, function as materializations of male desire. The density of their massing and urgency of their gestures fix the woman at the center of the composition as the victim of a collective assault. Such an interpretation of male desire and its effects on the woman whom it objectifies suggests a self-critical approach that Munch took to the representation of women's sexuality. Like his prints *The Alley* (cat. 17) and *In Man's Brain* (cat. 13), *The Hands* examines the notion of Woman as a male fantasy, configured by a male collective imagination. Such images attest to Munch's understanding of the social codes of gender relations as well as his own complex responses to female sexuality.

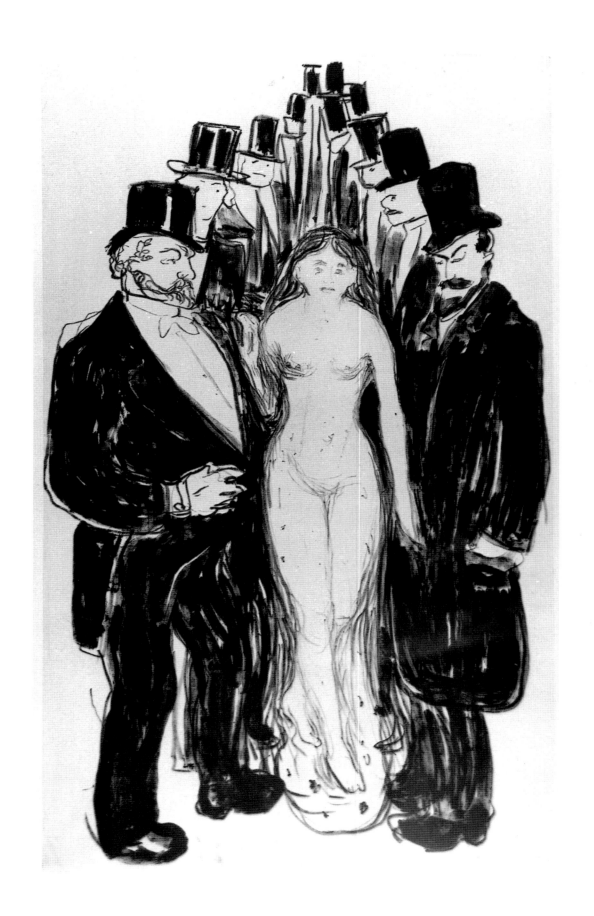

The Alley
1895
Lithograph
43 x 26.4 cm (16^{15}/$_{16}$ x 10^{7}/$_{16}$ in.)

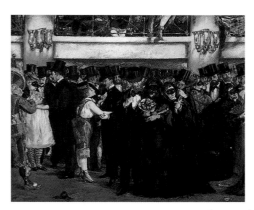

Edouard Manet, *Ball*
at the Opera, **1873,**
oil on canvas. National
Gallery of Art, Washington,
Gift of Mrs. Horace
Havemeyer in memory of
her mother-in-law, Louisine
W. Havemeyer

Alternatively entitled *Carmen*, referring to the opera by Georges Bizet (1875), *Stealth*, and, as Bente Torjusen proposes, *The Street* (Washington 1978, 188), *The Alley* represents a woman, her naked body exposed through what appears to be a diaphanous floor-length dress, entirely surrounding by a group of black-clad men. All of the men, dressed in evening clothing and wearing beaver-skin top hats, direct their attention to the diminutive woman and engulf her within the pyramidal structure formed by their bodies. The two men located closest to the viewer bear recognizable features—one of a bloated bourgeois and the other of a younger, sinister-looking dandy—while the others are undifferentiated.

The woman's response to this forest of leering men is ambiguous. Her face seems to register alarm, and her raised right arm, a gesture of self-protection, yet her left hand is held in close proximity to the groin of the forwardmost man. The ambivalence of her situation as the object of collective desire and potential ownership repeats motifs such as Edouard Manet's *Ball at the Opera* (illustration), which describes the phenomenon of bourgeois gentlemen vying publicly for the attention of and affiliation with women. Munch has translated the social space in which such liaisons are initiated into the metaphorical and highly claustrophobic space of male desire, and the woman into the half victim and half initiator of her own dissimulation.

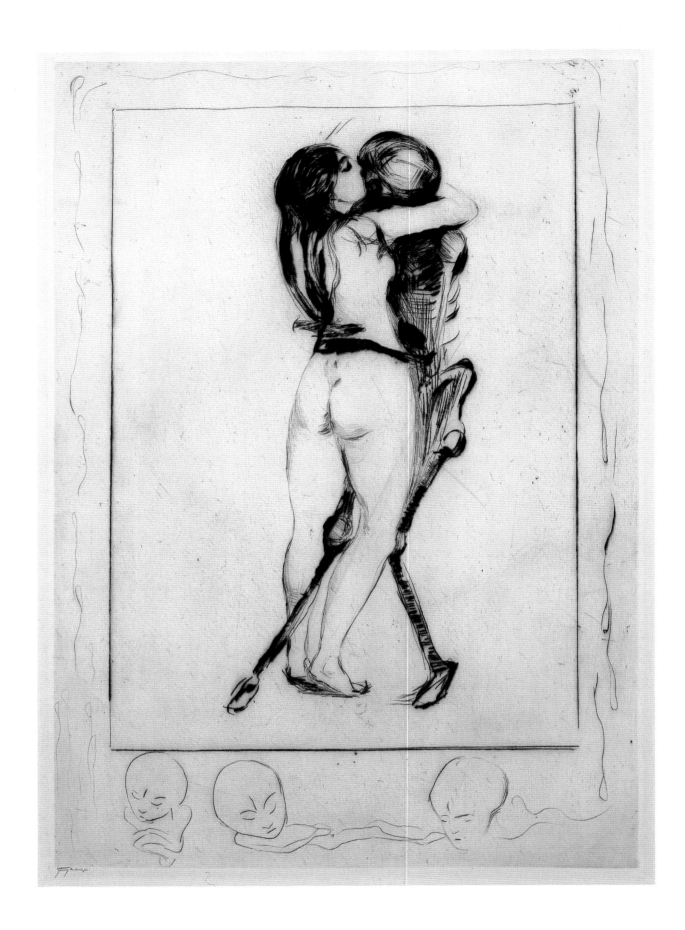

18 **Death and the Maiden**
1894
Drypoint
29.4 x 20.6 cm (11⁹/₁₆ x 8¹/₈ in.)

This etching represents a young and physically robust woman embracing and yielding to the highly sexual embrace of a skeleton: one of the skeleton's legs, thrust forward between the woman's slightly parted knees, suggests contact between the pelvic areas of the two figures, and the corresponding tension in the woman's buttocks and lower legs articulates a state of physical arousal. Her designation as a "maiden" (das Mädchen) identifies her as a sexual innocent, and because her eyes are closed it is not clear to the audience that she is aware of whom or what she embraces.

Munch intended a version of this motif as the frontispiece to a book that he, August Strindberg, and Stanislaw Przybyszewski had planned to publish in the early 1890s.[1] The two figures are extracted from a painting of the same title from 1893 in which the embracing pair are flanked by sperm cells and embryos (Munch Museum, Oslo). Like the motif *Madonna* (cats. 19 and 20), this image illustrates sexuality as part of a cycle of life. By removing these details to the periphery of the page so that they read as glosses, Munch both inscribes this message into the bodies of the woman and the skeleton and renders it less easy to determine. In fact, the sexual pairing of woman and skeleton invites speculation. This image has most frequently been understood through a determined reading of the motif as a literary emblem of Eros and Thanatos or of death implicated in love (see London 1992, 107), and in its pessimism it has been linked with the works of the Belgian artist Félicien Rops. Unlike Rops' similar motifs, however, Munch's maiden is not a seductress so much as she is seduced. With childbirth as the leading cause of mortality among young women in the 1890s, and with syphilis a direct consequence of sexual contact, Munch's decision to represent death in the form of a lover was as grounded in fact as it was shrouded in metaphor.

Note
1. K. E. Schreiner, "Minner fra Ekely," in *Vennene forteller,* 29.

19 **Madonna**
1895
Lithograph
60 x 44.1 cm (23⁵/₈ x 17³/₈ in.)

20 **Madonna**
1895 (1902 printing)
Color woodcut and lithograph
55.7 x 35 cm (21⁷/₈ x 13³/₄ in.)

These prints represent variant versions of a motif that Munch first explored in sketches dating to 1893 and a painting from that year that he alternately entitled *Madonna* and *Loving Woman*. In one pencil drawing of the motif (*Study for Madonna*, c. 1893, Munch Museum, Oslo), the woman's head is surrounded by a large circular halo. In these prints, the halo effect is achieved by the small band that crowns her hair and the wavering lines that surround her head and body. The merging of sacred and sexual themes in this image echoes Munch's objectives for his work of the 1890s, to examine sexual intimacy in its sacral dimensions, as the bond "linking thousands of generations who are dead and the thousands of generations to come" (London 1992, 74). The act of sexual love, emblematized by the body of the woman whose arms are pinioned behind her, is interpreted in the decorative frieze surrounding the central image as the moment of conception. Seminal fluid and the representation of a cowering embryo suggest the woman's body as a vessel and the physical act of love as one of cosmic beginnings (see also *Encounter in Space*, cat. 34). By representing the woman from the perspective of her lover (Eggum 1990, 188), Munch implicates the audience in the sexual, biological, and cosmic act.

Because Munch developed this motif in connection with his literary milieu in Berlin, it has often been speculated that the model for this image was Dagny Juel Przybyszewska (see p. 31). Munch, however, discouraged this idea, instead claiming that the model simply bore a similarity to her. The process of working from a studio model and translating her or his features into an abstracted, emblematic image seems to have been characteristic of Munch's working method in the 1890s (see also *Vampire*, cat. 30). Munch's mediation between the physical presence of his model and the content of his memory and imagination provided the grounding for his narrative series the Frieze of Life, of which this image was a central, thematically complex element.

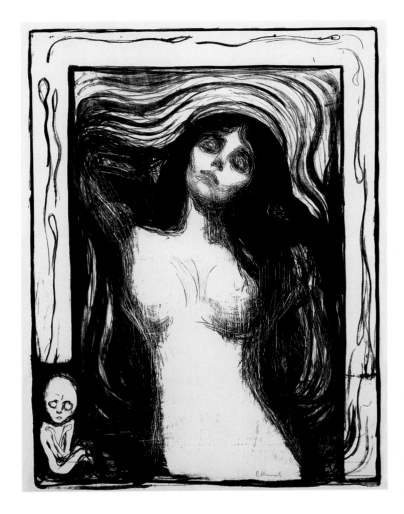
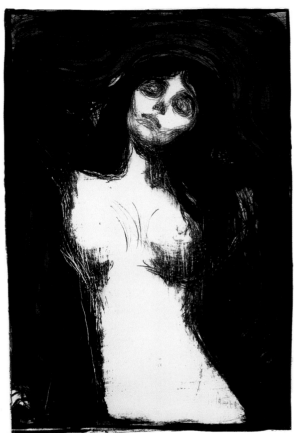

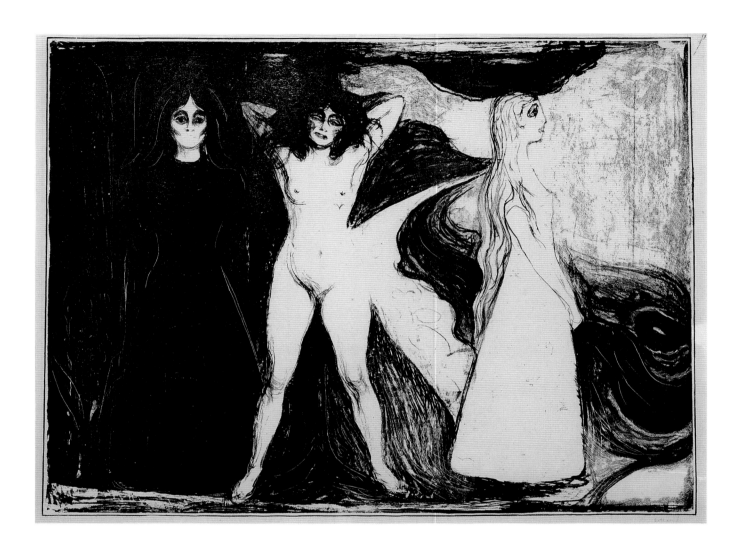

21 **Three Stages of Woman (The Sphinx)**
1899
Lithograph
44.8 x 59.4 cm (17⁵/₈ x 23³/₈ in.)

Reinhold Heller has analyzed this motif as one of the central images in Munch's Frieze of Life (see Heller 1970). In its many variants in graphic and painted versions, three women stand in a seaside landscape. On one side a youthful woman, clothed in a low-cut white dress, is framed by the shore; in the center stands a naked woman whose legs and arms are spread in a gesture of sexual presentation; and at the other side, framed by a dense forest, stands a woman clothed in black, her high-necked dress shrouding her entire body. The three are intended to represent distinct biological moments of a woman's life as it relates to male sexuality: "a saint, a whore, and an unhappy lover" (Heller 1970, quoting Munch, 79)—a state of virginity, sexual activity, and sexual withdrawal.

Munch's reframing of female sexuality as a site of male projection is suggested by the title "Sphinx," in which the women are absorbed into the literary identity of the emblematic mysterious, destructive, and monstrous woman. When exhibited at the 1894 Konstföreningen in Stockholm, the painted version of this motif was accompanied by a quotation from Gunnar Heiberg's play *The Balcony*: "All the others are one—you alone equal a thousand" (Heller 1970, 77). Munch's literary supplement to this image of fragmented female sexuality suggests his attempt to explain his translation of women into Woman, an idea shaped by, and in perpetual dialogue with, a collective set of male-generated symbols. As Woman, the motif collapses time as one woman is shown at three stages of her life and locates her meaning in the pivotal moment of her sexual confrontation with Man. *Woman in Three Stages (Sphinx)*, an image that privileges and moralizes women's sexual identities, is one of Munch's most abstracted and stereotyped representations of women, playing the "other" to his equal abstracted and stereotyped representations of recoiling, volitionless men in his Frieze of Life.

22 **Attraction II**
1896
Lithograph
40.8 x 63.7 cm (16^{1}/$_{16}$ x 25^{1}/$_{16}$ in.)

Created in the same year as *Separation I* (cat. 23), this image represents the physical attraction of two people through a veil of hair moving outward from a woman's head to embrace her male partner. A darkened landscape of pine trees, a becalmed sea, and the moon and its reflection hovering on the water's surface provide the setting for this scene of intense intimacy. As Reinhold Heller notes (Heller 1984, 131), such images as this were intended as supplements to Munch's original conception of the Frieze of Life, adding to and nuancing its theme of love's flowering and dissolution.

In this image, the woman's hair binds the two figures together, enhancing and protecting their sense of intimate isolation from the world around them. The heads are represented eye to eye, and both faces are given the vacant stares of somnambulists, suggesting attraction as an equal and dislocating sensation for both members of the couple. In other motifs from the period, including *Man's Head in Woman's Hair* (cat. 24) and *Separation*, the detail of the woman's veil-like hair becomes a site of possession and male disintegration as it functions as a trap. Here, like a pair of arms raised in an embrace, the hair encircles the man, whose shadowed features suggest his impassivity to entanglement.

23 **Separation I**
1896
Lithograph
46 x 56.5 cm (18¹⁄₈ x 22¹⁄₄ in.)

Munch examined this motif in painted and printed versions in 1896, producing two lithographic versions that explore a couple's parting as a kind of dismemberment. *Separation I* is similar in composition to *Three Stages of Woman (The Sphinx)* (cat. 21), the shoreline functioning as a fixed stage set within which erotic misery unfolds: a woman clothed in a white dress, echoing the young woman in *Three Stages of Woman (The Sphinx)*, stands staring out over the water, seemingly oblivious to the dazed man who seems to stagger behind her.

As in *Attraction II* of the same year (cat. 22), tendrils of the woman's long hair drift from her head to encircle and bind the man. As Munch noted in his literary diaries, the hair represents his state of longing: "When you left me over the sea, it was as if fine threads still united us— it pained me like a wound" (London 1992, 84). Providing a material bridge that links the retreating woman and the abandoned man, the undulating hair echoes the landscape elements throughout the motif, creating a confluence of the physical and the metaphorical. The man represents the same "type" pictured in *Attraction II*, *Ashes II* (cat. 26), and in several of Munch's paintings in the Frieze of Life. Pale, passive, and overwhelmed by emotion, he embodies, as Heller suggests (Heller 1984, 132), both a generalized image of a scorned lover and an emblem of the artist himself. The plant that grows at his feet, nurtured by the blood flowing from the wound to his heart, is a symbol that appears frequently in Munch's work of the 1890s.

Uniting the theme of abandonment with Munch's notion that artistic creativity is forged from pain, *Separation I* provides a kind of artistic credo. At its core is Munch's transformation of the dynamics between male and female lovers into an image of the loss of physical integrity and of individuation in the face of emotional need. In turn, fragmentation and pain are posited as the sources of artistic fulfillment, suggesting that the turmoil of love relationships is a precondition for creativity. In this equation, women do not assume the roles of femmes fatales as much as they do actors in a drama of male creative need.

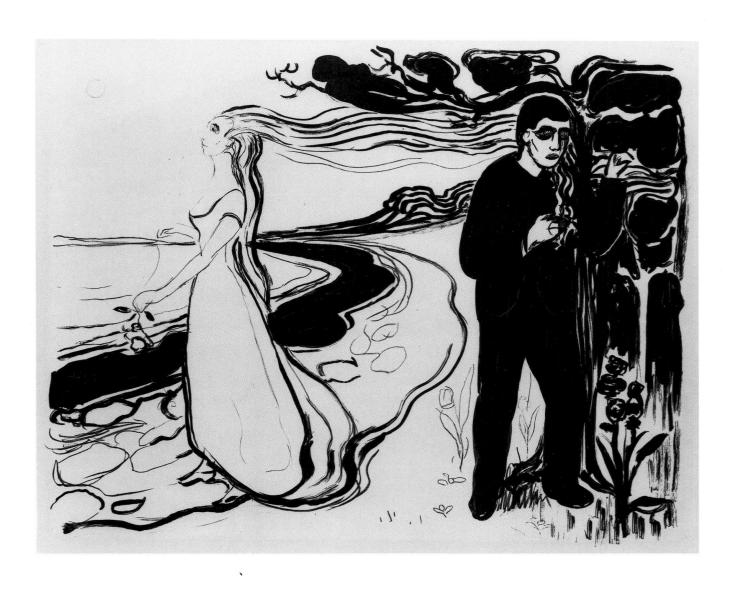

24

Man's Head in Woman's Hair
1897
Color lithograph printed in red,
green, and gold
70.8 x 53.4 cm (27^{7}/8 x 21 in.)

This image was used as the poster for Munch's 1897 exhibition in the Diorama Hall in Kristiania, where he exhibited his print cycle entitled The Mirror. This series of twenty-five graphic works in various media repeated the chief themes from the Frieze of Life and translated many of its motifs from oil paint on canvas to graphic media. *Man's Head in Woman's Hair* was the introductory motif to The Mirror, as Munch incorporated it within the cover of a portfolio that seems to have been intended for the series (Torjusen 1986, 186). The prominence of this motif in this large exhibition of 180 works, displayed from September 15 to October 17, suggests it as a theme for Munch that autumn. It was a subject new to Munch's work that year and had not previously been rendered in a painted version.

The motif seems to represent the face of the poet Stanislaw Przybyszewski enmeshed in the hair of his wife, Dagny Juel Przybyszewska. The faces are consistent with Munch's other representations of the couple, including *Jealousy* of 1896 (cat. 25). As Bente Torjusen has noted, the relationship between this motif and an 1898 woodcut entitled *Salome Paraphrase* (Schiefler 109) identifies this as a representation of Juel as Salome gazing down upon the head of John the Baptist. Both faces are given a hieratic appearance, Przybyszewski through the frontality and reduced detail of his face and Przybyszewska through the profile with frontal eye. Thus reduced, the heads function as signs for a highly unconventional marriage portrait. The woman's hair, which dually protects and entraps, operates as a sign of possession and demasculinization. In this case, Dagny and Stanislaw—the New Woman and the Decadent—engage in a relationship that destabilizes both gender roles. Munch made reference to this motif in his 1903 self-portrait with Eva Mudocci (cat. 61), in which desire on the part of the male is accompanied by his loss of control over his physical and emotional boundaries.

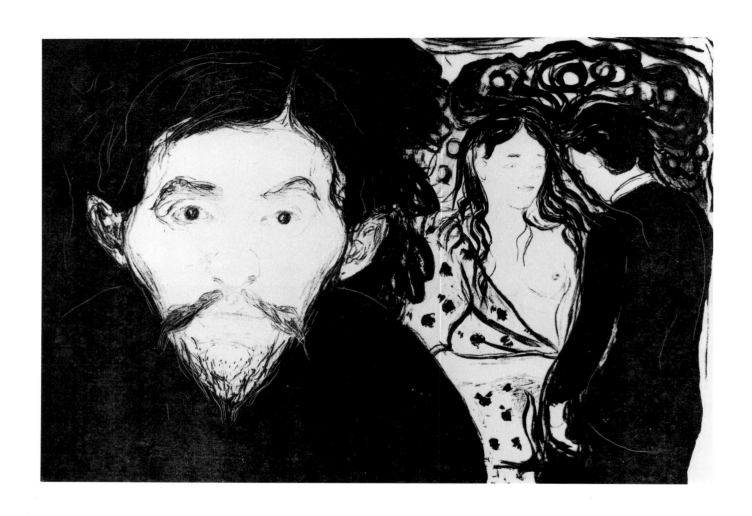

25 **Jealousy**
1896
Lithograph
33.3 x 45.7 cm (13^{1}/8 x 18 in.)

This is one of several versions of this motif in which a face, representing that of the author Stanislaw Przybyszewski, stares directly forward, while behind it a partially clad woman, representing his wife Dagny Juel Przybyszewska, engages in conversation with another man. Like Munch's earlier composition *Melancholy* (fig. 12), it is not clear from the composition whether the image is a representation of "real space," in which Przybyszewski appears in the extreme foreground and the couple stands behind him, or whether it represents the space of the imagination in which the background couple is intended to be read as Przybyszewski's thought projection. The title "Jealousy," identifying a state of mind, would indicate the second interpretation. Allowing the audience entrée into Przybyszewski's thoughts while simultaneously reading his facial expression, Munch provides a view of Przybyszewska through the veil of her husband's tortured imagination.

The Norwegian-born Dagny Juel Przybyszewska (see cats. 19 and 20), a musician and writer, was a member of Munch's bohemian circle in Berlin, where she met Przybyszewski. From all accounts an intellectually and sexually liberated woman, Przybyszewska became the focus of much erotic interest and speculation among members of Munch's literary circle. In particular, she was the focus of August Strindberg's fury in his novels *The Cloister* and *Inferno* (see pp. 31–33), inspiring a reading of Przybyszewska as a calculating sexual predator. Munch seems likewise to have been infatuated with her, but he portrayed her with far greater dignity and complexity as both an independent and assertive personality (fig. 17) and as a protagonist in complex erotic dramas. In *Jealousy*, her commerce with a male (whose face shown in profile seems to identify him as Munch) provokes the jealous response in her husband that prompts the rictus-like expression of his face. In some versions of this motif, Przybyszewska is represented as Eve, reaching into an apple tree as she exposes her body to her partner (see *Jealousy*, 1895, Rasmus Meyers Samlinger, Bergen). In this lithographic version, the tree is indicated as the decorative frame surrounding the heads of Munch and Przybyszewska and separating them (and their intimacy) from the silent, self-torturing Przybyszewski.

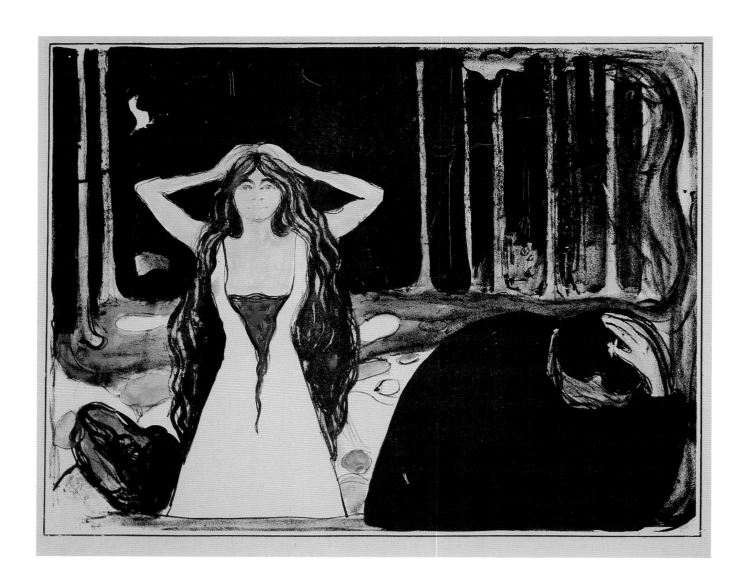

26 **Ashes II**
1899
Lithograph hand colored with watercolor
35.2 x 45.4 cm (13^7/$_8$ x 17^7/$_8$ in.)

Munch entitled the 1894 painting on which this motif is based *After the Fall*, undergirding the image with biblical resonance, and later *Ashes* (Oslo, Nasjonalgalleriet). The present title signifies remorse following sexual encounter. Notations from Munch's diaries overlay the image with autobiographical references: "We walked out of the stifling, flower-filled woods . . . into the light night—I looked at her face and I . . . had committed adultery—A gorgon's head—I bent over and sat down . . . I felt as if our love . . . was lying there on those hard rocks" (London 1992, 77). As Gerd Woll notes, the woman's stark frontality and long, undulating hair liken her to a Gorgon: to Medusa and her sisters. Munch's thematic borrowings from Christian and Greek mythology deepen the symbolic content of this image of moral self-inquiry.

In comparison to this upright, phallic woman, Munch has represented the man as a retreating, self-protective mass. From the frame around him issue smokelike tendrils that drift upward at the right of the composition to merge with the background trees. Like *Separation I* (cat. 23), the man's painful confusion in the shadow of physical love transforms him into a cipher. In comparison, the woman's blood-red underclothing and rhetorical gesture of grief and confusion provide her with an active response to the pleasures and disappointments of sexual engagement. Whether her gesture may be read as one of horror or triumph (see Heller 1984, 127–29; London 1992, 77), it locks the woman into the cycle of mutual attraction and destructiveness that forms the core imagery of Munch's Frieze of Life.

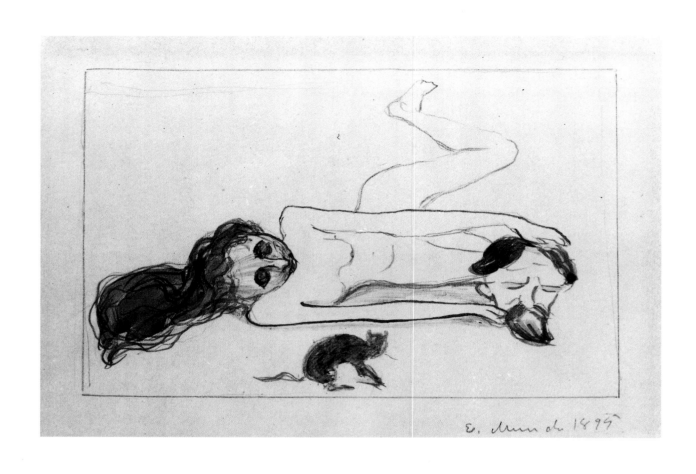

27	**The Cat**
	c. 1895
	Gray ink, wash, and pencil
	9 x 14.1 cm (3⁹/16 x 5⁹/16 in.)

27 The Cat
c. 1895
Gray ink, wash, and pencil
9 x 14.1 cm (3⁹/16 x 5⁹/16 in.)

Munch created this sketch in 1895 while living in Paris. There he was in close contact with the circle of artists and intellectuals who gathered at the home of the composer William François Molard and the sculptor Ida Ericson Molard. *The Cat*, which served as the basis for an etching of the same title (Schiefler 89b), seems to make reference to an encounter between his pet cat and one of his models. Munch recalled: "I was working with a female model—a little Parisienne, very lithe and supple—when suddenly I see the cat steal up to her white body, purring and affectionate. They were like two people, or two cats."[1] Overlaying the playful and dynamic position of the model with a severed male head, Munch evokes an association with the biblical Judith or Salome, suggesting a predatory identity for both model and cat.

The "little Parisienne" about whom Munch wrote has been speculatively identified as Ida Ericson Molard's adolescent daughter Judith (1881–1950), whom, according to Bente Torjusen, Munch had nicknamed "the white cat."[2] By all accounts a precocious and talented girl (she herself was a painter) who had developed a romantic attachment to the Molards' friend Paul Gauguin prior to his 1896 departure from Paris, Judith Molard was fifteen years old when the thirty-two-year-old Munch first met her. On the basis of passing references in Munch's correspondence, Bente Torjusen speculated that Munch and Judith engaged in a sexual relationship.[3] Arne Eggum counters Torjusen's interpretation of the evidence. Instead, he proposes that Munch shared an intimate relationship with the twenty-five-year-old painter Tupsy Jebe, the sister of his acquaintance, the violinist Halvdan Jebe (Eggum in Paris 1992, 206). Such a debate over the verity and chronology of Munch's sexual intimacies suggests the extent to which the artist's biographers map the meaning of his motifs with coordinates drawn from his intimate life—that Munch's images are implicated directly in his biography.

Although there is no direct evidence for a sexual liaison that can be mapped securely onto *The Cat*, Munch produced several motifs involving the perfidy of adolescent girls in 1896–97 suggesting his observation of youthful models in the period (see *Maiden and the Heart*, cat. 28), and perhaps articulating the complexity of an older man's erotic interests in younger women.

Notes
1. Quoted in Bente Torjusen, "The Mirror," in Washington 1978, 207.
2. *Ibid.,* 204ff.
3. See *Ibid.,* 204ff, and Bimer 1985, 100–01.

28 **Maiden and the Heart**
1896
Etching and drypoint
25 x 24.4 cm (9^{13}/$_{16}$ x 9^{5}/$_{8}$ in.)

In Paris during the general period in which Munch sketched *The Cat* (cat. 27), he represented in *Maiden and the Heart* a young girl holding an enlarged heart from which blood flows. A friezelike arrangement of trees in the background and the vertically ordered flowers to the right of the girl's body provide references to a landscape setting, although the episodic compositional space and the details of the model's earring and coiffed hair suggest a studio environment. The artificiality of the setting and the bizarre activity of the young woman establish a metaphorical environment. Although the model's upper arm muscles appear strained, her grip on the heart seems relaxed, suggesting that it is gravity and not compression that forces the blood from the heart: the maiden contemplates, rather than forces, the flow.

The tall plant that grows from the pool of blood at the model's feet links this motif with Munch's autobiographical image *The Flower of Pain* (Schiefler 114), in which blood from a wound in the artist's naked torso nourishes a flower, a metaphor for his art. In *Maiden and the Heart*, the ambivalence of the model's gesture and the dispassionate gaze with which she observes what is presumably the artist's own bleeding heart suggest that erotic misery, not malevolence, is a theme in this image.

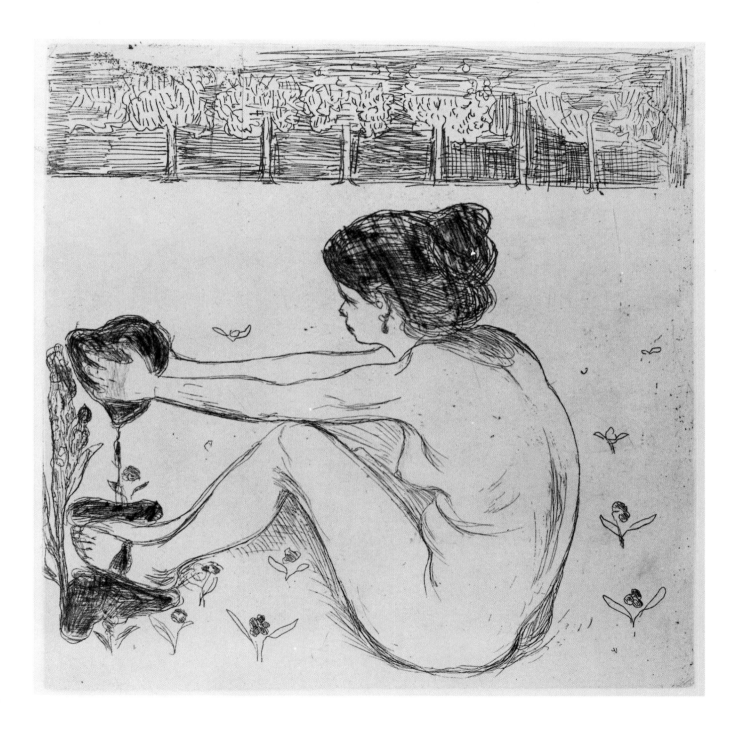

29 **Consolation**
1894
Drypoint and aquatint
21.8 x 32.4 cm (8⁹/₁₆ x 12³/₄ in.)

This image of extreme tenderness, in which the faceless man familiar from many of Munch's images of the mid nineties provides solace for a bereft woman, echoes the physical relationship portrayed in *Vampire* (cat. 30). In fact, when the two images are viewed in tandem, *Vampire* itself assumes a sudden sweetness, reinforcing Munch's claim that the image is merely "a woman kissing a man's neck." The weeping woman held tenderly in the arms of her lover is as much a part of Munch's allegorical repertory of representations of women as is his more widely publicized destructive Woman. Indeed, the vulnerability conveyed by the model's pose suggests that, in the mid nineties, Munch's observations of male-female sexual relations were more complex and varied than usually acknowledged.

Set against a field of summarily described floral wallpaper, the nude figures in *Consolation* huddle together on a bed (in a hand-painted version of this print, Munch sketched in a pillow to identify the location), the woman's thighs draped in what appears to be bunched fabric. The plate has been reworked, and the image is somewhat mysterious. The shadow rising behind and to the left of the couple repeats the looming form that appears in *Vampire*, *Puberty* (cat. 9), and *The Fat Whore* (cat. 45), intruding into the otherwise tranquil and intimate scene and transforming the bourgeois wall patterning into a turbulent zone of projected emotion.

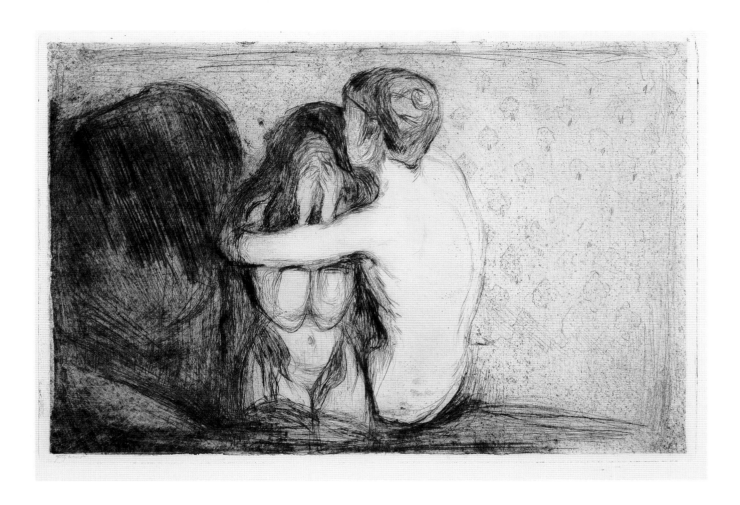

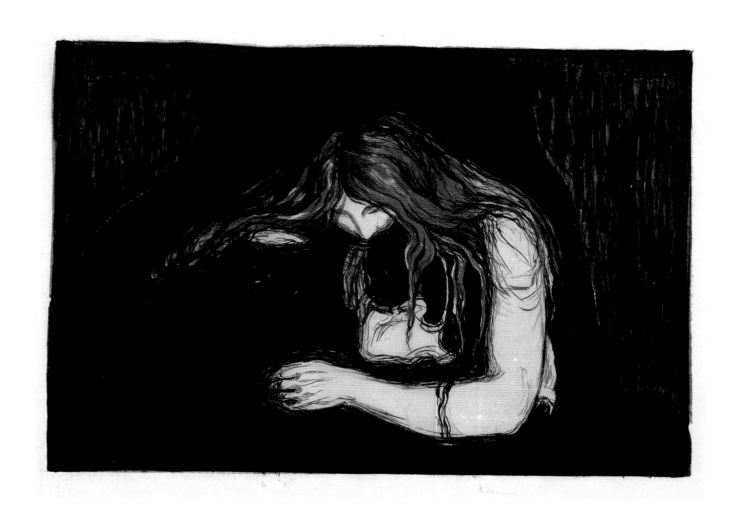

30

Vampire
1895 (1902 printing)
Lithograph and woodcut printed in black,
red-orange, blue-green, and yellow
38.4 x 55.6 cm (15 1/8 x 21 7/8 in.)

Routinely interpreted as one of Munch's most brutal images of women, *Vampire* has entered the canon of turn-of-the-century representations of women's sexuality as a destructive force. However, the motif was first exhibited under the title *Liebe und Schmerz (Love and Pain)* in 1893 and was only retitled *Vampire* in the following year. The commentary that Stanislaw Przybyszewski wrote about the image in 1894 provided a fashionable literary overlay that may have persuaded Munch to change the title: "A man broken in spirit; on his neck, the face of a biting vampire. . . . The man spins around and around in infinite depths, without a will, powerless—and he rejoices that he can spin like that, like a stone, totally without volition. But he cannot rid himself of that vampire nor of the pain, and the woman will always sit there, will bite eternally with the tongues of a thousand vipers, with a thousand venomous teeth" (see pp. 19–21). Years later, Munch seems to have regretted the directed reading that the title gave the motif. Admitting to his biographer Jens Thiis that the title made the painting "literary," Munch claimed that "it is just a woman kissing a man on the neck" (see p. 20).

Munch created the oil painting on which this combination print was based in 1893 (see fig. 7) and the graphic version in 1895. The writer Adolf Paul (1863–1943), a member of Munch's literary circle in Berlin, narrated the genesis of this composition, claiming himself to be the model: "One day I went up to [Munch]. He was living in a *chambre garnie*. . . . He was painting at the time. . . . His model was one with fire-red hair which streamed over her shoulders like spilled blood. 'Kneel down in front of her,' he shouted at me. 'Put your head in her lap!' I obeyed. She bent down over me, pressed her lips to my neck, her red hair fell over me. Munch painted, and in a short time he had his *Vampire* finished."[1]

When the motif is decoupled from its title and the woman is no longer defined as exsanguinating—emasculating—her partner, the image communicates a different relationship between the protagonists. Indeed, the cradling effect of the woman's arms, the delicate touch of her left hand, and the echoing gesture of enclosure made by the man's upturned right hand convey a tenderness that belies the moniker "vampire." While the woman's animated hair and the shadow looming behind her complicate the intimacy of her gesture, they link the motif to Munch's other statements about erotic suffering that shaped his painting series Frieze of Life and to *Consolation* (cat. 29) of 1894. Created in 1902, when Munch exhibited the fully formed Frieze of Life at the Berlin Secession, this version of *Vampire* made available one of Munch's most sought-after motifs to his expanding German audience.

Note
1. Adolf Paul, "Edvard Munch und Berlin," *Berliner Tageblatt* 178 (April 15, 1927), Beiblatt I, quoted in Heller 1969, 177.

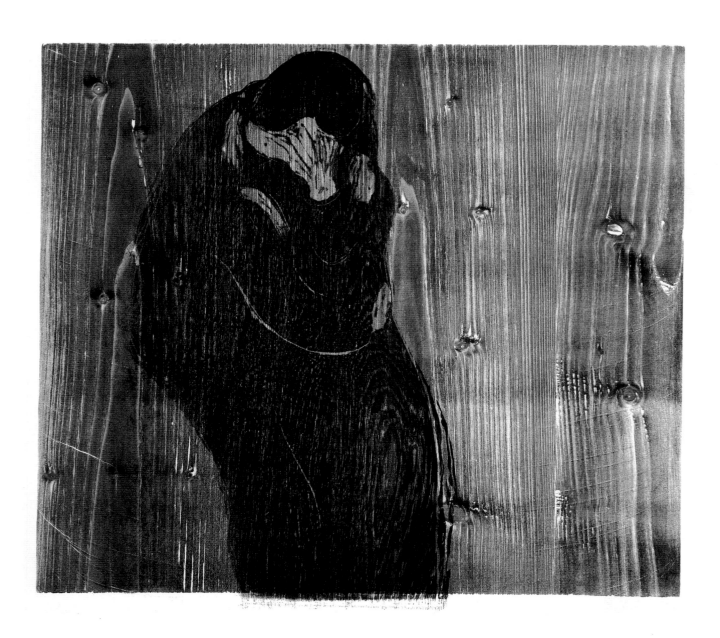

31 **The Kiss**
1898
Woodcut made from two blocks,
printed in black and gray
40.6 x 46.3 cm (16 x 18¹/₄ in.)

Edvard Munch, *The Kiss*,
1895, etching, drypoint,
and aquatint. Epstein Family
Collection

The Kiss is one of Munch's most tender images of sexual union and one of his most varied motifs. It explores the effect of an intimacy so overwhelming that the material world dissolves as the couple coalesces. Munch's initial exploration of the motif was in a sketch entitled *Adieu* from around 1890 (fig. 8). There a couple stands before a pair of windows, and an easel set off to the right establishes the setting as an artist's studio. In his literary diaries, Munch described an encounter that provides a narrative for the drawing (see p. 22), recounting the physical and emotional elation at the moment of intimate encounter and acute pain upon separation.

Munch reworked the motif in a range of media throughout the 1890s, creating increasingly abstracted and iconic images of *The Kiss* until, in this version, the couple appears as a pictograph representing one organism, flattened and enmeshed in the subtle texture of the woodblock's grain. Munch's suppression of anecdotal details, including any references to the separate integrity of the couple's faces, suggests the kiss as an emblem of complete union. Unlike earlier versions of the motif (illustration), the couple is removed from any temporal or spatial referents.

Munch's colleagues Stanislaw Przybyszewski and August Strindberg projected more sinister interpretations onto the present image, reading an earlier version of the motif as evidence that a heterosexual encounter demeans individual and psychic integrity. Of Munch's decision to elide the couple's faces, Przybyszewski wrote: "One sees two human forms whose faces have melted together. There is no single identifiable feature; one sees only the area where they melt together and this looks like a giant ear which went deaf in the ecstasy of the blood. It looks like a puddle of melted flesh: there is something repulsive in it. Certainly this type of symbolization is something unusual; but the entire passion of the kiss, the terrible power of painful, sexual longing, the disappearance of personal consciousness, that melting together of two naked individualities—this is so honestly depicted that the repulsive and unusual can be overlooked."[1] Strindberg's interpretation attributed cannibalistic or vampiric attributes to the woman, who, "shaped like a carp, seems on the point of devouring the larger as is the habit of vermin, microbes, vampires, and women."[2] Such vivid descriptions, which threaten to overwhelm the simplicity and integrity of the image, are extreme examples of the literary inventions that have been stimulated by Munch's images and that in turn have shaped and sometimes undermined their meaning for Munch's audience.

Notes
1. Stanislaw Przybyszewski, *Das Werk,* 18–19, quoted in Heller 1969, 173.
2. Strindberg 1896, 525–26.

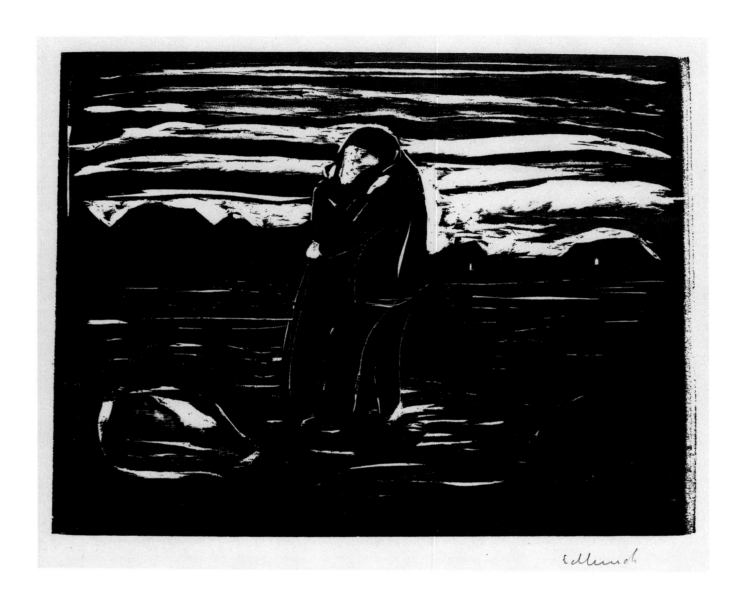

32 **Kiss in the Field**
1905
Woodcut
21 x 26.5 cm (8^1/4 x 10^3/8 in.)

Kiss in the Field transplants the iconic couple from Munch's earlier versions of *The Kiss* (cat. 31) into a natural setting. Here the couple is isolated by darkness and bathed in the night glow suggested by the variegated clouds around their heads. *Kiss in the Field* provides a rural back-drop for the scene of erotic intimacy that is many steps removed from Strindberg's reading of the motif *The Kiss* (see also pp. 21–22). In this setting, the sense of yearning and consumma-tion conveyed by the figures' postures is made poignant and perhaps surreptitious by the small group of houses silhouetted in the background.

Munch reexamined this motif in a number of settings from 1900 until 1943, using the image of the fused couple as a kind of linguistic sign. In 1904, when he created a painting cycle for the nursery in Max and Marie Linde's home in Lübeck (see cat. 53), one of his compositions included four couples, represented as compact triangular masses, embracing in a park setting (*Lovers in the Park*, 1904, Munch Museum, Oslo). Munch continued to consider this motif into the 1920s, creating *The Kiss on the Shore* in 1921 (Sarah Campbell Blaffer Foundation), in which he introduced the couple to the Åsgårdstrand shoreline familiar from his work of the 1890s. Like *Kiss in the Field*, this painting invests the motif with the mood of the landscape it-self. In 1943, in one of Munch's last woodcuts, the artist reexamined *Kiss in the Field* in a greatly reduced and schematic form, reimagining the isolation and intimacy of the embrace under the night sky and in the open arena of nature.[1]

Note
1. Arne Eggum, *Edvard Munch. Livsfrisen fra maleri til grafikk. Kjaerlihet—Angst—Død* (Oslo: J. M. Stenersens Forlag, 1990), 154–55.

33 **Man and Woman Kissing Each Other**
1905
Color woodcut printed in reddish brown,
red, green, blue-green, and light blue
39.5 x 53.8 cm (15½ x 21¼ in.)

Like *Encounter in Space* (cat. 34), Munch proposes a sense of isolation between a couple engaged in sexual intimacy by contrasting the colors in which they are represented. In this case, the hot red of the woman's face and hair differ markedly from the cool green of the man's head. The difference in optical "heat" is reinforced by contrasts in the figures' gestures: the woman seems ardent in her movement toward the man's cheek while the man seems subtly to pull away from her, his neck muscles and the tilt of his chin suggesting withdrawal. These fine contrasts are, at the same time, obviated by the series of halo-like lines that unifies the heads in the visual field of the woodcut. The conflicting messages of passion and emotional ambivalence in the couple's activity differ markedly from the moment of physical fusion proposed by *The Kiss* (cat. 31).

Because the male's prominent chin and straight nose bear similarities to Munch's features, it is tempting to read *Man and Woman Kissing Each Other* as an expression of Munch's own complex responses to sexual intimacy during this period of emotional instability following his break from Tulla Larsen (see cat. 43). However, the open-ended and conflicting messages conveyed in this print are consistent with Munch's narration of sexual encounter from the 1890s onward, in which attraction and repulsion, desire and ambivalence, are dually present.

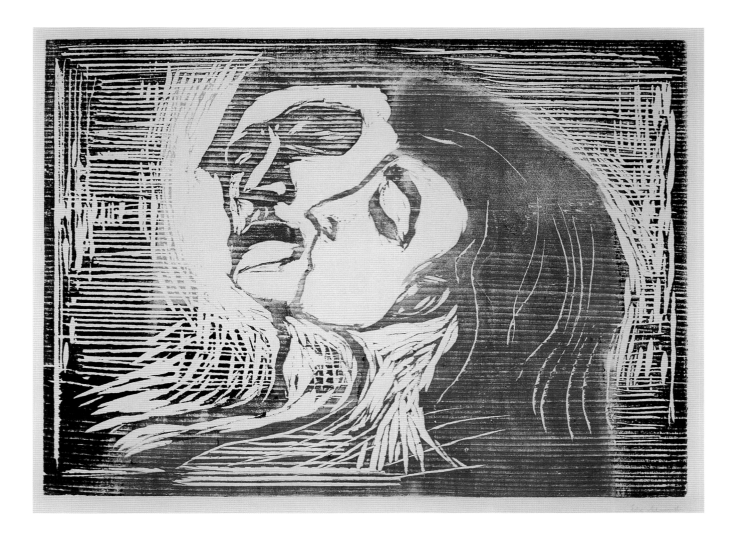

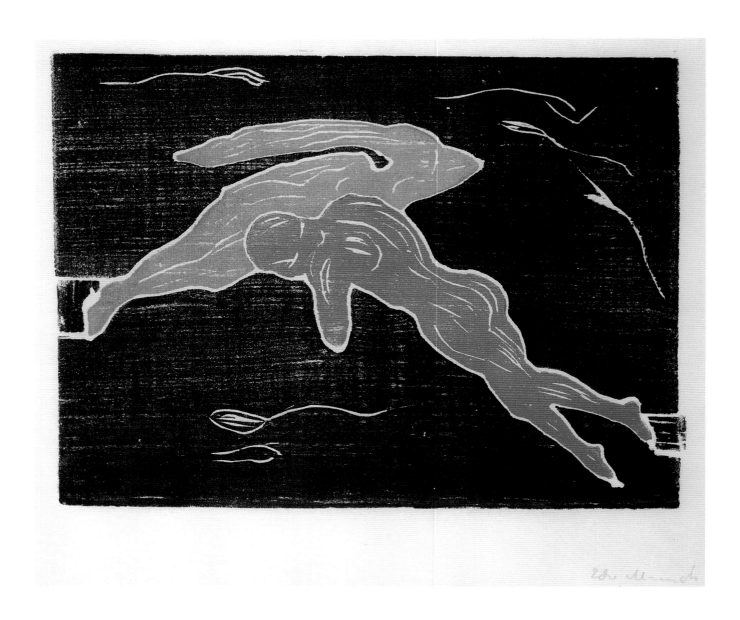

34 **Encounter in Space**
1899
Color woodcut printed in red,
green, and black
19 x 25.2 cm ($7^7/_{16}$ x $9^{15}/_{16}$ in.)

In this woodcut, Munch explores the dissonance between sexual attraction and emotional distance. Portraying a man and a woman in a dark, undifferentiated space, Munch examines the contrast between the naked couple's proximity to one another and their gestures of self-involvement. As they float by one another, the man buries his face in his hands, and the woman, her head supported by her left forearm, seems oblivious to his presence. The contrast between the figures' physical proximity and psychological isolation is enhanced by the way in which Munch exploited the woodcut medium: sawing his woodblock into separate puzzle-like pieces and then inking the pieces separately before reassembling and printing them, Munch enhanced the effect of the figures' separateness from one another (see Prelinger 1983, 80–82).

Several scholars have proposed sources for this motif in works of art illustrating Dante's *Inferno*, and in particular from Auguste Rodin's monumental project *The Gates of Hell* (begun 1880).[1] Such a link between *Encounter in Space* and the images of the great sinners in Hell provides both a literary overlay and a moralistic encoding of the image. However, Munch himself directed the symbolic content of the image by incorporating representations of spermatozoa floating around the couple and referring in the title to space in its cosmic dimension ("Weltenraum"). His symbolic pairing of seminal fluid and the cosmos, which Arne Eggum has linked to an 1892 publication by K. G. Kobler entitled *Ein neues Weltall* (Eggum 1990, 163), emphasizes sexual encounter as an originary experience suspended outside time and space, a theme that Munch treated in his writings (see p. 14) and in his Frieze of Life.

Note
1. J. A. Schmoll Gen. Eisenwerth draws parallels between this motif and *Fugit amour* (c. 1889) and *Paolo and Francesca* (after 1880), in "Munch und Rodin," in Henning Bock and Günter Busch, *Edvard Munch. Probleme—Forschungen—Thesen* (Munich: Prestel-Verlag, 1973), 103. Gösta Svæneus notes the resemblance between *Encounter in Space* and William Blake's engraving *The Circle of the Lustful: Francesca da Rimini* in *Edvard Munch: Das Universum der Melancholie* (Lund: The New Society of Letters, 1968), 126.

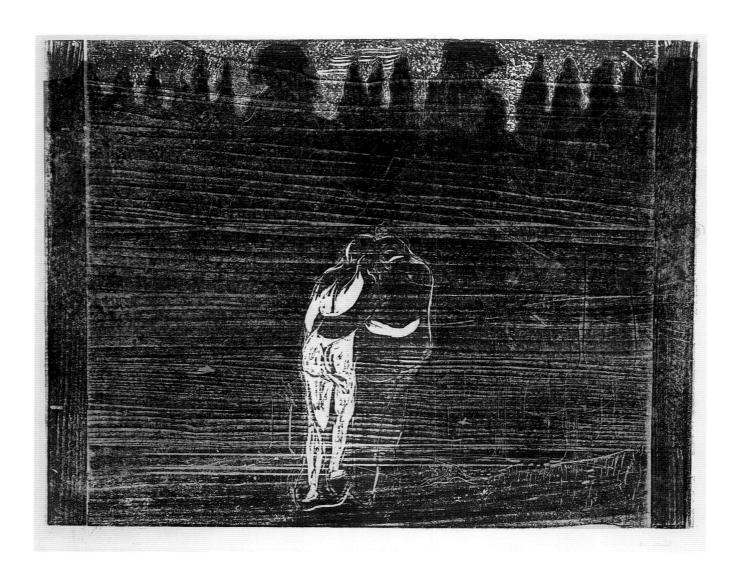

35

To the Forest
1897
Color woodcut from two woodblocks, printed in
blue-green, dark blue, and yellow
50 x 64.4 cm (19^{11}/16 x 25^{3}/8 in.)

To the Forest, one of Munch's most elegiac images, pictures a man and woman, their arms wrapped around each other's waists and their heads gently touching, walking away from the viewer toward a dense forest. The motif is related to a series of drawings executed by Munch between 1895 and 1898 that, as Arne Eggum suggests, evoke the theme of Adam and Eve in Paradise (Eggum 1990, 150–53). The man is clad in a black suit and the woman is either naked or wearing a long dress that is entirely transparent. The combination of the nude woman and the dressed man reprises the dynamic between the subjects of Edouard Manet's *Déjeuner sur l'Herbe* (1863), making any narrative association with Eden complex. The two strips of wood appended to either end of the woodblock expand the composition laterally and frame the central motif like curtains on a stage or, as Eggum suggests, like small wings of an altarpiece, creating a subtle sacral aura for the image (Eggum 1990, 148). Munch explored the motif through various combinations of color printing, and, in 1915, by reworking the composition so that the woman assumed a long white dress and the forest became less dense and distant. As in *Fertility* (cat. 36), this motif posits a coextension of male-female sexuality with the broad, benign forces of nature.

36 **Fertility**
1898
Woodcut
41.8 x 51.6 cm (16⁷/16 x 20⁵/16 in.)

Erik Werenskiold, *Shepherds*
***at Tåtøy*, 1883, oil on canvas.**
Nasjonalgalleriet, Oslo

This woodcut is the mirror image of an 1898 oil painting purchased in 1902 by Munch's collectors Max and Marie Linde (see cat. 53). *Fertility* represents an agrarian couple whose fruitfulness is symbolized by the basket held at groin level by the woman and through the physical proximity of their bodies to the nurturing land. In the oil painting, the verdant tree that separates the figures is laden with small red fruit, which the woman has collected in her basket. In both painting and woodcut, her presentation of the fruit, a displaced symbol of her sex, stages an offering to her male partner.

Separated by the tree (a compositional device that Munch repeated in *Metabolism* [1899] and *Eye to Eye* [1894, both Munch Museum, Oslo]), the man and woman operate as extensions of the landscape. A peasant Adam and Eve, the couple seems to spring from the same earth that produced the flamelike plants at their feet and the leafy canopy overhead. By pairing the peasants with the land, Munch enlists all of nature into the process of procreation and expresses in this motif one of the central themes of Norwegian nationalist painting of the later nineteenth century: the rootedness of the peasantry in native soil (illustration). The intersection here between this widely examined and much-exhibited theme and Munch's examination of heterosexual attraction suggests the complex sources of and outlets for the artist's ideas. Munch's interest in rural workers, which extended throughout his life, was most strongly engaged when he painted the murals for the University of Oslo Festival Hall beginning in 1909 (cat. 70). It has been suggested that the artist's concern with such themes and motifs was the result of his "cure" from psychological illness in 1908–09. However, *Fertility* testifies to the fact that Munch's interests were broader in the 1890s, and his "cure" less radical, than his early biographers have suggested.

37 **The Lonely One**
1896
Color mezzotint and drypoint on zinc plate with
pencil drawing
28.2 x 21.3 cm (11 1/8 x 8 3/8 in.)

One of the most delicate and exquisite of Munch's graphics, this image represents a young woman, her hair allowed to flow freely down her back, at the edge of the sea. Poised with her waist exactly meeting the raised line of the undulating shore, she appears to float before the abstracted, Synthetist landscape before her. The contours of her figure and of the rocks around her have been softened by the mezzotint medium, an effect that Munch corrected through the pencil lines with which he sharpened and outlined the forms in the lower part of the composition. The hazy effect, close tonal range, and reduced surface details of the motif translate the seaside geography to the space of the imagination. Dressed symbolically in white and confronting the continuous medium of twilit sky and sea, the figure is a trope of Romantic landscape painting, invested, through the title, with a sense of yearning. The glowing white dress and strip of yellow hair that seem to be bathed in moonlight etherialize the fragile, unknowable figure. In a recapitulation of this image from 1899 (*Two People*, cat. 38), a male figure joins the woman, radically shifting the valence of the motif.

38 **Two People**
1899
Color woodcut, hand colored
39.7 x 55.4 cm (15⁵/8 x 21³/4 in.)

This reinvention of Munch's 1896 motif *The Lonely One* (cat. 37) suggests the gulf in communication between a man and woman, both of whom face the sea and are unknowable to the viewer. The basis of the composition is a painting from 1891 (now lost), which Munch exhibited in Berlin in 1892, and a drypoint etching of the motif (Schiefler 20) from 1895. The woodcut, a mirror image of the original oil painting, presents the dark-clad man to the right of the white-clad woman. The contrast between the figures' clothing—his, which anchors him to the darkened shoreline, and hers, which pairs her with the water—creates a symbolic separation between them. Munch's experimental jigsaw technique—his woodblock sawn into discrete pieces in order to be inked separately—further enhances the sense of the figures' isolation from one another, as a thick line of white encapsulates their upper bodies. Suspended between them is the columnar (often interpreted as phallic) sign that Munch used to represent the moon and its reflection on the water, which Gerd Woll identifies as a stenciled addition to the woodcut.[1] One earthbound and the other ethereal, the figures, separated by the moon, articulate loneliness as a function of erotic desire. The greater sufferer seems to be the man, whose tentative step forward and awkwardly positioned right arm suggest his movement toward the immobile and seemingly oblivious woman.

Note
1. Gerd Woll in London 1992, 88.

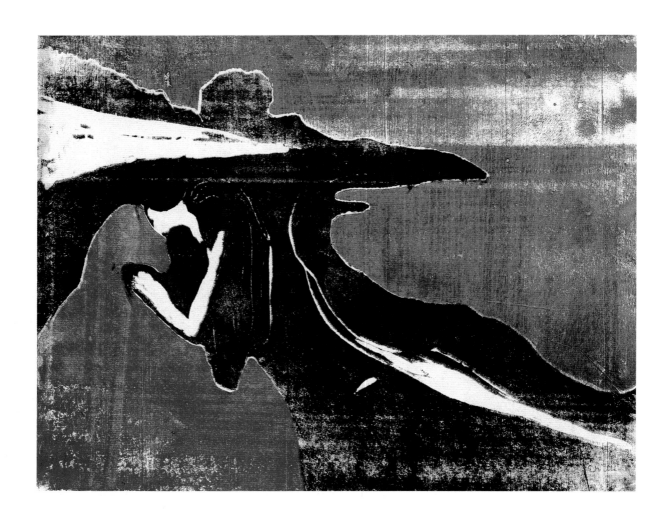

39 **Melancholy (Woman on the Shore)**
1898
Woodcut, made from two blocks,
printed in green, black, and red
33 x 42.2 cm (13 x 16$^{1/2}$ in.)

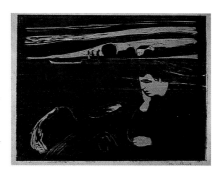

Edvard Munch, *Melancholy*
(Evening: On the Beach),
1901, color woodcut.
Epstein Family Collection

Pierre Puvis de Chavannes,
Solitude, reproduced in *The*
Studio 4, no. 24 (1895): 173.
Courtesy Harvard University
Libraries

A variation of the 1896 woodcut *Melancholy (Evening: On the Beach)*, a later version of which is illustrated here, *Melancholy (Woman on the Shore)* replaces the male figure in the extreme foreground with the image of a despairing woman. The motif was first explored in paintings by Munch in 1891–92. The painting *Melancholy* of 1892 (fig. 12) represents in the extreme foreground the artist's friend Jappe Nilssen sitting by the undulating shoreline of Åsgårdstrand. In the distance, the painter Oda Krohg (see pp. 26–27), his inamorata, prepares to depart by boat with her husband Christian. The sense of interiority suggested by the foreground figure's posture, the simplified and abstracted background, and the enveloping twilight mood of the painting led the painter and critic Christian Krohg to describe this painting as a breakthrough in Norwegian art.[1] In turn, the composition became one of the central motifs of Munch's painting series the Frieze of Life.

In the same way that the woodcut *Melancholy* reinterprets the painted motif on which it was based, *Melancholy (Woman on the Shore)* transforms the composition into a feminine space. Alone on the shore, the seated woman bends forward, her hair veiling her face like a shroud. Jane Van Nimmen has suggested as a direct source for this regendering of the motif an 1857 painting by Pierre Puvis de Chavannes entitled *Solitude* (illustration), which appeared in the March 1895 issue of *The Studio* and may well have caught Munch's attention between 1896 and 1898, the years in which he translated many of his Frieze of Life motifs into woodcuts. Munch later adapted the motif to monumental scale and translated it into tempera on canvas as part of the painting frieze commissioned by the theater impresario Max Reinhardt for his Chamber Theater in Berlin (*Weeping Woman*, 1906–07).

Note
1. Christian Krohg, "Aften" (1891), reprinted in *Kampen for Tilværelsen* (Oslo: Gyldendal Norsk Forlag, 1989), 48.

40 **Stormy Night**
1908–09
Woodcut
21.6 x 32.7 cm (8^1/2 x 12^7/8 in.)

This woodcut is the mirror image of an oil painting from 1893 entitled *The Storm* (Museum of Modern Art, New York). Set in Åsgårdstrand, the village on the Oslofjord where Munch had summered since the 1880s, the image represents a group of women clustered together at the right of the composition and a single woman, dressed in white, in the foreground. Her dress and hat are animated by the wind that also excites the tree in front of the house at the center of the composition and that shapes the sky into a series of agitated waves.

According to Jens Thiis, the motif was based on a storm that Munch observed in Åsgårdstrand.[1] Here, however, the artist has elided the meteorological with the psychological. As in *The Lonely One* (cat. 37) and *Melancholy (Woman on the Shore)* (cat. 39), and in particular *The Scream* (1893), to which the gesture of the central figure makes reference here, Munch equates the turbulence of human emotion with supra-human events. As Dorothee Hansen has recently suggested, such pairings of human and natural phenomena were common in nineteenth-century German salon painting, such as the works of Arnold Böcklin and Hans von Marées, with which Munch had an active dialogue.[2] While this image suggests Munch's equation of women with eruptive natural forces, other motifs such as *The Scream* and *Anxiety* (1894) suggest his assertions that all humans are embedded in nature.

The motif has often been read as an expression of female eroticism (see for instance Washington 1978, 39–40), but the way in which the group of women is compressed into a claustrophobic mass, echoing the rigid pattern of the picket fence behind them, might suggest other, more broadly social, interpretations.

Notes
1. Cited in Washington 1978, 39.
2. Dorothee Hansen, "Bilder der Empfindung. Munch und die deutsche Malerei im späten 19. Jahrhundert," in *Deutschland* (1995), 142.

41 **The Storm**
1901
Woodcut
17 x 19 cm (6³/4 x 7¹/2 in.)

Tiny in size and monumental in effect, *The Storm* recapitulates the theme of *Stormy Night* (cat. 40) by equating the mood of the woman standing in the foreground of the composition with the unstable atmosphere of twilight. The woman, static and facing rigidly forward in a posture familiar from such images as *Portrait of Inger* (see cat. 2), is framed by the tree behind her and by the cottage that appears over her right shoulder. Unlike *Stormy Night*, turbulent weather is communicated neither through her posture nor the landscape surrounding her. Like *Moonlight* (cat. 42), the image equates the totemic woman with nocturnal activity. In concert with the title, this pairing invests this static composition with a sense of the uncanny communicated through the presence of the woman.

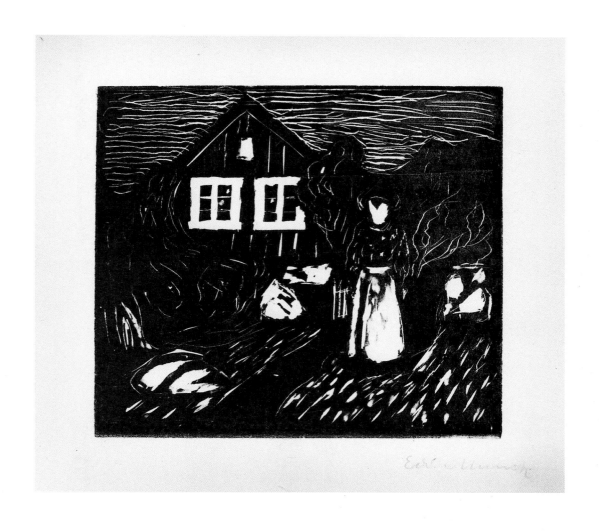

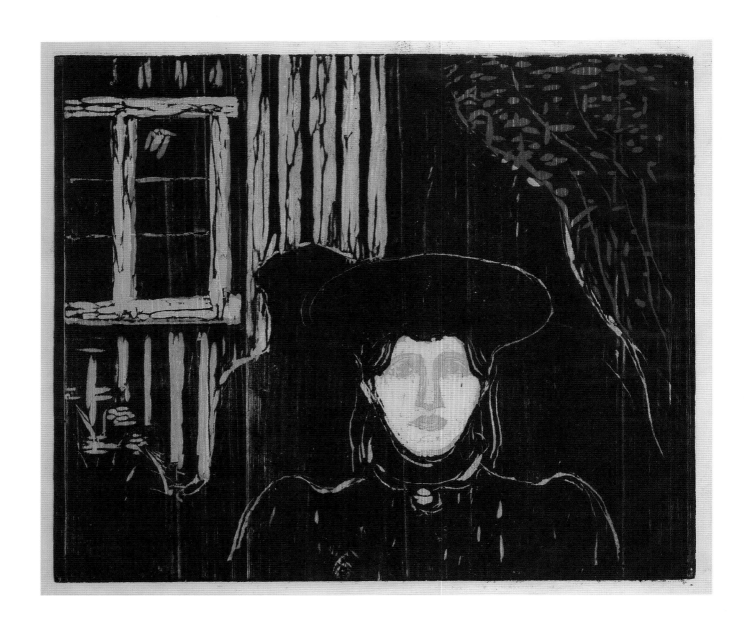

42 **Moonlight**
1896
Woodcut made from two blocks printed in brown, gray, brownish yellow, dark green, and light green
40 x 47.1 cm (15³/4 x 18⁹/₁₆ in.)

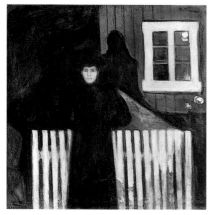

Edvard Munch, *Moonlight*,
1893, oil on canvas.
Nasjonalgalleriet, Oslo

One of a series of woodcuts that Munch based on his painted motifs for the series Frieze of Life, *Moonlight* represents a more intimate version of his 1893 painting of the same title (illustration). A woman, cropped at shoulder level and presented *en face*, stands before a house in Åsgårdstrand. Her shadow, greatly reduced in scale, is projected on the wall behind her. The vertical slats of the siding create a formal concurrence with the rough grain of the wood into which the motif was carved.

Like the oil version of this motif, the woman confronts the viewer with a direct gaze. In other ways the woodcut is fundamentally different. In the painting, the woman is cropped below the knees and framed from behind by a white fence, emphasizing her body and its ambivalent gesture. Her face appears luminous, a pale and indistinct oval floating against the field of dark clothing, shadows, and foliage. Although her form casts a dark shadow against the wall behind her, there is a suggestion that she radiates light, that she is paired metaphorically with the moon. In the woodcut, her form is limited to her head and shoulders, and her face seems to reflect, rather than originate, nocturnal light. A more anecdotal representation than the painting, the woodcut *Moonlight* nonetheless suspends the subject in a state of silent confrontation, her eyes gazing straight ahead and her face uninflected by emotion.

43 **Portrait of Tulla Larsen**
1898
Etching
19.1 x 13.65 cm (7$\frac{1}{2}$ x 5$\frac{3}{8}$ in.)

Edvard Munch, *Portrait of Munch and Tulla Larsen,* silver gelatin print. Munch Museum, Oslo

Tulla Larsen (1869–1942) was the only woman who was known as Munch's fiancée (although he later denied it; see Heller 1984, 166), and the only one whom he truly demonized in his work following their breakup (see fig. 5 and cat. 44). Born the eleventh of twelve children in a wealthy merchant family, Larsen was sent by her parents to a Norwegian finishing school but later sought her education in Berlin as a graphic artist. A member of the bohemian milieux in Berlin and Kristiania, Larsen was an independent and, according to Jens Dedichen (1981), sexually liberated woman. Dedichen suggests that Munch and Larsen knew each other for several years before becoming involved romantically in 1898. Their correspondence, published by Dedichen and analyzed more recently in a doctoral dissertation by Franck Høifødt,[1] suggests an increasing gulf in the relationship as Munch retreated from Larsen and she made efforts to increase their intimacy. In 1899, Munch attempted to circumscribe the terms of their relationship, suggesting, "We must live as brother and sister. You must primarily view my love for you as a brother's love. Perhaps after a while, your love will also become a different kind, that is, a sister's love—and without that, everything is impossible—with me."[2]

This etching was produced during the first year of their romance, when the tall, red-headed artist did not yet provoke feelings of panic in Munch (see illustration).

Larsen is a figure of particular fascination in the Munch literature more because of the terms of the couple's separation than for the fact that she was alleged to have become Munch's wife. In 1902, after Munch had broken off with her, Tulla Larsen staged a melodrama in the hope that it would reestablish their relationship. Via an intermediary, Larsen, threatening or feigning suicide, summoned Munch to her side. The ruse backfired when the couple grappled over a pistol and the artist was shot in the hand and had to have the upper two joints of one of his fingers amputated.

These events sent the artist into the most profound depression and period of instability of his life. The brutality of their parting, followed by Munch's sense of betrayal when Larsen shortly thereafter (October 1903) married the painter Arne Kavli (1878–1970), became an obsession of Munch's for several years. It was during this period, from 1902 to 1908, that the artist produced his most misogynistic and bestializing images of women. These images, however, are largely representations of Larsen, in allegorical guises such as *Death of Marat* (cat. 44) or narrative scenes depicting her as destructive and duplicitous. However, during the same period, Munch also produced images of sexual and emotional longing (cat. 33), suggesting a far more complex response to the dissolution of his relations with Larsen than the embittered allegorical images would suggest.

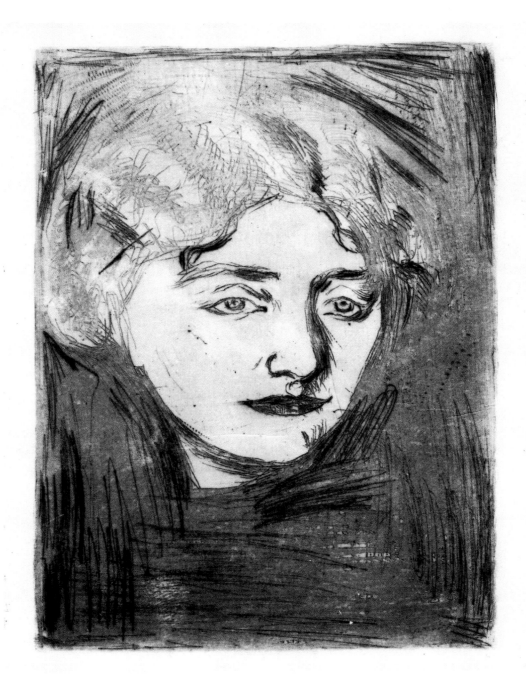

The virulence of Munch's images of Larsen is unmatched in any other period of his work and by any other body of his images of women. Nonetheless, many of his biographers have extrapolated from the these works interpretations of his earlier and later images that assume the same level of misogyny. This conflation of Munch's attitudes toward Larsen with his responses to all other women has clouded the interpretation of all of his work.

Notes
1. Franck Høifødt, "Kvinnen, kunsten, korset: Edvard Munch anno 1900," unpublished Ph.D. dissertation, Universitetet i Bergen, 1995.
2. Quoted in Heller 1984, 171.

44 **Death of Marat**
1906
Lithograph with chalk made from two stones, printed
in blue-green and ocher
43.5 x 35.9 cm (17^{1}/$_{8}$ x 14^{1}/$_{8}$ in.)

This motif, one of several painted and graphic variations that Munch produced under this title in 1906–08, refers to the violent end of his relationship with Tulla Larsen by alluding to the murder of the French revolutionary leader Jean Paul Marat in 1793. The protagonists are Tulla Larsen and himself. By equating Larsen with the counter-revolutionary Charlotte Corday, Munch invests his personal drama with layers of political and martyrial rhetoric.

As noted elsewhere (cat. 43 and pp. 15–16), Munch's relationship with Larsen was the most traumatic and destabilizing of his life, and much of the mythologizing that his biographers have made about his relations with women stems from the bitter imagery that he produced in the years after Larsen's departure from his life. From 1902 until 1908, Munch was preoccupied and at times obsessed with the failure of their relationship, the traumatic physical damage to his hand, and the ways in which their breakup polarized his circle of friends in Norway.

The lithograph repeats and simplifies the painting *Death of Marat I* (1907, Munch Museum, Oslo). The Charlotte Corday/Tulla Larsen figure stands rigidly in the foreground, and behind her, lying diagonally across the composition, is the body of Marat/Munch whose arms are held outward in a gesture of crucifixion. The symbolic appeals to the images of Christ and Marat that layer Munch's self-representation and the complete disregard that the phallic woman accords him overlay the composition with irony and reference to martyrdom. It is also a motif in which Munch ironically transgendered himself, both through the vulnerability with which he represents his own body and through his description of giving monstrous birth to the motif. Of the painted composition, Munch wrote to Christian Gierløff: "My and my beloved's child, the *Death of Marat*, which I have carried within me for nine years, is not an easy painting. . . . If you like, tell my enemy that the child has now been born and christened and hangs on the wall of L'Independants."[1]

Note
1. Letter from Munch to Christian Gierløff, March 19, 1908, quoted in Stang 1979, 206.

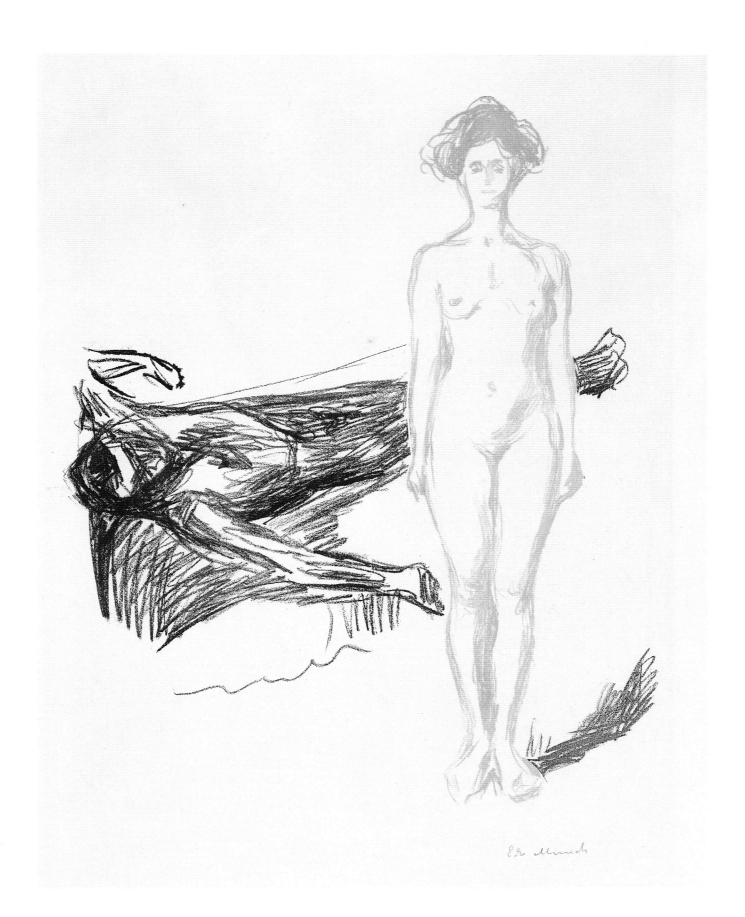

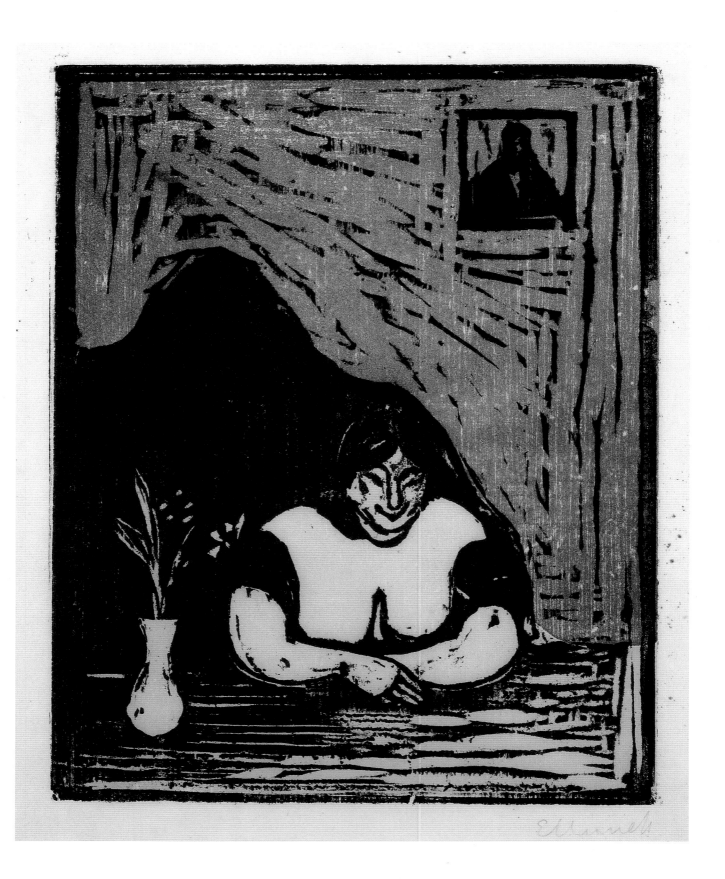

45 **The Fat Whore**
1899
Color woodcut made from two woodblocks,
printed in black, yellow, and gray-green
24.9 x 19.9 cm (9¹³/₁₆ x 7⁷/₈ in.)

This satirical image, presumably culled from Munch's earlier years in Berlin and Paris, represents a prostitute as obese and animal-like. As in other images of prostitutes in Munch's work—the painting *Rosa and Amlie* (1893, Rolf E. Stenersens Gift to the City of Oslo), an 1893–96 drawing entitled *Young Man and Whore* (Munch Museum, Oslo), and the 1895 lithograph *Tingel-Tangel*[1]—the woman is represented as a mound of flesh barely contained by her low-cut bodice, her arms folded and resting in feline repose on the table before her. To her right sits a vase of flowers, and behind her looms a vast large shadow.

Unlike Henri de Toulouse-Lautrec's individuated portraits of the prostitutes whom he knew and among whom he circulated, Munch represents this woman as a social type. The yellow color that defines her and the bilious green wall behind her communicate an atmosphere of illness, and the caricature with which Munch rendered her suggests moral condemnation. Nonetheless, the large scale of her body and the upright position of her torso provide her with the authority that makes this figure as powerful as she is laughable.

Note
1. These images are chronicled in Arne Eggum, *Edvard Munch: Livsfrisen fra Maleri til Grafikk* (Oslo: J. M. Stenersens Forlag, 1990), 181.

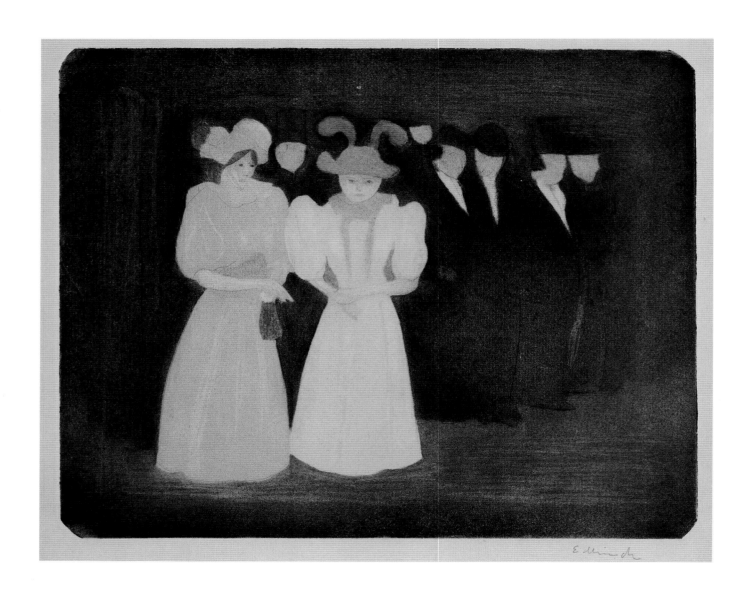

46 **Street Scene by Night**
1896
Color mezzotint with drypoint on zinc plate
23.5 x 29.9 cm (9$\frac{1}{4}$ x 11$\frac{3}{4}$ in.)

This satirical image of members of the Parisian bourgeoisie promenading after an evening at the theater represents two fashionably dressed women who stand out from the mass of face-less, black-clad men behind them. The women's bodies are intentionally distorted and awk-wardly proportioned, as though they were drawn by a child unfamiliar with anatomy. With their flattened bodies and lack of individual presence, they are presented as decorative motifs, as repositories of fashion. Both wear hats, one with feathers that resemble the antennae of an insect or a moth. The bright colors of their clothing stand out from the somber procession of men behind them and from the overall blue-green haze of the street, enhancing the sense of these women as on display and of the street as a space of spectacle.

47 **Homage to Society**
1899
Lithograph with crayon
41.8 x 53 cm (16^{7}/$_{16}$ x 20^{7}/$_{8}$ in.)

This lithograph, alternatively entitled *Farewell to the Party*, is reminiscent of the satirical prints of Honoré Daumier. Under the watchful protection of a policeman, bourgeois socialites greet each other with artificial smiles. So extreme is the tension caused by these smiles that the facade of civility has, in some members of the group, given way to grotesque animal-like expressions. Like the contemporaneous work of the Belgian artist James Ensor, *Homage to Society* represents through caricature the subhuman lurking behind the mask of social obligation. Both men and women are represented within this circle of deceit, their mutual regard and obsequiousness causing them to mass together. On the wall behind them, a shadow thrown by their clustered bodies suggests the presence of fewer figures than the eight who stand at the center. The consolidation of the shadows, further alluding to the insubstantial presence of the group, adds a sense of poignancy to this otherwise brutalizing image.

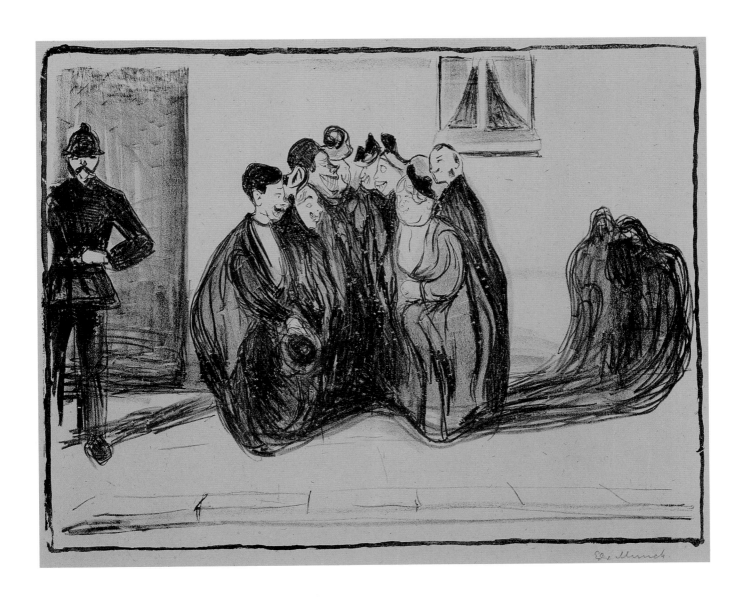

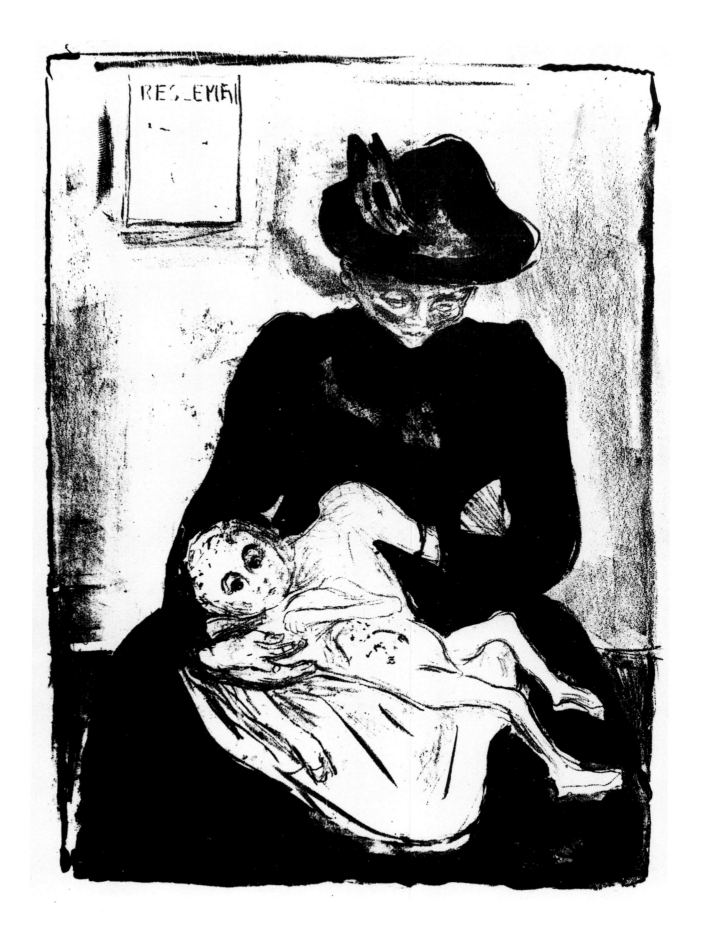

48 **Inheritance**
1897–98
Lithograph on zinc plate
42.9 x 31 cm (16^7/8 x 12^3/16 in.)

Syphilis, one of the most frightening diseases of the fin-de-siècle, was a phenomenon as much metaphorical as medical. As Sander Gilman has noted (Gilman 1988), syphilis was linked, throughout Europe, in the public imagination with unrelated social phenomena, such as immigrant populations, the New Woman, and socialism, that were perceived as threats to the social order. The disease, allied with the threat of sexual and social contagion, was frequently emblematized in the form of a seductive woman whose physical beauty masks the hidden threat within (see fig. 16). Perhaps the best-known image in that tradition is Pablo Picasso's *Demoiselles d'Avignon* (1907, Museum of Modern Art, New York), which began as an allegory of syphilis.[1]

Munch's lithograph narrates a fundamentally different story. Based on his memory of a mother with her syphilitic baby in a Paris hospital (Heller 1984, 168), *Inheritance* focuses on the image of a child deformed by hereditary syphilis. The disease is pictured here as a tragedy rather than a threat, a theme that was treated by Henrik Ibsen's play, *Ghosts* (1881), for which Munch would later design the sets (1906). Mother and child, victims of the disease (and of the man who was the carrier), rest on an austere wooden bench. On the wall behind them, a broadside listing "Regulations" establishes the setting as a public clinic and the working-class identity of the mother. This detail is an elaboration of Munch's oil painting of this theme (1897–99, Munch Museum, Oslo). Referring obliquely to sexually transmitted disease as a political issue, *Inheritance* is perhaps a legacy of the painter Christian Krohg's critique of the politics of police-regulated prostitution from the 1880s (see pp. 27–28).

Note
1. On this, see William Rubin, "The Genesis of Les Demoiselles d'Avignon," in *Studies in Modern Art 3* (1994), 13–144.

49 **Potsdamer Platz, Berlin**
1902
Etching, aquatint, and drypoint
22.8 x 28.6 cm (9 x 11¼ in.)

This casual and humorous view of the bustling public space in central Berlin illustrates a panorama of social class and economic activity. In the center of the composition stand two flower vendors, their baskets overflowing with blossoms and plants. Their rounded bodies and head scarves, identifying them as farm women, are in marked contrast to the fashionably hatted and corseted urban women seen in the foreground and at the far left. Behind the vendors rolls a horse-drawn hearse. Its tentlike shape, formed by the black bunting, functions as the point in the composition around which all other activity unfolds. Other vehicles—a modest flatbed carriage, a large horse-drawn delivery van, a baby carriage, and a tram—illustrate a panorama of conveyances around which the city residents bustle.

Potsdamer Platz, on one of the most congested sites in Berlin (in 1902 Europe's third-largest city), provided the experience of modernity "with every crossing of the street, with the tempo and multiplicity of economic, occupational, and social life" that the sociologist Georg Simmel described as crucial to the urban consciousness.[1] Framed in the background by hotels, the Potsdam Station, and a distant factory smokestack, consumers, delivery men, *flaneurs*, nursemaids, and matrons share the stagelike plaza, narrating the daytime spectacle of the city. In this setting, women appear as consumers, workers, producers of consumable goods, and as objects of visual consumption. A display of working women as well as working men, *Potsdamer Platz*, which repeats Munch's 1902 painting *Funeral Wagon on Potsdamer Platz* (Munch Museum, Oslo), narrates the artist's anecdotal view of the city as a site of social exchange and stratification.

Note
1. Georg Simmel, "The Metropolis and Mental Life," in *On Individuality and Social Forms* (1903; Chicago: University of Chicago Press, 1971), 325.

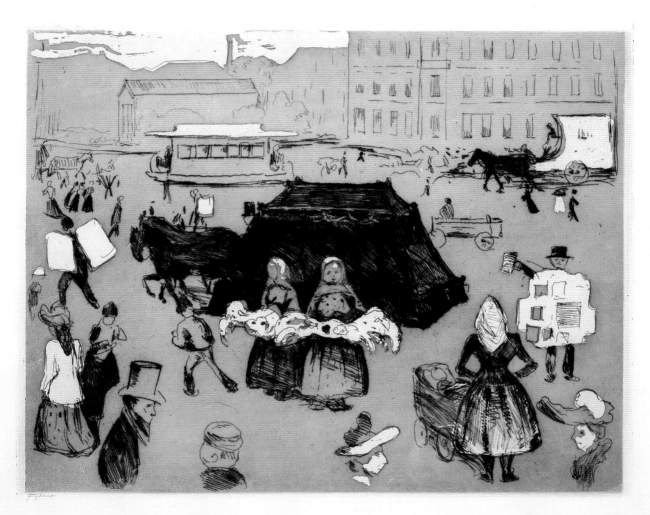

50 **Restaurant Hopfenblute**
1902
Drypoint
12.2 x 24.1 cm (4^{13}/16 x 9^{1}/2 in.)

Paralleling some of the themes depicted in *Potsdamer Platz* (cat. 49), this image depicts the interior of a Berlin beer hall and some of its habitués. Gustav Schiefler reports that in this period Munch carried a copper plate in his pocket "onto which he will etch some scene that particularly captures his imagination of the moment—a landscape, a waitress in a wine tavern, a couple of men playing cards, or a serious portrait."[1] This composition has the informality and spontaneity of such a drawing session. In the extreme foreground, seeming to share the artist's table, sit two women who are intent upon their game of cards. In the background, other patrons, male and female, engage in conversation, and a waiter hovers far beyond. The casual appearance of women drinking beer and playing cards in public belies the precariousness of their social situation. Unaccompanied by men and self-absorbed, the women are announced as shop girls, prostitutes, or other working-class types. Although it was acceptable for "ladies" to visit most beer restaurants in Berlin, according to the 1903 Baedeker Guide, it was not common for middle-class women to present themselves publicly as these women do here. Neither romanticizing nor admonishing his subjects (as in *The Fat Whore*, cat. 45), Munch depicts the quotidian activities of these women in their moment of leisure.

Note
1. Schiefler 1907, 20–21, quoted in Prelinger 1983, 12.

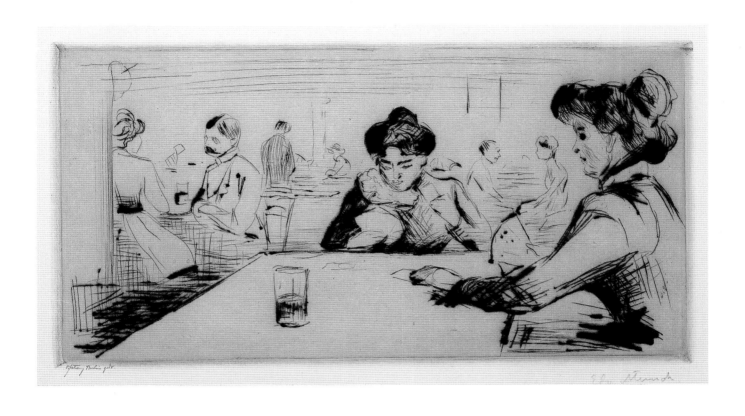

51 **Old Woman**
1902
Etching, aquatint, and scraper
32.2 x 49.4 cm (12¹¹/₁₆ x 19³/₈ in.)

Edvard Munch, *Photograph*
of Karen Bjølstad and Inger
Munch. **Munch Museum,**
Oslo

Old Woman is one of the rare dignified turn-of-the-century character studies of an elderly woman. Neither used for allegorical or satirical purposes nor deployed as a foil against which youth and fertility may be measured, the model is represented in near profile, her strong-featured head turned subtly over her left shoulder. Dressed in a simple bourgeois coat and hat and holding an umbrella, the woman conveys a sense of control and stateliness. The velvety surface of the print and the lightened areas around her body scraped into the plate soften and render monumental her solid form. The figure is curiously cropped at leg level, suggesting that the object on which she sits occludes the spectator's view. A similar cropping occurs in a photograph that Munch took of his sister Inger with their aunt Karen Bjølstad (illustration), an effect that compartmentalizes and stabilizes the body. Despite Munch's infelicitous addition of the woman's diminutive right hand, the artist's attention to the figure's refined bone structure, steady gaze, and ramrod posture invests her with the strength and beauty that underlay much of Munch's female portraiture.

52 **Anna and Walter Leistikow**
1902
Lithograph
52.1 x 86.4 cm (20¹/₂ x 34 in.)

Edvard Munch, *Walter*
***Leistikow in His Studio*,**
1902, gelatin silver print.
Munch Museum, Oslo

The painter Walter Leistikow (1865–1908) was one of Munch's staunchest supporters during the artist's first, controversial exhibition in Berlin. Later co-founder of the Berlin Secession, Leistikow wrote one of the few sympathetic reviews of Munch's maligned 1892 one-man exhibition that had opened and then been voted shut by the *Verein Berliner Künstler*, stating: "Anyone who can talk, paint, or sing with such depth of feeling, has the natural gifts of a poet. He sees the world that he loves with a poet's eye."[1] Leistokow's Danish wife, Anna Mohr Leistikow,[2] was a translator of the works of the Belgian writer Maurice Maeterlinck (1862–1949).[3] Her projects included an 1894 Danish translation of the play *Pelléas et Mélisande*, which was originally to have included illustrations by Munch.[4] The Leistikows, members of Berlin's younger artistic and literary milieu, opened their home to Munch and there put him in contact with painters, writers, and other members of the intellectual elite. Leistikow was also a visiter to the wine restaurant *Zum Schwarzen Ferkel*.

In this double portrait, Munch has positioned Mohr *en face* in the immediate foreground. Her husband is turned toward her, his gaze resting on her face. A childlike drawing of the couple's daughter floats in the far background above Walter's left shoulder. This type of marriage portrait, in which the wife is given prominence as the object of the husband's, the audience's, and the artist's collective gaze, was also used by Munch in his 1899 portrait of Harald and Aase Nørregaard (Nasjonalgalleriet, Oslo, see p. 15). Although the Leistikows are nearly isocephalic, Mohr's coiffure increases the height and mass of her head. Her subtle domination in scale and her direct gaze assert her independence and authority in the composition. Arne Eggum has demonstrated that this lithograph is based in part on a 1902 photograph of Leistikow (illustration), and Eggum has conjectured that Mohr's portrait may also be reliant on a photograph (Eggum 1989, 101). Munch's careful shading of the couple's faces and his attention to the nuances of Mohr's fleeting facial expression reinforce this notion. Sympathetic, accomplished, and assertive, Anna was one of a number of women who befriended, supported, and collaborated with Munch during his years in Germany.

Notes
1. Walter Leistikow, in *Die Freie Bühne* [1892], quoted in Stang 1979, 98.
2. Mohr's birth and death dates are unknown, according to Eggum 1994, 314.
3. Mohr's Danish translation of Maeterlinck's 1890 *Les Aveugles* (*De Blinde* [Copenhagen, 1891]), is still in Munch's library.
4. This project is noted in Eggum 1989, 100.

<table>
<tr><td>**53**</td><td>**Marie Linde**
1902
Lithograph printed in reddish brown
61.9 x 29.2 cm (24³/8 x 11¹/2 in.)</td></tr>
</table>

Marie Linde (1873–1940), the wife of Dr. Max Linde (1862–1940), was, as Jane Van Nimmen notes (see pp. 46–48), one of Munch's most important German patrons. In early 1902 the Lindes purchased Munch's painting *Fertility* (see cat. 36) and, later that year, invited the artist to create a series of etchings of their home and family. At the same time, Max Linde wrote a hagiographic study of Munch's work entitled *Edvard Munch und die Kunst der Zukunft* (Berlin: Friedrich Gottheimer Verlag), in which he compared the artist's genius to that of Rembrandt, Böcklin, Rodin, and Michelangelo. Munch became intimately familiar with the Lindes' home and art collection during his stay in late 1902. The Lindes' neoclassical estate in Lübeck in fact became the site of some of Munch's warmest images of domesticity: the series of etchings that Linde called the Lübecker Cycle and Munch's oil portrait of the Lindes' sons (*The Four Sons of Dr. Linde*, 1903, Museum für Kunst und Kulturgeschichte der Hansestadt Lübeck, Behnhaus). The Lindes also commissioned Munch to create a frieze of paintings for their sons' nursery in 1904, but they declined the finished paintings because of their erotic content and aggressive style and coloration.[1]

Jane Van Nimmen further notes that Marie Holthusen Linde was heir to the fortune that supported the Lindes' vast collection of modern art and that helped to support Munch during his period of residence. Munch created several portraits of Marie Linde in 1902, including an etching of her with one of her four sons (cat. 54) and this lithographic portrait. The Lindes' nephew Christian reports that Munch and Marie Linde shared a warm and companionable relationship,[2] a fact that is communicated in this portrait. Marie Linde's steady, direct gaze and sharply defined silhouette assert the art patron's strength and equanimity. Standing at a slight angle from the artist and framed by vertical lines on either side of her erect body, Marie Linde is represented by Munch as a powerful and austere woman. Playing the delicacy of Linde's facial features against the dark mass of her clothing, Munch balances intellect with physicality, presaging the sequence of oil paintings that he made of his male patrons and friends in the following years and belying the fact of Linde's frail health.

Notes
1. On this, see Arne Eggum, *Der Linde-Fries, Lübeck: Der Senat der Hansestadt* Lübeck, *Amt für Kultur* [vol. 20], 1982.
2. Christian Linde, interviewed by Carla Lathe and Sarah G. Epstein, April 1980, courtesy Epstein Family Archives.

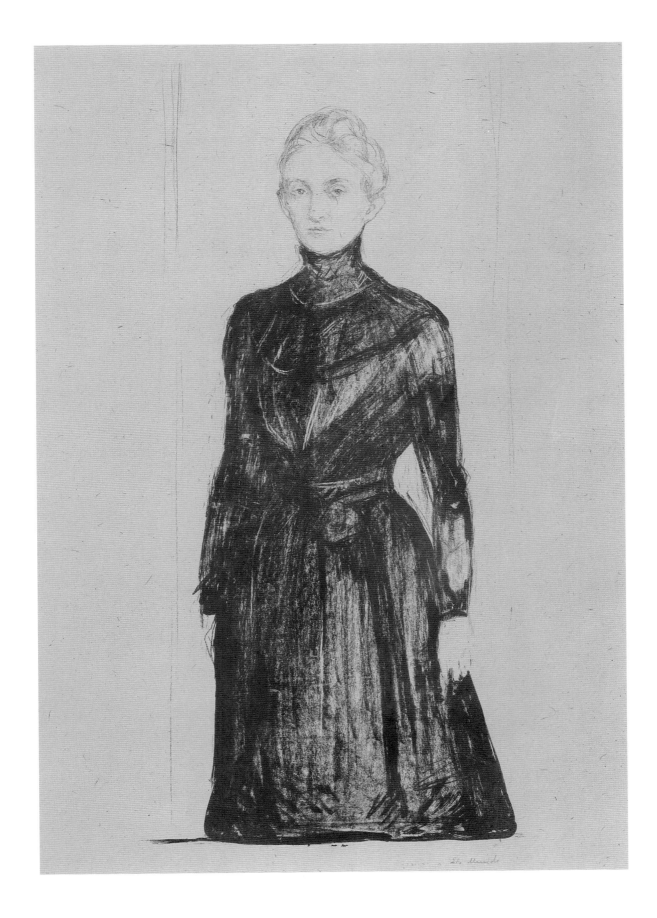

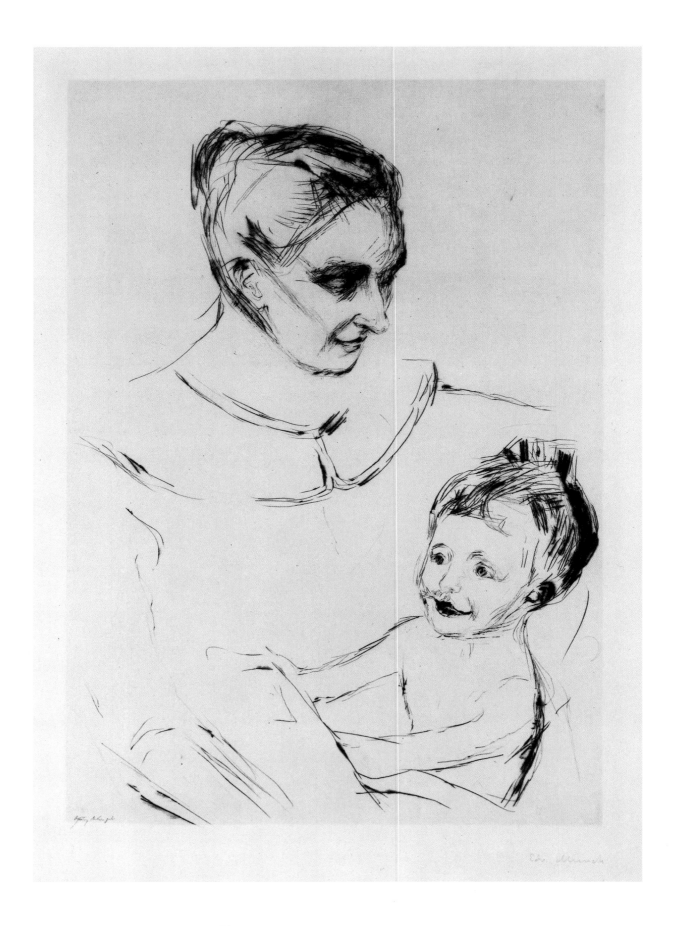

54 **A Mother's Joy**
1902
Drypoint
36.2 x 25.4 cm (14¼ x 10 in.)

One of the etchings that Munch created for Max and Marie Linde in late 1902 is *A Mother's Joy*, which depicts Marie with her youngest son Lothar (1899–1979). As Jane Van Nimmen has observed, the motif is closely related to a studio photograph of the family taken by Dr. Linde's father, Hermann Linde.[1] In the etching, Marie Linde's torso provides a protective frame for her child, and her gaze directs the viewer's attention to him. Unlike the pessimistic images of motherhood with which Munch is often associated (see *Inheritance*, cat. 48), *A Mother's Joy* suggests both the mother's emotional attachment to her child and the reciprocating object of her affection. Both figures are represented as if to suggest physical activity, the child through the extended arms and thrust of his head and the mother through her elongated left shoulder and beatific smile.

Marie Linde suffered from frail health and was absent from the Linde household during some of Munch's visits in 1903. In that spring, Max Linde commissioned the artist to paint a portrait of their four sons, Hermann, Theodor, Helmuth, and Lothar, to be completed by Marie's birthday in May. The resulting portrait is one of Munch's most sensitive and engaging (see cat. 53). In it, his affection for the boys and their parents and his feeling of being included in the household are reflected in the quirkiness and delicacy of the children's representations. Likewise, in *A Mother's Joy*, the palpable love passing from mother to child reflects back on Munch's integration into the family circle during this most difficult period of his middle life.

Note
1. Jane Van Nimmen, "Patrons and Friends at the Turn of the Century," in Epstein 1983, 106.

55 **Nurse and Child**
1902
Etching and drypoint
16.2 x 11.2 cm (6³/₈ x 4³/₈ in.)

Munch's etching of the Linde family's nurse holding Lothar was originally created for and then, according to Gustav Schiefler, deleted from the portfolio of prints that Max Linde commissioned in 1902.[1] The diminutive figure of Lothar has been overworked to the point that his body has become puppetlike. A swelling shadow or chair back behind him, echoing the dark mass of the nurse's body to the right, gives the composition a curious sense of the uncanny.

According to Max and Marie Linde's nephew Christian, the Lindes' sons were attended by a nurse named Sister Paula who acted as an assistant to the sickly Marie Linde (see cat. 53).[2] Munch's representation of the nurse and the child depicts the domestic worker as a support and protector of the child, but, in contrast to *A Mother's Joy* (cat. 54), as a somewhat distanced presence. Unlike the mother, the nurse displays a limited intimacy with the child, allowing him to sit upright on his own rather than rest in her arms. Her deflected gaze, somber dress, and concentrated attention to the child narrate her status, like Munch's in spite of his comfort there, as a paid participant in the family circle.

Notes
1. Gustav Schiefler, *Verzeichnis des graphischen Werks Edvard Munchs bis 1906* (1907; Oslo: J. W. Cappelens Forlag, 1974), 127.
2. Christian Linde, Lübeck, interviewed by Carla Lathe and Sarah G. Epstein, April 20, 1980, courtesy Epstein Family Archives.

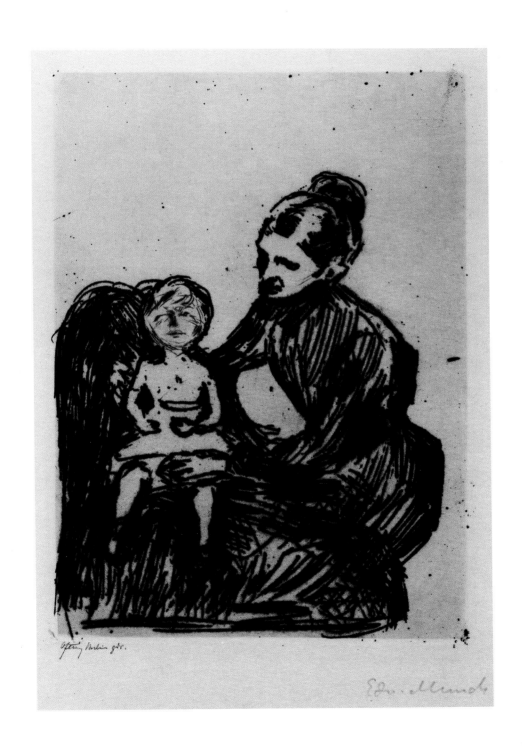

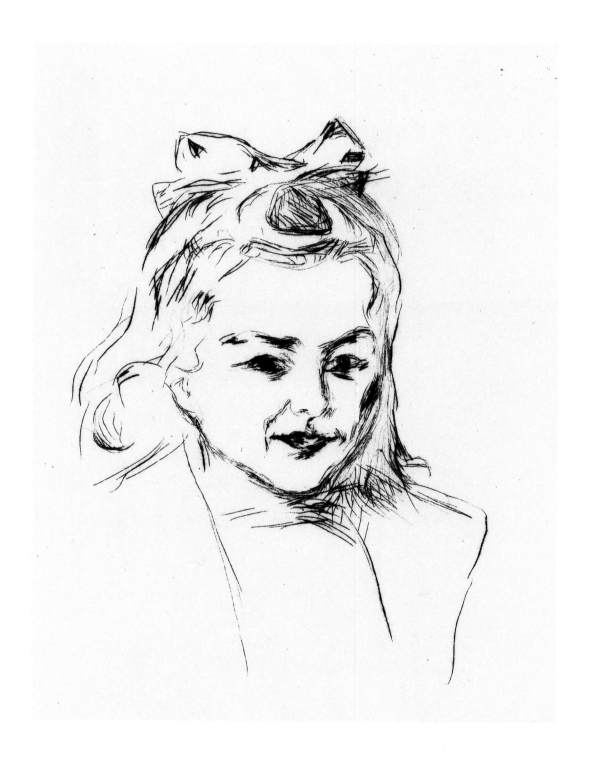

56 **Ottilie Schiefler**
1907
Drypoint
23.5 x 15.7 cm (9^1/4 x 6^3/16 in.)

This etching, one of a number of children's portraits that Munch created after the turn of the century (see also cats. 54 and 55), represents Ottilie Schiefler (1899–1992), the youngest daughter of the Hamburg magistrate Gustav Schiefler (1857–1935) and his wife Luise (1865–1967). The Schieflers began to collect Munch's works at the turn of the century and became some of his strongest supporters and patrons. Indeed, Gustav Schiefler helped to shape the terms of Munch's reception in Germany when he compiled and published two systematic catalogues of the artist's graphic work, in 1907 and in 1927. When Munch first met the Schiefler family, he was in a precarious emotional state following his breakup with Tulla Larsen (see cat. 43) and from his overwhelming work schedule.

Ottilie, the youngest of the Schieflers' four children, was special to Munch. In 1903, Schiefler reported to Munch that the precocious four-year-old said of the artist's painting of a nude woman that hung in the Schieflers' home: "The poor child doesn't have anything on; where did she leave her clothing?"[1] When Munch first saw Ottilie, seated in a tree, in May 1904, he remarked, "Little Angel, where are your wings?" (Eggum 1987, 92), coining the nick-name "the little angel" that he used thereafter to identify her. In 1905, realizing that the child was growing—"the little one will not remain an angel much longer"—Munch expressed his interest in portraying her (Eggum 1987, 117).

This portrait is one of several prints that Munch made of Ottilie, including an etching of 1905 (Schiefler 227) and a lithograph of 1908 (Schiefler 265). For this portrait, Schiefler reports that Munch arrived unbidden at their home in late March, expressing his desire to portray Ottilie. When he returned the next day, Ottilie posed for him but, according to her father, put on a sulky face (p. 233). Munch again sketched Ottilie in May (p. 245). The etching suggests both the child's angelic and mischievous aspects, her freshly combed hair and starched collar framing a mobile face. Munch's affection for children, which was strongly reciprocated, is an aspect of his personality that often goes unremarked. In 1980, Ottilie remembered that she admired Munch and felt him to be "half an angel."[2] As late as the 1920s, Munch continued to ask after her. Ottilie Schiefler suggested that part of his affection for her was that, as a child, she posed no social or intellectual threat to the artist,[3] who was at that time in an increasingly fragile psychological condition.

Notes
1. Eggum 1987, vol. 1, 58.
2. Interview with Ottilie Schiefler by Carla Lathe and Sarah G. Epstein, April 1980, courtesy of Epstein Family Archives.
3. *Ibid.*

57

Hjørdis Gierløff
1913–14
Drypoint
23.5 x 15.8 cm (9¼ x 6¼ in.)

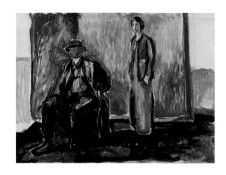

Edvard Munch, *Inspiration* (Christian and Hjørdis Gierløff), 1914, oil on canvas. Epstein Family Collection

Hjørdis Gierløff, née Nielsen (1889–1957), was portrayed by Munch several times in 1913–14. She was a member of Munch's inner circle after his return to Norway from Copenhagen in 1909 and was married to one of Munch closest friends, the journalist and author Christian Gierløff (1879–1962). It was Christian Gierløff who was summoned by telegram to Copenhagen when Munch entered Dr. Jacobson's clinic for treatment of his nervous disorder and who published a posthumous account of the events surrounding Munch's hospitalization in his 1953 book, *Edvard Munch selv*.[1]

This book, one of several volumes of reminiscences published by Munch's friends and associates following the artist's death, provides an anecdotal history of his life and work in an attempt to correct the misperceptions and myths circulating about him. Among his arguments is the proposition what Munch was not a misogynist. Gierløff attempts to nuance the reception of Munch's images and the stories about his social life by calling attention to the complexities of women's identities at the turn of the century. Citing on the one hand the assertion of women's intellectual and economic capabilities argued by the Norwegian feminists Gina Krog and Aasta Hansteen and on the other the evil attributes ascribed to women in Otto Weininger's *Sex and Character*,[2] Gierløff anchored Munch's imagery in fin-de-siècle cultural movements.

Munch portrays Hjørdis Gierløff obliquely and with a delicate touch. Relying on long contour lines to define her delicate features, Munch contrasts her almost flattened face to the variegated background that frames her profile as a moment of visual rest in a mildly turbulent environment. In other representations of her, Munch emphasizes the calming role that Hjørdis seemed to play in her family. She appears in two versions of a 1914 double portrait as her husband's muse or attendant (illustration). When one version of this painting was exhibited in 1917 (now in the Munch Museum, Oslo), a critic writing in the Copenhagen newspaper *Socialdemokraten* exaggerated the ways in which Munch emphasized the difference in gender roles suggested by the postures and placement of the husband and wife: "The man is represented as a *Man*, broad, large, and strong, full of vitality and ambition, self esteem and exuberance, a despot through whose expansive will the *Woman* is reduced to a gentle and mild reflection."[3] The extent to which the couple had an intimate rapport with Munch is suggested by the fact that they asked him to become the godfather of their son Åge Christian, born in 1914 (d. 1921), and through the insights that both husband and wife gleaned from their long friendship with the artist.

Notes
1. Gierløff 1953, 186ff. Gierløff also contributed to the 1946 book *Edvard Munch som vi kjente ham. Vennene forteller* (Oslo: Dreyers Forlag), a compilation of writings by members of Munch's inner circle.
2. Gierloff 1953, 146–55.
3. "J.P." in *Socialdemokraten* (November 11, 1917), quoted in Eggum 1994, 186–87.

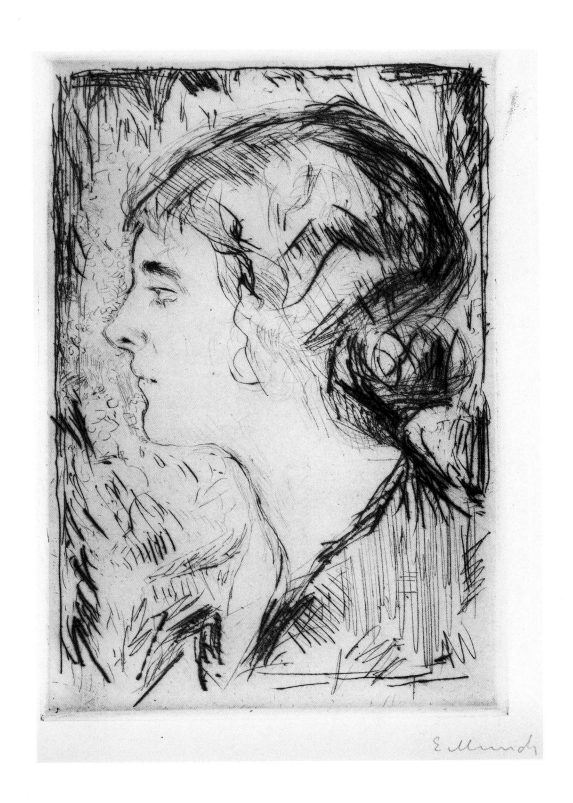

193

58 **Inger Barth (Woman with the Necklace)**
1920
Lithograph
58.7 x 60 cm (23^1/$_8$ x 23^5/$_8$ in.)

Inger Desideria Barth (1885–1950), née Jahn, posed for Munch in his studio at Ekely in 1920. According to Arne Eggum, Inger's husband, the physician Peter Barth, commissioned Munch to paint her portrait. In the years after World War I, portraits by Munch were valued by members of the Norwegian and German intelligentsia as assertions of a family's taste and social standing. Munch painted two oil versions of Inger Barth, both of which represent her from the knees up in three-quarter view, standing with her hands clasped at her right hip (1921, Rolf E. Stenersen's Gift to the City of Oslo, and Private Collection). According to Eggum (1994, p. 21), this lithograph was rendered at the same time.

The portrait presents a sympathetic and accessible view of Barth. Seated on a chair and leaning forward slightly, she thrusts her head outward, elongating her neck. The long necklace that she wears emphasizes the curve of her neck and helps to effect a transition between her head, seen in profile, and her upper torso, seen at a three-quarter angle. Her attention is directed away from the artist and, eyes dropped slightly and cheek muscles raised in a gentle smile, she is the subject of an image that manages to seem simultaneously intimate and monumental. According to Eggum, Inger Barth suffered from arthritis, the pain of which Munch conveyed in his painted portraits through her enigmatic facial expression and stiff posture. It is perhaps Munch's recognition of Barth's physical pain and her acknowledgement of it that inform this warm and sensitive portrayal.

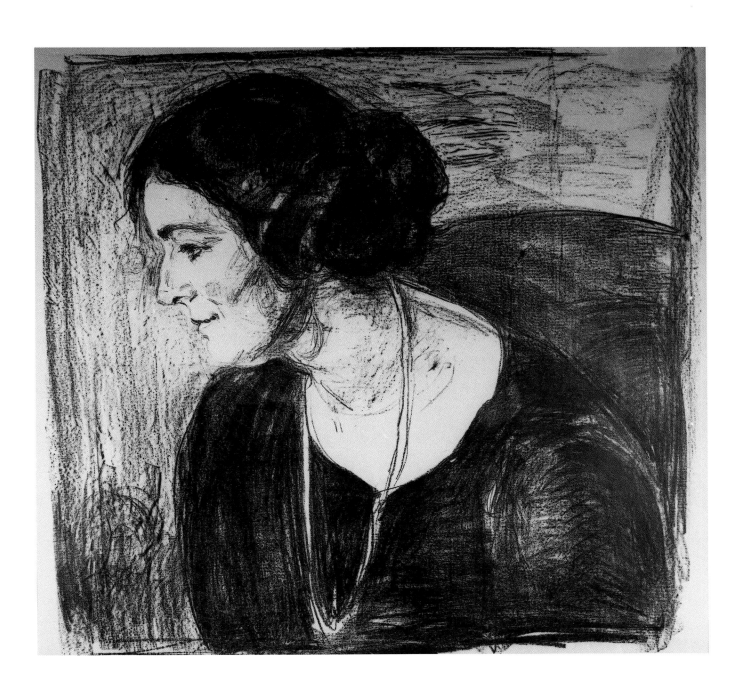

59 **Violin Concert**
1903
Lithograph
47 x 54 cm (18^1/$_2$ x 21^1/$_4$ in.)

This image is a double portrait of the musicians Eva Mudocci (1883–1953) and Bella Edwards (1866–1954), whom Munch met in Paris in 1903. The British-born violinist Mudocci (whose given name was Evangeline Muddock) became a particularly close friend of Munch's and perhaps one of his love interests. This image represents one of three portraits that Munch created of Mudocci (see cats. 60 and 61) and the only one that he rendered of Mudocci's musical and life partner, the Danish-born Bella (Isabella) Edwards.

Arne Eggum recounts that Munch was first informed of the musicians by his friend Jappe Nilssen, who wrote to Munch from Paris, calling upon the artist to assist the violinist to a "healthy" state of heterosexuality: "Two women are living as lovers here in Paris, the pianist Bella Edwards and the violinist Eva Mucicci [*sic*]. Bella Edwards exercises total control over Eva M., who, as a consequence, is miserable. On this note, I have a proposition, or a favor, to ask. Both are coming to Norway for a series of concerts. Would it be possible for you to look after Eva, romance her perhaps, try to make her more normal."[1] On the basis of the correspondence that exists between Munch and Mudocci, it seems that he approached her with a sense of desire but with a stronger sense of friendship. Indeed, it appears from the correspondence (excerpted in Stabell 1973) and from Mudocci's own account (Stabell 1973) that Munch established a friendship with both women (see pp. 16–17). They visited him in his cottage in Åsgårdstrand in 1903 and on several occasions in the following years returned to Norway, where they gave popular performances of the works of Edvard Grieg and Christian Sinding (Eggum 1994, 91). In both theme and format, the lithograph echoes the double portrait that Munch painted of the sisters Ragnhild and Dagny Juel in 1892 (*Musiserende søstre*, Private Collection), an image of musical collaboration and performance (on Dagny Juel Przybyszewska, see pp. 31–32 and cats. 24 and 25). Munch's representation of Mudocci is related to a publicity photograph of the violinist posed in a heavily beaded and embroidered gown (reproduced in Eggum 1989, 77). She holds in her left hand her Stradivarius violin and in her right, her bow, and she stands with her head tilted in concentration as she gazes at Bella. Edwards, whose portrait is likewise based in part on a publicity photograph (see Eggum 1989, 77), is viewed obliquely at the piano. Munch made her facial features and body somewhat more elegant in the lithograph than they appear in the photograph. Although the subjects are separated by the blank space at the center of the composition and contrasted by clothing and enframing areas of white and black, their concentration on the music produced by Bella's right hand resting on the piano keys creates a sense of intimacy and psychological proximity between the two. Echoing the sense of intimacy conveyed in Munch's other double portraits (see cat. 52), this might be considered a type of friendship or marriage portrait.

Note
1. Quoted in Eggum 1994, 91.

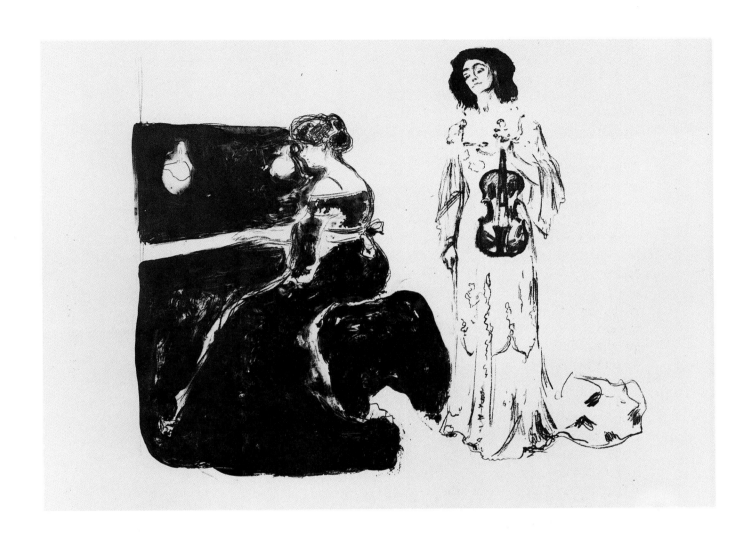

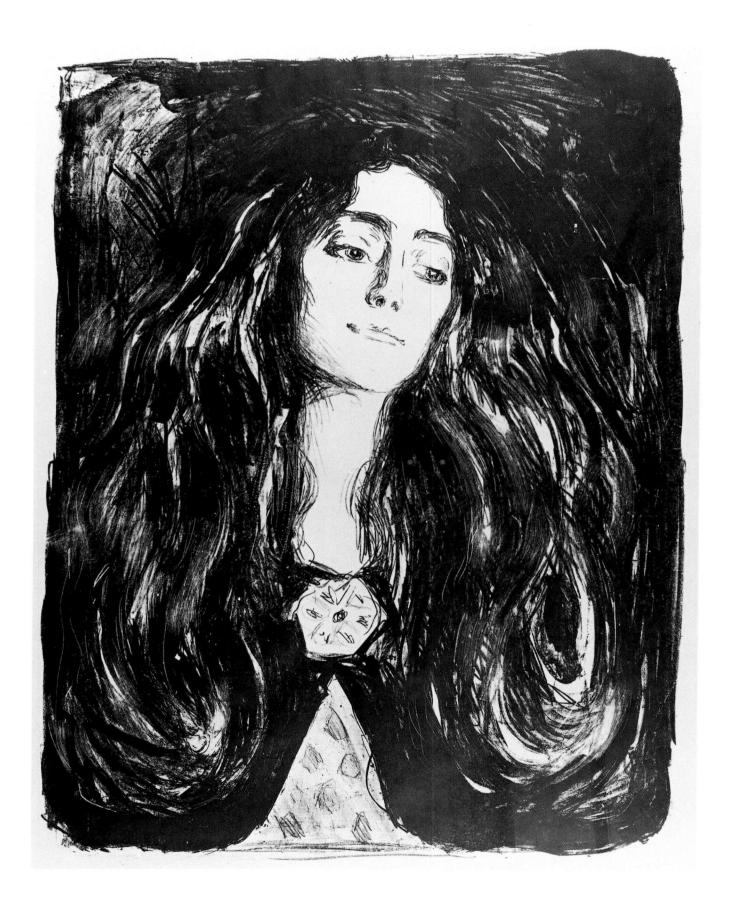

60 **Woman with a Brooch**
1903
Lithograph
60.6 x 46.4 cm (23^7/8 x 18^1/4 in.)

Munch produced this portrait of Eva Mudocci in 1903, the same year in which he created his double portrait of Mudocci and Bella Edwards (cat. 59). This image, one of Munch's most exquisite lithographic portraits, also bears the alternative title *Madonna*. The dark-haired and dramatic Mudocci is viewed from chest level, her loose hair creating a rippling frame around and strong contrast to her pale face and neck. The brooch, which serves as a visual anchor in the composition, was a gift from the art historian Jens Thiis to Mudocci in 1901 when she performed in Trondheim (Stabell 1973, 224).

In viewing Mudocci slightly from below, Munch has enhanced the length of her neck and the compression of her facial features. Her large eyes, which Munch described as appearing "two thousand years old" (Stabell 1973, 221), are directed downward and away from the viewer, creating a sense of mystery around this mute, looming presence. Mudocci reports that "It was [Munch's] ambition to make the most perfect portrait of me, but whenever he began a canvas for oils,—he destroyed it because he was dissatisfied with it. The lithographs went better, and the stones he used were sent up to our room in the hotel Sans Souci—in Berlin.—With one of them—the so-called 'Lady with the Broche' [*sic*] came a note—'Here is the stone that has fallen from my heart'" (Stabell 1973, 217).

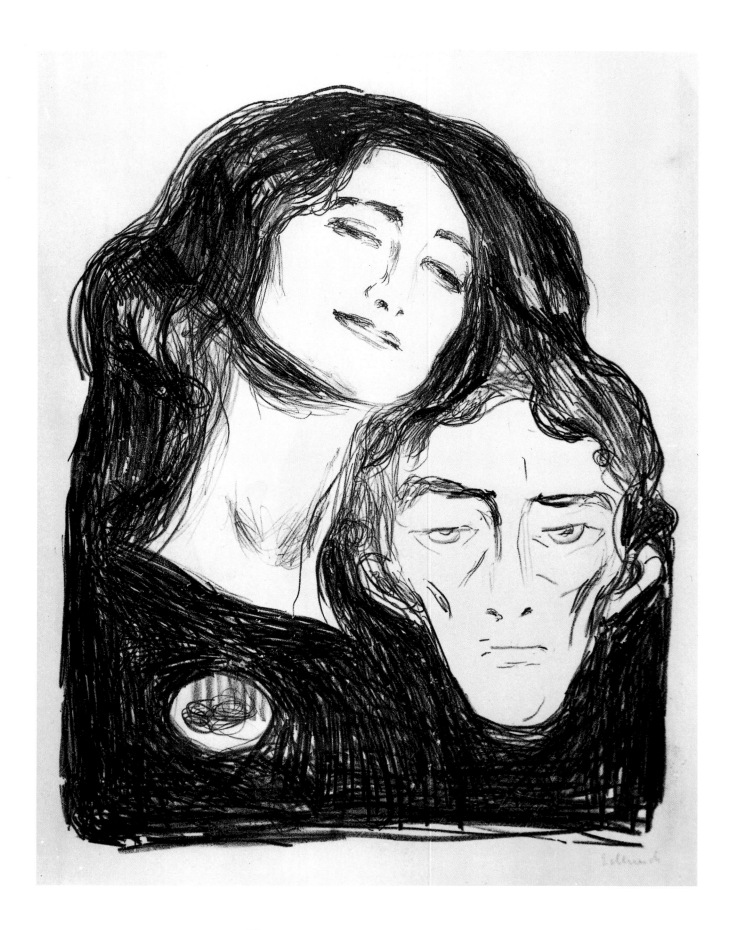

61 **Salome (Self-Portrait with Eva Mudocci)**
1903
Lithograph
39.4 x 30.5 cm (15½ x 12 in.)

Salome, a motif that repeats Munch's *Man's Head in Woman's Hair* from 1897 (cat. 24), represents Eva Mudocci in the role of Herod's daughter and the artist himself as John the Baptist in a recapitulation of the biblical story. Pictured from a similar angle to *Woman with a Brooch* (cat. 60), Mudocci wears an equally dreamy expression on her chiseled face and a brooch below her greatly attenuated neck. In this portrait, Munch has represented her with a slightly broader face and with eyes that meet the viewer's in a hooded, unfocused gaze. He has also inserted an image of his own head, triangular and nearly fleshless, below Mudocci's chin. Munch's face, large, linear, and caricatured in relation to Mudocci's refined features, appears over Mudocci's left shoulder. In a gesture that appears both protective and, ironically, as though she has substituted the artist for her violin, Mudocci rests her head against Munch's. The title, *Salome*, which transmutes the figures to the protagonists in the biblical story of John the Baptist's execution, assigns Mudocci the identity of one of the turn of the century's most widely represented femmes fatales. Mudocci reports that she objected to the title, causing "us the only disagreement we ever knew" (Stabell 1973, 217).

62

Female Nude
1896
Color mezzotint
14.9 x 12.8 cm (5⁷/8 x 5 in.)

Throughout his career, Munch worked with studio models. This study of a nude model, printed in Paris in 1896, is closely allied with model studies by Degas, Bonnard, and other French artists whose works Munch encountered in Paris. The closeness in tonality between the model's flesh and the enveloping green background renders her contours indistinct. The care with which Munch observed the diffused light that falls on her shoulder, arm, back, and upper thigh and that casts a glow on her buttocks suggests that this was a motif based on direct observation. The model's feet are obscured as though she wades through a pool of water. This detail links the nude thematically with *Bathing Girls* (cat. 7) and with Munch's aquatint of 1896–97, *Bathing Boys*, although the figure's isolation on the page and her lack of overt physical activity differ markedly from the other motifs. As an image of a model posing, *Female Nude* presages Munch's preoccupation with female studio models in his later years.

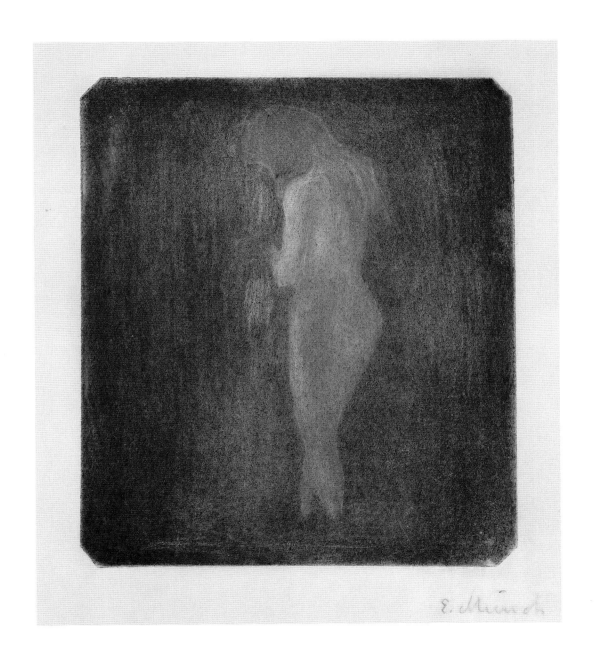

63 **The Sin**
1902
Lithograph printed in orange, ocher, and green
69.5 x 40 cm (27³/8 x 15³/4 in.)

Edvard Munch, *Photograph of a Studio Model*, silver gelatin print. Munch Museum, Oslo

Until Arne Eggum identified the studio model on which this motif is based (illustration), *The Sin* was often assumed to be an image of Munch's ex-fiancée, Tulla Larsen (see cat. 43).[1] The photograph, probably taken by Munch in his Berlin studio in 1902, depicts the professional model who, according to Eggum, posed for the artist daily.

The image defines the model in purely carnal terms. Her flowing mane of red hair functions as a set of curtains opening to reveal breasts whose heaviness is emphasized by the shadows under them, their reddened nipples, and their proximity to the her navel. Her eyes are open and staring off to the spectator's left, their green irises both attracting attention in this otherwise warm-toned composition and suggesting vacuousness. The linear frame with which Munch terminates the composition crops the model's arms so that she appears as a sexual spectacle, mute and immobilized. The title, repeating that of the German painter Franz Von Stuck's turgid representations of women (see *Sin*, 1899, Wallraf-Richartz-Museum, Cologne), moralizes the model's physicality, overlaying it and the spectator's view of it with a reference to temptation and damnation.

Note
1. Eggum 1989, 98–99.

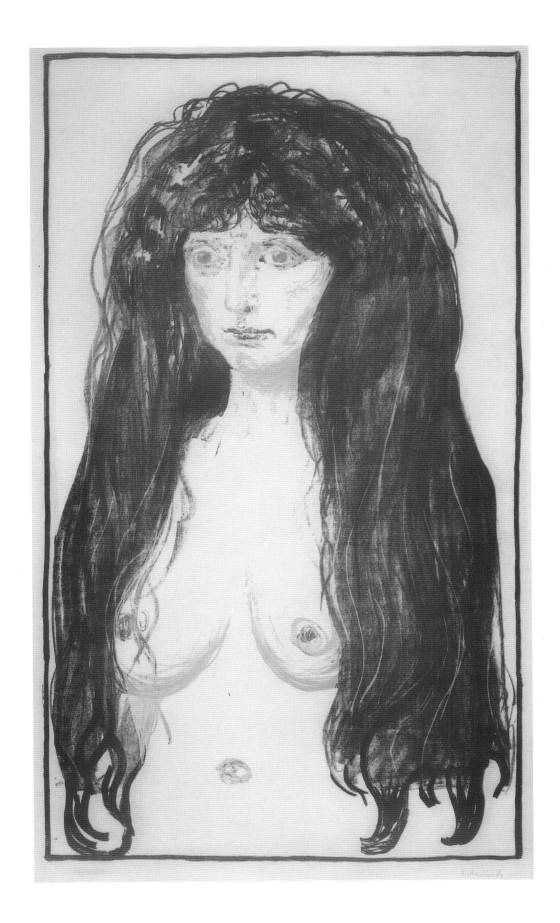

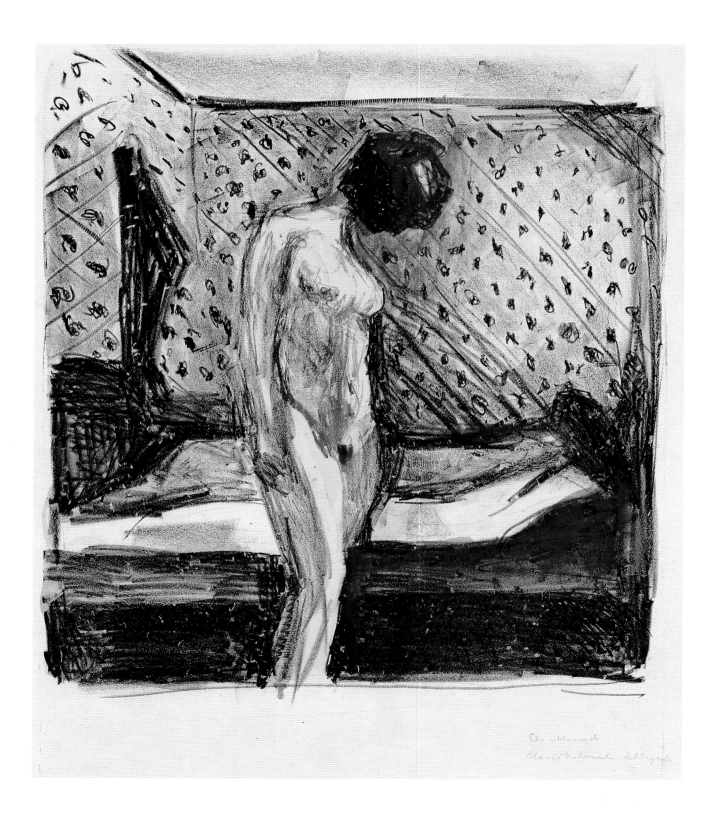

64

Weeping Girl
1930
Lithograph, hand colored
38.3 x 36.5 cm (15^1/$_{16}$ x 14^3/$_8$ in.)

**Edvard Munch, *Photograph
of Rosa and Olga Meissner*,
1907. Munch Museum, Oslo**

This composition reprises a motif that Munch created in 1908. Closely associated with a photograph of a nude model that he took in the previous year (illustration), *Weeping Girl* translates the studied posture of the model (similar to cat. 62) into a gesture of grief. In the photograph, the model stands before a bed, her left leg bent as though she is walking forward. Arne Eggum has identified her as Rosa Meissner, a professional model from Berlin, who appears in the photograph with a blurred image of her sister Olga (Eggum 1989, 128).

The contours of the room in which the model stands have been exaggerated slightly in the lithograph so that she appears oppressed by the low ceiling and the repetitively patterned wallpaper. Munch had similarly combined a compressed interior space and bold wallpaper patterning as expressive elements in his painting series from 1907, the Green Room, a vituperative narrative of seduction and betrayal through which the artist expressed his obsession with Tulla Larsen in that year (see cats. 43 and 44).

This later lithograph shares no other characteristics with the Green Room paintings, but instead incorporates the 1907 photographic image into Munch's work with nude female models from around 1930. In his later years, Munch revised and reinterpreted many of his earlier motifs, investing them with new and often elegiac meanings. This particular figure was also realized as a small-scale sculpture, cast in bronze in 1932.

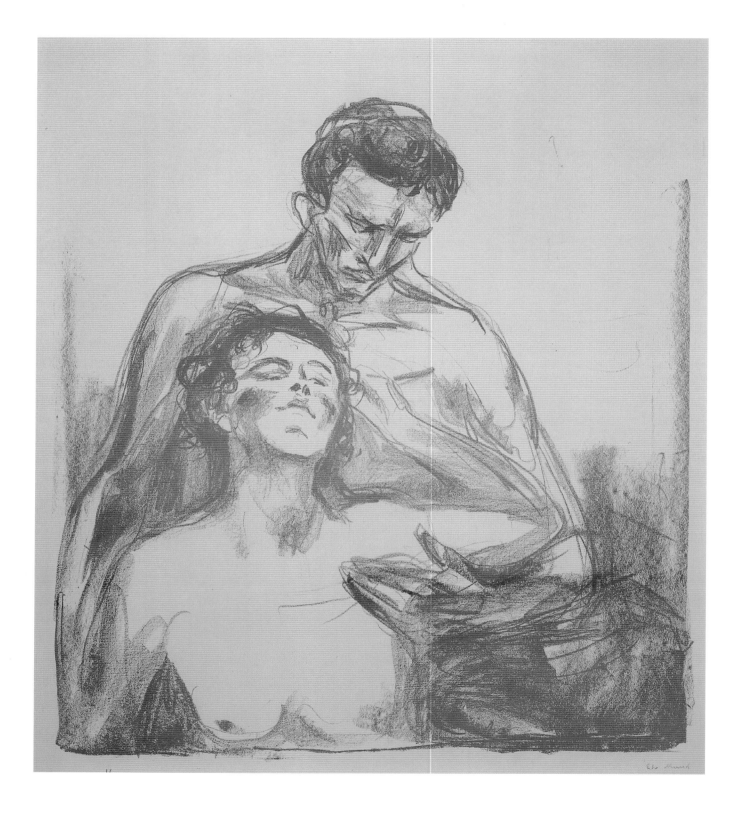

65 **Two People**
1920–23
Lithograph printed in brown
63.5 x 60.6 cm (25 x 23^{7}/$_{8}$ in.)

Two People is one of a several images that Munch produced of male and female models posing together in 1919–20. At this time, as Arne Eggum notes, Munch reexamined his motif *Madonna* from the 1890s (see cats. 19 and 20), directing a studio model to raise her arm and tilt her head in a similar manner (Eggum 1988, 80–81; see Schiefler 504). In *Two People*, the female model is represented in that position. The male, standing behind her and framing her with his naked torso, lifts his left hand to cup her underarm or perhaps present something to her. Her eyes, barely open as she gazes downward from her radically tilted head, seem to focus on the male's raised hand. His gaze seems focused in the same direction. A far less overtly erotic image than Munch's series of male and female models at sexual play from 1913 (see Eggum 1988, 60–63), *Two People* represents Munch's studio practice in his later years of engaging and stage-managing his models.

66 **Female Nude, Lying on the Ground with Baby**
1920–22
Reed pen drawing
10.3 x 13.6 cm (4^{1}/$_{16}$ x 5^{3}/$_{8}$ in.)

Cursorily rendered using a flat-nibbed pen, the sketch represents a female model lying prone in a grassy field, her attention absorbed by the baby whose face rests against her own. The baby, described by a series of tiny arching lines, is the miniaturized mirror image of the woman's anatomy. Both figures are represented nude. In the background, summarily described landscape elements marking a tree and a body of water seem to locate the pair in an expansive natural setting. The intimacy of the image and the absorption of the woman and baby in their play suggest both Munch's manifold approaches to the representation of the female body and his acknowledgement of the erotics of motherhood. Here acknowledging the body as a site of nurturing, Munch romanticizes the pleasures of maternity and of dependent infancy in an arcadian setting. Maternity was a theme that ran throughout Munch's work and that he framed in a number of ways, including the deeply pessimistic images of his own lost mother (cats. 3 and 5), maternity as a metaphor (cats. 48, 70, and 71), and motherhood as a state of emotional fulfillment (cat. 54).

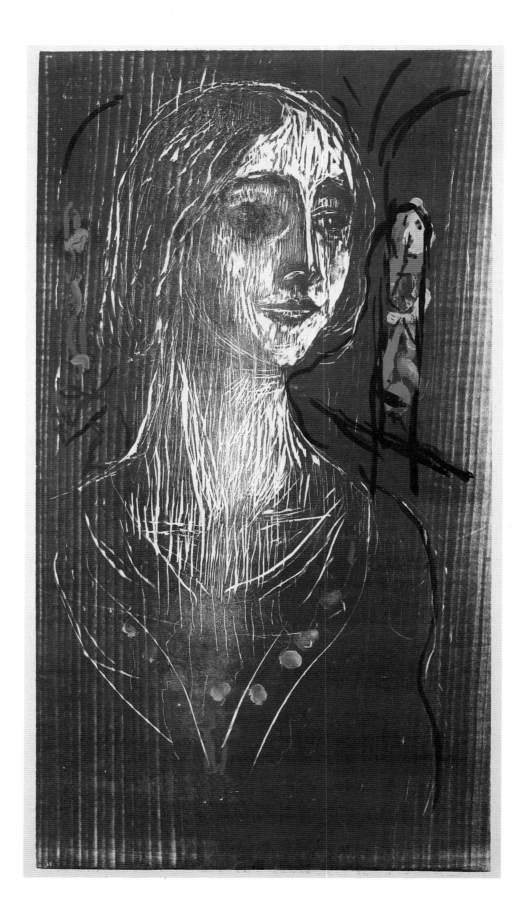

67 **Birgitte III (The Gothic Girl)**
1930
Woodcut, hand colored with gouache and touched
with oil
59.7 x 32.1 cm (23¹/2 x 12⁵/8 in.)

This woodcut represents Munch's primary studio model from the mid-1920s through the early 1930s, Birgit Prestøe (1906–86). Her sleek oval head, slim body, and compact features appear in many of Munch's works from the period, including *Bohemian's Wedding* (cat. 68). As Arne Eggum has observed, Munch's fluidly painted and richly colored studies of Prestøe are the closest that he came to paralleling the work of Henri Matisse in the period.[1]

Prestøe was born in Bergen and attended school in Kristiania. In order to support her aspirations as an actress, she took a job in an insurance company, but was able to quit when she began to model full-time for Munch. She first became aware of Munch when, on the occasion of his sixtieth birthday, the Oslo newspapers ran a series of articles about the celebrity painter. In 1924, at age 17, Prestøe presented herself to Munch as a potential model and worked with him for several years, only stopping when she moved to Stockholm in 1932.[2] On the basis of several articles that she wrote after Munch's death, Prestøe relayed valuable anecdotes about Munch and his dynamics with his models. She recalled, "I was Munch's model for many years, and came to know him as a fine and noble man, noble in all of his conduct, sympathetic and helpful when one was in trouble."[3]

The historian Bodil Stenseth describes the typical relationship between a male artist and female model in Oslo in the 1920s as, predictably, one in which the model is treated as an object. In contrast, Prestøe helped to establish modeling as a legitimate mode of work, viewing herself as a professional and as a partner.[4] In her book about Prestøe, *Modellen* (1988), Stenseth calls attention to the unusual collaborative, friendly relationship that Prestøe had with Munch. Prestøe worked as a model for a number of other artists as well, including Henrik Sørensen, and modeled for art classes. Through Munch and Sørensen, Prestøe's face was one of the most widely recognizable in Norwegian art of the 1920s and 1930s.

In *Birgitte III (The Gothic Girl)*, Munch paired Prestøe's compact head and elongated neck with the long, elegant wood grains in his panel. On the velvety surface of the print, he painted in stained glass windows and references to Gothic arches, transforming this image of Prestøe into a religious icon.

Notes
1. Arne Eggum, *Edvard Munch og hans modeller* (exh. cat. Oslo: Munch-Museet, 1988), 140–42.
2. Birgit Prestøe, interview from 1984 in the Epstein Family Archives.
3. Birgit Prestøe, "Minner om Edvard Munch," in *Edvard Munch som vi kjente ham. Vennene forteller* (Oslo: Dreyers Forlag, 1946), 106.
4. Bodil Stenseth, "Betraktninger om kunstnermodellens status," in Eggum 1988, 195.

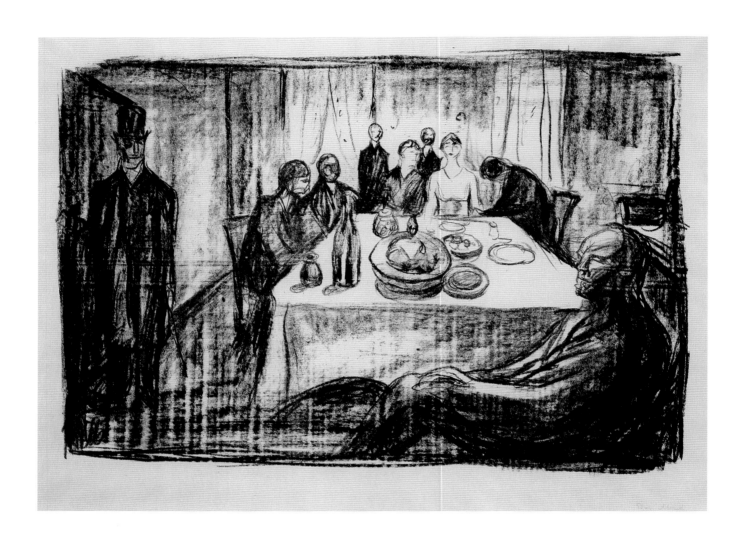

<table>
<tr><td>**68**</td><td>**Bohemian's Wedding**
1926
Lithograph
34.3 x 49.5 cm (13^{1}/$_{2}$ x 19^{1}/$_{2}$ in.)</td></tr>
</table>

Birgit Prestøe (see cat. 67) was the model for this composition, which Munch created in several painted versions in 1924–25. In it, the remains of a meager wedding banquet are spread across a table behind which sits a bride surrounded by several admiring men. In the foreground of this vast stagelike room, which includes a door, two windows, and a sofa, looms an aging man who resembles Munch. Although he is seated in front of the table with the members of the wedding party, he appears isolated from the other figures and disjunctive in scale. Because no one acknowledges him save for the nattily dressed figure at the door, it may be assumed that the scene being enacted behind Munch is a fantasy or the materialization of his thoughts.

Prestøe reports that the composition was begun at Christmastime in 1924 when Munch became inspired by a posture that she assumed while reaching for a piece of fruit at the table. Prestøe suggested, through her anecdotal account of modeling for this composition, that Munch expressed an elliptical infatuation with her: "One day when I posed for Munch he sat beside me and began to draw himself. He saw the motif reflected in a mirror that stood there. . . . Finally he said, 'It could be father and daughter sitting there and talking, or we could say that it is an old man who has fallen in love with a young girl. As it often occurs in the Old Testament . . . it occurs so much there. That an old man falls in love with a young girl, that is common, but that a young girl should fall in love with an old man, that almost never happens—but it happens nonetheless'" (Eggum 1988, 150–51).

Whether prompted by the death of Munch's colleague from the Kristiania Bohème, Christian Krohg, in 1925, or, as Arne Eggum speculates, Munch's retrospective fantasy about the wedding that he never had with Tulla Larsen (cat. 43), the title *Bohemian's Wedding* seems to make reference to events from Munch's past, perhaps overlaid with the contemporary musings that Prestøe recounts. The woman is framed by the windows in the background. She anchors the composition as the focal point of all six men who surround her and as the point of convergence of the lines defining the tabletop and the room. The men are presented in postures that indicate their attention, and in one case, supplication, to her. The woman sits impassively, her right hand resting on the table surface, as she is contemplated by the men who surround her. Indeed, the critic Pola Gauguin likened *Bohemian's Wedding* to the motif *Kristiania-Bohème II* (cat. 12) because of the central position that the woman assumes in the composition. Distanced from the man in the foreground and unmoved by the anguish expressed by the figure to her left, she appears as a self-contained and independent person, the avatar of the independent bohemian women with whom Munch associated in the 1880s and 1890s.

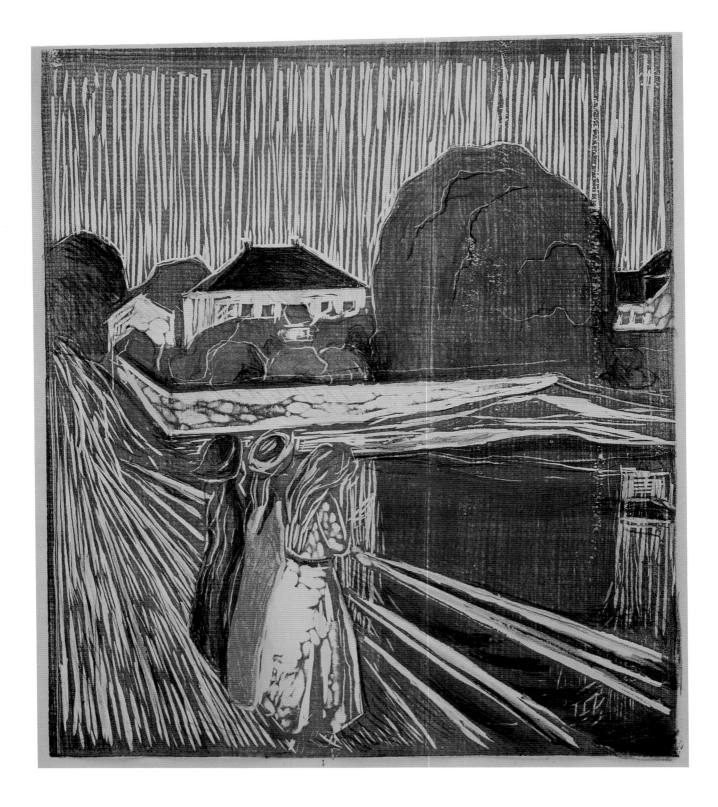

69 **Girls on the Pier**
1920
Color woodcut/color lithograph
50 x 42.8 cm (19^{11}/$_{16}$ x 16^{3}/$_{4}$ in.)

The location for this motif is the town pier in Åsgårdstrand, the small village on the Oslofjord where Munch had a summer cottage. In the background is Kiøsterudgården, the large white house and yard, and to the left is Havnegatan, the road that leads through the town and spills onto the pier like a waterfall. In the foreground of the composition stand three young women who face away from the viewer as they gaze at the water. They are dressed in black, red, and white, repeating the colors signifying the biological stages of life that Munch had explored in painted versions of *Three Stages of Woman (The Sphinx)* in the 1890s (see cat. 21). However, the massing of the three together, their contemplative postures, and the golden light that bathes them and their setting in an evening glow seem incidental to the rest of the composition.

The composition itself is the mirror image of *Girls on the Pier*, an oil painting from around 1901 (Nasjonalgalleriet, Oslo). In this later version, the gently nuanced colors, suggestive of the summer night, have been translated into a variety of repetitive linear effects and printed in a rich green. The vitality of the lines and the sense of fertility conveyed by the green coloration recall the vibrancy of the setting as it was used by Munch in his portrait of Aase Nørregaard in 1902 (fig. 1). At times providing a setting for the gathering of young girls and grown women, the bridge became for Munch a public site at which women congregated from the turn of the century to the 1930s.

70 **Alma Mater**
1914
Lithograph hand-colored
with watercolor and blue pencil
37.5 x 84.1 cm (14³/4 x 33¹/8 in.)

Edvard Munch, *History*,
1914, lithograph. Epstein
Family Collection

Ara Pacis, c. 13–9 B.C.
Museum of the Ara Pacis,
Rome

This lithograph is based on one of the central motifs that Munch created for a mural cycle for the University of Oslo between 1909 and 1916. Munch created the eleven monumental paintings for the Festival Hall, the university's chief ceremonial hall, for a competition in celebration of the university's centennial in 1911. The motifs, which include *Alma Mater*, a vast image of the rising sun, an image of an old fisherman and young boy entitled *History* (illustration), and smaller allegorical compositions, articulate simultaneously the aspirations of the university and of the fledgling nation (Norway became independent from Sweden in 1905). Representing a Norwegian peasant woman seated in a verdant landscape surrounded by her children, *Alma Mater* locates motherhood at the center of national discourses of political renewal and continuity.

Framed by a stand of trees on one side and the water, rocks, and hillocks of the southern Norwegian coastal landscape on the other, the woman is endowed with multiple nurturing roles. Bringing together Christian and secular icons of the nurturing mother and making reference to such personifications of native soil as the mother on the ancient Roman sculptural relief on the *Ara Pacis* (illustration), the peasant's sturdy body protects the children who are simultaneously hers, the fruit of the Norwegian landscape, and the future charges of the university.

Because of the important role that the university played in the Norwegian nationalist movements of the nineteenth century, the Festival Hall operates as the symbolic cradle of the nation's intellectual history.[1] Within it, *Alma Mater* is the mother and *History* the father of an ongoing national genesis. Created during the lengthy period it took for the university to accept his paintings, Munch issued this lithographic version of *Alma Mater* in part to publicize his efforts and garner support for his images. The image also reflect's Munch's interpretation of motherhood as a source of social stability and not merely, as some of his early biographers alleged, the partner of morbidity.

Note
1. On this, see Patricia G. Berman, "Edvard Munch's Peasants and the Invention of Norwegian Culture," in *Nordic Identities: Exploring Scandinavian Cultures,* ed. Berit I. Brown (Westport, Ct.: The Greenwood Press, forthcoming 1996).

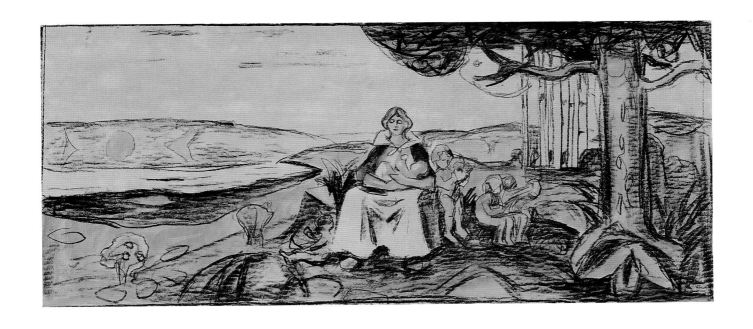

71 **Pregnant Woman Leaning against a Tree**
1915
Lithograph
68 x 48 cm (26³/4 x 18⁷/8 in.)

Created during World War I, while Munch was at work on the murals for the University of Oslo Festival Hall (see cat. 70), *Pregnant Woman Leaning Against a Tree* functions as both personal cosmology and political commentary. The woman's pregnant body acts as the locus of meaning: with face, breasts, and rounded stomach facing the sun and a child resting at her feet, the woman seems to represent the fecundity of a nurturing and peaceful landscape. Below her feet, a skeleton provides the nourishment from which her protective tree grows. By linking an emblem of death with the body of a pregnant woman, Munch calls attention to death as part of a cycle of natural regeneration and the woman's body as an agency for rebirth. Munch's numerous writings, speculating on life, death, and rebirth as parts of a biological continuum, support the reading of this image as a Monist tract.[1]

As Gerd Woll has demonstrated,[2] Munch's concern with the war in Europe was reflected in a small group of prints that he produced between 1914 and 1919. Several of the images recapitulate Munch's motifs for the University of Oslo Festival Hall. *Neutralia* (1915–16, Schiefler 459), which represents two youthful nude women picking apples while a ship founders in the background, seems to criticize Norway's neutrality during World War I. *The Tree* (1915–16, Schiefler 433), in which the base of a large central tree is overlaid with bodies, repositions the giant oak in *History* (see illustration, cat. 70), one of the Festival Hall's central motifs, as a vast memorial. Similarly, in *Pregnant Woman Leaning Against a Tree*, the background landscape familiar from *Alma Mater* (cat. 70) frames the image of a life-giving land, nourished by the sun, while the image of death lingers just below the surface. As paired motifs that originated in Munch's work of the 1890s (see for example *Life and Death*, 1897, Schiefler 95), the fertile woman and the nurturing corpse extend the theme of eros and death, which preoccupied Munch throughout his career, into a realm of metaphysics, resisting any narrow interpretation of his iconography and his aspirations.

Notes
1. On this, see Gerd Woll, "The Tree of Knowledge of Good and Evil," in Washington 1978.
2. Gerd Woll, "Kunst, Krig, og Revolusjon," in *Die Brücke—Edvard Munch* (Oslo: Munch Museum, 1978), 49–51.

Select Bibliography

Agerholt, Anna Caspari. *Den norske kvinnebevelgelses historie.* 1937. Oslo: Gyldendal Norsk Forlag, 1973.

Battersby, Christine. *Gender and Genius: Towards a Feminist Aesthetics.* Bloomington: Indiana University Press, 1989.

Berman, Patricia G. *Edvard Munch: Mirror Reflections.* Exhibition catalogue. West Palm Beach: The Norton Gallery of Art, 1985.

_____. "Body and Body Politic in Edvard Munch's *Bathing Men.*" In *The Body Imaged. The Human Form and Visual Culture Since the Renaissance,* edited by Kathleen Adler and Marcia Pointon, 71–83, 195. Cambridge University Press, 1993.

_____. "Edvard Munch's *Self-Portrait with Cigarette:* Smoking and the Bohemian Persona." *Art Bulletin* 75, no. 4 (December 1993): 627–46.

_____. "(Re-)Reading Edvard Munch: Trends in the Current Literature." *Scandinavian Studies* 66, no. 1 (Winter 1994): 45–67.

Bimer, Barbara Susan Travitz. "Edvard Munch's Fatal Women: A Critical Approach." Unpublished M.A. thesis, North Texas State University, Denton, Texas, 1985.

Boulton-Smith, John. *Frederick Delius and Edvard Munch: Their Friendship and the Correspondence.* Rickmansworth: Triad Press, 1983.

Brenna, Arne. "Edvard Munch og Hans Jæger." I and II, *Nordisk Tidskrift* 52, nos. 2 and 3 (1976): 89–115, 188–215.

_____. "Edvard Munch og Dagny Juel." *Samtiden* 87 (1978): 51–64.

Bøe, Alf. *Edvard Munch.* New York: Rizzoli, 1989.

Chamberlin, J. Edward, and Sander Gilman, eds. *Degeneration: The Dark Side of Progress.* New York: Columbia University Press, 1985.

Christian Krohg. Exhibition catalogue. Oslo: Nasjonalgalleriet, 1987.

Comini, Alessandra. "Vampires, Virgins and Voyeurs in Imperial Vienna." In *Woman as Sex Object: Studies in Erotic Art, 1730–1970,* edited by Thomas B. Hess and Linda Nochlin, 206–21. New York: Allen Lane, 1973.

Dedichen, Jens. *Tulla Larsen og Edvard Munch.* Oslo: Dreyers Forlag, 1981.

Deknatel, Frederick B. *Edvard Munch.* New York: Chanticleer Press, 1950.

Dijkstra, Bram. *Idols of Perversity: Fantasies of Feminine Evil in Fin-de-Siècle Culture.* New York: Oxford University Press, 1986.

Dittmann, Reidar. *Eros and Psyche: Strindberg and Munch in the 1890s.* Ann Arbor: UMI Research Press, 1982.

Dowling, Linda. "The Decadent and the New Woman." *Nineteenth Century Fiction* 33, no. 4 (March 1979): 434–53.

Duncan, Carol. "Virility and Domination in Early Twentieth-Century Vanguard Painting" (1973). In *Feminism and Art History: Questioning the Litany,* edited by Norma Broude and Mary D. Garrard, 293–314. New York: Harper & Row, 1982.

Edvard Munch som vi kjente ham. Vennene forteller. Oslo: Dreyers Forlag, 1946.

Eggum, Arne. *Edvard Munch. Paintings, Sketches and Studies.* Oslo: J. M. Stenersens Forlag, 1984.

_____. *Edvard Munch og hans modeller 1912–1943.* Exhibition catalogue. Oslo: Munch Museum, 1988.

_____. *Munch and Photography.* New Haven: Yale University Press, 1989.

_____. *Edvard Munch: Livsfrisen fra Maleri til Grafikk*. Oslo: J. M. Stenersens Forlag, 1990.

_____. *Edvard Munch: Portretter*. Exhibition catalogue. Oslo: Labyrinth Press, 1994.

Eggum, Arne, Sibylle Baumbach, Sissel Biørnstad, and Signe Böhn. *Edvard Munch/Gustav Schiefler. Briefwechsel*. 2 volumes. Hamburg: Verlag Verein für Hamburgische Geschichte, 1987.

1880-årene i Nordisk maleri. Exhibition catalogue. Oslo: Nasjonalgalleriet, 1985.

Epstein, Sarah G. In *Master Prints from the Epstein Family Collection*. Exhibition catalogue. Washington: National Gallery of Art, 1990.

Epstein, Sarah G., and Jane Van Nimmen. *The Prints of Edvard Munch; Mirror of His Life*. Exhibition catalogue. Oberlin: Allen Memorial Art Museum, 1983.

Gierløff, Christian. *Edvard Munch selv*. Oslo: Gyldendal Norsk Forlag, 1953.

Gilman, Sander L. *Disease and Representation: Images of Illness from Madness to AIDS*. Ithaca: Cornell University Press, 1988.

Graen, Monika. *Das Dreifrauenthema bei Edvard Munch*. Thesis, University of Freiburg. Frankfurt: Europäische Hochschulschriften, Reihe 28, Kunstgeschichte, v. 48, 1985.

Hagemann, Sonja. "Dagny Juel Przybyszewska: Genienes Inspiratrise." *Samtiden* 72, no. 10 (1963): 655–68.

Heber, Knut. "Dagny Juel: Utløseren av Edvard Munchs Kunst i Kampårene 1890–1908. *Kunst og Kultur* 60, no. 1 (1977): 1–18.

Heller, Reinhold. "Strømpefabrikanten, Van de Velde og Edvard Munch." *Kunst og Kultur* 51, no. 2 (1968): 89–104.

_____. "Edvard Munch's 'Life Frieze': Its Beginnings and Origins." Unpublished Ph.D. diss. Bloomington: Indiana University, 1969.

_____. "The Iconography of Edvard Munch's *The Sphinx*." *Artforum* 9, no. 2 (October 1970): 72–80.

_____. *Edvard Munch: The Scream*. New York: Viking Press, 1973.

_____. "Edvard Munch's "Night," the Aesthetics of Decadence, and the Content of Biography." *Arts* 53, no. 2 (October 1978): 80–105.

_____. *Edvard Munch. His Life and Work*. London: John Murray Publishers, Ltd., 1984.

Heller, Reinhold, et al. *The Earthly Chimera and the Femme Fatale: Fear of Woman in Nineteenth-Century Art*. Exhibition catalogue. The David and Alfred Smart Gallery, The University of Chicago, 1981.

Hennum, Gerd. *Ingrid Lindbäck Langaard. Viljesterk kvinne i Kunsten*. Oslo: Dreyers Forlag, 1987.

Hofmann, Werner, et al. *Eva und die Zukunft: Das Bild der Frau seit der Französischen Revolution*. Exhibition catalogue. Munich: Prestel-Verlag, 1986.

Høifødt, Franck. "Smertens Blomst: Et Supplement." *Kunst og Kultur* 72, no. 4 (1989): 219–31.

_____. "Livetsdans." *Kunst og Kultur* 73, no. 3 (1990): 166–81.

Jaworska, Wladyslawa. "Edvard Munch and Stanislaw Przybyszewski." *Apollo* (October 1974): 312–17.

Jayne, Kristie. "The Cultural Roots of Edvard Munch's Images of Women." *Woman's Art Journal* 10, no. 1 (Spring/Summer 1989): 128–34.

Jullian, Philippe. *The Symbolists*. Translated by Mary Anne Stevens. London: Phaidon Press, 1973.

Kingsbury, Martha. "The Femme Fatale and Her Sisters." In *Woman as Sex Object: Studies in Erotic Art, 1730–1970*, edited by Thomas B. Hess and Linda Nochlin, 182–205. New York: Allen Lane, 1973.

Krog, Gina. *Norske Kvinders Retslige og Sociale Stilling*. Kristiania: H. Aschehoug & Co. Forlag, 1894.

Krohg, Christian. *Kampen for Tilværelsen*. Oslo: Gyldendal Norsk Forlag, 1989.

Langaard, Ingrid. *Edvard Munch. Modningsår*. Oslo: Gyldendal Norsk Forlag, 1960.

Lathe, Carla. "The Group *Zum Schwarzen Ferkel*. A Study in Early Modernism." Unpublished Ph.D. diss., University of East Anglia, Norwich, 1972.

_____. "Edvard Munch and Modernism in the Berlin Art World 1892–1903." In *Facets of European Modernism. Essays in Honour of James McFarlane,* edited by Janet Garton, 99–129. Norwich: University of East Anglia, 1985.

Linde, Max. *Edvard Munch und die Kunst der Zukunft*. Berlin: Friedrich Gottheiner Verlag, 1902.

Lippincott, Louise. *Edvard Munch. Starry Night*. Malibu: J. Paul Getty Museum, 1988.

London 1992
Wood, Mara-Helen, ed. *Edvard Munch: The Frieze of Life*. Exhibition catalogue. National Gallery.

Lombroso, Cesare. *The Man of Genius*. London: The Walter Scott Publishing Co., Ltd., 1905.

Lombroso, Cesare, and William Ferrero. *The Female Offender*. New York: D. Appleton & Co., 1895.

Marandel, Patrice J. "Rodin's *Thinker:* Notes on the Early History of the Detroit Cast." *Bulletin of the Detroit Institute of Arts* 62, no. 4 (1987): 33–52.

Meier-Graefe, Julius. "Edvard Munch. Eight Intaglio Prints." In *Edvard Munch 1895. Første år som grafiker*. Oslo: Munch-Museet, 1895.

Moen, Arve. *Edvard Munch: Woman and Eros*. Oslo: Forlaget Norsk Kunstreproduksjon, 1957.

Montreal 1995
Clair, Jean, et al. *Lost Paradise: Symbolist Europe*. Exhibition catalogue. Montreal Museum of Fine Arts.

Munch und Deutschland. Exhibition catalogue. Munich: Kunsthalle der Hypo-Kulturstiftung, 1994.

Munch, Edvard. "Dagny Przybyszewska." *Kristiania Dagsavis* (June 25, 1901).

Munch, Inger, ed. *Edvard Munchs brev: Familien*. Oslo: Munch-Museets Skrifter I, Oslo, 1949.

Nordau, Max. *Degeneration*. New York: D. Appleton and Company, 1895.

Norseng, Mary Kay. *Dagny: Dagny Juel Przybyszewska, The Woman and the Myth*. Seattle: University of Washington Press, 1991.

Paris 1987
Lumières du Nord. La peinture Scandinave 1885–1905. Exhibition catalogue. Musée du Petit Palais.

Paris 1992
Eggum, Arne, and Rodolphe Rapetti. *Munch et la France*. Exhibition catalogue. Musée D'Orsay.

Pater, Walter. *The Renaissance*. Introduction by Arthur Symons. 1873; New York: Random House, 1924.

Pollock, Griselda. "Degas/Images/Women; Women/Degas/Images: What Difference Does Feminism Make to Art History." Edited by Richard Kendall and Griselda Pollock, 22–39. In *Dealing with Degas: Representations of Women and the Politics of Vision*. New York: Universe, 1992.

Prelinger, Elizabeth. *Edvard Munch: Master Printmaker. An Exhibition of the Artist's Works and Techniques Based on the Philip and Lynn Straus Collection*. Exhibition catalogue, Busch-Reisinger Museum, Harvard University. New York: W. W. Norton and Co., 1983.

Przybyszewski, Stanislaw, Franz Servaes, Willy Pastor, and Julius Meier-Graefe. *Das Werk des Edvard Munch: Vier Beiträge*. Berlin: S. Fischer Verlag, 1894.

Ravenal, Carol. *Edvard Munch: Paradox of Woman.* Exhibition catalogue. New York: Aldis Browne Fine Arts, Ltd., 1981.

Schiefler, Gustav. *Verzeichnis des graphischen Werks Edvard Munchs bis 1906.* 1907. Oslo: J. W. Cappelens Forlag, 1974.

_____. *Edvard Munch: Das graphische Werk, 1906–1926.* 1927. Oslo: J. W. Cappelens Forlag, 1974.

Schmidt-Burkhardt, Astrit. "Curt Glaser—Skizze eines Munch-Sammlers." *Zeitschrift des Deutschen Vereins für Kunstwissenschaft* 42, no. 3 (1988): 63–75.

Schneede, Uwe M. *Edvard Munch: Das kranke Kind.* Frankfurt: Fischer Taschenbuch Verlag, 1984.

Showalter, Elaine. *Sexual Anarchy: Gender and Culture at the Fin de Siècle.* New York: Penguin Books, 1990.

Silverman, Deborah L. *Art Nouveau in Fin-de-Siècle France: Politics, Psychology, Style.* Berkeley: University of California Press, 1989.

Skedsmo, Tone. "Tautrekking om Det syke Barn." *Kunst og Kultur* 68, no. 3 (1985): 184–95.

_____. *Edvard Munch i Nasjonalgalleriet.* Oslo: Nasjonalgalleriet, 1989.

Stabell, Waldemar. "Edvard Munch og Eva Mudocci." *Kunst og Kultur* 56, no. 4 (1973): 209–36.

Stang, Ragna. *Edvard Munch: The Man and His Art.* Translated by Geoffrey Culverwell. New York: Abbeville Press, Inc., 1979.

Stenersen, Rolf. *Edvard Munch: Close-Up of a Genius.* 1944. Translated and edited by Reidar Dittmann. Oslo: Gyldendal Norsk Forlag, 1969.

Stockholm 1977
Edvard Munch 1863–1944. Exhibition catalogue. Liljevalchs och Kulturhuset.

Strindberg, August. *The Cloister.* Edited by C. G. Bjurström, translated by Mary Sandbach. New York: Hill and Wang, 1969.

_____. "L'exposition d'Edward Munch." *La Revue Blanche* 10 (June 1, 1896): 525–26.

Strindberg, Frida. *Marriage with Genius.* London: Jonathan Cape, 1937.

Torjusen, Bente. *Words and Images of Edvard Munch.* Chelsea, Vt.: Chelsea Green Publications, 1986.

Varnedoe, Kirk. "Christian Krohg and Edvard Munch." *Arts* 53, no. 8 (April 1979): 88–95.

_____. *Northern Light. Realism and Symbolism in Scandinavian Painting 1880–1910.* Exhibition catalogue. The Brooklyn Museum, 1982.

Von Schemm, Jürgen, et al. *Edvard Munch. Sommernacht am Oslofjord, um 1900.* Exhibition catalogue. Städtische Kunsthalle Mannheim, 1988.

Washington 1978
Edvard Munch: Symbols and Images. Exhibition catalogue. National Gallery of Art.

Weininger, Otto. *Sex and Character.* Translated from the sixth German edition. London: William Heinemann, 1903.

Weisner, Ulrich, ed. *Edvard Munch—Liebe—Angst—Tod. Themen und Variationen.* Exhibition catalogue. Kunsthalle Bielefeld, 1980.

West, Shearer. *Fin de Siècle: Art and Society in an Age of Uncertainty.* Woodstock, N.Y.: The Overlook Press, 1993.

Wichstrøm, Anne. "Asta Nørregaard og den unge Munch." *Kunst og Kultur* 65, no. 2 (1982): 66–77.

_____. Kvinner ved staffeliet: *Kvinnelige malere i Norge før 1900.* Oslo: Universitetsforlaget, 1983.

_____. *Oda Krohg: Et Kunstnerliv.* Oslo: Gyldendal Norsk Forlag, 1988.

Yarborough, Bessie Rainsford (Tina). "Exhibition Strategies and Wartime Politics in the Art and Career of Edvard Munch, 1914–1921." Unpublished Ph.D. diss., University of Chicago, 1995.

Index